Artists' Books:

A Critical Anthology and Sourcebook

ARTISTS'

A Critical Anthology

Edited by Joan Lyons

Gibbs M. Smith, Inc.

Peregrine Smith Books

BOOKS:

and Sourcebook

in association with

Visual Studies Workshop Press, 1985

Grateful acknowledgement is made to the publications in which the following essays first appeared: "Book Art," by Richard Kostelanetz, in *Exhaustive Parallel Intervals*, Future Press, 1979; "The New Art of Making Books," by Ulises Carrión, in *Second Thoughts*, Amsterdam: VOID Distributors, 1980; "The Artist's Book Goes Public," by Lucy R. Lippard, in *Art in America* 65, no. 1 (January-February 1977); "The Page as Alternative Space: 1950 to 1969," by Barbara Moore and Jon Hendricks, in *Flue*, New York: Franklin Furnace (December 1980), as an adjunct to an exhibition of the same name; "The Book Stripped Bare," by Susi R. Bloch, in *The Book Stripped Bare*, Hempstead, New York: The Emily Lowe Gallery and the Hofstra University Library, 1973, catalogue to an exhibition of books from the Arthur Cohen and Elaine Lustig collection supplemented by the collection of the Hofstra Fine Arts Library.

Designed by Joan Lyons
Typeset by Susan Cergol at the Visual Studies Workshop
Cover design by Janet Zweig

Visual Studies Workshop Press
31 Prince Street, Rochester, New York 14607

Distributed by
Gibbs M. Smith, Inc., Peregrine Smith Books
P.O. Box 667, Layton, Utah 84041

1985

Library of Congress Cataloging in Publication Data
Main entry under title:
Artists' books.

 Bibliography: p.
 Includes index.
 1. Artists' books. 2. Conceptual art. I. Lyons,
Joan, 1937-
N7433.3.A75 1985 700'.9'04 85-3180
ISBN 0-89822-041-6
ISBN 0-87905-207-4 (Peregrine Smith)

Contents

Introduction and Acknowledgements

O VER THE LAST twenty years visual artists, increasingly concerned with time-based media, have rediscovered the book, investigating and transforming every aspect of that venerable container of the written word. They have manipulated page, format, and content—sometimes subtly, sometimes turning the book into a reflexive discussion of its own tradition. They have illustrated real time in simple flip books or collaged real time with fictive time into complex layers. They have disguised artists' books as traditional books and made others that are scarcely recognizable. The best of the bookworks are multi-notational. Within them, words, images, colors, marks, and silences become plastic organisms that play across the pages in variable linear sequence. Their importance lies in the formulation of a new perceptual literature whose content alters the concept of authorship and challenges the reader to a new discourse with the printed page.

Artists' books began to proliferate in the sixties and early seventies in the prevailing climate of social and political activism. Inexpensive, disposable editions were one manifestation of the dematerialization of the art object and the new emphasis on art process. Ephemeral artworks, such as performances and installations, could be documented and, more importantly, artists were finding that the books could *be* artworks in and of themselves. It was at this time too that a number of artist-controlled alternatives began to develop to provide a forum and venue for many artists denied access to the traditional gallery and museum structure. Independent art publishing was one of these alternatives, and artists' books became part of the ferment of experimental forms. Many saw the book as a means for reaching a wider audience beyond the confines of the art world; others anticipated the appropriation of images and/or techniques of mass media for political or aesthetic reasons.

Women artists in large numbers began to make books responding, in part, to the adaptability of the medium to narrative and diaristic concerns. Conceptual artists recognized the systemic potentials of the book. The activity was spontaneous and worldwide. If artists in North America had all the fallout of a media-mad society to work with, including corner quick-copy centers and cast-off offset equipment, those in Eastern Europe and Latin America had rubber stamps and mimeographs.

Now, twenty years and thousands of artists' books later, it is clear that this highly independent and under-acknowledged art form is here to stay. The books are becoming richer, their language more complex. A support structure has developed that includes artist-run printshops, distributors, bookstores, collections, exhibitions, at least a few publications that review books, and—importantly—some funding support from public, and to a lesser extent, private sources.

Although several highly successful conferences have helped to identify key issues and potential authors, most of the writing on bookworks to date has been limited to brief surveys, essays in exhibition catalogues, and book reviews. This anthology, then, is the first in-depth look at the territory. What are the origins, attributes, and potentials of artists' books? What are their historical precedents? What issues are they addressing? Who is making them and publishing them? Where are collections and resources to be found? The texts that follow, written by long-time participants in and observers of the field, form a survey from which a much-needed critical discourse might evolve. Located as we are in the terrain, we have probably missed an island or two or exaggerated the size of a mountain. In some charted areas suitable material was not forthcoming. What is here is our best shot—a wealth of information about an exciting new medium. We have begun the work of sewing the bits and pieces into a fabric. Perhaps a pattern will emerge. If so, it will no doubt be a crazy-quilt, that quirky design-defying piecework that achieves harmony through infinite variety.

This book has been a group effort, the product of the contributions of many individuals. It has grown out of the resources of the Visual Studies Workshop. First, I would like to thank Nathan Lyons who, when he began the Workshop in 1969, understood that a focus on making, collecting, and viewing visual books is indispensible to visual studies—and that print is a necessary tool for artists and photographers.

Helen Brunner and Don Russell are largely responsible for developing a number of book-related projects at the Workshop including the Independent Press Archive, information files, and book exhibition

program. Brunner compiled the collections listing and supervised work on the bibliography, which appear at the back of the book. "Independent Art Publishing," a 1979 international book conference, coordinated by Russell, laid the groundwork that made this book possible. Both Brunner and Russell were involved in the preliminary editorial decisions that shaped this work. Although other commitments prevented them from seeing the project through, primary credit for initiating it belongs to them.

The bibliography of secondary sources was compiled by Glenn Knudson and Barbara Bosworth. Although a listing of all those who contributed to the bibliography appears at the beginning of that section, special acknowledgement is due to Barbara Tannenbaum who not only generously contributed her own research but provided an update from the time the project was completed at the Workshop in the summer of 1983.

All of the books illustrated, unless otherwise credited, are from the collection of the Visual Studies Workshop. Every effort has been made to contact the artists for permission for this use. We are grateful for their contributions. The photographs were made by Dana Davis, Linda McCausland, and Cindi Coyle. Susan Cergol has typeset the entire manuscript and, in addition, helped with proofreading and mechanicals. Thanks to Martha Gever for help wth copy editing and to Karen Brown, Elizabeth Caldwell, Aimée Ergas, and Susan Kinney for help with various editorial chores. Thanks also to David Trend, Robert Bretz, and the rest of the staff at the Workshop for assistance and support.

The impetus to produce this anthology came from a community of people passionately committed to the new book discussed in these pages. They helped in many ways, some directly, by reading manuscripts, advising, contributing research—others indirectly, by example of their work in the field. So thanks to Judith Hoffberg, for her tireless effort on behalf of artists and their books, to Clive Phillpot, Janet Dalberto, Ken Friedman, Jean-Paul Curtay, Dick Higgins, Alison Knowles, Gary Richman, Dale Davis, Keith Smith, Stan Bevington of Coach House Press. Thanks to Martha Wilson and Matthew Hogan of Franklin Furnace, to the staff of Printed Matter, and to many others.

This book has been funded, in part, by grants from the New York State Council on the Arts and the National Endowment for the Arts.

Finally, thanks to Gibbs M. Smith and the staff of Peregrine Smith Books for committing their resources to this traditional book about those "other books."

Joan Lyons
Rochester, New York 1985

A Preface

by Dick Higgins

*T*HERE IS A MYRIAD of possibilities concerning what the artist's book can be; the danger is that we will think of it as just this and not that. A firm definition will, by its nature, serve only to exclude many artists' books which one would want to include.

Given that caveat, let's try for a grey, rather than a black and white, definition. I'd suggest: a book done for its own sake and not for the information it contains. That is: it doesn't contain a lot of works, like a book of poems. It *is* a work. Its design and format reflect its content—they intermerge, interpenetrate. It might be any art: an artist's book could be music, photography, graphics, intermedial literature. The experience of reading it, viewing it, framing it—that is what the artist stresses in making it.

The illusion is that it is something new. Not so. Blake's most visual books are obvious early artists' books. But probably there have always been some of them being done. They didn't begin with Blake in the late eighteenth century. But many were lost, and many nearly lost. For example, these might include the not-so-strange but certainly unusual books of André Bayam, a Portuguese from Goa in India, who worked in the early seventeenth century. His language was Latin and he used it as part of his flow, not for the sake of making powerful works but for the sharing of joy, as artists are so apt to. Most of his books were made in miniscule editions and most copies are lost. Perhaps they should be reprinted, starting with the *Panegyricus sine verbis de s. Philippi Nerii laudibus, dictus in eius celebritate Urbeveteri in maiori basilica anno 1629 . . .* (Urbe Veteri: ex typographia Rainuldo Ruuli, 1629)—"A panegyric without words in praise of Philip Nerii, spoken in his celebration at Urbe Veteri in the big cathedral in the year 1629 . . ." One would like to know just what was spoken—sound poetry? Something like sound poetry was in vogue at the time, as was pattern poetry, the

visual poetry which our learned professors have been hiding from us all these years because it confuses their neat pictures, but that's another story. Anyway, the importance to us of knowing of our brothers and sisters doing artists' books and such-like in earlier times is that it tells us that what we're doing is not some weird modern eccentricity "for specialists only," but a perfectly natural human expression. It gives us continuity with other times and cultures.

Of course, looking towards modern times, the "books" (sometimes called "non-books" too) of Dieter Roth and Bern Porter in the 1950s are also artists' books, as anyone knows who visited Porter's show at Franklin Furnace in New York City ca. 1981, or the various big shows of Roth's books in London, Amsterdam, and elsewhere in the 1970s. So, what we have is a form which is not, per se, new, but whose "time has come." And what this means is a matter of audience more than of artist. Not that artists' books are being done in production runs of 10,000 copies, but the genre is now defined in some way. There are stores and outlets for the books and, as a result, the perception of the artist's book has changed from it being an eccentricity to it being an integral part, sometimes central to an artist's work—the main medium of expression, and sometimes an important venture for an artist whose main concern lies elsewhere. We see an artist's non-book work, and we say, "Gee, wouldn't it be interesting if so-and-so would do a book." And maybe so-and-so does.

Perhaps the hardest thing to do in connection with the artist's book is to find the right language for discussing it. Most of our criticism in art is based on the concept of a work with separable meaning, content, and style—"this is what it says" and "here is how it says what it says." But the language of normative criticism is not geared towards the discussion of an experience, which is the main focus of most artists' books. Perhaps this is why there is so little good criticism of the genre. Besides, where would it be published? Traditional art magazines are too busy servicing their gallery advertisers, and the focus on the book experience is not what the critics are used to doing anyway. "What am I experiencing when I turn these pages?" That is what the critic of an artist's book must ask, and for most critics it is an uncomfortable question. This is a problem that must be addressed if the audience for artists' books is to continue to grow, if they are to reach a larger public.

But it will happen. The making of artists' books is not a movement. It has no program which, when accomplished, crests and dies away into the past. It is a genre, open to many kinds of artists with many different styles and purposes, and so its likely future is that it will simply be absorbed into the mainstream and will be something which artists do as a matter of course, each in his or her own way. To that we can look forward with delight.

Plates: A Visual Preface

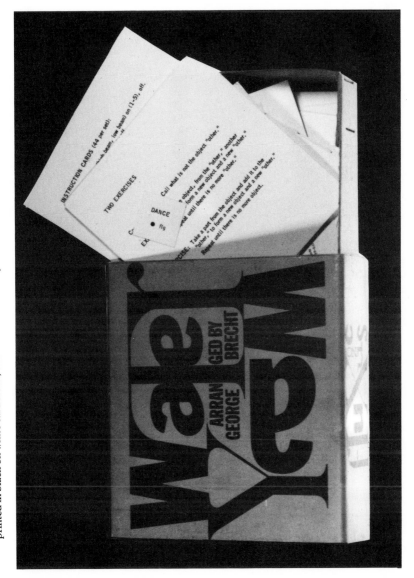

George Brecht, *Water Yam* Fluxus Edition, 1963. Cardboard box containing eighty scores of various sizes printed in black on white card stock, 6x6½x1¼ in. Courtesy of the Gilbert and Lila Silverman Fluxus Collection.

Bern Porter, *Found Poems*, Millerton, New York: Something Else Press, Inc., 1972. 240 pp hardbound, 8½x11 in., printed in black on cream text with color dust jacket.

Charles Henri Ford, *Spare Parts*, New York: Horizon Press, 1966. 160 pp hardbound, 10x11¾ in., printed in Greece in several colors under the supervision of the author, one-of-a-kind color dust jackets, edition of 950.

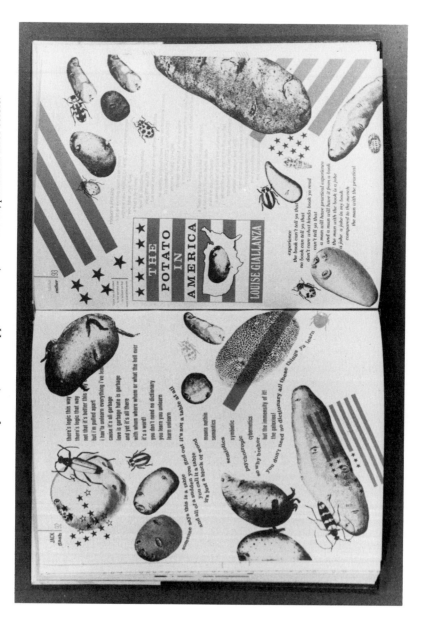

Warren Lehrer and Dennis Bernstein, *French Fries*, Purchase, New York: ear/say books, and Rochester, New York: Visual Studies Workshop Press, 1985. 104 pp hardbound, 8¼x10¾ in., printed in three colors.

Tom Phillips, *A Humument*, New York: Thames and Hudson, 1982. 367 pp, folded at fore edge, paper covers, 5x7 in., full-color separations throughout from color originals.

Madeline Gins, *Word Rain or a Discoursive Introduction to the Intimate Philosophical Investigations of G,r,e,t,a, G,a,r,b,o, It Says*, New York: Grossman Publishers, 1969. 116 pp hardbound, 6¼x8½ in., printed in black.

As I started to read the third paragraph of page thirteen, I finished up the crabmeat salad sandwich which was good. Now I found myself reading word for word. The second line was about the nature of the logical guess. The third line was an extension of the premise of the first two. The fourth line was the words seems, getting, to, be, quite, late. Although this sentence was necessary for the progress of the story, it tended to warp that particular paragraph out of shape. Then someone in the fifth line suggested that a thorough study should be made of the act of guessing. If a ratio could be found for the respective inputs of the logic of intuition, emotion and reason, for what would make up a good guess, it would be of tremendous importance. In the next line (in which?) he admitted that there would be a lot of guesswork involved.

The mist was almost dripping down as it snuggled about close and far. "Well as I live and breathe, if it isn't Ben's little boy. Will you tell me ..."

"Step up and watch out for the doo..."

"Right off the bat." "The law is the law." "It... that homogeneous grouping is of course out of ... tion." Stepping all over everything, not a care in mind." "About nothing." "Don't mention it." "The alarm clock didn't ring this morning." "Don't let a thing like that upset you." "Either you have the knack for telling a joke or you don't." "And are you going to leave it just at that?" "That isn't it is underneath it."

I came from a small town on Long Island where the earth was fairly fertile. Many little inlets let the water reach the potato and duck farms which circle the town. Mary came from a hill town rich with streams. Judy comes from some of the richest farmlands in this country

The speaker was at the rostrum again. "Delicious, thank you," I screamed into the other room. As I paid attention in the direction of the kitchen, waiting patiently for my answer. I heard Will's mother explain how she would love to stay for Linda's party, but something, something, something and she'd be back for him at ____30 or 7:00 at the latest.

I came down from the rostrum and walked back to my seat on the noduled platform. As I picked up the fourteenth page, the word and the blow came to me with ease. Mary's guess in a word was pismire-col-ony. Why, because they had ordered them from Cali-fornia seventy-four years ago. And though the request had never been answered in her grandmother's lifetime, the receipt was still on hand. In fact, letters about the difficulties of procuring and then maintaining a healthy colony, and the complications involved in the shipment of it were still part of their current affairs.

That was piss for urine and mire for ant, so named for their discharge, which was an irritant fluid so named because popularly regarded as urine.

The bottom corner of the package was already moist. Also, the lack of organization of the ant colony company would easily explain the absence of any marking on the package and the missing letter. By the end of the page, the others were mistily saying doubtful yet possible. Their guessing was startlingly interrupted by cries from outside.

Don't touch me. Stop it. I told you before. What! I don't care, leave it you want to. Don't leave. Don't touch me.

To describe how they'd reacted to this the author wrote. They felt the ™ centers of their feeling slip several vertebrae (or the equivalent distance but a little

Janet Zweig, *Heinz and Judy*, Boston: The Photographic Resource Center, 1985. 16 pp, hardbound, 8¾ x 11 in., printed in full color.

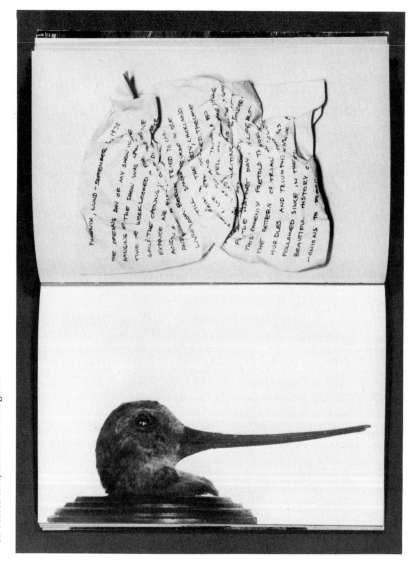

Susan Weil, *Birdsong Heartbeats*, Sweden: Kalejdoskop, 1980. 78 pp. paper covers, 6½x9¾ in., printed in black on coated text, halftones throughout.

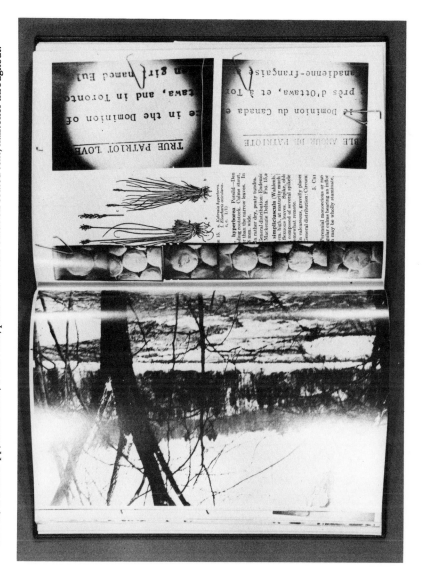

Joyce Weiland, *True Patriot Love (Véritable amour patriotique)*, Ottawa, Canada: The National Gallery of Canada, 1971. 222 pp, hardbound, 6½x9¾ in., printed in brown-black on coated text, halftones throughout.

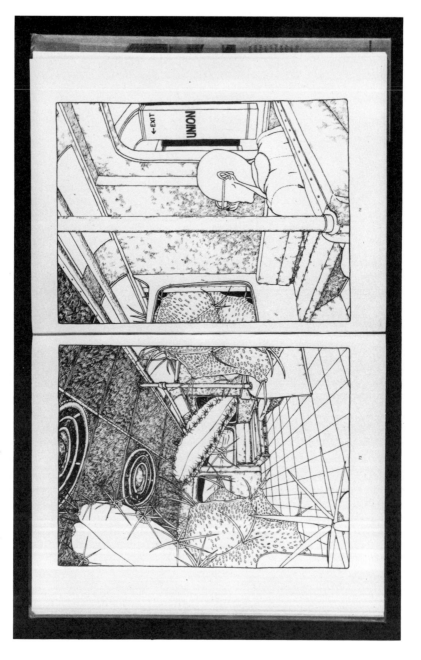

Martin Vaughn-James, *The Projector*, Toronto: The Coach House Press, 1971. 124 pp, hardbound with two color dust jacket. 9x11¾ in., printed in black on olive text, edition of 1000.

Keith Smith, *Patterned Apart*, Rhinebeck, New York: Space Heater Multiples, 1983. 40pp, hardbound by the author in printed paper and leather. 9x11¼ in., printed in red and green, hand colored, edition of 50.

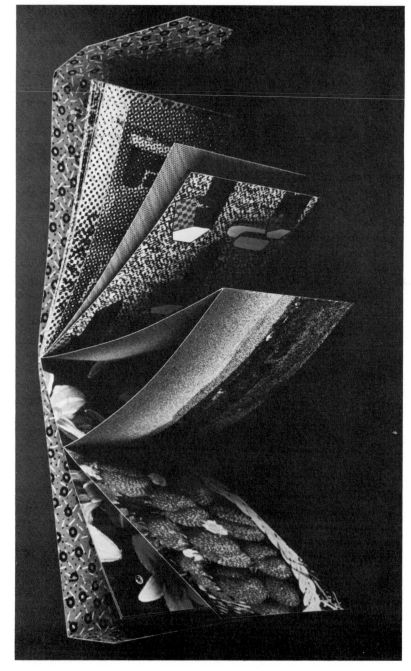

Philip Zimmermann, *Civil Defense*, Barrytown, New York: Space Heater Multiples, Rochester, New York: Visual Studies Workshop Press, 1984. 30 pages, self- cover 8x5 in., color separations by the author, edition of 1000.

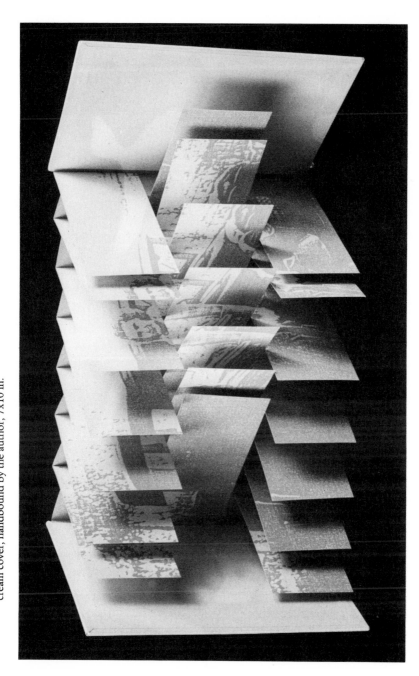

Susan E. King, *Women and Cars*, Rosendale, New York: Women's Studio Workshop, 1983. Printed in pink on cream cover, handbound by the author, 7x10 in.

Book Art

by Richard Kostelanetz

HE PRINCIPAL DIFFERENCE between the book hack and the book artist is that the former succumbs to the conventions of the medium, while the latter envisions what else "the book" might become. Whereas the hack writes prose that "reads easily" or designs pages that resemble each other and do not call attention to themselves, the book artist transcends those conventions.

The book hack is a housepainter, so to speak, filling the available walls in a familiar uniform fashion; the other is an artist, imagining unprecedented possibilities for bookish materials. The first aspires to coverage and acceptability; the second to invention and quality.

Common books look familiar; uncommon books do not. Book art is not synonymous with book design or literary art; it is something else.

Three innate characteristics of the book are the cover, which both protects the contents and gives certain clues to its nature; the page, which is the discrete unit, and a structure of sequence; but perhaps neither cover nor pages nor sequence is a genuine prerequisite to a final definition of *a book*.

The process indigenous to book-reading is the human act of shifting attention from one "page" to another, but perhaps this is not essential either.

The attractions of the book as a communications medium are that individual objects can be relatively cheap to make and distribute, that it is customarily portable and easily stored, that its contents are conveniently accessible, that it can be experienced by oneself at one's own speed without a playback machine (unlike theater, video, audio or movies), and that it is more spatially economical (measured by extrinsic experience over intrinsic volume) than other non-electronic media. A book also allows its reader random access, in contrast to audiotape and

videotape, whose programmed sequences permit only linear access; with a book you can go from one page to another, both forwards and backwards, as quickly as you can go from one page to the next.

Because a book's text is infinitely replicable, the number of copies that can be printed is theoretically limitless. By contrast, a traditional art object is unique while a multiple print appears in an edition whose number is intentionally limited at the point of production. It is possible to make a unique book, such as a handwritten journal or sketchbook, or to make an edition of books limited by number and autograph; but as a communications vehicle, the first is really a "book as art object," which becomes known only through public display, while the second is, so to speak, a "book as print" (that is destined less for exhibition than for specialized collections).

The economic difference between a standard book object and an art object is that the latter needs only a single purchaser, while the former needs many buyers to be financially feasible. Therefore, the art dealer is a retailer, in personal contact with his potential customers, while the book publisher is a wholesaler, distributing largely to retailers, rather than to the ultimate customers.

The practical predicament of commercial publishers in the eighties is that they will not publish an "adult trade" book unless their salesmen can securely predict at least several thousand hardback purchasers or twice as many paperback purchasers within a few months. Since any proposed book that is unconventional in format could never be approved by editorial-industrial salesmen, commercial publishers are interested only in book hacks (and in "artists" posing as book hacks, such as Andy Warhol).

What is most necessary now, simply for the development of the book as an imaginative form, are publishers who can survive economically with less numerous editions at reasonable prices.

There is a crucial difference between presenting an artist's work in book form—a retrospective collection of reproductions—and an artist making a book. The first is the honorific, *art book*. "Book art" should be saved for books that are works of art, as well as books.

The book artist usually controls not just what will fill the pages but how they will be designed and produced and then bound and covered, and the book artist often becomes its publisher and distributor too, eliminating middle-men all along the line and perhaps creatively reconsidering their functions as well.

One practice common to both books and paintings is that the ultimate repository of anything worth preserving is the archive—the art museum for the invaluable painting, and the research library for the essential book.

One trouble with the current term "artists' books" is that it defines a

work of art by the initial profession (or education) of its author, rather than by qualities of the work itself. Since genuine critical categories are meant to define art of a particular kind, it is a false term. The art at hand is *books*, no matter who did them; and it is differences among them, rather than in their authorship, that should comprise the stuff of critical discourse.

Indeed, the term "artists' books" incorporates the suggestion that such work should be set aside in a space separate from writers' books— that, by implication, they constitute a minor league apart from the big business of real books. One thing I wish for my own books is that they not be considered minor league.

The squarest thing "an artist" can do nowadays is necessarily compress an imaginative idea into a rectangular format bound along its longest side. Some sequential ideas work best that way; others do not.

In theory, there are no limits upon the kinds of materials that can be put between two covers, or how those materials can be arranged.

This essential distinction separates imaginative books from conventional books. In the latter, syntactically familiar sentences are set in rectangular blocks of uniform type (resembling soldiers in a parade), and these are then "designed" into pages that look like each other (and like pages we have previously seen). An imaginative book, by definition, attempts to realize something else with syntax, with format, with pages, with covers, with size, with shapes, with sequence, with structure, with binding—with any or all of these elements, the decisions informing each of them ideally reflecting the needs and suggestions of the materials particular to this book.

Most books are primarily about something outside themselves; most book art books are primarily about themselves. Most books are read for information, either expository or dramatized; book art books are made to communicate imaginative phenomena and thus create a different kind of "reading" experience.

An innovative book is likely to strike the common reviewer as a "nonbook" or "antibook." The appearance of such terms in a review is, in practice, a sure measure of a book's originality. The novelist Flannery O'Connor once declared, "If it looks funny on the page, I won't read it." Joyce Carol Oates once reiterated this sentiment in a review of O'Connor. No, a "funny" appearance is really initial evidence of serious book artistry.

Imaginative books usually depend as much on visual literacy as on verbal literacy; many "readers" literate in the second respect are illiterate in the first.

One purpose for the present is to see what alternative forms and materials "the book" can take: can it be a pack of shufflable cards? Can it be a long folded accordion strip? Can it have two front covers and be

"read" in both directions? Can it be a single chart? An audiotape? A videotape? A film?

Is it "a book" if its maker says it is?

With these possibilities in mind, we can recognize and make a future for the book.

The New Art of Making Books

by Ulises Carrión

WHAT A BOOK IS

A book is a sequence of spaces.

Each of these spaces is perceived at a different moment—a book is also a sequence of moments.

A book is not a case of words, nor a bag of words, nor a bearer of words.

. . . .

A writer, contrary to the popular opinion, does not write books.

A writer writes texts.

The fact, that a text is contained in a book, comes only from the dimensions of such a text; or, in the case of a series of short texts (poems, for instance), from their number.

. . . .

A literary (prose) text contained in a book *ignores* the fact that the book is an autonomous space-time sequence.

A series of more or less short texts (poems or other) distributed through a book following any particular ordering reveals the sequential nature of the book.

It reveals it, perhaps uses it; but it does not incorporate it or assimilate it.

. . . .

Written language is a sequence of signs expanding within the space; the reading of which occurs in the time.

A book is a space-time sequence.

. . . .

Books existed originally as containers of literary texts.

But books, seen as autonomous realities, can contain any (written) language, not only literary language, or even any other system of signs.

. . . .

Among languages, literary language (prose and poetry) is not the best fitted to the nature of books.

. . . .

A book may be the accidental container of a text, the structure of which is irrelevant to the book: these are the books of bookshops and libraries.

A book can also exist as an autonomous and self-sufficient form, including perhaps a text that emphasizes that form, a text that is an organic part of that form: here begins the new art of making books.

. . . .

In the old art the writer judges himself as being not responsible for the real book. He writes the text. The rest is done by the servants, the artisans, the workers, the others.

In the new art writing a text is only the first link in the chain going from the writer to the reader. In the new art the writer assumes the responsibility for the whole process.

. . . .

In the old art the writer writes texts.
In the new art the writer makes books.

. . . .

To make a book is to actualize its ideal space-time sequence by means of the creation of a parallel sequence of signs, be it verbal or other.

. . . .

PROSE AND POETRY

In an old book all the pages are the same.

When writing the text, the writer followed only the sequential laws of language, which are not the sequential laws of books.

Words might be different on every page; but every page is, as such, identical with the preceding ones and with those that follow.

In the new art every page is different; every page is an individualized element of a structure (the book) wherein it has a particular function to fulfill.

. . . .

In spoken and written language pronouns substitute for nouns, so to avoid tiresome, superfluous repetitions.

In the book, composed of various elements, of signs, such as language, what is it that plays the role of pronouns, so to avoid tiresome, superfluous repetitions?

This is a problem for the new art; the old does not even suspect its existence.

. . . .

A book of 500 pages, or of 100 pages, or even of twenty five, wherein all the pages are similar, is a boring book considered as a book, no matter how thrilling the content of the words of the text printed on the pages might be.

A novel, by a writer of genius or by a third-rate author, is a book where nothing happens.

. . . .

There are still, and always will be, people who like reading novels. There will also always be people who like playing chess, gossiping, dancing the mambo, or eating strawberries with cream.

. . . .

In comparison with novels, where nothing happens, in poetry books

something happens sometimes, although very little.

. . . .

A novel with no capital letters, or with different letter types, or with chemical formulae interspersed here and there, etc., is still a novel, that is to say, a boring book pretending not to be such.

. . . .

A book of poems contains as many words as, or more than, a novel, but it uses ultimately the real, physical space whereon these words appear, in a more intentional, more evident, deeper way.

This is so because in order to transcribe poetical language onto paper it is necessary to translate typographically the conventions proper to poetic language.

. . . .

The transcription of prose needs few things: punctuation, capitals, various margins, etc.

All these conventions are original and extremely beautiful discoveries, but we don't notice them any more because we use them daily.

Transcription of poetry, a more elaborate language, uses less common signs. The mere need to create the signs fitting the transcription of poetic language, calls our attention to this very simple fact: to write a poem on paper is a different action from writing it on our mind.

. . . .

Poems are songs, the poets repeat. But they don't sing them. They write them.

Poetry is to be said aloud, they repeat. But they don't say it aloud. They publish it.

The fact is, that poetry, as it occurs normally, is written and printed, not sung or spoken, poetry. And with this, poetry has lost nothing.

On the contrary, poetry has gained something: a spatial reality that the so loudly lamented sung and spoken poetries lacked.

. . . .

THE SPACE

For years, many years, poets have intensively and efficiently exploited the spatial possibilities of poetry.

But only the so-called concrete or, later, visual poetry, has openly declared this.

. . . .

Verses ending halfway on the page, verses having a wider or narrower margin, verses being separated from the following one by a bigger or smaller space—all this is exploitation of space.

. . . .

This is not to say that a text is poetry because it uses space in this or that way, but that using space is a characteristic of written poetry.

. . . .

The space is the music of the unsung poetry.

. . . .

The introduction of space into poetry (or rather of poetry into space) is an enormous event of literally incalculable consequences.

One of these consequences is concrete and/or visual poetry. Its birth is not an extravagant event in the history of literature, but the natural, unavoidable development of the spatial reality gained by language since the moment writing was invented.

. . . .

The poetry of the old art does use space, albeit bashfully.

This poetry establishes an inter-subjective communication.

Inter-subjective communication occurs in an abstract, ideal impalpable space.

. . . .

In the new art (of which concrete poetry is only an example) com-

munication is still inter-subjective, but it occurs in a concrete, real, physical space—the page.

· · · ·

A book is a volume in the space.

It is the true ground of the communication that takes place through words—its here and now.

Concrete poetry represents an alternative to poetry.

Books, regarded as autonomous space-time sequences, offer an alternative to all existent literary genres.

· · · ·

Space exists outside subjectivity.

If two subjects communicate *in* the space, then space is an element of this communication. Space modifies this communication. Space imposes its own laws on this communication.

Printed words are imprisoned in the matter of the book.

· · · ·

What is more meaningful: the book or the text it contains?

What was first: the chicken or the egg?

· · · ·

The old art assumes that printed words are printed on an ideal space.

The new art knows that books exist as objects in an exterior reality, subject to concrete conditions of perception, existence, exchange, consumption, use, etc.

· · · ·

The objective manifestation of language can be experienced in an isolated moment and space—the page; or in a sequence of spaces and moments—the 'book.'

. . . .

There is not and will not be new literature any more.

There will be, perhaps, new ways to communicate that will include language or will use language as a basis.

As a medium of communication, literature will always be old literature.

. . . .

THE LANGUAGE

Language transmits ideas, i.e., mental images.

The starting point of the transmission of mental images is always an intention: we speak to transmit a particular image.

The everyday language and the old art language have this in common: both are intentional, both want to transmit certain mental images.

. . . .

In the old art the meanings of the words are the bearers of the author's intentions.

Just as the ultimate meaning of words is indefinable, so the author's intention is unfathomable.

. . . .

Every intention presupposes a purpose, a utility.

Everyday language is intentional, that is, utilitarian; its function is to transmit ideas and feelings, to explain, to declare, to convince, to invoke, to accuse, etc.

Old art's language is intentional as well, i.e., utilitarian. Both languages differ from one another only in their form.

. . . .

New art's language is radically different from daily language. It neg-

lects intentions and utility, and it returns to itself, it investigates itself, looking for forms, for series of forms that give birth to, couple with, unfold into, space-time sequences.

. . . .

The words in a new book are not the bearers of the message, nor the mouthpieces of the soul, nor the currency of communication.

Those were already named by Hamlet, an avid reader of books: words, words, words.

. . . .

The words of the new book are there not to transmit certain mental images with a certain intention.

They are there to form, together with other signs, a space-time sequence that we identify with the name 'book'.

. . . .

The words in a new book might be the author's own words or someone else's words.

A writer of the new art writes very little or does not write at all.

. . . .

The most beautiful and perfect book in the world is a book with only blank pages, in the same way that the most complete language is that which lies beyond all that the words of a man can say.

. . . .

Every book of the new art is searching after that book of absolute whiteness, in the same way that every poem searches for silence.

. . . .

Intention is the mother of rhetoric.

. . . .

Words cannot avoid meaning something, but they can be divested of intentionality.

. . . .

A non-intentional language is an abstract language: it doesn't refer to any concrete reality.

Paradox: in order to be able to manifest itself concretely, language must first become abstract.

. . . .

Abstract language means that words are not bound to any particular intention; that the word 'rose' is neither the rose that I see nor the rose that a more or less fictional character claims to see.

In the abstract language of the new art the word 'rose' is the word 'rose'. It means all the roses and it means none of them.

. . . .

How to succeed in making a rose that is not my rose, nor his rose, but everybody's rose, i.e., nobody's rose?

By placing it within a sequential structure (for example a book), so that it momentarily ceases being a rose and becomes essentially an element of the structure.

. . . .

STRUCTURES

Every word exists as an element of a structure—a phrase, a novel, a telegram.

Or: every word is part of a text.

. . . .

Nobody or nothing exists in isolation: everything is an element of a structure.

Every structure is in its turn an element of another structure.

Everything that exists is a structure.

. . . .

To understand something, is to understand the structure of which it is a part and/or the elements forming the structure that that something is.

A book consists of various elements, one of which might be a text.

A text that is part of a book isn't necessarily the most essential or important part of that book.

. . . .

A person may go to the bookshop to buy ten red books because this color harmonizes with the other colors in his sitting room, or for any other reason, thereby revealing the irrefutable fact that books have a color.

. . . .

In a book of the old art words transmit the author's intention. That's why he chooses them carefully.

In a book of the new art words don't transmit any intention; they're used to form a text which is an element of a book, and it is this book, as a totality, that transmits the author's intention.

. . . .

Plagiarism is the starting point of the creative activity in the new art.

Whenever the new art uses an isolated word, then it is in an absolute isolation: books of one single word.

. . . .

Old art's authors have the gift for language, the talent for language, the ease for language.

For new art's authors language is an enigma, a problem; the book hints at ways to solve it.

. . . .

In the old art you write "I love you" thinking that this phrase means "I love you."

(But: what does "I love you" mean?)

. . . .

In the new art you write "I love you" being aware that we don't know

what this means. You write this phrase as part of a text wherein to write "I hate you" would come to the same thing.

The important thing is, that this phrase, "I love you" or "I hate you," performs a certain function as a text within the structure of the book.

. . . .

In the new art you don't love anybody.

The old art claims to love.

In art you can love nobody. Only in real life can you love someone.

. . . .

Not that the new art lacks passions.

All of it is blood flowing out of the wound that language has inflicted on men.

And it is also the joy of being able to express something with everything, with anything, with almost nothing, with nothing.

. . . .

The old art chooses, among the literary genres and forms, that one which best fits the author's intention.

The new art uses any manifestation of language, since the author has no other intention than to test the language's ability to mean something.

. . . .

The text of a book in the new art can be a novel as well as a single word, sonnets as well as jokes, love letters as well as weather reports.

. . . .

In the old art, just as the author's intention is ultimately unfathomable and the sense of his words indefinable, so the understanding of the reader is unquantifiable.

In the new art the reading itself proves that the reader understands.

THE READING

In order to read the old art, knowing the alphabet is enough.

In order to read the new art one must apprehend the book as a structure, identifying its elements and understanding their function.

. . . .

One might read old art in the belief that one understands it, and be wrong.

Such a misunderstanding is impossible in the new art. You can read only if you understand.

. . . .

In the old art all books are read in the same way.

In the new art every book requires a different reading.

. . . .

In the old art, to read the last page takes as much time as to read the first one.

In the new art the reading rhythm changes, quickens, speeds up.

. . . .

In order to understand and to appreciate a book of the old art, it is necessary to read it thoroughly.

In the new art you often do NOT need to read the whole book.

The reading may stop at the very moment you have understood the total structure of the book.

. . . .

The new art makes it possible to read faster than the fast-reading methods.

. . . .

There are fast-reading methods because writing methods are too slow.

. . . .

The old art takes no heed of reading.

The new art creates specific reading conditions.

. . . .

The farthest the old art has come to, is to bring into account the readers, which is going too far.

. . . .

The new art doesn't discriminate between its readers; it does not address itself to the book-addicts or try to steal its public away from TV.

. . . .

In order to be able to read the new art, and to understand it, you don't need to spend five years in a Faculty of English.

. . . .

In order to be appreciated, the books of the new art don't need the sentimental and/or intellectual complicity of the readers in matters of love, politic, psychology, geography, etc.

. . . .

The new art appeals to the ability every man possesses for understanding and creating signs and systems of signs.

. . . .

This essay was written originally in Spanish. Its title is an allusion to a polemical poem by the Spanish playwright Lope de Vega, *El Arte Nuevo de Hacer Comedias* or *The New Art of Making Comedies.*

Author's Note: *The two following articles were written in late 1976 and in summer, 1983. The first is drenched in the enthusiasm that engendered Printed Matter that same year. The second reflects a certain disillusionment with the direction artists' books took in the interim. The process continues, and were I writing yet another piece today (the end of 1984), I might produce yet another view, affected by the fact that I'm now making collaborative artists' books myself.*

The production of and market for artists' books continue to grow and this is a good indication of the form's ongoing vitality. As the second article suggests, I am still more interested in those books that sidestep internal vicissitudes in favor of fantasies and realities that reach further out. These are still plentiful and some of my favorites have emerged since both these articles were written. I could add an equally impressive new list of works with social and/or political content. Printed Matter and its colleagues struggle on against economic adversity and artworld trends. The audience grows as libraries become more receptive. We await some distribution genius, or godmother, to inflame the hearts of a broader public with the burning desire to own artists' books. Until then, harsher criticism and deeper knowledge of the genre will have to suffice.

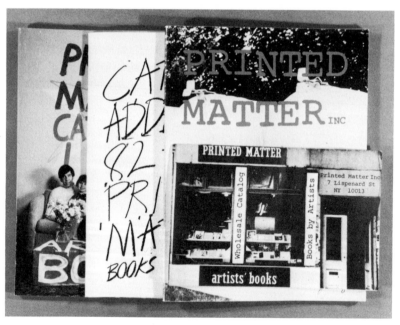

Sales Catalogues from Printed Matter.

The Artist's Book Goes Public

by Lucy R. Lippard

T HE "ARTIST'S BOOK" is a product of the 1960s which is already getting its second, and potentially permanent, wind. Neither an art book (collected reproductions of separate art works) nor a book on art (critical exegeses and/or artists' writings), the artist's book is a work of art on its own, conceived specifically for the book form and often published by the artist him/herself. It can be visual, verbal, or visual/verbal. With few exceptions, it is all of a piece, consisting of one serial work or a series of closely related ideas and/or images—a portable exhibition. But unlike an exhibition, the artist's book reflects no outside opinions and thus permits artists to circumvent the commercial gallery system as well as to avoid misrepresentation by critics and other middlepeople. Usually inexpensive in price, modest in format, and ambitious in scope, the artist's book is also a fragile vehicle for a weighty load of hopes and ideals: it is considered by many the easiest way out of the art world and into the heart of a broader audience.

The artist's book is the product of several art and non-art phenomenona of the last decade, among them a heightened social consciousness, the immense popularity of paperback books, a new awareness of how art (especially the costly "precious object") can be used as a commodity by a capitalist society, new extra-art subject matter, and a rebellion against the increasing elitism of the art world and its planned obsolescence. McLuhan notwithstanding, the book remains the cheapest, most accessible means of conveying ideas—even visual ones. The artist's adaptation of the book format for works of art constitutes a criticism of criticism as well as of art-as-big-business. Its history, however, lies in the realm of literature and *éditions de luxe*.

The ancestors of artists' books as we know them now were the products of friendships between avant-garde painters and poets in Europe

and later in New York. It was not until the early 1960s, however, that a few artists began to ignore literary sources, forego the collaborative aspect and make their own books—not illustrations or catalogues or portfolios of prints but books as visually and conceptually whole as paintings or sculptures. Among them were some of the Fluxus artists—George Brecht in particular, who produced curious little publications with roots in games or the surrealist collage and box.

The new artists' books, however, have disavowed surrealism's lyrical and romantic heritage and have been deadpan, anti-literary, often almost anti-art. Ed Ruscha's *Twentysix Gasoline Stations* (1962), followed by his *Various Small Fires* (1964), *Some Los Angeles Apartments* (1965), *Every Building on Sunset Strip* (1966), *Colored People*, and so forth, initiated the "cool" approach that dominated the whole conception of artists' books for years. Ruscha's books were a major starting point for the as-yet-unnamed conceptual art, a so-called movement (actually a medium, or third stream) which made one of its most vital contributions by validating the book as a legitimate medium for visual art.

By 1966, if you were reading the signs, you noticed that the book was a coming thing. Dan Graham's and Robert Smithson's hybrid magazine articles—neither criticism nor art—were one of the signs; Mel Bochner's "Working Drawings" show at the School of Visual Arts, where drawings that were "not necessarily art" were xeroxed and exhibited in notebooks, was another. The point (having to do with a broader definition of art, among other things) was followed up in 1967 by the Museum of Normal Art's show called "Fifteen People Present Their Favorite Book"; the same year, Brian O'Doherty, as editor of a boxed issue of *Aspen Magazine*, included artworks (not reproductions) by Sol LeWitt, Tony Smith, Graham, and Bochner; the 0-9 Press, one of whose editors was Vito Acconci, then a poet, published single artworks in booklet format by Acconci himself, Rosemary Mayer, Adrian Piper, and others; Sol LeWitt published the first of his many books; and in England, the first Art & Language publications appeared, promulgating an extreme and incommunicative use of texts as art.

By 1968, when dealer Seth Siegelaub began to publish his artists in lieu of exhibiting them, the art world took notice. Lawrence Weiner and Douglas Huebler had "no-space" shows; Hanne Darboven and the N.E. Thing Company published their first independent books: *The Xerox Book* presented serial xerox works by Andre, Barry, Huebler, Kosuth, LeWitt, Morris, and Weiner; Siegelaub's "Summer 1969" exhibition took place in fragments all over the world and existed as a whole only in its catalogue.

Since then, hundreds of artists' books have appeared. Yet they are never reviewed, not even in art magazines, either as books or as exhibitions. So far, artists' books have been dispersed (usually as gifts) to

friends and colleagues, then left to languish in warehouses, studios, and gallery back rooms. They are published by the artists themselves, by small underground presses, or by a few galleries—the latter more often in Europe than in America. Art dealers are more interested in selling "real art," on which they can make a profit, and tend to see artists' books as handy hand-outs to potential buyers of expensive objects. Even art bookstores make so little profit on artists' books that they neglect them in favor of more elaborate tomes. Artists unaffiliated with galleries have no way to distribute their books widely and rarely recoup printing costs, which, though fairly low, many cannot afford in the first place.

It is difficult to find organizational funding for printing artists' books because the visual arts sections of the various councils do not give money for publications. Subsidies exist for all the conventional visual arts—film, video, "mixed media" (which covers a multitude of sins, but rarely books)—as well as for plays, fiction, and poetry. But the artist's book—a mutation clinging to the verbal underside of the visual art world—tends to remain an economic pariah even in its own domain. (It *is* difficult to distinguish an artist's book consisting entirely of text from a book of "poetry," or one consisting of a series of "anti-photographs," whose importance lies in sequence rather than in individual composition, from a conventional photography book.)

With some luck and a lot of hard work, problems of distribution may be solved by Printed Matter, a New York collective of artists and artworkers which has just been set up both to publish a few books and to distribute and operate a bookstore for all artists' books. This task was taken over from Martha Wilson, an artist whose non-profit organization Franklin Furnace briefly distributed artists' books but now limits itself to an archive and exhibition service. Printed Matter hopes to maintain an effective liaison between an international audience and individual artists, galleries and small presses, such as Vipers Tongue, Out of London, and the Women's Graphic Center.

At the moment, the artist's book is defined (and confined) by an art context, where it still has a valuable function to serve. To an audience which is outside the major art centers and, for better or worse, heavily influenced by reproductions in magazines, the artist's book offers a first-hand experience of new art. For an artist, the book provides a more intimate communication than a conventional art object, and a chance for the viewer to take something home. An artist's book costs far less than any graphic or multiple and, unlike a poster, which may cost as much or more, it contains a whole series of images or ideas. The only danger is that, with an expanding audience and an increased popularity with collectors, the artist's book will fall back into its *édition de luxe* or coffee table origins, as has already happened in the few cases

when such books have been co-opted by commercial publishers and transformed into glossy, pricey products.

Needless to say, there are good artists' books and bad ones—from anyone's point of view. They have in common neither style nor content—only medium. (Economically determined strictures, as much as a fairly ubiquitous minimalist stylist bent, can be blamed for the tendency to the white, black, or gray cover with stark type that until recently was the trademark of the artist's book.) They are being made everywhere. Printed Matter's first ten books come out of Oregon, Pennsylvania, Illinois, California, and Massachusetts, as well as New York. They range from the hilarious to the bizarre, romantic, deadpan, decorative, scholarly, and autobiographical; from treatises to comic books. Their political possibilities are just beginning to be recognized too. One of the basic mistakes made by early proponents of conceptual art's "democratic" stance (myself included) was a confusion of the characteristics of the medium (cheap, portable, accessible) with those of the actual contents (all too often wildly self-indulgent or so highly specialized that they appeal only to an elite audience). Yet the most important aspect of artists' books *is* their adaptability as instruments for extension to a far broader public than that currently enjoyed by contemporary art. There is no reason why the increased outlets and popularity of artists' books cannot be used with an enlightenment hitherto foreign to the "high" arts. One day I'd like to see artists' books ensconced in supermarkets, drugstores, and airports and, not incidentally, to see artists able to profit economically from broad communication rather than from lack of it.

Conspicuous Consumption:
New Artists' Books

by Lucy R. Lippard

*T*HE ARTIST'S BOOK is/was a great idea whose time has either not come, or come and gone. As a longtime supporter of and proselytizer for the genre (and co-founder of Printed Matter, the major nonprofit distributor), it pains me to say this. But all is not lost, just misplaced.

My carping could certainly be questioned. The National Endowment for the Arts finally gives grants and the Museum of Modern Art has a curator for artists' books; big publishers are picking up on some of the sure things; there are exhibitions and even occasionally reviews. A browse through Printed Matter can restore one's faith in the eternal inventiveness of visual artists. They seem to have thought of everything, from flipbooks (home movies) to flopbooks (made of fabric, like droolproof babies' books), from severe neo-textbooks to scruffy rubberstamp and xerox anarchies, to slicknesses rivaling *Vogue*. Some are one-liners, and once you've got the punch line you have no urge to take it home and get punched out daily, but some truly tickle the Freudian funnybones. Some are luscious. You can picture pulling them out on a winter Sunday afternoon to fondle or chuckle over. I could list hundreds of artists' books I'm glad to see in the world.

Yet the real vision with which the phenomenon gained momentum in the mid-to-late sixties has not yet been fulfilled. It's still necessary to define an "artist's book" for any but a specialized audience. So—artists' books are not books about art or on artists, but books *as* art. They can be all words, all images, or combinations thereof. At best they are a lively hybrid of exhibition, narrative, and object—cinematic potential co-existing with double-spread stasis.

Artist and bookmaker Pat Steir once said she liked artists' books because they are "1. portable, 2. durable, 3. inexpensive, 4. intimate,

5. non-precious, 6. replicable, 7. historical, and 8. universal." (She was talking, as I am here, about mass-reproduced, potentially "democratic" works of art rather than about "one-of-a-kind" art objects in book form, or signed and numbered limited editions.)[1]

Virtually all of the 2,000 artists' books in Printed Matter's illustrated mail-order catalogue and the 9,000 titles in Franklin Furnace's Artists' Book Archive are portable and replicable (though print runs vary drastically); most are durable and intimate; some are non-precious and inexpensive; very few are historical and universal, which may be a contradiction in terms anyway. However, they do all mark a genuine historical moment of dissatisfaction with art's outreach, a declaration of independence by artists who speak, publish, and at least try to distribute themselves, bypassing the system.

Artists' books have existed since early in the century but as a named phenomenon they surfaced with conceptual art in the sixties, part of a broad, if naive, quasi-political resistance to the extreme commodification of artworks and artists. Accessibility and some sort of function were an assumed part of their *raison d'être*. Still, despite sincere avowals of populist intent, there was little understanding of the fact that the accessibility of the cheap, portable form did not carry over to that of the contents—a basic problem in all of the avant-garde's tentative moves towards democratization in the sixties and early seventies. The New York art world was so locked into formal concerns (even those of us who spent a lot of time resisting them) that we failed to realize that, however neat the package, when the book was opened by a potential buyer from "the broader audience" and she or he was baffled, it went back on the rack.

In 1981, Carol Huebner, curator of a college book exhibition, announced enthusiastically, "An art form that has been accessible for years has finally found its audience."[2] It depends on what audience you're after. True, Printed Matter, Franklin Furnace, and others have successfully made artists' books available worldwide to collectors, museums, scholars, and other artists. At the same time, practitioner Mike Glier wrote a few years ago that the next step for artists' books was "to become politically effective and to communicate to a diverse audience." A few years and no giant step later, Glier is saying, "We're past the careful nurturing stage and into do or die competition with mass culture. If artists' books remain a novelty in the art world, they are a failure."

The fantasy is an artist's book at every supermarket checkout counter, or peddled on Fourteenth Street ("check it out"). The reality is that competing with mass culture comes dangerously close to imitating it, and can lead an artist to sacrifice precisely what made him or her choose art in the first place; and when "high art" tries to compete, it

also has to deal with what's been happening all along on "lower" levels—comics, photo-novels, fanzines, as well as graphic design or so-called commercial art. An article I saw in an airline magazine was subheaded "Packaging sells products, and the designers of those critical marketing tools are more than merely artists." Author Bernie Ward described the packages as "thousands of individual little salespersons demanding, pleading, for your attention and dollars in the fierce competition of the supermarket." Many artists' books and comics look downright amateurish (and, though deliberately, not necessarily endearingly) next to the work of professionals not so highly regarded, but more highly paid than most "high" artists.

The central question revolves around function, and the role of art in general. How is the artist's book form special? At what point is it merely an ineffective and poorly distributed stepchild to big-time publishing, and at what point does it offer something (invention, criticism, alternative information) that the other media can't? Well, it is a quick and noncumbersome means of receiving information or stimuli. It should be popular in a society that perceives and experiences everything rapidly. (Even our president prefers to get his briefings in pictures.) I learned some of the little economics I know (don't test me) from an innovative non-artist's book published by the Institute for Labor Research and Development in which David Gordon's text is paralleled page by page by Howard Saunders's comic strip where a cast of characters live out the dilemmas posed by the theory. And the book accompanying Avis Lang Rosenberg's exhibition of feminist cartoons—*Pork Roast*—has probably raised more consciousness than most "high" feminist art.

In his recent book on pop culture as covert propaganda, *The Empire's Old Clothes*, Ariel Dorfman tells a revealing story about a woman in the Santiago slums who begged him not to deprive her of her photonovellas: "Don't do that to us, *compañerito*, don't take my dreams away from me." After Allende was elected and the people in the *barrios* had taken hope, he met her again and she told him she no longer read "trash." "Now," she said, "We are dreaming reality."[3]

There *are* artists' books that present a reality rather than a fantasy, which gives access to ideas and information harder to come by in other forms, books that are serious works of reflection rather than unconsidered reflections. Janice Rogovin's *A Sense of Place/Tu Barrio* is a bilingual photobook subtitled "Jamaica Plain People and Where They Live." It includes brief, warmhearted texts by and about the subjects, from a working-class Massachusetts community. It is at once an appealing picture of what a neighborhood can be, a mini-sociology, "human interest" story, and a warning on the pending evils of gentrification.

Maybe Rogovin's book, like Wendy Ewald's moving *Appalachian*

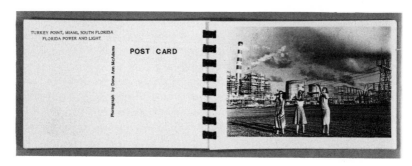

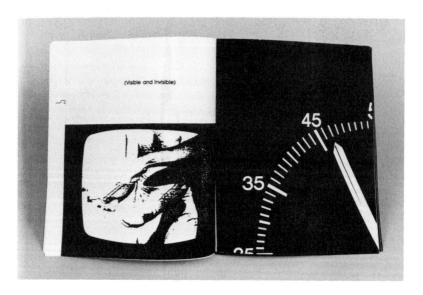

Women: Three Generations—also photos and oral history, is a photography book, not an artist's book. The lines blur, especially when they confront the taboo against art that deals with "real world" issues. It's important that artists' books cross over and are integrated into that real world, but it's also important that without being bound by categories, they retain a certain identity of their own. Masao Gozu's *In New York (Feb. 1971-Nov. 1980)*, a totally photographic book of wistful, full-frame images of people in inner city New York windows, is probably an artist's book because it is uncaptioned, unbordered, and invisibly titled (on the spine only); in other words, its form as well as its content provide a bit of a jolt.

Some artists' books have no pictures, and are categorized by an esoteric but inescapable "visual" component that also separates them from concrete poetry. (If this sounds vague, you can fall back on the Duchampian prop: "It's an artist's book if an artist made it, or if an artist says it is.") I. Rose's books and postcards offer the kind of poetic insight into our absurd social condition that art is supposed to offer; sometimes she omits images or provides them vicariously. ("Bad news ... bad news ... i am looking for my anger but it's not there. Instead i find this grey cloud of cotton.") Mariona Barkus's annual *Illustrated History* offers twelve monthly postcards, pictures sparked by newspaper clippings on the pressing issues of our time from the defeat of the ERA to "bone dogs." Matthew Geller's *1983 Engagements* is a calendar offering a *New York Post* headline for every day of your year—an apocalyptic assurance that it will probably happen to you, eventually. Still less overtly "artistic" is Jane Greengold's marvelous unillustrated *Excerpts from the Diaries of Agatha Muldoon*, the take-away part of a meticulously realistic installation under the Brooklyn Bridge; both book and art were so convincing that many viewers thought the fictional character of Agatha was as real as the history of her environment.

Don Russell has pointed out that an awareness of the book form is an absolute necessity. The page is a very specific space in a very specific context and must be as carefully considered as the surface of a canvas *and* the space in which it's exhibited. Given the avant-garde mandate to "experiment," the best artists' books are either those that invent and enrich within this formal consciousness, or those that are aware of the special uses for content this form allows. (Ideally there is no either/or, but integrated examples are rare.)

Here, in brief, are a few more recent books that fulfill some of my

Top: Mimi Smith, *This is a Test*, 1983.
Center: Dona Ann McAdams, *The Nuclear Survival Kit*, 1981.
Bottom: Sharon Gilbert, *A Nuclear Atlas*, 1982.

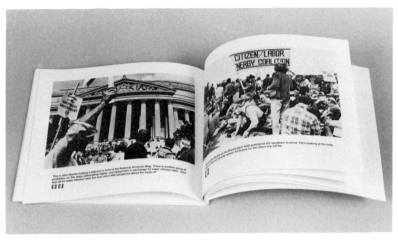

Paul Rutkovsky, *Commodity Character*, 1982.

criteria. (Many more have been published over the last decade; by 1979, the "Vigilence" show at Franklin Furnace offered a reading room of over 100 books for social change.) Mimi Smith in *This is a Test*, Sharon Gilbert in *A Nuclear Atlas*, and Dona Ann McAdams in *The Nuclear Survival Kit* have all made witty and scary books about the grimmest news of all, the first two couched in almost appallingly lyrical graphics. John Greyson's *Breathing Through Opposing Nostrils: A Gay Espionage Thriller* is a hybrid that began (in Canada) as a performance and evolved into a series of text/drawings, a complex slide/video/film piece, and an artist's book. A fictionalized narrative of divisiveness, paranoia, and infiltration in Toronto's gay and lesbian community, it's a riveting tale told with political irony and morality. Strictly speaking, it could be called an illustrated book, but you can tell it's an artist's book because you've never seen anything quite like it in bookstores or libraries. *Unexpectedness (not to be confused with obscurity) is a hallmark of the best of the genre.*

For instance, Paul Rutkovsky's *Commodity Character* is a deceptively straightforward photobook with long narrative captions. It delves into the daily lives of several working families and individuals. These people may or may not be fictional composites (their pictures are definitely "posed"), but their relationship to what they want, can afford, and actually buy is nothing if not real. Each episode is accompanied by "commodity symbols" which are the key to "the money value and the time value of each character's situation: too much money, too little money, too much time, too little time." This sounds simple enough, and probably sounds boring. But it has humor, accessibility, and quiet graphic

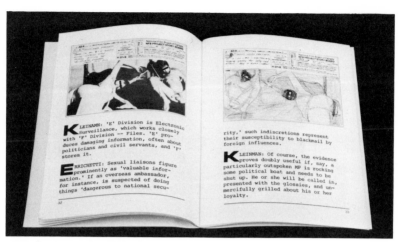

John Greyson, *Breathing Through Opposing Nostrils:*
*A Gay Espionage Thriller,*1983.

surprises. Rutkovsky has managed to cram into each plain parable an astonishing amount of information about how life in these United States works, avoiding pretentiousness and condescension. Unlike many artists' books this one can be read and studied over and over. It would make a great text for high school civics classes. *Commodity Character*'s companion is a flimsy newsprint would-be supermarketer—a fake mail order *Catalogue: Order Now*. With ambiguous photos and deadpan phrases, it describes unidentified products by their shopping mall location, color, texture, weight, and price: "GAMES N' GADGETS. Upper Level between Maas Brothers and Rainbow Shop. Color: yellow, blue, white, orange, green. Texture: fuzzy and smooth. Weight: 2 lbs. Price: $14.99 + tax = $15.74."

On the same subject, Micki McGee's *Something for Nothing: A Department Store of a Different Order* (which was also an exhibition, a giveaway event, and a videotape) is a literate and varied analysis of supply and demand under Southern California capitalism. Paul Goodman's *Empire City* is quoted: "'Is it bad stuff?' 'no, just useless,' said Horatio sadly. . . ." McGee too plays on the mail-order catalogue format (and museum catalogues) for her main section, dividing her products into their "functions"—"to disguise nature or the effects of nature," "to show you have time to play, time to waste, time to kill," "to demonstrate class ascendancy," "to enhance sexual exchange value," etc. These books make fine analytical accomplices to Beverly Naidus's packets of stickers for guerrilla actions at the supermarket, questioning products' usefulness, prices, and ingredients.

There is a certain irony to all this exposure of conspicuous consump-

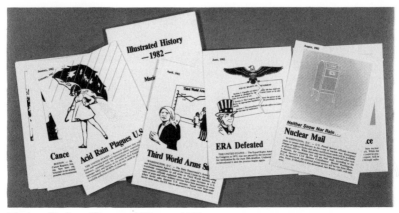

Mariona Barkus, *Illustrated History*, 1983.

tion in that artists' books themselves are distinctly luxury items, commodities with dubious exchange value on the current market. What *are* they for? You'd think there was already enough stuff flashing by us. But artists' books, like performance art, seem to have located yet another mysterious lacuna crying to be filled. I know, because I'd miss them if they went away. Also, like performance art, artists' books are best defined as whatever isn't anything else. They aren't quite photobooks, comic books, coffee-table books, fiction, illustration.

Perhaps this negative definition defines the trap of inaccessibility artists' books have fallen into. They can seem just another instance of artistic escapism, elitism, and self-indulgence. But they are also an indication of a growing need for direct exchange and communication with audiences who have more to teach artists than the existing ones. Maybe artists' books are a state of mind. Despite their general lack of visible effectiveness, they are part of a significant subcurrent beneath the artworld mainstream that threatens to introduce blood, sweat, and tears to the flow of liquitex, bronze, and bubbly.

NOTES

1. *Art Rite*, no. 14 (Winter 1976-1977).
2. *Artery: The National Forum for College Art* 5, no. 4 (April, 1982).
3. *The Empire's Old Clothes*, Ariel Dorfman. New York: Pantheon.

BIBLIOGRAPHY—BOOKS BY ARTISTS

Barkus, Mariona. *Illustrated History*. Los Angeles: Litkus Press, 1982, 2nd 1983.
Dorfman, Ariel. *The Empire's Old Clothes*. New York: Pantheon.

Ewald, Wendy. *Appalachian Women: Three Generations* (Exhibition catalogue). Whitesberg, Kentucky: Appalshop, no date.

Geller, Matthew. *1983 Engagements.* New York: Works Press, 1982.

Gilbert, Sharon. *A Nuclear Atlas.* Rosendale, New York: Women's Studio Workshop Press, 1982.

Gozu, Masao. *In New York (Feb. 1971-Nov. 1980).* Japan: Masao Gozu, 1981.

Greengold, Jane. *Excerpts from the Diaries of Agatha Muldoon.* New York, 1983.

Greyson, John. *Breathing Through Opposing Nostrils: A Gay Espionage Thriller.* New York: John Greyson, 1983.

McAdams, Dona Ann. *The Nuclear Survival Kit.* New York: Dona Ann McAdams, 1981.

McGee, Micki. *Something for Nothing.* San Diego, California: Micki McGee, 1982.

Rogovin, Janice. *A Sense of Place/Tu Barrio.* Boston: Janice Rogovin, 1981.

Rose, I. *New York . . . New York* New York: I.R.D. Productions, 1981.

Rosenberg, Avis Lang, ed. *Selections from Pork Roasts: 250 Feminist Cartoons.* Vancouver, Canada: Pink Primate Projects, 1981.

Rutkovsky, Paul. *Commodity Character.* Rochester, New York: Visual Studies Workshop Press, 1982.

Rutkovsky, Paul. *Catalogue: Order Now.* Tallahassee: Paul Rutkovsky/Florida State University Institute for Contemporary Art, 1983.

Smith, Mimi. *This is a Test.* Rochester, New York: Visual Studies Workshop Press, 1983.

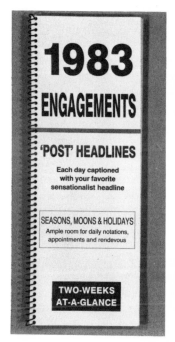

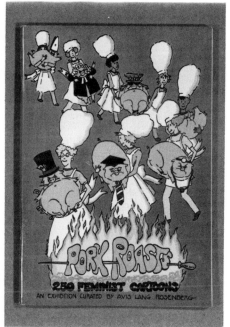

Matthew Geller, *Engagements*, 1982.
Avis Rosenberg, editor. *Selections from Pork Roasts: 250 Feminist Cartoons*, 1981.

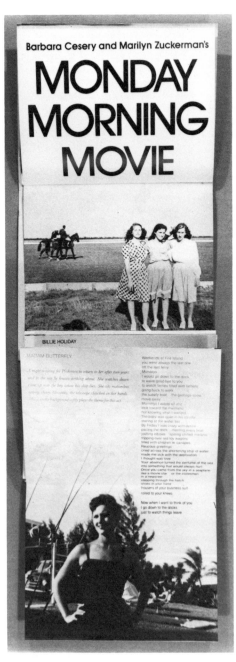

Barbara Cesery and Marilyn Zuckerman, *Monday Morning Movie*, 1981.

Words and Images:
Artists' Books as Visual Literature

by Shelley Rice

A RTISTS' BOOKS gained a foothold in the art world during the radical years of the late sixties and early seventies, and they are often perceived as exemplifying the spirit of experimentation and rebellion which characterized that era. When discussing this relatively new art form, critics and artists tend to focus primarily on the book's function as an alternative space—an alternative mode of distribution which allows artists to circumvent the gallery system and make their work inexpensive and thus accessible to a large audience. This populist aspect of artists' books is, of course, extremely significant, but it is, nevertheless, not the whole story. The fact remains that artists' books are a new art form which has spawned new expressive and creative means. Now that this art form has a history and at least a few outlets, archives, presses, and publications, it is time, I think, to luxuriate in aesthetics—to grapple with some of the ways in which artists have used the book as an expressive medium and, in the process, redefined its essential nature.

Possibly the most far-reaching innovation of artists' books is their juxtaposition of images and words on a page. Words and pictures have, of course, shared the pages of books for centuries; and every childhood primer, history textbook, and morning newspaper attests to the fact that such combinations are standard fare in our contemporary technological society. But generally the cultural uses of words and pictures share some important characteristics: there is usually a *direct* relationship between language and images—one illustrating the other—most often in the service of a linear narrative. This straightforward relationship, this norm, has been imitated, parodied, altered, undermined, and sometimes completely revamped in artists' books. And, in the process, a new form of visual literature has been created.

There are thousands of artists' books juxtaposing words and images. Some of them are reasonably simple, others remarkably complex; some reflect trends in bookmaking, while others represent unique explorations. While it is impossible to mention all of these books, or even hint at all of the diverse solutions to the picture/text problem, it is possible to give an overview of some of the more important ways in which artists have chosen to use these elements as expressive modes on the pages of a bookwork. In surveying these myriad formal and thematic solutions, one can catch a glimpse of the amazing range of works and ideas which, until recently, have all been lumped together under the generic rubric of "artists' books."

To begin with, a number of artists' books are straightforward narratives, which juxtapose words and images in relatively direct relationships. *The Big Relay Race,* by Michael Smith, for instance, is a story that unfolds through a series of black and white photographs accompanied by short dialogue texts. Smith, who is best known as a performance artist, is the star of this show, and he and the fellows in his club do a practice run for a competition whose rules and purposes are never clarified. The comedy of errors that results involves briefcases, pencil batons, and a solo commuter course and ends up being a spoof on male bonding and the rat race of the business world.

Michael Smith, *The Big Relay Race,* 1981.

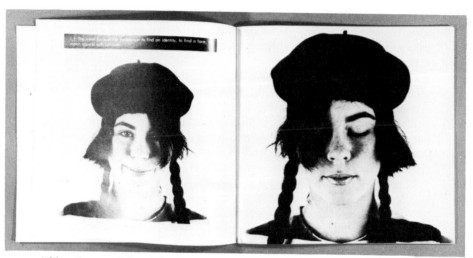

Eldon Garnet, *Cultural Connections*, 1981.

In both tone and format, *The Big Relay Race* resembles a comic book. (A number of artists—like Lynda Barry, Karen Fredericks, Gary Panter, and Mark Beyer—have, by the way, adopted the comic book mode wholesale and use that popular form as a platform for their own ruminations about modern life.) As in a comic, there is a direct relationship between the photographs and the texts: the reader/viewer understands that the pictures set the scene for the quotes printed beneath them. There's also a direct relationship between words and pictures in Eldon Garnet's *Cultural Connections,* a narrative which, like Smith's, is developed through black and white photographs and texts. But whereas Smith's photographs serve a straightforward documentary function, Garnet's are suggestive and psychological and, therefore, complement the text rather than simply illustrating it.

Originally an exhibition organized at the Canadian Centre of Photography under the curatorship of Bradford G. Gorman, *Cultural Connections* (which was published as *Image Nation #24*) traces, in Gorman's words, "the development of its ... post-feminist heroine ... through different social and cultural environments." The narrative is divided into five distinct sections, each corresponding to one of the five different personae acted out by the protagonist as she adopts and then rejects a series of social roles: student, word processor, "kept" mistress, photographer, and finally scientist. Each time she takes on a new profession, she subjects her appearance, her environment, and her day-to-day habits to a total overhaul. These transformations are effec-

tively suggested by the photographs, which provide the viewer with selective and often metaphoric glimpses of the heroine and of the objects and spaces that define both her visual and psychological landscape at a given time.

Garnet's heroine ultimately finds no real meaning in her life. Three other narrative works—*Difficulty Swallowing*, by Matthew Geller; *Ransacked*, by Nancy Holt; and *Thirty Five Years/One Week*, by Linn Underhill—focus not on life but on death: specifically, the death of a loved one. When examined together, these three works can suggest the range of formal, conceptual, and even spiritual solutions possible in bookworks with ostensibly the same subject.

Matthew Geller's *Difficulty Swallowing* is a medical case history which chronicles the death from leukemia of the artist's girlfriend. The text, which dominates the book, consists of doctors' reports, nurses' notes, and official medical forms, as well as excerpts from Geller's and his girlfriend's diaries; the few photographic snapshots of the patient at various stages of her illness illustrate the deteriorating condition described in the text. *Difficulty Swallowing*, though poignant, is calculatedly unsentimental: its straightforward presentation of facts and

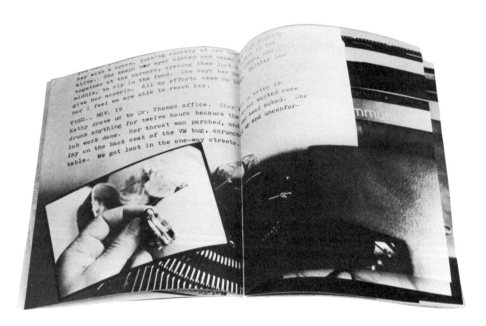

Linn Underhill, *Thirty Five Years/One Week*, 1981.

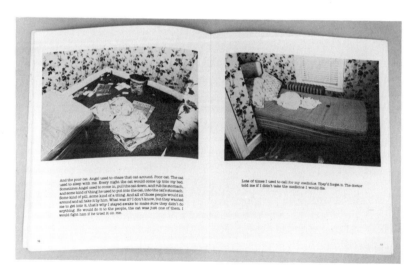

Top: Matthew Geller, *Difficulty Swallowing: A Medical Chronicle,* 1981.
Bottom: Nancy Holt, *Ransacked,* 1980.

documents serves to distance both the artist and the reader from the emotional tragedy of the situation and leaves no room for speculation about the meaning of either the life or the death.

Like Geller's book, Nancy Holt's *Ransacked*, the story of her aunt's last days and death, is straightforward. The first half of the book consists of black and white photographs of her aunt's ransacked house, which was taken over and looted by the "nurse" who held the sick woman hostage. These documentary images are juxtaposed with quotes from the aunt about this experience. The second half of the book contains family snapshots, recorded evidence, background information, and excerpts from Holt's diary which describe the resolution of the situation.

The narrative itself is frightening, yet the tone of Holt's book is cool; like Geller, Holt functions primarily as an observer and a recorder. It is only in the last paragraph that the artist summarizes her understanding of the incident, thus allowing herself to speculate, not only on the death but on the metaphoric meanings inherent in life: "To me the story of the dying of my aunt and the falling apart of her house will always be interconnected, the gradual decline of her body through cancer coinciding with the harsh invasion and deterioration of her long cherished house." In this one sentence, the entire story comes together. The structure of the book resonates with new meaning, and the relationship of photographs and texts—which at first seems simply documentary—suddenly becomes infused with metaphysical significance.

Whereas Holt's musings about the meaning of life and death are a tiny but significant part of *Ransacked*, these speculations are the central concern of *Thirty Five Years/One Week*, Linn Underhill's memorial to her sister. A more subjective book than either Holt's or Geller's, hers is an emotional summary of thirty five years of a life that was abruptly terminated in one week of illness. The clinical, objective tone is absent from this book, which reproduces only excerpts from the artist's diary during the illness. The predominant black and white photographs, on the other hand, rarely deal with the disease at all; they record aspects of the sister's normal life: her daughter, her room, her snapshots, the objects she loved. The pictures, which are often printed in soft focus, blurred, or bleached out, become repositories of memory—especially the series of snapshots of the sister from childhood to adulthood which is repeated continuously and expressionistically throughout the narrative.

Unlike Geller's and Holt's books, Underhill's puts forth no direct relationship between text and photographs: the one deals with illness and death, the other with love and life. But the emotional climate of the book is a subjective bond which unites life and death, images and words, into a unified representation of a full life cut short. There are numerous artists' books which, like Underhill's, depend on a dominant

emotional and/or psychological climate to create links between pictures and texts. Two such works, very different from each other in form and content, are Jacki Apple's *Trunk Pieces* and Barbara Rosenthal's *Clues to Myself.*

Trunk Pieces has the look and feel of a family album created during an era of charm and elegance whose glory has long since faded. Printed in sepia tones, the images—snapshots, old postcards, passports, records of places visited, and pictures of objects with special significance to the protagonist—are accompanied by several related narrative texts that chronicle travels: physical, emotional, and intellectual. Centering on the protagonist as well as her grandmother and mother and telling tales of unrequited love, fantasy, deception, and betrayal, the book ultimately uses photographs as evocative mementoes of the "illusions, expectations and lost dreams" described in the texts.

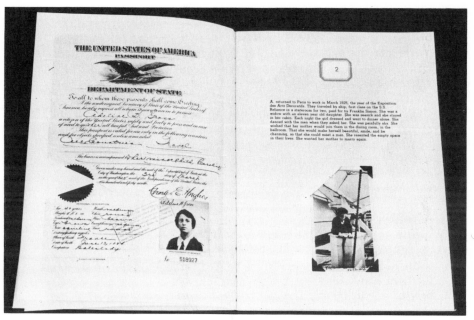

Jacki Apple, *Trunk Pieces*, 1978.

In *Trunk Pieces*, Apple uses pictures as springboards to memory, much as Proust used the madeleine in *Swann's Way*. In *Clues to Myself*, on the other hand, Rosenthal uses photographs in a dreamlike, associative way. This autobiographic journal of black and white photographs and texts, dealing primarily with the internal life of the artist, dispenses completely with unified narratives and direct word/picture relation-

ships. The pictures are evocative visions of mundane objects and vistas: roads, dolls, houses, trucks, dogs, trees. The fragmented texts are diary entries, musings, quotes, dream transcriptions, memories, and stories that are related only indirectly—through mood or suggestion—to each other and to the photographs. Read together, these highly personal images and texts illuminate one artist's subjective world.

While Apple and Rosenthal use mood and emotional climate to hold together words and pictures, Richard Nonas and Lawrence Weiner count on more conceptual devices to unify seemingly unrelated images and texts. In Nonas's *Boiling Coffee*, the text consists of phrases scrawled large on each page; the size of the handprinting alone gives the reader the impression that the protagonist is consistently shouting. Most of these emphatic phrases simply chronicle mundane urban activities: the protagonist walks around the block, talks to someone on the street, goes home, makes sculpture, and boils coffee, among other things. Yet interspersed among these ordinary activities are intimations of mortality—"I'm young now, but not like it once was"—and these intimations are reinforced by the stark, abstract, and expressionistic black drawings that surround both the text and the photographs, black and white pictures of men and women obviously from a culture different than the protagonist's. Juxtaposed with the scrawled texts, these images, which at first seem to have nothing to do with the words, become more and more insistent, until the narrator eventually identifies so completely with one of the photographed men that the boundaries between them dissolve. In this context, the protagonist's mundane activities become existential assertions of shared humanness: "I'm boiling coffee/to keep me warm/to keep me here/to keep him me."

Nonas's narrative forges connections between seemingly unrelated images and texts. There is, however, no narrative in Weiner's *Passage to the North*. The photographs in the book, printed in sepia tones, are snapshots of the artist, his friends and family hanging out, talking, using the telephone. Yet these ostensibly casual pictures have a stilted air to them, as if they were posed tableaux. The photographs are printed on the right hand pages; on the left are a series of short phrases, usually printed one to a page. The pictures and words are not related in content, yet they become referential by juxtaposition. Thus, the attenuated statement, "grouped by virtue/of being there/what is necessary to bring about/what in fact is a natural phenomenon," suddenly makes the reader wonder how, in fact, the people in the photographs came together in this particular time and place. At this point, these snapshots become loaded with philosophic implications.

All of the above-mentioned artists work, in different ways, to create connections between images and texts, while other artists take the opposite approach and use the book format to underline the disjunction

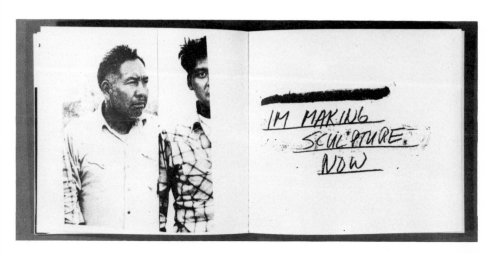

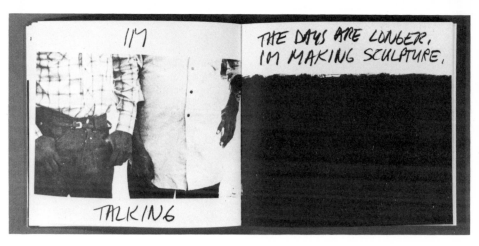

Richard Nonas, *Boiling Coffee* (two openings), 1980.

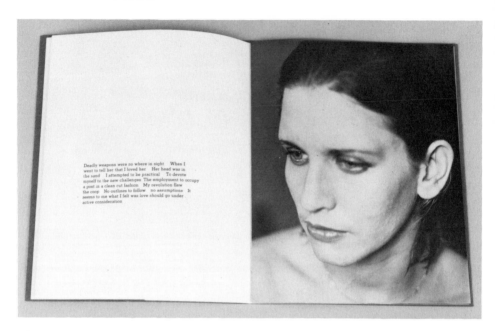

Top: Glenda Hydler, *The Human Dilemma, Part 1,* 1978.
Bottom: Ida Applebroog, *Look at me,* 1979.

between pictures and words. Anne Turyn's *Real Family Stories*, for instance, is composed of typical black and white family snapshots—of children, homes, meals, vacations, and the like—which give the reader/viewer a stereotypic image of American family life. The fragmented text that accompanies these pictures, however, is a collage of stories that expose the sheer insanity of family interactions. The book unfolds in the context of a family dinner, during which we hear about secret fetishes for brothers, cousins, or sisters-in-law; about affairs and divorces and feuds; about unrequited love and mental illness and half-dead mice in quaint old houses. Juxtaposed, these pictures and texts point up the huge gap separating our idealized image of "normal" family life from its sordid reality.

In a less cynical manner, Glenda Hydler uses photographs and words to differentiate between internal and external experience. Since November 1972 Hydler has been creating an ongoing series of "diaries" with alternating pages of texts and black and white photographs bound in individual looseleaf notebooks. (Though there are well over eighty such books, only one of them has been published, *The Human Dilemma, Part I*.) These works have usually focused on the relationships between the artist and others in both personal and social contexts. The autobiographical texts, generally typed in fragmented segments without punctuation, maintain stream-of-consciousness intensity and explore the internal states of the artist during the period of time encompassed by each book. The photographs, on the other hand, are repeated variations of images that describe one particular aspect of the visual world on which the artist chose to concentrate during the same time span.

Most of the photographs are portraits of Hydler, although some depict landscapes, scenes, or objects. Sometimes these pictures relate directly, either in subject matter or mood, to the text; sometimes they serve as metaphoric allusions to the emotional states described; at other times they have little if anything to do with the text, and act as visual counterpoints. But always in Hydler's work the juxtaposition of texts and photographs creates a play-off between the intense emotion of the verbal expression and the cooler, more objective description of the world of appearances, and thus makes a statement about the different layers of reality that define personal experience.

The portraits of Hydler included in her books are, in many ways, like mini-performances. So are the books of Ida Applebroog, which were created as a series over a period of years. These small bookworks consist of a single, or at most two, drawings, repeated obsessively. Most often these drawings represent two people frozen in gestures clearly signifying that a crisis point in their relationship has been reached. Since the viewer always sees these figures through a window, with the

shade half-closed and the curtains pulled back (so the window resembles a proscenium stage), an element of voyeurism creeps in. The power of Applebroog's books lies in the fact that they imply narrative but never allow a resolution; the moment of crisis pictured is simply repeated over and over and over again, like a broken record, and is thus almost unbearably attenuated throughout the book.

In most of Applebroog's bookworks the reader is given one or two phrases, strategically placed. These phrases hint at the problem, but never at its final outcome. *Look at me*, for instance, depicts a man and a woman; she, lying down, reaches for his arm in longing while he turns away. The viewer reads the phrase, "Look at me," and sees the picture three times before the next phrase, "We are drowning, Walter." And yet the book ends with the people in the same positions—as if the dialogue only pointed up that nothing changes, and that the real definition of hell is to be frozen in these charged moments for all eternity.

Applebroog perceives her books as theatrical works and, indeed, calls them "performances." There have been a number of performance artists who have turned to bookmaking as a way of preserving their transient art works. In some cases—notably *Seven Cycles: Public Rituals*, by Mary Beth Edelson, and *More Than Meat Joy*, by Carolee Schneemann—artists have chosen to compile retrospective monographs of their collected performances which often include photographs, scripts, and working notes. In other cases, less documentary and therefore more relevant to this study, words and images on a printed page have been used expressively, to transcribe, interpret, and/or summarize the meaning of individual performance works. The resulting book is conceived as a separate, but equal, art work based on the same material used in the original performance.

One such bookwork is Donna Henes's *Dressing Our Wounds in Warm Clothes*, a transcription of a project carried out on Ward's Island in 1980. Done in conjunction with, and on the grounds of, the Manhattan Psychiatric Center, this "energy trance mission" was actually a participatory sculpture project designed to pool the creative energies of the artist and the 4,159 patients, staff members, and visitors on the island. The artist collected beloved old clothes from the art community, tore them into strips and then, with the help of the denizens of Ward's Island, tied 4,159 knots of cloth on trees, bushes, and fences around the Manhattan Psychiatric Center. Since tying knots at healing waters is a widespread custom practiced by women in countries as diverse as Morocco, Scotland, and Armenia, Henes's ritual became a magic rite for the health of project participants.

The book based on this project is composed of transcriptions of Henes's working notes, including conversations, stories, musings, and dream transcriptions. It also contains black and white and color photo-

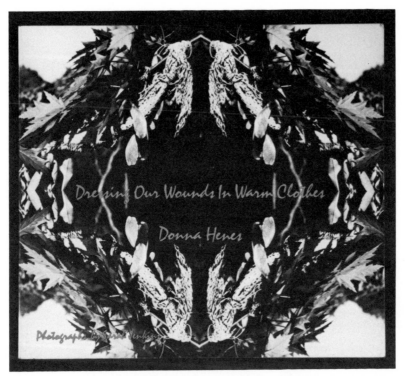

Donna Henes, *Dressing Our Wounds in Warm Clothes*, 1981.

graphs, straightforward documents, and composite images, all by Sarah Jenkins, recording the island, the sculpture, and the artist at work. But the composite images—stunning repetitious montages—transform "straight" photographs into visual mandalas that metaphorically describe the "network (of) ... connectivity" at the heart of Henes's work. In this case, images become visual translations of this particular artist's world view, another way of expressing the ideals embodied in Henes's sculpture, notes, dreams, and interactions with people.

Dressing Our Wounds in Warm Clothes records Henes's ritual in detail, both in pictures and words, serving as both a documentary and an interpretive work. Mary Fish's *The Persepolis Context*, on the other hand, is barely descriptive of the original project. The book is based on a private ritual performed over a period of twelve hours in the spring of 1976 at Persepolis, an archaeological site in Southern Iran. In the artist's words, "The activity consisted of scribing a circle on the ground and dividing that circle into twelve equal parts, one for each hour of the

day that I was to spend there. Each hour on the hour I placed a rose in the circle in one of the parts until at the twelfth hour twelve roses fanned outward to complete the circle."

This is about as descriptive as Fish gets; there are no working notes and no photographs of the site or the artist in this book. Instead, in *The Persepolis Context*, the artist functions almost purely interpretively, by using the bookwork to clarify the meaning of this ritual act. The book consists of a series of texts and drawings sequenced to represent each of the twelve hours she spent in performance. Texts, in the shape of pyramids, occupy the left hand pages; on the right are delicate brown drawings integrating words and pictures. Images and texts merge and become cross-referential, as do subjects and themes. Both the drawings and the texts forge connections, often in free association style, between Persepolis, a sacred capitol of the Persian Empire 2,500 years ago (now in ruins), and the rose. As the book progresses, the architecture and history of Persepolis become analogous with the structures and phases of this flower; in the process, the cycles of civilization begin to be perceived as part of the larger cycles of nature.

Henes transcribes and Fish interprets; Michael Kirby recreates a performance in book form. *Photoanalysis*, a structuralist play about the relationship of photographs and words, was first produced in November 1976. Kirby, who is best known for his involvement with

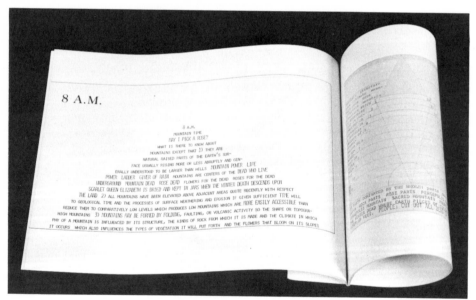

Mary Fish, *The Persepolis Context*, 1977.

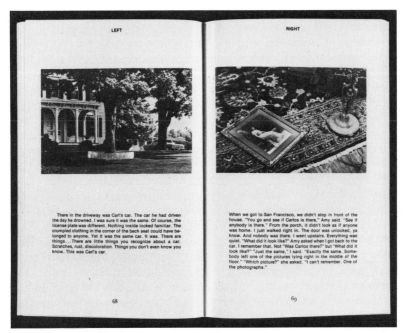

Michael Kirby, *Photoanalysis: A Structuralist Play*, 1978.

happenings and avant-garde theater since the late sixties, chose a dramatic format in which three actors—a man and two women, positioned respectively in the center and on the two sides of the performance space—spoke directly to the audience and illustrated their words with a series of black and white slides projected on screens behind them. The actors spoke alternately, each showing slides that related to his or her narrative, so that the spectator saw a continuous slide show while listening to three different, interwoven monologues. The same basic format is retained in the book *Photoanalysis*, which presents the same sequence of photographs, accompanied by expository texts and stage directions indicating which words were spoken by which actor.

The male actor's monologue is a lecture on the new "science" of photoanalysis; the women, on the other hand, tell personal stories as if they were leafing through their family snapshot albums. All three narratives depend for their development on "clues" gleaned from visual "evidence," and this is where the plot of *Photoanalysis* thickens. The three very different monologues are illustrated by the same series of photographs, each arranged in a different order. Considered alone, the pictures—of houses, people, street scenes, nature, and commonplace

objects—are simply mundane, not very interesting snapshots, but taken as the basis of these three very different story lines, they serve to undermine the very credibility of photographic "realism." Kirby's book, like Muntadas's *On Subjectivity*, which reproduced photographs from *Life* magazine with their original captions—and with solicited interpretations from a number of people who were unaware of the "real" meaning of the pictures, suggests that "objective" photographs may simply be elaborate fictions, always open to interpretation.

Kirby and the other performance artists who translate their pieces into book form are working in a multi-media context. So are the writers and visual artists who choose to pool their talents to create multi-media bookworks. There is, of course, a long and venerable tradition of illustrated books, books in which visual artists illustrate, either directly or indirectly, existing literary works. (Some contemporary examples are Samuel Beckett's *Fizzles*, with illustrations by Jasper Johns, J.L. Borges's *Ficciones*, with graphic equivalents by Sol LeWitt; and *Homage to Cavafy*, a work consisting of ten poems by the homosexual poet Cavafy and ten photographs by Duane Michals.) But there are also bookworks which are created specifically as collaborations, in which the words of a writer and the visual creativity of an artist are merged into a single work. Two such books are *Vampyr*, by Stephen Spera and Suzanne Horovitz, and *Monday Morning Movie*, by Barbara Cesery and Marilyn Zuckerman.

Vampyr: being a diary/fragments of his visit, is printed on creamy parchment paper and resembles a lush and antiquated album. The text, a prose poem narrative by Stephen Spera, tells the story of a family which lives with a vampire. The pictures, layered xeroxed images of skulls, long fingernails, reclining bodies, and lace, seem to grow around the text like ivy and provide this Gothic tale with an appropriately eerie backdrop. As the tale progresses, the distance between the family and the vampire diminishes, until "the identity of killer/victim merge"; at the same time the words and images become more and more intertwined, their "dreamy fascination" blending into one indivisible collage.

The romanticism of *Vampyr* is brought into the twentieth century in *Monday Morning Movie*. This is a pull-out book, a collaboration between visual artist Cesery and poet Zuckerman. The black and white, sometimes soft-focus images (most of them are photographic snapshots, although some are drawings) are the personal counterpoints to the poetry, which chronicles the rise and fall of romantic love in the movies since World War I. Structured like a filmic montage, the first part of the text deals primarily with male sexual stereotypes, embodied in movie stars like Cagney, Valentino, and Gable; the heroines and mothers ("the girls you come home to") are always waiting, "sick with

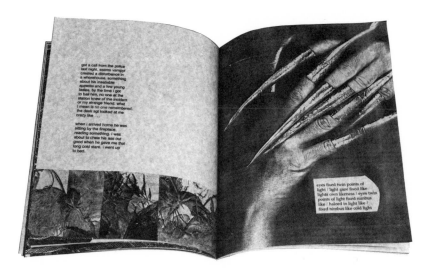

Stephen Spera and Suzanne Horovitz, *Vampyr: being a diary/fragment of his visit,* 1982.

deprivation." The second part, by contrast, presents verbal images of strong, self-sufficient women—Lupino, Mae West, Crawford—and explores the resilience of, and bonds between, women alone in the modern world. The text is either juxtaposed with or superimposed upon the pictures, and, as a result, the book suggests the subtle blend, in each of our lives, of popular stereotypes and personal emotions.

Monday Morning Movie deals with romantic love from an obviously feminist perspective. Artists' books have often been used, in many ways, to make ideological or political statements; the inexpensiveness and accessibility of these works makes them the perfect platform for distributing ideas on a popular scale. In many of these books, the message is communicated primarily through language: photographs or drawings are used essentially as illustrations of, or metaphors for, verbal statements. Martha Rosler's "in, around and afterthoughts (on documentary photography)" in *3 Works*, for instance, describes political situations and uses photographs to illustrate her arguments; Nan Becker's *Sterilization/Elimination* and Greg Sholette's *The Citibank Never Sleeps* (which metamorphosizes the Citibank logo into an image of a screw) make their statements with words and then use cultural images as emblems symbolizing the circumstances under discussion. Jenny Holzer and Peter Nadin's *Living—Daytime* is a series of

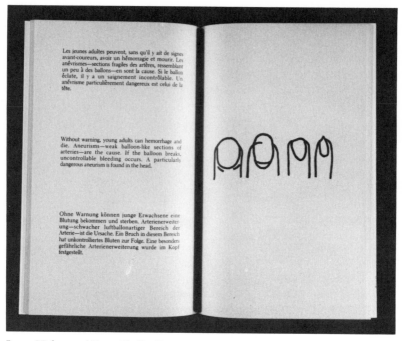

Jenny Holzer and Peter Nadin, *Living—Daytime*, 1980.

aphorisms about modern malaise, political powerlessness, and social suicide; the cumulative impact of these verbal messages is reinforced by the anonymous-looking line drawings of Everyman, Everywoman, and brick walls interspersed throughout the text. There are other books, however, in which graphics are an integral part of the political message. Hans Haacke, Barbara Kruger, and Mimi Smith, for example, have all created bookworks which use the visual elements of popular culture and the mass media to criticize contemporary social policies.

In *Der Trompf Pralinemeister (The Chocolate Master)*, Haacke turns the corporate image against itself by appropriating the format of corporate advertising. Each page of this book is designed as if it were a public relations poster. The pages on the left all depict Peter Ludwig, Chairman of the Mondheim Group of chocolate manufacturers. Beneath this business tycoon's idealized image, small and centered at the top of the page, is copy about the man and his career as an art collector and museum benefactor. At the bottom of the page are pictures of diverse brands of chocolate manufactured by his Group, and these chocolates are also featured on the bottom of the right hand pages, which have the same format. These pages, however, are topped by pictures of factories

and workers, and the texts deal with the often greedy and insensitive history of the Mondheim Group. Haacke's parallel verbal reports are factual, but as the book progresses, Ludwig's two "images" begin to merge, and the reader gradually comes to understand that this man is attempting, so far successfully, to wield the same tyrannical control over the European artworld that he wields in the chocolate industry. And at this point, art, industry, and public relations start to seem indistinguishable—in the "real" world as they are within the format of Haacke's book.

Graphics are also central to Barbara Kruger's feminist *No Progress in Pleasure*. In Kruger's earlier book, *Picture/Readings*, words and photographs had been separate, though juxtaposed; in this work the two are integrated in slick graphic configurations making obvious references to mass media advertising and design. The verbal messages are short, generalized, and punchy, the pictures to the point. The text, "Your manias become science," for instance, is superimposed on an image of a bomb explosion, and the combination strongly criticizes patriarchy: men's actions among themselves, in relation to women, and, by extension, within the political arena.

Whereas Haacke appropriates the look of corporate PR imagery, and Kruger alludes to Madison Avenue design, in *This is a Test* Mimi

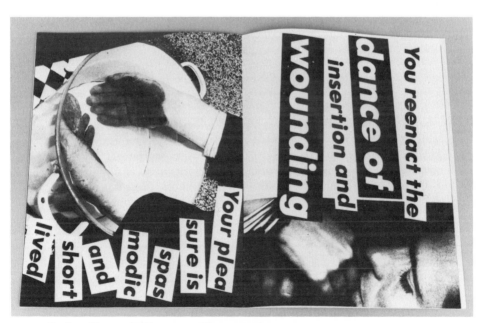

Barbara Kruger, *No Progress in Pleasure*, 1982.

Smith refers to broadcast television. Basing her work on the nuclear "test" signals with which we are all familiar, Smith gives us five pseudo-broadcasts describing "possible" bombings of Washington, D.C., Peking, Paris, Moscow, and Tripoli. Each of Smith's broadcasts is hand-written on a TV screen, yet the television set itself is "drawn" with words, scrawled in script, such as "Listen. This is a test . . . a warning." The book is obviously an anti-war political statement, but its format encompasses more. By completely integrating her words and pictures, Smith is telling us that we cannot separate form and content—that in this information-oriented society, the medium is indeed the message.

There are several artists who, like Smith, have taken that maxim literally, and created books which completely integrate words and images in unique and fascinating ways. These artists have rejected the linear format of most bookworks, and have instead used book pages as arenas for the expression of non-linear, multi-dimensional visions of a time, space, and experience. Eileen Berger's *A Novel in Progress About a Woman Named Sylvia*, for instance, is not a novel in the traditional sense; the narrative is non-linear, and specific situations and events are never described. Instead, Berger compares her work to the writings of literary artists such as Proust, Joyce, Woolf, and Nin, since her novel progresses as the heroine undergoes certain mental processes and shifts from one state of consciousness to another. These states of consciousness are reflected in arrangements of contemporary words and images, which Berger "finds" in the popular media, photographs, and then arranges in tight graphic montages.

Berger maintains a precarious balance between the controlled graphic order of each page and the unpredictable, seemingly chaotic interplay of disparate visual elements. The structure of each page is different (as of this writing, over thirty pages of a projected 200 have been completed, and these are now exhibited rather than bound), since none of them are preplanned. The artist allows her visual elements to suggest their own orders and relationships based on the associations they trigger in her. Within these tight configurations, fragments of a contemporary woman's visual experience—advertisements, dress patterns, art reproductions, illustrations, anatomical parts, phrases from books and magazines, etc.—appear and reappear, connect and disconnect, and alter in scale and importance. The completed pages document Sylvia's odyssey through her inner life as she confronts her various personae; longs for escape into a Garden; initiates a betrayal; and suffers a Fall and its consequences. So the life of a particular woman converges with the archetypal patterns of myth, and these shifting fragments of information formulate a multi-dimensional vision of reality—of time and space, of emotion and memory, of the conscious and the unconscious mind.

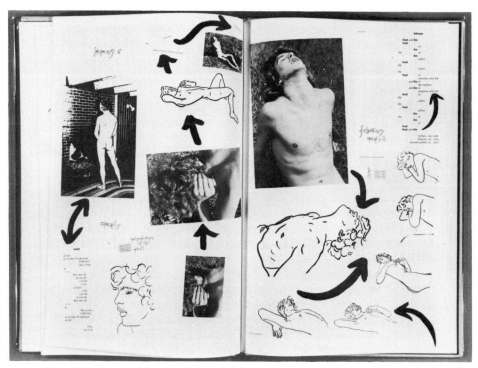

Dick Higgins, *of celebration of morning*, 1980.

Dick Higgins's *of celebration of morning* is also designed to give reader/viewer a multi-dimensional vision of reality. Each of the eighty pages of this large, beautiful book is a montage of photographs, photo derivations, line drawings, poems, musical scores, rhetorical questions, and symbols from the *I Ching*. Together these pages compose a narrative (or a "polysemiotic fiction," as Higgins describes it) about a young musician/dancer named Justin who overdoses on drugs while struggling to make the transition from youth to adulthood.

The "polysemiotic" format allows Higgins to depict his protagonist from different points of view and within different contexts, and, as a result, the viewer/reader experiences a cross-section of the spiritual, moral, intellectual, physical, psychological, and social forces that converge to define Justin's world. The book is divided into monthly sections that document a year in the young man's life. This chronological narrative is counterpointed by, and interwoven with, a number of non-linear elements and organizational devices that provide alternative readings to the story. The individual pages, or "worlds" in Higgins's

words, are self-contained in both form and content. Combining diverse media in random arrangements, they suggest open-ended, shifting meanings and can be interpreted independently or cumulatively. Higgins recommends a non-consecutive, indeed a cyclical, reading of the book. So the meaning of *of celebration of morning* is constantly in flux, as the reader chooses between different relationships and progressions.

Many of the images in Higgins's book depict Justin frolicking in the nude within natural settings and, thus, place his passage from boyhood to manhood within the seasonal cycles of nature—as well as in relation to the cosmic forces represented by the *I Ching*. Paul Zelevansky, in *The Case for the Burial of Ancestors: Book 1*, is also concerned with cosmic spiritual forces, but his book chronicles the history of a fictional people called the Hegemonians who resemble the Hebrews of the Old Testament. *Book 1* corresponds roughly to Genesis, and the cosmic drama it describes is produced and directed by the Puppeteer, who plays with his Forty Shards in the four hours before lunch, and is acted out by twelve Co-Creators, who include the Artist, the Narrator-Scholar, the Shaman, the Hatmaker, the Jericho Mapmaker, and the Projectionist. The narrative develops episodically through a sequence of graphically designed pages that function as geographic grounds for text, pictograms, diagrams, symbols, and maps framed in constantly shifting relationships. This format makes it possible for Zelevansky to explore his subject from a number of different perspectives and to adopt different historical viewpoints on the historical processes he describes. The main events traced in the book are the creation of the Four Edges of the known world: the Bindery Wall, the boundary between the old and the new worlds; the Waters of Separation, which serve as an arena for exploration and dispersal; the Ground, the physical plane of existence; and the Hill, the place to which the Hegemonians may ascend. These edges serve simultaneously as physical, formal, and spiritual guideposts, for Zelevansky records not only the literal and metaphorical structures of these markers but also their metamorphoses in time: the "layers of understanding" that are uncovered as these sacred locations become mythic rather than functional, and are transmuted into legends, rituals, books, parables, pictures, songs, and such. So the whole history of these Four Edges—and, by extension, of the Hegemonian geography—is contained within the story of their creation. As the artist writes, "past, present and potential exist at once" in this book.

Zelevansky telescopes time and space; Bonnie Gordon, in her "Image-Maps," telescopes time and culture. Her recently published work, *The Anatomy of the Image-Maps*, is not an artist's book in the conventional sense; rather, it is a reference work explaining the genesis of her imagery, and as such can be compared to Marcel Duchamp's

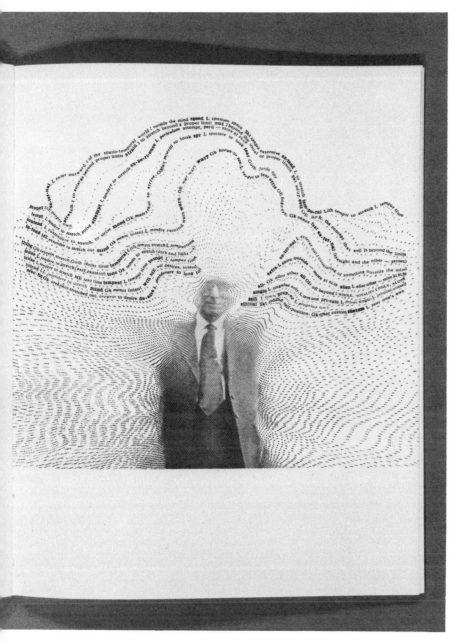

Bonnie Gordon, *The Anatomy of the Image-Maps, According to Merriam-Webster's Third New International Dictionary of the English Language Unabridged*, 1982.

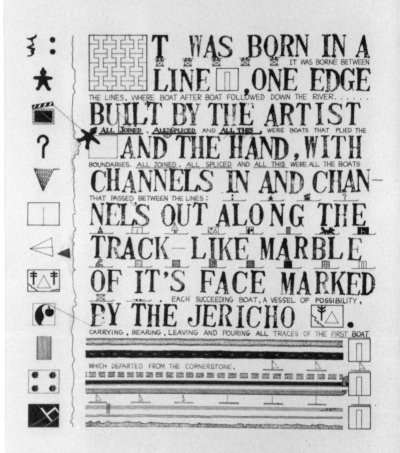

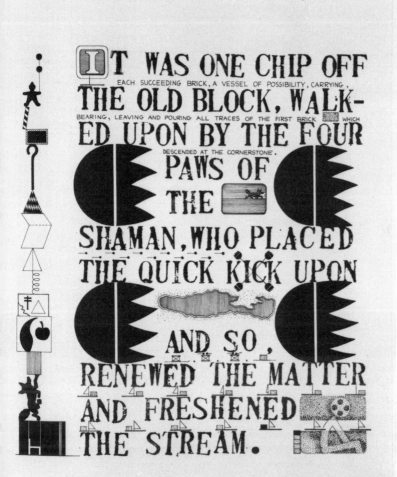

Paul Zelevansky, *The Case for the Burial of Ancestors, Book 1*, 1982.

Notes and Projects for the Large Glass. For over a decade, Gordon has been exploring the contents of *Merriam-Webster's Third Unabridged Dictionary*. By examining the etymons of words and by grouping together dictionary definitions which contained identical words, Gordon discovered that "the recurrence of similar tales of human commonplaces suggested that an organic system of emblems and allegories might underly the overt content of the dictionary and that linkages of identical words might be able to reweave and restore some semblance of that hidden structure." Since her word groupings inevitably suggested analogies to human forms, Gordon combined these verbal clusters with a stretchable halftone photograph of an anonymous adult male. The result is a series of "Image-Maps": word pictures which represent a merger of these two forms of language and thus attempt to recreate the primal roots of human symbolic communication.

The Anatomy of the Image-Maps is an explanation of one of the most far-reaching bodies of work being produced by an artist today. And it is, I think, appropriate to end this essay with this book—because by tracing the roots of words and pictures, *The Anatomy of the Image-Maps* probes the conceptual and imagistic origins of all artists' books which combine words and images.

© *1984 by Shelley Rice*

BIBLIOGRAPHY—BOOKS BY ARTISTS

Apple, Jacki. *Trunk Pieces*. Rochester, New York: Visual Studies Workshop Press, 1978.
Applebroog, Ida. *Look at me*. New York: Dyspepsia Works, 1979.
Becker, Nan. *Sterilization/Elimination*. New York: Nan Becker, 1980.
Beckett, Samuel, ill. Jasper Johns. *Fizzles*. London: Petersburg Press.
Borges, Jorge Luis, ill. Sol LeWitt. *Ficciones*. New York: Limited Edition Club.
Cavafy, Constantine. (10 Photos by Duane Michaels). *Homage to Cavafy*. Danbury, New Hampshire: Addison House, 1978.
Cesery, Barbara, and Marilyn Zuckerman. *Monday Morning Movie*. New York: Street Editions, 1981.
Duchamp, Marcel. *Notes and Projects for the Large Glass*. Edited by Arturo Schwarz, New York: Abrams, 1969.
Edelson, Mary Beth. *Seven Cycles: Public Rituals*. New York: Mary Beth Edelson, 1980.
Fish, Mary. *The Persepolis Context*. no place, Mary Fish, 1977.
Garnet, Eldon. *Cultural Connections*. Toronto, Canada: Image Nation No. 24, 1981.
Geller, Matthew. *Difficulty Swallowing: A Medical Chronicle*. New York: Works Press, 1981.
Gordon, Bonnie. *The Anatomy of the Image-Maps, According to Merriam-Webster's Third New International Dictionary of the English Language Unabridged*. Rochester, New York: Visual Studies Workshop Press, 1982.
Haacke, Hans. *The Chocolate Master*. Toronto: Art Metropole, 1982.
Henes, Donna. *Dressing Our Wounds in Warm Clothes: Ward's Island Energy Trance*

Mission. Los Angeles: Astro Artz, 1982.

Higgins, Dick. *of celebration of morning*. New York: Printed Editions, 1980.

Holt, Nancy. *Ransacked*. New York: Printed Matter/Lapp Princess Press, 1980.

Holzer, Jenny and Peter Nadin. *Living—Daytime*. New York: Holzer/Nadin, 1980.

Horovitz, Suzanne. See Spera, Stephen.

Hydler, Glenda. *The Human Dilemma, Part I*. Rochester, New York: Visual Studies Workshop Press, 1978.

Kirby, Michael. *Photoanalysis: A Structuralist Play*. Seoul, Korea: Duk Moon Publishing Co., 1978.

Kruger, Barbara. *No Progress in Pleasure*. Buffalo, New York: CEPA, 1982.

Kruger, Barbara. *Pictures/Readings*. New York: Barbara Kruger, 1978.

Muntadas, Antonio. *On Subjectivity*. Cambridge, Massachusetts: Muntadas, 1978.

Nonas, Richard. *Boiling Coffee*. New York: Tanam Press, 1980.

Rosenthal, Barbara. *Clues to Myself*. Rochester, New York: Visual Studies Workshop Press, 1981.

Rosler, Martha. *3 Works*. Halifax, Nova Scotia: The Press of the Nova Scotia College of Art and Design, 1981.

Schneemann, Carolee. *More Than Meat Joy*. New Paltz, New York: Documentext, 1979.

Sholette, Greg. *The CITI Never Sleeps, but Your Neighborhood May be Put to Rest*. New York: Greg Sholette, 1980.

Smith, Michael. *The Big Relay Race*. Chicago: Chicago Books, 1981.

Smith, Mimi. *This is a Test*. Rochester, New York: Visual Studies Workshop Press, 1983.

Spera, Stephen and Suzanne Horovitz. *Vampyr: being a diary/fragments of his visit*. Philadelphia: Synapse, 1982.

Turyn, Anne. *Real Family Stories*. (Top Stories #13). Buffalo, New York: Hallwalls, 1982.

Underhill, Linn. *Thirty Five Years/One Week*. Rochester, New York: Visual Studies Workshop Press, 1981.

Weiner, Lawrence. *Passage to the North*. Great River, New York: 1981.

Zelevansky, Paul. *The Case for the Burial of Ancestors, Book 1*. New York: Zartscorp Inc., Books and Rochester, New York: Visual Studies Workshop Press, 1982.

The Page as Alternative Space 1950 to 1969

by Barbara Moore and Jon Hendricks

*I*N *TriQuarterly 43*, an issue devoted to "The Little Magazine in America," Michael Anania points out that earlier researchers had estimated a total of 600 little magazines being published in English between 1912 and 1946. He calculates that at least 1500 such magazines were published in 1978 alone. These figures represent only one segment of the alternative press scene—the segment with a literary bias, periodicals rather than one-time publications, and material in one language only.

There are no such statistics available for the relatively recent phenomenon of artist-produced bookworks, very few of which fit neatly into the categories above. With hindsight it is possible to trace the trend back twenty or more years, but the vocabulary to describe it is not older than ten. Definitions of the term "artists' books" are as plentiful as the books themselves. Being given the title "The Page As Alternative Space" has allowed us the freedom of ignoring all criteria save one: that the works mentioned represent an artist or artist's colleague in control of their own work, outside of the gallery system.

If the publications are arranged chronologically, some surprises emerge. Try as we might, we could find very little published by American artists in the early fifties that was designed as an expression of their work rather than a statement about or reproduction of it. Original art was synonymous with "fine art," the mediums of painting, drawing, and hand-pulled print. Publications were for expressing ideas (sometimes accompanied by photographs of paintings) or showcasing literary talent. *Trans/formation*, edited by artist Harry Holtzman (who had taught briefly with Hans Hofmann in the thirties and was also an official of the Federal Arts Project from 1936-37), had an international board of consulting editors that included Nicolas Calas, Le Corbusier, Stuart Davis,

Marcel Duchamp, Buckminster Fuller, S. I. Hayakawa, S. W. Hayter, and Nelly Van Doesburg. Its intention was to "cut across the arts and sciences by treating them as a continuum." In its once-a-year issues published from 1950 to 1952, it carried essays on everything from current music (by John Cage and others) to quantum theory (by physicist Werner Heisenberg). Aside from an Ad Reinhardt art comic in each issue, the visuals were illustrations of the texts, albeit often eccentric in choice such as children's drawings or commercial comic strips.

Semi-Colon (ten issues?, 1952-56) was primarily a poets' newsletter, edited and published single-handedly by John Bernard Myers, who throughout the fifties and sixties exerted considerable influence in bringing together the poets and artists of the New York School in collaborative fine art prints and in theatrical works as producer of the New York Artists Theatre. *Semi-Colon* thus was also a vehicle for poetry by artists, among them Fairfield Porter.

Group ideas could be effectively disseminated through print. Publication of the first issue of *Reality* triggered more than 4000 letters to the editorial committee, which consisted of realist artists Isabel Bishop, Edward Hopper, Henry Varnum Poor, and Raphael Soyer, among others. Subtitled "A Journal of Artists' Opinions," its three issues (1953-55) rage against the "ritual jargon" and newly-abstract taste of a "dominant group of museum officials, dealers, and publicity men." Interestingly, it preceded the publication of *It Is*, the most famous organ for the Abstract Expressionists, by five years.

Small press activity in the United States in the decade following the mid-fifties was distinguished by a progression of influential poetry magazines that to varying degrees incorporated the work of artists. Among them were Robert Creeley's *The Black Mountain Review* (not as exclusively linked to the famous college as its name implies), Gilbert Sorrentino's *Neon*, LeRoi Jones's *Yugen*, and Marc Schleifer and Lita Hornick's *Kulchur*. But none attempted to turn the magazine into art with the exception of *Folder*, edited by Daisy Aldan and Richard Miller between 1953 and 1956. Each of its four issues has at least one original serigraph plus a serigraph cover, and consists of loose printed sheets of fine laid paper, enclosed in a paper portfolio. Aldan credits a major influence on the format of the magazine to Caresse Crosby's *Portfolio* series that was published by the Black Sun Press in the forties.

On the West Coast, Wallace Berman painstakingly created nine issues of *Semina* between 1955 and 1964. Each issue was put together literally from scraps of paper, the printing done by Berman himself to avoid censorship problems that had plagued him from the beginning, as well as high costs. Working alone, out of the mainstream, he published poems, drawings, and photographs by himself and others in editions of about two or three hundred. Fewer exist today as many copies

were destroyed along with his home in a 1964 landslide.

In the mid-fifties widespread attempts to disassociate photography from the mass-media were still nearly fifteen years in the future. The most notable alternative publications by photographers adapted to (and sometimes revolutionized) the mass market, in particular the books of William Klein, beginning with *New York* in 1956, and Robert Frank's *The Americans*, the American edition of which appeared in 1959. Klein was an established fashion photographer as well as a painter who composed his photographic layouts in highly personal ways. Frank, a Swiss who had emigrated to the United States in 1947, has been called the "graphic spokesman of the Beat Generation."

These photographic books eliminated the language barrier (Frank's book had initially been published in Paris a year earlier, Klein's was printed in Switzerland for an English publisher), but most of the above developments were somewhat isolated in the United States, largely concentrated on the East Coast, with particular energy surrounding the New York School of painters and poets. Independent development was taking place in Europe and South America.

From 1949 to 1951, eight issues of *Cobra*, "Organe du front international des artistes experimentaux d'avant-garde," were published, with rotating editorship and printers (the review and subsequently the group took its name from the three main centers where its contributors worked: COpenhagen, BRussels, and Amsterdam). This lively journal covered areas of pop culture (Charlie Chaplin appears several times) and anthropology as well as art. Its subtitle indicates two important impulses that motivated some of the publications already discussed as well as many later on: the possibilities of being an organ for a group and of linking individuals in different countries.

In contrast to much of the literary orientation in the United States at this time, some Europeans relied more on a concept of limited editions going back at least to Vollard. The work of two prominent individual artists is a case in point: Bruno Munari and Diter Rot (a.k.a. Dieter Roth). Munari, a painter, sculptor, photographer, and graphic and industrial designer working out of Milan, began in the late forties to make a variety of "Libro Illegible," which were handmade combinations of stitched and cut pages, using different colors and textures of paper, that were bound as a book. In the fifties he rejected "craft" and successfully adapted some of his ideas to the manufacturing process, as in his cut-page *Quadrat Print* produced in an edition of 2000 copies in 1953 or, a few years later, his mass-market children's books, which contain different-size pages, die-cuts, overlays, and books-within-books, very much an extension of his handmade works.

The Icelandic artist Diter Rot, schooled in Germany and Switzerland, was only twenty three and already skilled at graphic experimenta-

tion when he published his work in the first issue of *Spirale* (nine issues, 1953-64), which he co-edited with graphic designer Marcel Wyss and concrete poet/designer Eugen Gomringer. In 1957 he founded his own press (with Einar Bragi), Forlag Ed, in Iceland, and began publishing books with elaborate hand-cuts and die-cuts that create different effects as the pages are turned. Bindings are notebook-style spirals or loose-leaf rings, or the pages are loose in a folder; editions were small and signed. The large majority of Rot's books have been self-published, first through Forlag Ed and, from the mid-sixties on, via his partnership in Edition Hansjörg Mayer.

In 1957 Rot's friend, Daniel Spoerri, began the review *Material* (four issues, ca. 1957-59). In contrast to *Spirale*, which is oversize in format but finely printed on colored papers, and which includes woodcuts and lino prints by established artists such as Hans Arp, *Material* is completely unpretentious. Devoted to concrete poetry, its issues were composed on the typewriter and avoided conventional sewn or glued bindings; the first and second issues, an international anthology of concrete poetry and Rot's "Ideograms" respectively, are held together by rivets; the third issue, Emmett Williams's "Konkretionen," has an ingenious rubber band binding designed by André Thomkins. Although published in a very small edition of 200 copies per issue, *Material* only cost three Deutschmarks (about 60¢?). Early issues of *Spirale*, published in editions of 600 copies each, had cost ten Swiss francs each (about $2 or $3?). A few copies were signed and sold for more. So while *Spirale* represented an attempt to make fine art available at a price far lower than in a gallery, *Material* made an even more radical break with the past by being produced cheaply and made available at the lowest possible price.

But *Spirale* and *Material* had other things in common. One of *Spirale*'s editors, Eugen Gomringer, has been called the father of concrete poetry, having written his first poems in that style in 1951. Haroldo and Augusto de Campos and Décio Pignatari formed the Noigandres group in São Paolo in 1952 and, unbeknownst to them or to Gomringer at the time, Oyvind Fahlström had published his manifesto for concrete poetry in Stockholm in 1953. In Vienna Friedrich Achleitner, H.C. Artmann, Konrad Bayer, Gerhard Rühm, and Oswald Wiener were experimenting with sounds and concrete forms, most intensely in the period from 1954-59, although their publications didn't begin appearing until the late fifties. Concrete poetry, whose practitioners should be considered both artists *and* poets, was becoming a truly international movement.

By the beginning of the sixties the variety as well as the quantity of what were soon to be called artists' books was steadily increasing, and the trend toward publishing one's own work was becoming world-

wide. There had been a subtle shift from the derogatory concept of self-publishing-as-vanity-press to the possibilities inherent in an artist controlling his or her own work.

Distribution systems underwent parallel changes. As early as the mid-fifties Ray Johnson began using the mails to disseminate his artwork. In addition to the collages for which he is best known, he sent small but bulky sculptural pieces and even, circa 1965, page-by-page, *The Book About Death*, for which complete sets of pages were never sent to the same person.

From about 1957 into the early sixties George Brecht printed, at first by himself on a ditto machine, later by offset, small numbers of copies of his analytical and carefully footnoted essays, *Chance-Imagery* and *Innovational Research*, plus, on small slips of paper, the first of his tersely worded scores and events that would later be collected and republished by Fluxus as *Water Yam*. These were given or mailed to friends, sometimes accompanied by small objects or collages.

Graphic designer George Maciunas, who was responsible for publishing and designing most of the Fluxus editions, experimented in other ways with the mails. The yearbox *Fluxus I* (1964) could be mailed without additional packaging just by stamping and addressing its integral container of wood or masonite. In 1965 he paired Henry Flynt's essay, *Communists Must Give Revolutionary Leadership In Culture* with some of his own architectural plans, the two folded sheets sandwiched between samples of the plastic materials to be used in construction, which made a self-contained package. The design did not please the post office, which refused to mail it.

The significance of *Fluxus I* goes far beyond its role in mail art. Maciunas designed this anthology to accommodate a wide variety of objects as well as printed matter. Most of the pages are manila envelopes with loose items inside; the whole is held together with three nuts and bolts. (It is uncertain whether, at that time, Maciunas was aware of Fortunato Depero's bolted book of 1927, *Depero Futurista*, but he sometimes openly cribbed other formats, noting that he could improve them by a better alliance of form and content.) Aside from taking the book form as far as possible into object form, *Fluxus I* represents the performance scores and conceptual pieces (many of them "gesture pieces" inherent in the format itself) of artists and musicians from half a dozen countries.

This growing internationalization was also apparent in most of the seven issues of *Dé-coll/age*, edited and designed by Wolf Vostell in Germany from 1962 to 1969. Vostell, who had been a commercial book designer, was considered a rival by Maciunas, both for his strong graphic sense and his vying for publication material from more or less the same group of artists.

Publications in this period could be as small as Rot's two-centimeter-cubed (*Daily Mirror Book*) of 1961, a spine-glued chunk of 150-odd pages cut from the newspaper; or as large as Alison Knowles's *Big Book* of 1967, an eight-foot high unique construction with a pole for a spine, "pages" on casters, and each page a three-dimensional room.

They could be as meticulously printed as publisher Hansjörg Mayer's early oversize portfolios of fine prints with typography, or perfectly laid out concrete poems, each numbered and signed in small editions; or as immediate as the mimeo miniatures of Peter Schumann, which could be cranked out on the spur of the moment, sold for a dime or given away free, created by Schumann himself or by any of his associates, always anonymously.

Some books were obscure and (at the time) unmarketable, such as Jack Smith's *The Beautiful Book* of 1962. An unknown number of copies were handmade of 2¼-inch contact-printed photographs mounted one to a page. An even smaller number in the edition have added handwritten text.

At least one book even got mass-produced, although its published version presents a somewhat slicker aspect than the artist's rough-hewn maquette. Allan Kaprow's *Assemblage, Environments and Happenings* was published by the commercial artbook publisher Harry N. Abrams, Inc. in 1966 in both hardcover and paperback editions, the former about 1500 copies, the latter 5000 or more.

Esoteric books could also be made to *look* mass-produced, as with most of the publications of the Something Else Press, founded by Dick Higgins in 1964 to promote avant-garde material. Higgins's somewhat subversive approach was to manufacture the most radical texts in conventional, high-quality bindings so that standard libraries would be more willing to put them on their shelves.

Some books were banners, propagandizing for aesthetic or political points of view. Such were the publications of the Czech happenings group Aktual which, beginning in 1964, published a magazine of that title, then a "newspaper" (edition of fifty copies!), as well as elaborate near-object-like books by two of its leaders, Milan Knížák and Robert Wittman. Their extensive use of hand-printing and collage was less from a desire to make precious objects than due to the "unofficial" nature of their work; as with the underground samizdat that began to appear in iron curtain countries in the early sixties, Aktual's manuscripts had to be hand-typed in carbon duplicates or otherwise handmade in order to be published at all. Printing equipment of any kind was totally inaccessible and illegal. The frustration and compulsion behind these publications can perhaps be read into the title of the third and last issue of *Aktual* magazine, "Necessary Activity."

The variety of formats, contents, purposes, processes, and distribu-

tion systems begins to seem infinite. Unrestricted by conventions of size, for example, and seeking the cheapest, fastest means of offset, some artists published in newspaper format. Painter Alfred Leslie edited and published *The Hasty Papers* in 1960 in tabloid size printed on newsprint with a newspaper-style masthead, but bound as a book. This "one-shot review" contains essays, poems, playscripts, reprints, and the photographs of Robert Frank.

Scrap was more of an actual newsheet; in its eight issues published between 1960 and 1962 editors Anita Ventura and Sidney Geist summarized the meetings of the Artists' Club and allowed a forum for the artists' circle of which they were a part.

Also in 1960, in Paris, for a Festival of Avant-Garde Art, Yves Klein published his one-day newspaper, *Dimanche*, which mimicked the real life *Dimanche Soir*, and features his manifesto "Théâtre du Vide."

The newspaper format was particularly well-suited for putting forward the work of a group. In 1964, George Maciunas turned a small double-sided sheet that had been published by George Brecht two years previously into the official Fluxus organ. In its expanded, four-page, *Times*-size format, *V TRE* displays occasional poster-like announcements of concerts or pictures of past events, plus scores that can be performed and pages that can be cut up to form self-contained "editions." All material was created expressly for the printed page by contributors from all over the globe. There were nine issues of *V TRE* under Maciunas, a tenth edited by Robert Watts and Sara Seagull with Geoff Hendricks, and an eleventh edited by Hendricks, the latter in 1979.

To herald the first Bloomsday event in 1963 at the Dorothea Loehr Gallery in Frankfurt, Bazon Brock, Thomas Bayrle, and Bernhard Jäger had their *Bloom-Zeitung* handed out at a major intersection of the city. This newspaper was a transformation of a common scandal paper, *Bild-Zeitung*, by the insertion of the word "Bloom" throughout the front page, with a poster double spread inside.

By the end of the decade Steve Lawrence in New York was publishing a newspaper called simply *Newspaper* that contains pictures but no text. And the artist's newspaper came full circle as a conveyer of news and gossip with the founding of both Les Levine's *Culture Hero* and Andy Warhol's *Interview* in 1969.

Discussion of newspapers inevitably leads to the issue of artist politization in the mid and late sixties—in the United States over racism and the Vietnam War, in Europe in disgust with materialism and later in sympathy with the student movements of 1968. *Guerrilla*, "a broadside of poetry and revolution," (1966-?, number of issues unknown, begun in Detroit by John Sinclair and Allen Van Newkirk) became part of a world-wide counter-culture press. Publications such as the *East Village*

Other in New York and *International Times* and *Oz* in England drew from local and international communities of artists and poets for contributions. Among the most direct political publications were the Dutch *Provo* (15 issues plus one bulletin, 1965-67) and later, the hundred or more single sheets issued by New York's Guerrilla Art Action Group, which began in 1969.

Unconsciously at first, then deliberately, the self-published artwork had become a way of circumventing the entire gallery system and, taking a cue from the literary small press revolution, subverting the traditional publishing/distribution system as well. In 1962 artist Ed Ruscha published his first book, *Twentysix Gasoline Stations*, in an edition of 400 numbered copies. Five years later he reprinted it in an unnumbered edition of 500 copies. A third edition of 3000 copies came out in 1969. Ruscha was by then a well-known artist, whose paintings and drawings were being promoted in a major establishment gallery. His decision to keep old titles in print while regularly creating new ones was acknowledgement of the irrelevance of the limited edition.

Other artists found they could use the independent book form to supplement an exhibition, in place of a catalogue. The most famous of these was Daniel Spoerri's "catalogue" for his 1962 exhibition at the Galerie Lawrence in Paris. This unassuming little pamphlet, *Topographie Anecdotée du Hasard (An Anecdoted Topography of Chance)* used the objects on Spoerri's table at a particular moment as the springboard for a series of autobiographical musings, a text that amplifies the same concerns evident in his table-top assemblages. In addition to the original French the *Topographie* has appeared in English and German (expanded and re-anecdoted by various of the artist's friends) plus Dutch, making it one of the most widely published artist's books.

Another example of the catalogue-as-artwork is Marcel Broodthaers's *Moules Oeuf Frites Pots Charbon (Mussels Eggs French Fries Pots Coal)*. Created for his 1966 exhibition at the Wide White Space Gallery in Antwerp, this shows the same attention to typography and layout as any of his more elaborate publications.

Taking this idea one step further implies doing away with the gallery exhibition altogether. *March 1-31, 1969* by Robert Barry, Douglas Huebler, Joseph Kosuth, Lawrence Weiner, and twenty seven other artists is just one of several publications issued by Seth Siegelaub in New York in the late sixties that takes this conceptual approach. This book *is* the exhibition, easily transportable without the need for expensive physical space, insurance, endless technical problems or other impediments. In this form it is relatively permanent and, fifteen years later, is still being seen by the public.

Economics played, and still plays, a large role. The "mimeo revolu-

tion" that began in the fifties provided quick, cheap and very direct methods of printing. One could even draw directly on the stencil, as Claes Oldenburg did for his *Ray Gun Poems*, one of a series of "comics" made by the participants in the 1960 Ray Gun Spex. Works could be produced frequently without subsidy, and therefore could exist outside the commercial marketplace.

Poet Ed Sanders edited and published thirteen issues of *Fuck You* magazine, plus at least fourteen other publications, plus an assortment of flyers and catalogues between 1962 and 1965. In England, Jeff Nuttall's *My Own Mag* had a run of at least seventeen issues between 1964 and 1966. Compare this with a typical publication of the early fifties. *Trans/formation* had been carefully typeset and offset by a regular printer, a time-consuming and expensive process. Originally planned as three issues *per* year, it only appeared three times in three years. And while *Fuck You* ran into serious trouble with the New York police, in which several issues were confiscated, the majority of such mimeographed publications avoided advance censorship by typesetters and printers.

Another economic short-cut is to have each artist in an anthology actually produce his or her own page in the requisite number of copies for the edition, in a predetermined size. An early example of such an "assembling"-type work is *Eter*, which was coordinated by Paul Armand Gette beginning in 1966 in Paris. Not all of the issues used this method of publication, but under somewhat different titles (*Ether, Eter Contestation, New Eter*) the magazine continued publication into the early seventies.

This article has barely touched on a whole range of other possibilities that can turn an ordinary page into alternative space. The Situationists, Group Zero and the Lettrists are only a few more of the groups that made significant use of printed matter in the two decades covered here. If any trend was discernible as the seventies approached, it was the tendency away from limited editions and toward making work available cheaply to as many people as possible. But back in 1969, this was not so clear cut. The developing medium, faced with adolescent growing pains, possessed enormous unfocused energy, but lacked full evidence of maturity, even an efficient distribution system. It would be during the next decade that artists' books would finally come of age.

© *1980 by Barbara Moore and Jon Hendricks*

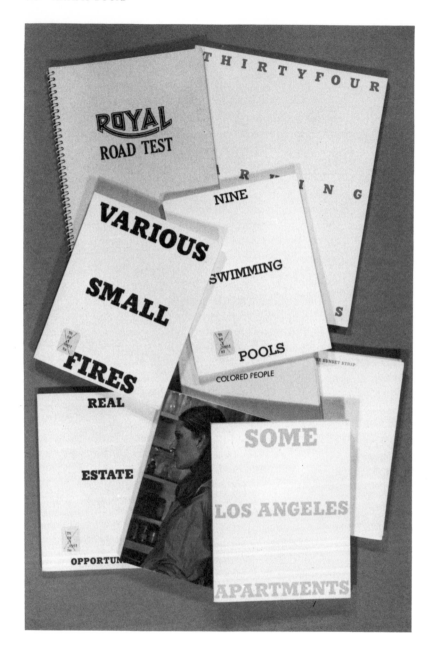

Books by Edward Ruscha

Some Contemporary Artists and Their Books

by Clive Phillpot

*I*N ORDER to illustrate the rise of multiple books and bookworks since the early 1960s, this survey examines and reflects upon the publications of twelve artists who have been making books for at least ten years, who have demonstrated a commitment to the medium, and who have either been prolific bookmakers or have made books which were widely distributed and furthered the development of book art.

The principal credit for showing that the book could be a primary vehicle for art goes to Ed Ruscha. While one can identify publications and tendencies which might be said to have some historical significance for the development of book art, Ruscha's distinction is that for several years he produced books as a first-order activity and published them in comparatively large numbers. The consequence of this was that not only did Ruscha's books become highly visible in galleries and bookstores—even boutiques—but the idea that an artist might use the book form to make artworks was also promoted and validated. Ruscha's books did not simply appear in many places, they also appeared in bunches of five or ten copies at a time. Their multiplicity was apparent. His books were unsigned, unnumbered (after the very first printing of the first title), and the editions were unlimited. This was a radical break with the nature of previous interactions between artists and books. The customary aura of artworks was instantly dispelled. These were no precious objects to be locked away and protected from inquisitive viewers. They were obviously for use, and intended to be handled and enjoyed. Thus, Ruscha created the paradigm for artists' books.

Ruscha's first book, *Twentysix Gasoline Stations* (1962), set the pattern and the tone for many of his subsequent books. Its cover was carefully designed, but not ostentatious; the typography was distinctive,

and the title was a precise description of what was to be found inside. A good many of Ruscha's books are simply collections of depictions of related objects, though not without certain surreal touches. For instance, the cover titles of two of his books are *Various Small Fires* (1964) and *Nine Swimming Pools* (1968), but the full titles of these books, which are to be found inside, are *Various Small Fires and Milk* and *Nine Swimming Pools and a Broken Glass*. Sure enough, the pages depict fires and pools, except for the last image in each book which is a glass of milk and a broken glass respectively.

If there are concerns which unify the various books they would seem to be photography, words and signs in the landscape, and motion. With regard to the latter, *Twentysix Gasoline Stations* relates to driving, *Dutch Details* (1971) to walking, and *Thirtyfour Parking Lots, in Los Angeles* (1967) to flying. Ruscha's books might therefore be compared with those of Hamish Fulton, for example, since walking is central to his art and to his books.

Royal Road Test (1967), made in collaboration with Mason Williams and Patrick Blackwell, which documents the road test given to an old Royal typewriter by hurling it out of the window of a moving car, parodies road test reports and resembles a slim manual sold with a mechanical device. It also demonstrates an ironic affinity with books which land artists and conceptual artists have produced in order to re-

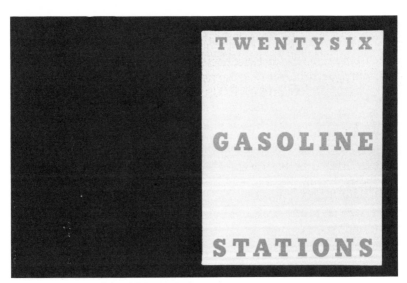

Edward Ruscha, *Twentysix Gasoline Stations*, 1962.
Collection of the Museum of Modern Art.

cord their activities in remote locations. A book by Ruscha was also the subject of perhaps the first in-joke in contemporary book art. In 1967 Bruce Nauman produced a fold-out book entitled *Burning Small Fires*. The subject of this book was simply the documenting of the burning of an actual copy of Ruscha's *Various Small Fires*.

Ruscha's books embody primarily visual content, multiplicity, cheapness, ubiquitousness, portability, nonpreciousness—even expendability—features inherent in his first book in 1962, and thus predating most of the related book art activity of the late sixties and early seventies. His early books also predate the ascent and apogee of conceptual art at the end of the sixties.

For many conceptual artists the book was the most appropriate means to record and disseminate their ideas, theories, diagrams, or drawings, or to embody their artworks. At this time many artists were also concerned with writing—as art or about art—thus, they too were led naturally to use the book form. The interest of several pop artists in book production also peaked in the late sixties. Indeed, this moment seems to have been a particularly fruitful time for publishing.

The social unrest of the period was accompanied by an efflorescence of leaflets, posters, pamphlets, and magazines. At the same time those who had opted out of mainstream urban society were also active in publishing, both for self-help and for communal exchange. Music had

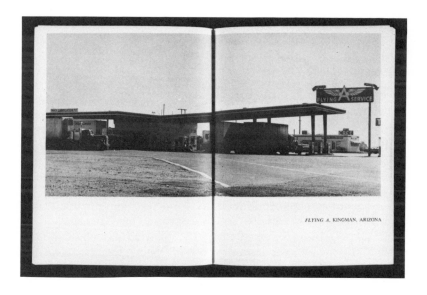

Edward Ruscha, *Twentysix Gasoline Stations*, 1962.

also taken on a new social character, and many magazines were spawned by rock culture. A climate existed in which many people were hungry for news and information which the general media did not provide and consumed a great deal of more pertinent printed communication. Underground publishing, political publishing, minority publishing of all kinds thrived as more and more groups catered to their own needs and those of others like themselves. More vivid graphics than had been seen for a very long time, and perhaps never before on such a public scale, became rampant.

Another influence upon artists was the fact that art books had become plentiful. Color illustrations had also become commonplace, not only in art books, but also in illustrated histories and biographies. Photography books also multiplied. Most people, including artists, experienced more art through books, magazines, and reproductions than in the original. Perhaps it is not so surprising that artists should take over the art book, so long the domain of the critic, use it for their own ends, and make a secondary medium suddenly primary. The advent of the artist's book now made it possible for people to experience art in a form for which it was conceived; artists' books were not books of reproductions but books which contained exactly repeatable art, or statements. By working with the medium—printing—artists were able to ensure that their art reached the public in exactly the manner which they intended.

The street politics of the late sixties were conspicuously democratic, even socialist, and these tendencies colored the intellectual and cultural climate of the time, as well as generating much talk, much writing, and much printing. It is not surprising, therefore, that artists working in this climate should also absorb or manifest such democratic tendencies. Of all the relatively inexpensive media available to the artist, printing is the one that most facilitates wide communication of ideas. After posters, books are the most effective agents in this process. Books, almost uniquely, can filter into every nook and cranny of every level of society. Thus, the comparative ease of printing plenty of copies of a book and the ease with which books are assimilated into the culture made them ready vehicles for the democratic gestures of artists. There is a certain irony in the fact that our exemplar, Ed Ruscha, does not seem to have been responding to an overarticulated democratic impulse in making large, relatively cheap editions, and in reprinting them frequently.

One other factor in the emergence and expansion of book art should be noted. By the time the sixties were in full swing, the fine art media hierarchy, for so long dominated by painting and sculpture, had been torpedoed by the rise in the awareness and use of photography, not only by artists themselves, but also, to an overwhelming extent, in the whole wrap-around world of the advertising, communications, and

media continuum. The affluence of the period also made it possible for some artists to dabble in film and television. At the same time, the boundaries between art and theater, literature, dance, and music, became very ragged. Many artists began to experiment in areas adjacent to the visual arts, and in this way the book structure was rediscovered by painters, sculptors, printmakers, and others. This decade was also a time when more artists felt compelled to discuss their intentions in print than ever before. The artist's statement, the facts from the horse's mouth, became an essential component of exhibition catalogues. Writing and books had for too long been the products of the hands and minds of critics and art historians. There were a great many articulate artists who wished to communicate without intermediaries, as well as many opportunities for them to contribute in many more publications.

The book art which sprung out of the sixties differed radically from the products of previous associations between artists and books. Earlier in the century futurist artists, dada artists, and constructivist artists had all been print-oriented. There exist large numbers of manifestoes, leaflets, pamphlets, magazines, and books which were edited, written, or designed by artists associated with these movements. But the artists functioned within conventional, largely literary, norms—if not typographic norms. This was hardly surprising given the importance of the writers Marinetti, Tzara, and Mayakovsky in the publishing activities of these movements. The artists, who worked also as writers, typographers, illustrators, or graphic designers, did not conceive of their work in these specialities as anything other than contributions to the effectiveness of a literary form. Their art was something separate. It is only in recent times that dada magazines, for example, have retrospectively been accorded the aura of art: virtually none of the artists of that time consciously employed the structure of the book as a primary vehicle for art. They were often exceptionally good designers or illustrators. It was the social and artistic revolutions of the fifties and sixties that made possible the conception of the book as an integrated reproducible artwork.

In the fifties and sixties artists who were just as diverse in their interests and practices as certain of the dada, futurist, and constructivist artists helped to bring about the phenomenon of book art. Many artists who were active in printmaking, graphic design, photography, typography, and particularly in concrete poetry—activities geared closely to the idea of multiple results—began to make books which grew out of their preoccupations. Dieter Roth personifies this trajectory.

Before discussing Roth's work, a comment upon the phenomenon of multiples may be appropriate. The idea of the multiple and its eventual realization paralleled the development of book art. The term multiple generally signified three-dimensional objects, rather than two-dimen-

sional multiple printed art, and the objects were generally conceived of as inexpensive editions of sculptural works which could be replicated with contemporary materials, such as plastics. The appearance of multiples in the sixties can perhaps be associated with the same democratic impulse that has been identified in connection with book art, but their appearance may also be related to the wave of conspicuous consumption evident at that time. Multiples enjoyed only a brief popularity before fading away in the seventies. It now appears that books are the most efficient and effective form of multiple art.

Dieter Roth (a.k.a. Diter Rot) has made multiple objects as well as various kinds of printed multiples. Some of his experiments with the book form have also led him towards book objects; for example, his *Literaturwurst* or *Literature Sausage* (1961), which was a sausage skin filled with cut up newspapers mixed with water and gelatine or lard and spices, was later produced as a multiple.

His earliest books, executed in the fifties, are related to the prints he made at the time. His preoccupation with geometric imagery led him to make several printed sheets with hand-cut and die-cut holes and slots. Inevitably, Roth bound certain of these sheets and thus confirmed the need to turn them as pages in order to experience the whole work and the interaction of its parts. The first book of this kind, known, significantly, as *Children's Book*, was begun in 1954 and published in 1957 (*Collected Works*, Volume 1, 1976).

Most of Roth's early books were made in signed and numbered limited editions, a reflection of their printmaking origins. Thus, Roth and Ruscha must be taken together to demonstrate the full potential of the new book art: Roth creating art dependent upon the book form; Ruscha creating books in open editions. Ruscha has generally produced books which have affinities with photography and documentation, while Roth has often demonstrated affinities with printmaking and object-making.

At the end of the sixties Roth collaborated with Hansjörg Mayer, who began to republish the earlier work in a standard format and in editions of at least 1,000 copies, thus bringing them out of the limited edition framework and into the multiple book art arena. Some of the volumes in the *Collected Works* recreated unique bookworks as multiples; others effectively transmuted earlier works into new bookworks; others again reproduced literature or functioned as documentation. In some cases the subject matter of the book went through several metamorphoses before publication in the *Collected Works*.

In 1961 Roth broke away from his geometric style and began to work with found printed material, as in *Bok 3a, Bok 3b, Bok 3c* and *Bok 3d*. These books are made respectively of pages from newspapers, comics, printers' run-up sheets, and children's coloring books, which were sim-

Dieter Roth, *Collected Works, Volume 10: Daily Mirror*, 1970.
Collection of the Museum of Modern Art.

ply cut into uniform sized blocks and given an adhesive binding. Two of them also had holes cut in their pages. After making these books, which were all approximately 20 cms x 20 cms, Roth made the *Daily Mirror Book* from pages of the London tabloid newspaper, the *Daily Mirror*. This time, however, the book's pages measured only 2 cms x 2 cms; in every other respect it was similar to the *Bok 3* series.

One of Roth's most effective books is also a reconstituted earlier one, *246 Little Clouds (Collected Works*, Volume 17, 1976), first published in a rather murky version by Something Else Press in 1968. The 1976 reconstruction is technically superb, every page gives the term "photo-realism" a new dimension, since the illusion of torn pieces of paper taped to the original pages is strong enough to fool the eye into thinking that the hand can actually feel these scraps. In addition every crease and scruffy mark on each sheet is reproduced with the greatest fidelity, thereby enhancing the illusion further.

246 Little Clouds comes complete with the original instructions for turning the sheets and their contents into a book. 246 phrases, questions, sentences, paragraphs, or single words were spread over 180

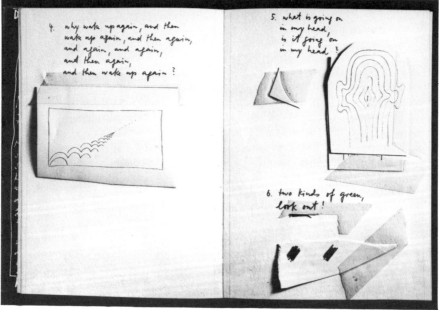

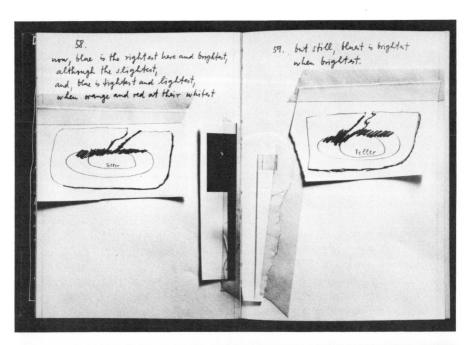

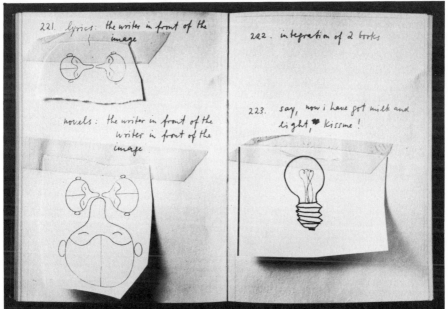

Dieter Roth, *Collected Works, Volume 17: 246 Little Clouds* (four openings), 1976.

pages. At the behest of Emmett Williams these phrases were subsequently illustrated by Roth. The resulting drawings on scraps of paper were then taped onto the pages in the space below the phrase to which they referred. When these "little clouds" were photographed, they were illuminated first from the right, as if by the rising sun. The light source was then moved one degree at a time until it lit them from above, as if at noon. Finally they were lit from the left, as if at sunset. The taped scraps of paper therefore cast shadows much as clouds might do.

The result of this process is a complex verbi-visual book in which the so-called illustrations sometimes accompany the verbal imagery in a predictable and passive way but may also interpret or restate the words in a totally unexpected way, juxtaposing an apparently unrelated visual image with the verbal image or phrase to create an electric dialectic between them. Because *246 Little Clouds* is dependent for its effect upon a fixed sequence of pages it has the hallmark of a classic bookwork.

It is possible to take a purist view of the books authored or designed by artists, and, out of the welter of so-called artists' books, to separate out such bookworks (artworks dependent upon the structure of the book) from book objects (art objects which allude to the form of the book) and those books which just happen to be by artists and do not differ fundamentally from books by writers, scientists, gardeners, or philosophers. These distinctions will be useful if borne in mind, since many artists' books are far from being artworks. It is also the case that artists' books tend to mimic other types of publications, such as trade catalogues, magazines, exhibition catalogues, comics, photography books, and literary texts. In the hands of a thoughtful artist, a publication which does not seem to be dependent upon the inherent structure of the book has, in fact, become dependent upon a particular book form by just such mimicry. In these cases one is not looking at yet another book of photographs or another exhibition catalogue: instead, the genre has been appropriated by the artist for other purposes.

If one is concerned with the book as artwork, then bookworks are generally the most significant of the subdivisions of book art. Multiple bookworks, as opposed to unique bookworks, are also more expressive of the nature, and indeed the purpose of the book. Unique bookworks are often only one step away from mute sculptural book objects that at best simply provoke reflections on the history and role of the book as a cultural phenomenon. Furthermore, art conceived for mechanical replication, and which therefore incorporates exactly repeatable verbal, visual, or verbi-visual narratives, is not only realized through the agency of the printing press, but, as a result, is also disseminated more widely. Compared with the unique artwork, the multiple artwork has an enormously expanded potential audience simply because of the multiplication of its locations, for the original artwork can reside at each location

simultaneously. Art presented almost surreptitiously in the familiar form of the book also achieves the potential to reach many people who would not cross a threshold framed with classical columns in order to see books or art behind glass.

Few artists who worked with the book form in the sixties have continued to publish in the seventies, apart from Roth. Rusha, for example, has published very little since 1971. However, two artists whose books were published mainly in the sixties should be acknowledged here, since these works were quite well distributed and, therefore, affected the viability of the idea that art could exist in book form. They are Eduardo Paolozzi and Andy Warhol.

Eduardo Paolozzi's book *Metafisikal Translations* was published in 1962, the same year as Ruscha's first book. Like his sculpture and two-dimensional work, it is constructed on the collage principle, but it also grows specifically out of his collage movie, *The History of Nothing*. The text, which is derived from altered, collaged, found texts, reprinted with a child's printing set, leads one further and further away from anything resembling logical exposition, and is accompanied by a miscellany of found images, including old engravings, magazine illustrations, and diagrams, which are positioned and enlarged so that they give off strange new reverberations.

In 1966 Paolozzi's second book, *Kex*, was published by the Copley Foundation. On this occasion his collaged texts were typeset and given a formal coherence which initially tends to disguise their inner randomness. The illustrations are integrated with the text and appear to be recycled from a wide range of magazines. Many of the illustrations are in-

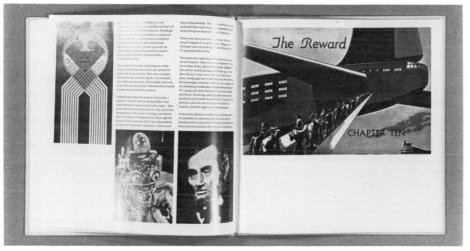

Eduardo Paolozzi, *Kex*, 1966. Collection of the Museum of Modern Art.

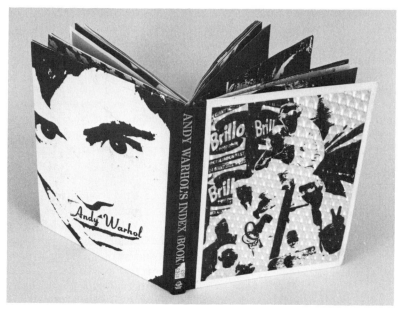

Andy Warhol, *Andy Warhol's Index (Book)*, 1967 (front cover).
Collection of the Museum of Modern Art.

herently odd, but other more inert images appear odd only in their new context.

Abba-Zaba, Paolozzi's next book, published by Hansjörg Mayer in 1970, is similar in conception to *Kex* but loses the possibility of either typographic vitality or pseudo-slickness by employing fairly uniform typewritten texts throughout. Once again, slightly odd illustrations culled from a wide range of sources are juxtaposed with collaged texts, but the association of a random caption and text with each image gives each page more focus than does the continuous text in *Kex*. While Paolozzi's books were never as vivid as his print series *Moonstrips Empire News* (1967) and *General Dynamic FUN* (1965-70), their very existence made them markers in the progress of book art through the sixties.

In addition to such English pop artists as Paolozzi and Allen Jones, several American pop artists were also drawn to publishing, though not until they were well-established did they produce publications that entered the mainstream. Claes Oldenburg, for example, did not have *Store Days* published until 1967. Although Andy Warhol had made conventional books in his early illustrational style, it was not until 1967 that he, too, had a substantial book published in a large edition.

Andy Warhol's Index (Book) was published by Random House,

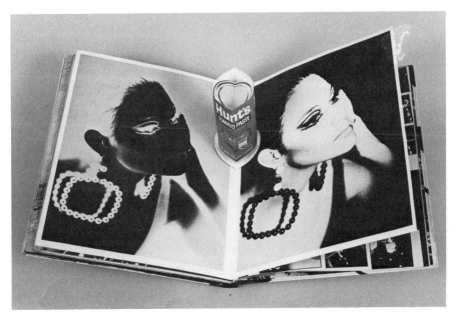

Andy Warhol, *Andy Warhol's Index (Book)*, 1967 (back cover).

which meant that the book was positioned to take advantage of trade distribution channels. Both on account of Warhol's notoriety and the novelty of the work, awareness of its existence and knowledge of the book itself was widespread. Warhol's inventive appropriation of the children's book pop-up picture format, his use of brightly colored images, and his occasional games with the page asserted that enjoyable encounters with the book, and paper engineering in particular, need not be consigned solely to the period of childhood. Although *Andy Warhol's Index (Book)* is a mixture of the conventional and the experimental, or playful, it helped to open up possibilities for artists who were interested in the form of the book. Given his audience and resources, as well as the subsequent development of book art, it would be interesting to see what Warhol might accomplish in this area today.

Practically the only other artist to have had a book published by a major publisher is Sol LeWitt; in 1979 Abrams published his *Geometric Figures and Color*, the only bookwork in their series of "Books by Artists." Since this was distributed via mainstream booktrade outlets, it was, therefore, made much more accessible to the general public than most book art. LeWitt is probably the most prolific multiple-book artist. His first book, *Serial Project #1, 1966,* was published as one of a collection of items in "the magazine in a box"—*Aspen*, in 1966. His first

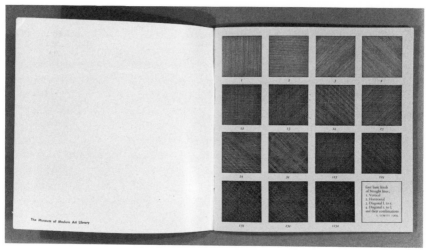

Sol LeWitt, *Four Basic Kinds of Straight Lines*, 1969.
Collection of the Museum of Modern Art.

autonomous book, *Four Basic Kinds of Straight Lines*, was published in
1969. By 1983 he had at least thirty titles to his name.

The principal attribute of LeWitt's books is one common to all
books: a dependence upon sequence, whether of families of marks or
objects, or of single or permuted series which have clear beginnings and
endings. While books are a convenient form in which to present such
sequences, the content of LeWitt's work is rarely intrinsically depend-
ent upon the structure of the book; in fact, many of his books amount
to documentation of work in other media.

Four Basic Kinds of Straight Lines (1969) is a square book which dis-
plays four kinds of lines singly and in all their combinations. It is a book
of perfect clarity of idea, execution, and production. Subsequent books
generally follow this pattern of setting down a vocabulary of forms and
then permuting or combining them in logical sequences, either directly
on the page or indirectly through photographs of sculptural forms un-
dergoing similar processes.

Around 1977 LeWitt began to publish photographic books which
contained progressions or variations which were not limited. For ex-
ample, *Brick Wall* (1977) contains thirty almost identical black and
white photographs of an exposed, unpainted brick wall, while *Photo-
grids* (1977) uses color photography to document found grids, such as
grating in the street or on buildings. Although the latter are grouped in
families, as are the objects in *Autobiography* (1980), they do not, can-
not, demonstrate closed progressions.

Although his books generally only exploit the sequential properties of the book, LeWitt has on many occasions made works specifically for this medium, and the results have been highly accomplished. Furthermore, his own commitment to the book form has been a factor in keeping other artists aware of the option of working in this way—not just in America, for he has had books published in many countries and has encouraged their exhibition alongside his works in other media.

Lawrence Weiner is also a prolific book artist, and his involvement with the book also began in the late sixties. 1968 saw the publication of his first book, *Statements*, as well as the offset publication known familiarly as "The Xerox Book," but which has no more and no less of a title than *Carl Andre, Robert Barry, Douglas Huebler, Joseph Kosuth, Sol LeWitt, Robert Morris, Lawrence Weiner*. Seth Siegelaub was involved in the publication of both these books, and in the following year he published important catalogues of exhibitions, including one entitled

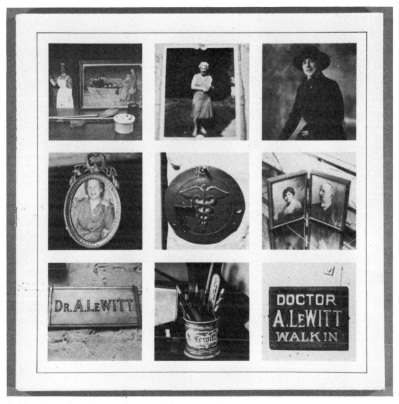

Sol LeWitt, *Autobiography*, 1980 (front cover).

July, August, September 1969 which practically amounted to a self-contained exhibition, since many of the featured exhibits were scattered around the world while others required only that the catalogue entry be read.

Statements contains phrases which, while general in character, such as "One standard dye marker thrown into the sea," actually conjure up specific pictures in the mind's eye of the reader. Thus the connection between Weiner's previous artworks and the words in *Statements* remains close. In his second book, *Traces* (1970), however, the succession of single words are all verbs, for example: "Thrown," "Removed," "Poured," etc. While these words are generally less specific in their meaning than those in *Statements*, the connection with Weiner's earlier art is still apparent, since the verbs refer to the active processes common to this work. Not until 1971 did Weiner begin to arrive at texts which are both self-referential and dependent upon the book form. In *10 Works* such phrases as "under and over" and "back and forth"— particularly when strung together—finally reach an effective level of generality.

In *Green as well as Blue as well as Red* (1972) the most concrete items in the book are the three colors referred to in the title. Concurrently with his arrival at this level of abstraction Weiner also introduced a degree of permutation of terms. He had selected families of terms in his earlier books such as *Flowed* (1971) and *10 Works* and had also displayed permutations in *10 Works* and *Causality: Affected and/or Effected* (1971), but *Green as well as Blue as well as Red* is the most abstract and systematic book up until this time. Practically every word is a building block to be added to others, rearranged, and substituted. This book also epitomizes Weiner's developed use of typography and page layout.

The next development in Weiner's books was the incorporation of photographs with texts. In *Once Upon a Time* (1973) his texts accompany photographs by Giorgio Colombo. These photographs appear to be unconnected to each other and unconnected to the text; instead, they seem to provide a living context for Weiner's abstractions, and, indeed, for his musings. *Once Upon a Time* is full of doubts and questions; apparent abstractions are colored by the artist's feelings. Later books frequently incorporate photographs because they grow out of movie projects; examples include: *Towards a Reasonable End* (1975) and *Passage to the North* (1981).

It would seem that not only was language a fundamental aspect of Weiner's art from the beginning but that it also provided a medium through which he could extricate himself from the specifics of sculpture and painting and from their almost inescapable physicality and uniqueness, and ease himself into the insubstantial, repeatable, and

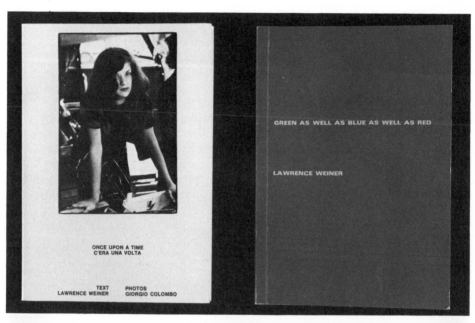

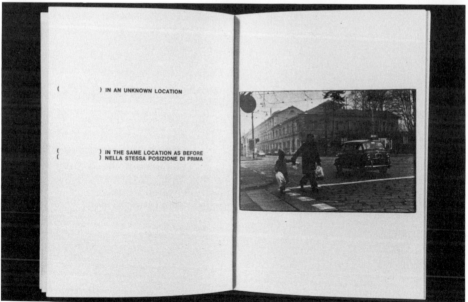

Top: Lawrence Weiner and Georgio Colombo, *Once Upon a Time,* 1973.
Lawrence Weiner, *Green as well as Blue as well as Red,* 1972.
Bottom: Lawrence Weiner and Georgio Colombo, *Once Upon a Time,* 1973.

verbally hospitable medium of film. The book form has played an essential part in structuring his language works, but Weiner, as emphatically as anyone, has also made multiple books because of his opposition to the creation of unique objects, and to make his work accessible.

At the beginning of the seventies many of the more ubiquitous books by artists were extremely unostentatious. In keeping with their origins in conceptual, minimal, and allied art forms, they frequently took the form of slim white pamphlets which evoked great seriousness, and they often contained only words. Books published in Holland and Italy, in particular, contributed to this fairly pervasive style. Weiner's early books conformed with this form of presentation. So, too, did some by Richard Long: *From Along a Riverbank* (1971) for example.

Since many of Long's works are executed in very remote locations and are subject to the ravages of time and the elements, their existence might never be known or shared by other people unless a record of their appearance was exhibited. Photographs are the principal means for making these inaccessible works known, and books of photographs further increase their potential audience. It might be thought that Long's books are just documentation, but in his first book he established that his work in the landscape may not be separable from its re-

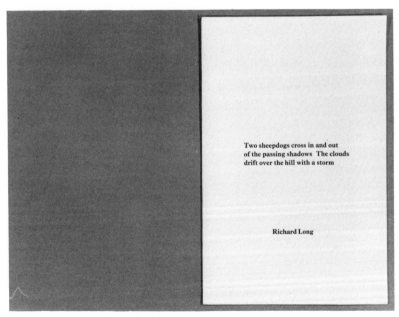

Two sheepdogs cross in and out
of the passing shadows The clouds
drift over the hill with a storm

Richard Long

Richard Long, *Two Sheepdogs . . .*, 1971 (cover).
Collection of the Museum of Modern Art.

corded image or from a book of such images. In this book, *Sculpture by Richard Long made for Martin and Mia Visser, Bergeijk* (1969), he clearly states that the collection of photographs does "not have the function of a documentation: it is the sculpture made for Martin and Mia Visser." Other remarks amplify this statement; the work "was conceived for the purpose of photographic reproduction." Long "made a system of trenches, which was created according to special camera views." The first statement, that the book, or the photographs, *were* the sculpture, perfectly exemplifies a charged situation in the recent history of art. In the same year, 1969, in the first issue of *Art-Language*, the then "journal of conceptual art," there is a passage which also reflects the same attitude: "Can this editorial, in itself an attempt to evince some outlines as to what 'conceptual art' is, come up for the count as a work of conceptual art?" The very fact that such a question could be posed demonstrates the incredible elasticity and openness of art at the end of the sixties. Siegelaub's exhibition *July, August, September 1969*, in which Long participated, and which was embodied in its catalogue, also took place in the same year.

In one sense the expansion and permeability of the parameters of art at this time made it possible for almost any object or phenomenon, or

The brook and the clapper bridge are old friends

Stone dance

Richard Long, *Two Sheepdogs ...*, 1971.

indeed any book, to be designated art. But this expanded understanding was almost coterminous with the more general meaning of art which embraces all human artifacts. While one might consider that Long's Visser book was subsumed by the first sense, his subsequent books might more appropriately be termed art, or book art, according to the second sense. For in the case of the subsequent books, whatever status the photographs alone might be said to have, the books themselves have been expressions of Long's art as a designer. Regardless of their origins in several different countries, these books generally bear a family resemblance, as manifested in the choice of type, the layout of the page, and the images, but the content is rarely dependent upon the book form.

In 1971 Art and Project published Long's *From Along a Riverbank*, which, with the exception of the similar *From Around a Lake* published by Art and Project two years later, is a more book-dependent work than any of his other books. Curiously, it also resembles Ruscha's *A Few Palm Trees*, published in the same year, not merely because of its botanical concerns but also because of the way that the photographs have been stripped so that their subjects are presented in isolation in the space of the page. The book known in brief as *Two Sheepdogs*, also published in 1971, demonstrates yet another variety of content: short sentences in the form of captions are associated with photographs of rocky moorland. However, these captions are by no means passive. When a phrase such as "The stream says I can touch you as I pass by," is placed below a picture, it gives an anthropomorphic cast to simple elements in the landscape.

Long has made at least one book, *Twelve Works* (1981), with solely verbal content, as well as another, *South America/Puma, Sun, Spiral* (1972), that contains pictographic drawings and words, but his recent books generally conform to a similar prescription. Most contain photographs of his work, in remote locations and in galleries and museums, that are not connected to each other, but are simply strung together to make an album. The photographs are frequently astonishing, but the books are only picture books.

Daniel Buren takes a diametrically opposite attitude to Long, since he denies that his books are artworks. Those of his books which discuss pre-existing works can certainly be regarded as pure documentation. But Buren has also been a frequent contributor to many anthological publications, and his contributions to these take one of three forms: he presents writing illustrated by photodocumentation, writing accompanied by unrelated "photosouvenirs," or he presents his art directly. Since Buren's art, expressed through striped surfaces, relates to the experience of looking in a specific place and to the appreciation of context, his art contributions are striped pages. The July/August 1970

issue of *Studio International* contains eight pages of alternate yellow and white stripes of standard width; in the Winter 1975 issue of *TriQuarterly* he presents six pages of green and white stripes. Thus, the reader or viewer examines the art in the context of the magazine space.

Buren has generally made pageworks rather than bookworks, but the books which collect his writings, present his theories, or record his works are quite numerous. He has, therefore, contributed to the visibility and viability of the book as a medium for visual artists. One could, in fact, argue against Buren's assertion that the books which document his art are not in themselves art by suggesting, as one could of Jan Dibbets's *Robin Redbreast's Territory Sculpture 1969* (1970), that without the existence of these books the artworks would not be perceived in their totality. Buren himself is well aware of this dilemma and refers to it in his provocative book *Reboundings* (1977). Until this book appeared, the work which is discussed and documented was silent. The subtleties of the work were, perhaps inevitably, not appreciated, so Buren's dilemma was whether to leave the work pure but silent or to compromise it somewhat through explanation in a printed medium and thus convey its nature to another audience. It will be apparent, therefore, that the distinction between a book and a bookwork can become somewhat blurred.

John Baldessari, *Choosing: Green Beans*, 1972 (cover and left hand page). Collection of the Museum of Modern Art.

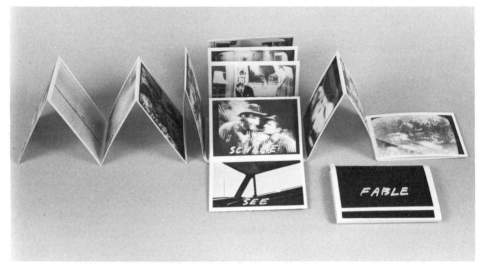

John Baldessari, *Fable*, 1977.

Photography, alongside drawing and writing, is one of the principal means that book artists employ in order to communicate their content and purpose. Even books which do not overtly communicate through photographs would not generally exist without photographic processes, such as plate-making, etc. In most cases photography is used expressively, not to produce the kind of souvenir that Buren juxtaposes with some of his texts. John Baldessari uses photography extensively, both to produce wall pieces and to make films. His books employ photographic imagery and conventions, but they also derive from work apparently not initially conceived with the book in mind; once again we are somewhere in the hinterland between the book and the bookwork. Baldessari has explained his attitude very clearly: "... since a lot of people can own the book, nobody owns it. Every artist should have a cheap line. It keeps art ordinary and away from being overblown" (*Art-Rite* #14, Winter 1976-77).

None of Baldessari's books are exhibition catalogues or pure documentation, even when exhibitions occasioned their publication. Indeed, he is sensitive to different book formats; for example the wall calendar format of *Ingres, and Other Parables* (1971), the portfolio format of *Throwing Three Balls* ... (1973), and the concertina or accordion format of *Fable* (1977). One could say that the form of the latter work successfully liberates it from its origins as a wall piece, and reinterprets its contents through a historical book structure.

Most of Baldessari's books are visual narratives. Only in *Ingres, and*

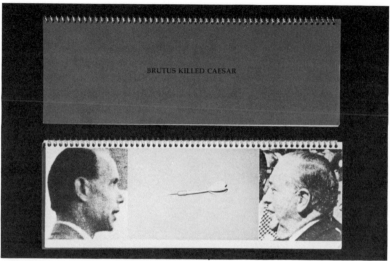

John Baldessari, *Brutus Killed Caesar*, n.d.

Other Parables do the texts become more important than the images. In other works, such as *Choosing: Green Beans* (1972) and *Four Events and Reactions* (1975), the short prefaces are essential to an understanding of the images. In the case of *Throwing Three Balls in the Air to Get a Straight Line: (Best of Thirty-Six Attempts)* the title also takes on the burden of a text. But unlike *Throwing Three Balls . . .*, *Brutus Killed Caesar* (1976) is entirely dependent upon its title for its meaning; were it not for the title it would not be apparent that the paraphernalia of life depicted in the book might also be the instruments of death.

Of the artists whose work has been discussed so far, two have used the medium of the book principally as a vehicle for words. Weiner constructs verbal phrases and sequences which require the structure of the book to articulate them; Buren writes in order to explain and, therefore, finds the book appropriate to his ends because of its traditional efficiency and convenience in presenting information. Davi Det Hompson (a.k.a. David E. Thompson) uses words in yet another way by stressing the visual qualities of both words and letters. Because written or printed words stand in for spoken language it is easy not to see that reading is a visual activity.

Davi Det Hompson has been making books since the mid-sixties, though he did not begin to print his editions in hundreds of copies until the mid-seventies. The books of the sixties, and in particular the books of 1966, have affinities with concrete poetry. Both Hompson and Roth exemplify this route into book art, and Hompson, like Roth, is not only

```
Actually, Ron          While we were
said a lot of          speaking,
his friends            something fell
never wore any         in the other
socks at all.          room.
```

Davi Det Hompson, *You know it has to be a hairpiece*, 1977.
Collection of the Museum of Modern Art.

a book artist; he is involved with media from posters to performance.

Although *Blue Light Containment* (1966) through its arrangement of words and images on the page reveals a keen awareness of the reading process and of book structure, *Disassemblage* (1966) is a more radical work since, in theory at least, each copy should not survive its first reading. The book demands that the reader become physically involved with it. Apart from the title page each page carries an instruction, for example, "crumple this element into the smallest unit possible," and "ignite it with entire disassemblage." The destruction of the book is a theme which is echoed in several other books by artists.

In 1976 Hompson began another period of sustained involvement with the book, but the books of 1976 and 1977 do not display the tricks of the sixties. Visually, the majority of them are almost ordinary. Most simply carry a single typed sentence, placed alone on a page but photographically enlarged to perhaps twice the normal size, thereby accentuating the letter forms of which the words are comprised. Although his works suggest an acute visual sensitivity to words and letters, Hompson's use of language also demonstrates an acute ear for spoken words. The sentences, arranged on successive pages of these books, do

not seem at all contrived, but rather snipped out of a conversation still hanging in the air. Hompson has referred to his activity not as storytelling but as image-telling and it is true that most of his short pieces are absorbed whole like a Gestalt rather than read. The words and the books have a strange inevitability and authority: *"Understand. This is only temporary"* (1977). *May I have a glass of water with no ice, please?* (1976). *You know it has to be a hairpiece* (1977). These phrases, both titles and opening pages, exist as naturally as mountain ranges. The simplicity of these slim white pamphlets is refreshing; the art is unusually transparent.

In some extraordinary books from 1980, *11., xp-ix, Bla.", Easy.,* and *Eleanor.,* whole words and sentences become restless, enlarged, and hover between images and signs. The activity of turning pages to follow the progress of a story becomes absolutely essential, and disruptive, as sentences flow across several pages or the verso and recto of a sheet. These books require that they be disassembled if they are to be read and understood. If one does try to read the books in the orthodox manner, the enlarged letters, the colored inks and papers, and the framing function of the page help to slow down the reading process so that one can linger over the exquisite fragments that are normally looked at but not seen. Ultimately, the book form could not stand up to Hompson's

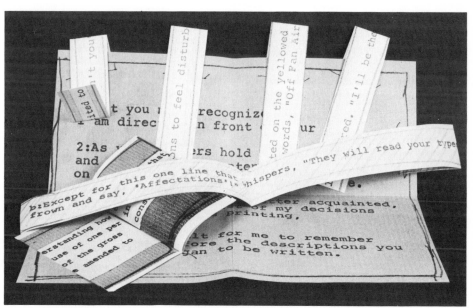

Davi Det Hompson, *1(a.b)18.*, 1980. Collection of the Museum of Modern Art.

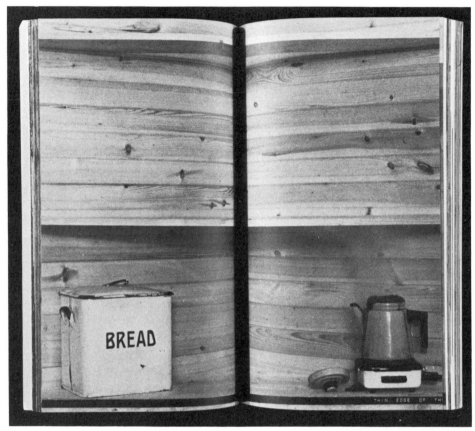

Telfer Stokes and Helen Douglas, *Chinese Whispers*, 1976 (pp. 58, 59).

relentless pressure. In *1(a,b)18* (1980) the book becomes just a blip on the page; sentences snake off the poster/page in all directions; the traditional book form is turned inside out.

Hompson's works illustrate how the book artist may almost literally wrestle with words. Since words function as both images and signs, their combination with pictures can take several forms. When used as captions, words can manipulate the meanings of pictures, emphasize particular readings, or create dissonance between the two elements. When words and images simply lie side by side, a so-called artist's book very often turns out to be just a cheap remnant of the illustrated book tradition. One characteristic of artists' books and bookworks is indeed their fusion of word and image. Helen Douglas and Telfer Stokes, in their book *Chinese Whispers* (1976), solve the problem of integrating

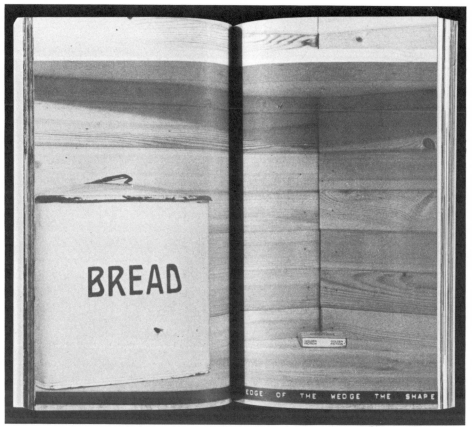

Telfer Stokes and Helen Douglas, *Chinese Whispers*, 1976 (pp. 60, 61).

words and images by giving words object status. The phrases "Turn over a new leaf" and "Life is an open book" exist in the pictures themselves. The artists also play with the image of a bread bin labeled "BREAD," so that as the camera closes in the word fills up the page until only the exhortation "READ" remains visible. In all these cases, however, the words are embedded in the image; they do not float on the surface of the page.

Chinese Whispers is Stokes's fifth book, the last two coauthored with Helen Douglas. These five books demonstrate a remarkable progression over four years. The first book, *Passage* (1972), is full of brilliant visual anecdotes which exist as separate entities in the volume, but which refer to, or depend upon, the book form time and again. Pages with images of two halves of a sandwich are constantly pried open and

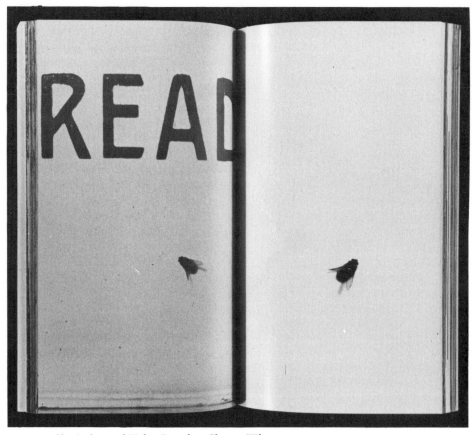

Telfer Stokes and Helen Douglas, *Chinese Whispers*, 1976 (pp. 64, 65).

stuck shut again. A roller picks up paint from the lefthand page and transfers it to the right. Sequences of pages build up odd rhythms. *Foolscrap* (1973) uses sequences similarly but handles individual components so that they are moved across pages as the book is flipped by the reader; while in *Spaces* (1974) Stokes begins to interweave sequences of images together. There is a much greater sense of progression through this book, as well as movement into and out of the page as the camera pulls away or moves in. A staccato rhythm is set up by the gymnastics of a versatile piece of furniture.

The fourth book in the series, *Loophole* (1975), is a marvelous invention. The reader is led smoothly through a remarkable visual adventure that takes place in the shallow space of the book. By turning the pages one is continually peeling off layers of imagery until ruptured surfaces

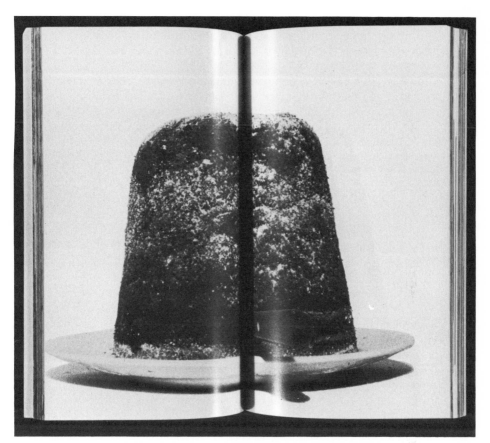

Telfer Stokes and Helen Douglas, *Chinese Whispers*, 1976 (pp. 66, 67).

are successively overlaid again—but inexactly. Towards the end movement in and out of the book is disrupted by a new rhythm of movement up and down the page, which appropriately related to images of an old sewing machine. What one witnesses and savors during the course of the book is an authentic visual fiction.

Chinese Whispers (1976), which succeeded *Loophole*, is another rich narrative incorporating quite different rural imagery, except for some construction work, a recurring theme in four of the five books. Both the book and the photographs are very handsome and reveal a growing ease in working on an extended narrative and with the book structure.

Stokes and Douglas's next book, entitled *Clinkscale* (1977), is very different. This book photographically represents, and structurally mimics, an accordion. If the boards of the book are opened on one side

the folded pages suggest the bellows of the accordion. If they are opened on the other side they expand into a continuous strip of lush green meadow, as if the accordion's music were equated with the lilt of the grasses, undulating like the sea.

Back to Back (1980) is the first of Stokes's books to contain a text. Both text and pictures describe an excursion from a stone house into hilly country. The images of the landscape are immensely powerful and are starkly printed. The short text is not such a tight fit as the pictures, but it does evoke movement through the book and a strange timeless-ness. In a curious way, *Back to Back*, though different in every detail, has a similar overall rhythm to *Loophole*. In both cases about three quarters of each book has a great deal of movement in and out of the space of the page; then, at the end, there is less agitation and a slow peaceful glide to a conclusion.

Stokes, particularly when working with Douglas, has amply demon-strated the capacity of the book to convey complex visual narratives. These sequences amount to a totally new form of visual poetry which has more affinities with an intricately cut and edited movie suddenly frozen on the page than with traditional book content.

Clinkscale is one of the few books discussed here which has an un-conventional binding; Baldessari's *Fables* shares a similar format. Hompson's *1(a,b)18* is even more unusual, though it can be seen to have developed from more common forms. Other experiments with the structure of the book have not been featured because it seems to be generally the case that the more conspicuous the structure of the book, the less significant the content. Furthermore, the codex form, in which a uniform collection of leaves are fastened along one edge, is at least 2,000 years old, and its engineering has been confirmed as eminently practical to carry and transmit the kinds of content entrusted to it. It is this form of the book which has been part of the lives of generations of artists and their audiences, and which was rediscovered, almost as a "found structure," around 1960.

Nevertheless it seems that Kevin Osborn has rarely been willing to uncritically accept this structure that is so familiar as to be unconsid-ered by most of its users. It is as if Osborn wishes to jolt his readers out of their easy acceptance of the book form so that they will be more alert to its inherent properties.

While Osborn's handling of the imagery in *Salamander* (1976) is very assured, the form of the book is conventional. Whereas *Repro Memento* (1980) has an unusual form, which is, however, inseparable from its content. Since the pages of this book are trapezoidal, with the shortest sides in the gutter, the pages open into an exaggerated perspective, thus emphasizing the repeated motif of the book: a receding vista converg-ing dead center. The book is bound accordion-style; the paper is semi-

transparent; and some pages have been printed on the back as well as on the front. Fragments of the total picture appear on different pages, so that one is obliged to look at the whole book in order to absorb the complete picture.

Parallel (1980) entails another unusual format. The sheets which make up the pages have not been folded conventionally, but from corner to corner, so that the book is a triangle which opens up into a diamond-shaped double spread. *Parallel* is a very quiet book. On creamy-colored paper the faintest pastel-colored inks have been laid down, so that the abstract imagery only becomes visible as the book is angled into and out of the light. The center pages appear to be completely blank at first sight, but actually bear one almost invisible word repeated right across the page from corner to corner. The imagery, though muted, appears very busy at the beginning and the end of the book when contrasted with the virtually empty pages at the still center of the book.

It would have been very difficult to anticipate Osborn's *Real Lush* (1981) on the basis of his earlier work. The reader is first struck by the shape of the book. It is just over twice as wide as it is high and appears almost as thick as it is high. Over three hundred sheets have been

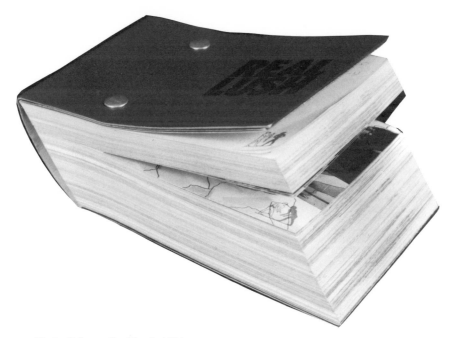

Kevin Osborn, *Real Lush*, 1981.

bolted together so as to give the book a rhombic cross-section. This configuration facilitates the flipping of the pages, determines the principal direction for reading, and signals a different reading experience.

While *Real Lush* can be seen to have some features in common with Osborn's earlier publications, the ambition, density, and complexity of this book represent a remarkable imaginative leap. Through many pages and many printings Osborn creates a variety of modular sequences linked together to provide the reader with a roller-coaster ride through different visual experiences and states of mind. As many as a dozen layers of ink and images may coexist on a single page. When this happens the result is generally a visual cacophony, but other sections are as spacious and tranquil as in his earlier books, and act as keys with which to unlock the denser pages. The excavation of images and moods is accomplished through the reading of many pages, rather than by the intense scrutiny of a single page as if it were a painting.

In the past, book artists have frequently worked with printers, either on an impersonal or a collaborative basis, to achieve the results which they sought. However, there are some book artists, such as Hompson, Stokes, and Osborn, who use the camera and the printing press as tools and who personally see their ideas through from their inception to their embodiment in a finished book. Indeed, because they understand and are involved in virtually every process, it is possible for them to compose or alter their books during the production process, rather than to create a finished maquette prior to photography and printing.

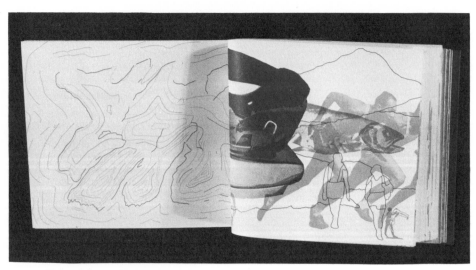

Kevin Osborn, *Real Lush*, 1981.

The emergence of the printer-artist in recent years and the related growth of artists' presses promises to move us into a new era of book art. In America alone the existence and accomplishments of yet more artists, such as Conrad Gleber, Michael Goodman, Janet Zweig, Philip Zimmermann, Miles DeCoster, and Rebecca Michaels highlight the expanding creative possibilities within the areas of book art, page art, and magazine art. But most of these artists have not only created significant works of their own; they have also fostered the work of others through their additional roles as printers, publishers, and teachers.

The burgeoning activity of artists' presses, and the growth in numbers of artists' books and book artists, has been accompanied by developments in visual content, and awareness of still greater potential. It may be that even the best of the visual books which have so far been published are but the primitives of a new era.

Reading sequences of pages in bookworks sometimes has an affinity with the way in which one reads a painting or a photograph, rather than a novel, in that it is a non-linear, quasi-random process. Reading page by page might be likened to traversing the surface of a collage or montage in which the eye experiences disjunctions between discrete sections of the work. It can also be likened to one's experience of a movie, in that visual images are sometimes juxtaposed in time instead of in space and cumulatively create an experience. Another analogy might be with poetry, in which disparate images, conjured in words, are juxtaposed and then synthesized by the reading process into something other than the sum of the parts. The fact that certain bookworks combine words and pictures intimately, in a non-illustrative manner, complicates these analogies and makes for further richness. Book art also stands at the intersection of many disciplines and draws its strength from just this cross-fertilization.

The book has been around for a long time, but the growth of new visual literatures and new visual languages, articulated by means of old and new book structures in the last twenty years, suggests that it will be around for much longer, especially when new technologies have relieved it of many of its more pedestrian functions.

BIBLIOGRAPHY—BOOKS BY ARTISTS

Baldessari, John. *Brutus Killed Caesar*. Akron: University of Akron, Emily H. Davis Gallery, no date.

Baldessari, John. *Choosing: Green Beans*. Milan: Edizioni Toselli, 1972.

Baldessari, John. *Fable*. Hamburg: Anatol AV und Filmproduktion, 1977.

Baldessari, John. *Four Events and Reactions*. Florence: Centro Di, 1975.

Baldessari, John. *Ingres and Other Parables, 1971*. London: Studio International Publications, 1972.

Baldessari, John. *Throwing Three Balls in the Air to Get a Straight Line: (Best of Thirty-Six Attempts)*. Milan: Edizioni Giampaolo Prearo & Galleria Toselli, 1973.

Blackwell, Patrick. *see* Williams, Mason.

Buren, Daniel. *Reboundings*. Brussels: Daled & Gevaert, 1977.

Buren, Daniel. *Voile/Toile: Toile/Voile; Sail/Canvas: Canvas/Sail* . . . Berlin: Berliner Kunstlerprogramm des DAAD, 1975.

Colombo, Giorgio. *see* Weiner, Lawrence.

Dibbets, Jan. *Robin Redbreast's Territory/Sculpture 1969*. Cologne/New York: Verlag Gebr. König/Seth Siegelaub, 1970.

Douglas, Helen. *see* Weproductions.

Hompson, Davi Det. *Bla."* Kansas City, Hompson, 1980.

Hompson, Davi Det. *Easy*. Kansas City, Hompson, 1980.

Hompson, Davi Det. *Eleanor*. Kansas City, Hompson, 1980.

Hompson, Davi Det. *May I have a glass of water with no ice, please?* Richmond: Hompson, 1976.

Hompson, Davi Det. *"Understand. This is only temporary."* Richmond: Hompson, 1977.

Hompson, Davi Det. *You know it has to be a hairpiece*. Richmond: Hompson, 1977.

Hompson, Davi Det. *1 (a,b) 18*. Kansas City: Hompson, 1980.

Hompson, Davi Det. *II*. Kansas City: Hompson, 1980.

Hompson, Davi Det. *xp-ix*. no place: Hompson, 1980.

Hompson, Davi Det. *see also* Thompson, David E.

LeWitt, Sol. *Autobiography*. New York: Multiples & Boston: Lois & Michael K. Torf, 1980.

LeWitt, Sol. *Brick Wall* . New York: Tanglewood Press, 1977.

LeWitt, Sol. *Four Basic Kinds of Straight Lines* London: Studio International, 1969.

LeWitt, Sol. *Geometric Figures and Color*. New York: Abrams, 1979.

LeWitt, Sol. *Photogrids*. New York: Paul David Press/Rizzoli, 1977.

LeWitt, Sol. *Serial Project #1, 1966*. New York: *Aspen Magazine*, number 5/6, Fall/Winter, 1967. (Section 17).

Long, Richard. *From Along a Riverbank*. Amsterdam: Art & Project, 1971.

Long, Richard. *From Around a Lake*. Amsterdam: Art & Project, 1973.

Long, Richard. *Sculpture by Richard Long Made for Martin and Mia Visser, Bergeijk: Dartmoor January 10, 1969*. no place: no publisher, no date.

Long, Richard. *South America/Puma, Sun, Spiral* . . . Dusseldorf: Konrad Fischer, 1972.

Long, Richard. *Twelve Works, 1979-1981*. London: Coracle Press for Anthony d'Offay, 1981.

Long, Richard. *Two Sheepdogs* . . . London: Lisson Publications, 1971.

Nauman, Bruce. *Burning Small Fires*. no place: no publisher, no date.

Oldenburg, Claes. *Store Days*. New York: Something Else Press, 1967.

Osborn, Kevin. *Parallel*. Atlanta: Nexus Press/Osborn, 1980.

Osborn, Kevin. *Real Lush*. Glen Echo: The Writer's Center Offset Works/Osborn, 1981.

Osborn, Kevin. *Repro Memento*. Glen Echo: The Writer's Center Offset Works/Os-

born, 1980.
Osborn, Kevin. *Salamander*. Rochester: Visual Studies Workshop Press, 1976.
Paolozzi, Eduardo. *Abba-Zaba*. no place: Edition Hansjörg Mayer, 1970.
Paolozzi, Eduardo. *Kex*. Chicago: William and Noma Copley Foundation, 1966.
Paolozzi, Eduardo. *Metafisikal Translations*. no place: Kelpra Studio, 1962.
Rot, Diter. *Bok 3a*. Reykjavik: Forlag Ed., 1961.
Rot, Diter. *Bok 3b*. Reykjavik: Forlag Ed., 1961.
Rot, Diter. *Bok 3c*. Reykjavik: Forlag Ed., 1961.
Rot, Diter. *Bok 3d*. Reykjavik: Forlag Ed., 1961.
Rot, Diter. *Children's Book*. Reykjavik: Forlag Ed., 1957.
Roth, Dieter. *Collected Works, Volume 1: 2 Picture Books*. Stuttgart . . .: Edition Hansjörg Mayer, 1976.
Roth, Dieter. *Collected Works, Volume 10: Daily Mirror*. Cologne . . .: Edition Hansjörg Mayer, 1970.
Roth, Dieter. *Collected Works, Volume 17: 246 Little Clouds*. Stuttgart . . .: Edition Hansjörg Mayer, 1976.
Rot, Diter. *Daily Mirror Book*. Reykjavik: Forlag Ed., 1961.
Rot, Diter. *Literaturwurst/Literature Sausage*. Akureyri: Rot, 1961; Berlin: Galerie René Block, 1970.
Rot, Diter. *Quadrat Print (Daily Mirror Book)*. Hilversum: Steendrukkerij de Jong, 1965.
Rot, Diter. *246 Little Clouds*. New York: Something Else Press, 1968.
Ruscha, Edward. *Dutch Details*. no place: Octopus Foundation, 1971.
Ruscha, Edward. *A Few Palm Trees*. Hollywood: Heavy Industry Publications, 1971.
Ruscha, Edward. *Nine Swimming Pools and a Broken Glass*. no place: no publisher, 1968.
Ruscha, Edward. *Thirtyfour Parking Lots, in Los Angeles*. no place: Ruscha, 1967.
Ruscha, Edward. *Twentysix Gasoline Stations*. no place: no publisher, 1962.
Ruscha, Edward. *Various Small Fires and Milk*. no place: no publisher, 1964.
Ruscha, Edward. *see also* Williams, Mason.
Stokes, Telfer. *Back to Back*. Yarrow: Weproductions, 1980.
Stokes, Telfer. *Foolscrap*. London: Weproductions, 1973.
Stokes, Telfer. *Passage*. London: Weproductions, 1972.
Stokes, Telfer. *Spaces*. London: Weproductions, 1974.
Stokes, Telfer. *see also* Weproductions.
Thompson, David E. *Blue Light Containment*. Bloomington: Indiana University, 1966.
Thompson, David E. *Disassemblage*. Bloomington: Indiana University, 1966.
Thompson, David E. *see also* Hompson, Davi Det.
Warhol, Andy. *Andy Warhol's Index (Book)*. New York & Toronto: Random House, 1967.
Weiner, Lawrence. *Causality: Affected and/or Effected*. New York: Leo Castelli, 1971.
Weiner, Lawrence. *Flowed*. Halifax: Nova Scotia College of Art and Design, Lithography Workshop, 1971.
Weiner, Lawrence. *Green as well as Blue as well as Red*. London: Jack Wendler, 1972.
Weiner, Lawrence. *and* Giorgio Colombo. *Once Upon a Time*. Milan: Franco Toselli, 1973.
Weiner, Lawrence. *Passage to the North*. Great River: Tongue Press, 1981.
Weiner, Lawrence. *Statements*. New York: Louis Kellner Foundation/Seth Siegelaub, 1968.
Weiner, Lawrence. *10 Works*. no place: Yvon Lambert Editeur, no date.
Weiner, Lawrence. *Towards a Reasonable End*. Bremerhaven: Kabinett fur Aktuelle Kunst, 1975.
Weiner, Lawrence. *Traces*. Genova: Sperone Editore, 1970.
Weproductions. (Helen Douglas & Telfer Stokes). *Chinese Whispers*. London: We-

productions, 1976.

Weproductions. *Clinkscale.* no place: Weproductions, no date.

Weproductions. *Loophole.* London: Weproductions, 1975.

Weproductions. *see also* Stokes, Telfer.

Williams, Mason, Edward Ruscha and Patrick Blackwell. *Royal Road Test.* no place: no publisher, 1967.

BIBLIOGRAPHY—OTHER SOURCES

Art-Language volume 1, number 1, May 1969.

Art-Rite number 14, Winter 1976-77.

Aspen Magazine, numbers 1-10, 1965-1971.

Carl Andre, Robert Barry, Douglas Huebler, Joseph Kosuth, Sol LeWitt, Robert Morris, Lawrence Weiner. (The Xerox Book). New York: Seth Siegelaub & John Wendler, 1968.

July, August, September 1969. New York: Seth Siegelaub, 1969.

Studio International volume 180, number 924, July/August 1970.

TriQuarterly number 32, Winter 1975.

The Book Stripped Bare

by Susi R. Bloch

DURING THE EIGHTEENTH and nineteenth centuries a rich tradition of book illustration developed in France. Yet it is only at the end of the nineteenth century that the book was perceived as a formal, analytic entity—one whose physical properties of scale and design were inextricable from content. One signal work, Stéphane Mallarmé's *Un Coup de dés*, defines this intuition of the whole. A poem whose sense articulates itself in the interdependence of its prose and format, *Un Coup de dés* was Mallarmé's last poem. Published for the first time in a tentative version in 1897, a year before Mallarmé's death, the final *ne varietur* edition appeared some seventeen years later in 1914. The two dates are important for they bracket a period of time during which the influence of Mallarmé's poem spawns a progeny of innovative works.

Mallarmé insisted upon a recognition of the *meaning of format*: a recognition which moved against the "artificial unity that used to be based on the square measurements of the book." He demanded a precisely reckoned and designed volume in which everything was to be "hesitation, disposition of parts, their alternations and relationships." A book in which typography and even the foldings of the pages achieve an ideational, analytic, and expressive significance. Mallarmé saw the book as "a total expansion of the letter, finding its mobility in the letter, and in its spaciousness (it) must establish some nameless system of relationship which will embrace and strengthen fiction." [1] Towards this end he was attentive to commercial typographic and printing techniques— especially those of the daily press and popular advertising poster.

For the reader unfamiliar with *Un Coup de dés* the recollection of Paul Valéry, the first, or certainly among the first, to be shown the manuscript by Mallarmé in 1897, perhaps best describes what most immediately resounded as revelatory in the poem:

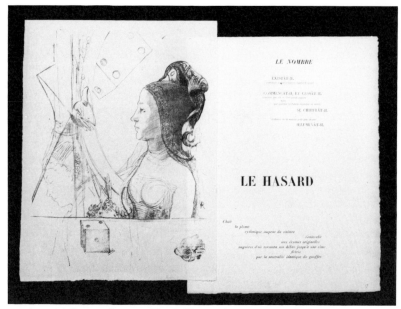

Stéphane Mallarmé, illustrated by Odilon Rédon, *Un Coup de dés . . .*, 1914.
Photograph courtesy of Arthur and Elaine Lustig Cohen.

Mallarmé finally showed me how the words were arranged on the
page. It seemed to me that I was looking at the form and pattern
of a thought, placed for the first time in finite space. Here space it-
self truly spoke, dreamed, and gave birth to temporal forms. Ex-
pectancy, doubt, concentration, all were *visible things*. With my
own eye I could see silences that had assumed shapes. Inappreci-
able instants became clearly visible; the fraction of a second dur-
ing which an idea flashes into being and dies away; atoms of time
that serve as the germs of infinite consequences lasting through
psychological centuries—at last these appeared as beings, each
surrounded by palpable emptiness.

Concluding this recollection of his own impressions on first seeing
the poem, Valéry moves to interject Mallarmé's own thoughts, relying
on his own close intimacy with Mallarmé and the poet's own writings
relating to the poem:

We have a record in his (Mallarmé's) own hand of what he
planned to do; he was trying to "employ thought nakedly and fix
its pattern." He dreamed of a *mental instrument* designed to ex-
press the things of the intellect and the abstract imagination.

His invention, wholly deduced from analyses of language, of books, and of music, carried out over many years, was based on his consideration of the page as a visual unity. He had made a very careful study (even on posters and in newspapers) of the effective distribution of blacks and whites, the comparative intensity of typefaces. It was his idea to develop this medium, which till then had been used either as a crude means of attracting attention or else as a natural ornament for the printed words. But a page, in his system—being addressed to the glance that precedes and surrounds the act of reading—should "notify" the movement of the composition. By providing a sort of material intuition and by establishing a harmony among our various modes of perception, or among the *rates of perception* of our different senses, it should make us anticipate what is about to be presented to the intelligence.[2]

For the most part, the publications described here, books as well as the related spectrum of printed material, reflect the influence of Mallarmé's theory and ambition. Most, like Marinetti's *Les mots en liberté futuristes* and Apollinaire's *Calligrames: Poèmes de la paix et de la guerre, 1913-1916* transcend the example rather than the implications of *Un Coup de dés*. Marinetti's futurist grammar, begun in 1912 and published in 1919, advocates the complete destruction of Latin syntax and demonstrates a verbal revolution, a new and expressive orthography and typography whose form was to be capable of conducting the peculiar, complex intelligence of the modern industrial, scientific world. Apollinaire's *Calligrames* transforms Mallarmé's implied imagery to that of a literal pictograph. He subverted the mechanistic rigidity of the typewriter to achieve pictorial contours whose design seems to issue from the mundane, whimsical sense of the poem and the unorthodox splaying of its words. In the Blaise Cendrars/Sonia Delaunay, *Prose du Transsibérien et de la petite Jehanne de France*, 1913; Blaise Cendrars/Fernand Léger, *La Fin du Monde, filmée par l'Ange Notre Dame*, 1919; Francis Picabia, *Poèmes et dessins de la fille née sans mère*, 1918; Max Ernst, *Histoire Naturelle*, 1926; Max Ernst/Paul Éluard, *A l'intérieur de la vue*, 1947; El Lissitzky, *Suprematisch worden van twee kwadraten in 6 konstrukties*, 1922, respectively, the particular facets of design and intelligences of the whole carry the impress of the concept announced by *Un Coup de dés*: that the typographical design of a phrase could expand and/or clarify its meaning; that pages and foldings compose a structure effecting the intelligence of prose and/or image.

More than any other group, the expositional, programmatic set of *Bauhaus Bücher* engineers one of the most consistently remarkable

László Moholy-Nagy, *Bauhaus Bücher Vol. 8, Malarie, Fotographie, Film*, 1924.
Illustrations from the English translation, M.I.T. Press, 1969.

episodes in the history of the art of the book. A series of fourteen volumes (1925-1930), edited by Walter Gropius and László Moholy-Nagy, the books rigorously demonstrate format as a systemic support of content and are discussed in Jan Tschichold's classic and influential *Die Neue Typographie* of 1928. In the *Bauhaus Books* the precepts and sense of content are palpably clear in the logic and decisions of design and format. Content is not so much conveyed *by* as *in* the carefully considered means and methods of presentation. Nowhere is the book more completely accomplished as a *mental instrument*; form and content virtually assume the operation of a mathematical proposition, arriving at a language in which everything formal belongs to syntax and not to vocabulary. For Moholy-Nagy,

> ... typography is an instrument of communication. It has to be clear communication in the most penetrating form. Clarity must be particularly emphasized since this is the essence of our writing as compared with pictorial communication of ages ago. Our intellectual approach to the world is individually precise in contrast to the former individually and later collectively amorphous. Foremost, therefore: absolute clarity in all typographical works. Legibility—communication, that is, must never suffer from a priori assumed aesthetics. The letter types must never be squeezed into a pre-determined form.[3]

It is important to keep in mind that the first forty years of twentieth century art are marked by a proliferation of aesthetic manifestoes, theoretic and didactic texts, and that the publication of this material inevitably occasioned its own special history—one in which the manipulation of the book as a formal medium obviously was of paramount importance. The very qualities and differences in format displayed by these books, pamphlets, periodicals, and sheets translate directly a particular aesthetic, or intellectual and analytical system. One has only to juxtapose the above statement by Moholy-Nagy to the following by Tristan Tzara to quickly appreciate that systems of notation are formulated as the visible shape of an idea, and that these systems will be as different as the intelligence they express:

> To put out a manifest you must want: ABC to fulminate against 1, 2, 3, to fly into a rage and sharpen your wings to conquer and disseminate little abcs, to sign, shout, swear, *to organize prose into a form of absolute and irrefutable evidence* (my emphasis).[4]

The diversity of the publications which compose this significant history of the formalization of the book and related printed material is

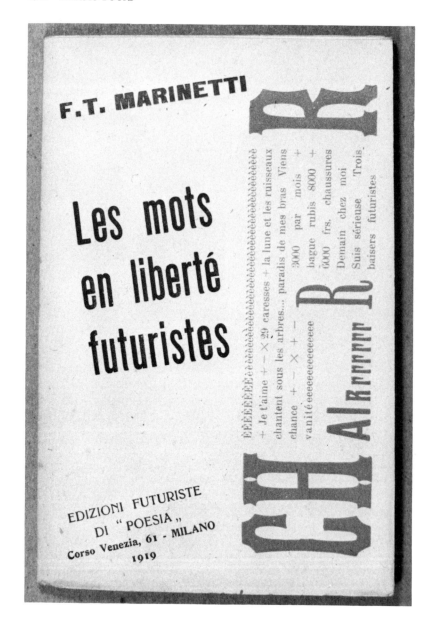

Marinetti, *Les mots en liberté futuristes*, 1919.
Collection of Arthur and Elaine Lustig Cohen.

amply demonstrated by a comparison of such publications as: *Der Blaue Reiter*, 1912, edited by Wassily Kandinsky and Franz Marc; *Dictionnaire Abrégé du Surréalisme*, 1938, edited by André Breton and Paul Éluard; Marinetti's *Les mots en liberté futuristes*, 1919; Kurt Schwitters's *Die Kathedrale*, 1920; Tristan Tzara's *Sept manifestes dada*, 1924; and *Papillons Dada*, 1919-1920; *391*, 1917-1924, edited by Francis Picabia; *Merz*, 1923-1932, edited by Schwitters; *Mécano*, 1922-1931, edited by Theo van Doesburg; *Wendingen*, 1925, edited by H. T. Wijdeveld.

A notable result of this "science" of the book is that the *livre de peintre*[5] developed as something quite different than a category of the illustrated book.[6] In its comprehension and refinement of the special anatomy which is the book and in the fleshing out of its form, it is probably Matisse's *Jazz* of all the *livres de peintre* that most nearly achieves the ambition of the specialized instrument anticipated in *Un Coup de dés*. Generally when the book is displayed, it is as a collection of prints, arranged serially and placed on a wall. When perceived properly as a book it becomes clear that the scale of *Jazz* is precisely proportioned so that the spread of its pages does not exceed the spread of the "reader's" arms. As a book *Jazz* functions and performs effectively as it is drawn near, in the manner that books are—that is, as it adjusts to the carefully taken into account range of head and torso and manipulation by the hands. The substantial weight and texture of its paper; the acute physical and visual sensing of the page's perimeter; the sense of order, interval, and revelation provided by the consecutive turning of the pages; the impetus of the whole, instantaneous in every part; the brilliant dense flatness of its color, accelerated by the sharp contour and close focus of its blazon-like images; the spontaneous, purely linear exercise of the script; the combinations and isolations effected by the order of the pages—all of these carefully establish the unique perceptual context and mechanism which is *the book*.

The text, reproducing the large script of the artist and conceived as part of the visual language and organization of the whole, begins introspectively with a few ideas pertaining to the making, elaboration, and special privilege of the project *Jazz* and completes itself with incidental passages taken by the painter from his notebooks. From the information provided by the text it is clear that the manuscript sequence has a visual rather than an ideational function and thus embellishes the optical address of the whole.

Similar in its appreciation of the unique unity of the book is the elegantly ingenuous Lise Hirtz/Joan Mirò *Il était une petite pie*. Here, unlike the purely formal exercise of *Jazz*'s script, Hintz's "10 songs for Hyacinthe" impose the distinction of their poetry yet, at the same time, barely reserve themselves from the decorative, informal, and calli-

un moment
d'libes.
Ne devrait-on
pas faire ac-
complir un
grand voyage
en avion aux
jeunes gens
ayant terminé
leurs études.

54

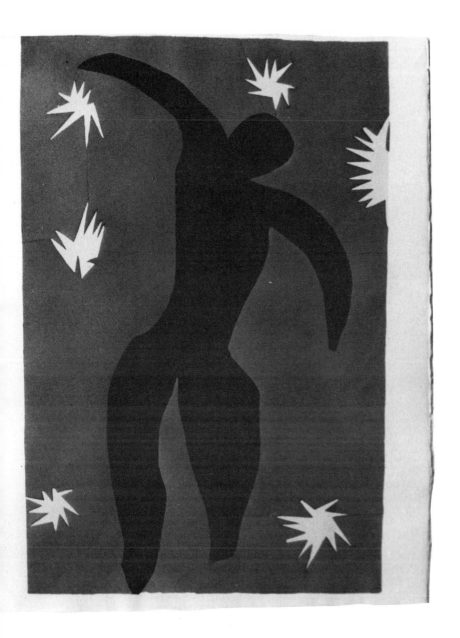

Henri Matisse, *Jazz,* 1947. Collection of Authur and Elaine Lustig Cohen.

graphic invention of Miró's hand. The text is not illustrated. The songs appear to realize and render themselves calligraphically. They are, so to speak, inseparable from their writing. The eight major images which illustrate the book have no anecdotal reference to the songs but simply annotate those events which are the events of the book itself: the *Ist* marked as *au commencement du livre*, the *IInd* marked as *après la première histoire*, and finally the *VIIIth* marked as *à la fin du livre*.

It is within this period of dada and surrealist activity that the book emerges as a major, rather than an incidental or peripheral, medium of expression. While individual works cannot be discussed here for want of space, a few comments may suggest some general considerations which qualify these as a distinct group. To begin with, although many of the dada and surreal books are limited, signed editions, they are rarely, in the sense that *Jazz* and *Il était une petit pie* are *livres luxes*; and even less so are they, with regard to such examples as Max Ernst's *Histoire Naturelle* or André Masson's *Nocturnal Notebook*, *livres de peintre*. While the proliferation of the dada and surrealist book is, as has been stated, the inevitable result of the literary thrust of both movements, it is not simply the fact of this activity that accounts for or determines the particular quality of dada and surrealist publications. Certainly, on one level, the predilection for the book evolves from the fact that, in theory and practice, dada and surrealism tended to deny such traditional concepts maintained as peculiar to the definition "work of art" as uniqueness, methods, tools, and materials of execution whose authority is only that of historical example. And, in so far as the history of modernism itself was concerned, both movements rejected the imperative of the largely self-critical, refining preoccupation of content and form.

The ordinary book—the *ordinariness* of the book, the intellectual habit of the book, the eminent quality of intimacy and introspectiveness provided by a volume, ideally lent its form to the polemical, theoretical, and hermetic concerns of both, and other related movements. One has only to compare *Jazz* with Max Ernst's *Histoire Naturelle* to realize the enormous conceptual and visual differences between the address and intention of both books. Foremost, of course, is the operation and habit of "reading" imposed by Ernst's "novel without words" as against the purely retinal refinement and assault of Matisse's imagery and color.

Although far removed from the ideal ambition of Mallarmé's aesthetic, the surrealists, and to a different extent the dadas, retained what was crucially central in the investigative and complex system of *Un Coup de dés*. That is, the nature of the activity of thought, its conscious and unconscious process and expression, the invented and to-be-invented systems of its notation, and the cogitative nature and function of

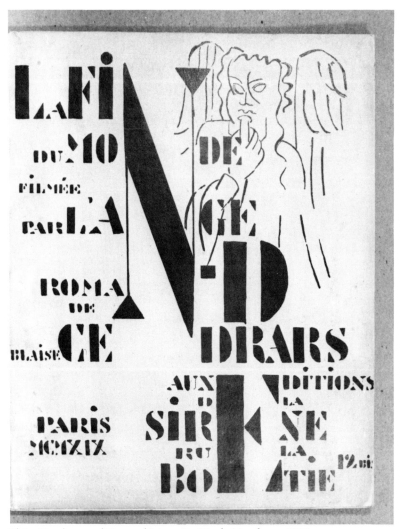

Blaise Cendrars and Fernand Léger, *La Fin du Monde...*, 1919.
Collection of Arthur and Elaine Lustig Cohen.

art as such a system of notation.

It is this concern with the manipulation and recording of thought and thought process which lends a conceptual unity to, and in a way explains, the enormous variety apparent in this group of published material—encompassing as it does the gross complication and careful, elaborate manufacture of Marcel Duchamp's *La Mariée mise a nu par ses célibataires, même* (known also as the *Green Box*) and the simple

conceit of Tristan Tzara's *Papillons Dada,* which are nothing more than separately issued small pieces of colored paper carrying deliberately startling and provoking directives and definitions.

Art historically, the book and its associated forms have as yet to be investigated and understood as a distinct, formal phenomenon of the modern period, as a methodically developed medium, born from the specific considerations of the necessity, function, and nature of art peculiar to the various and related movements of the twentieth century.

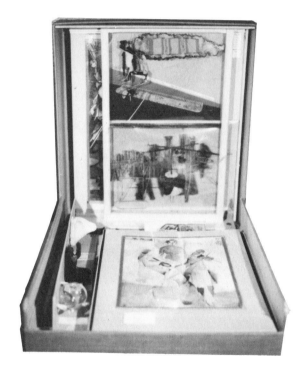

Marcel Duchamp, *Boîte-en-Valise,* 1938.
Photograph courtesy of Arthur and Elaine Lustig Cohen.

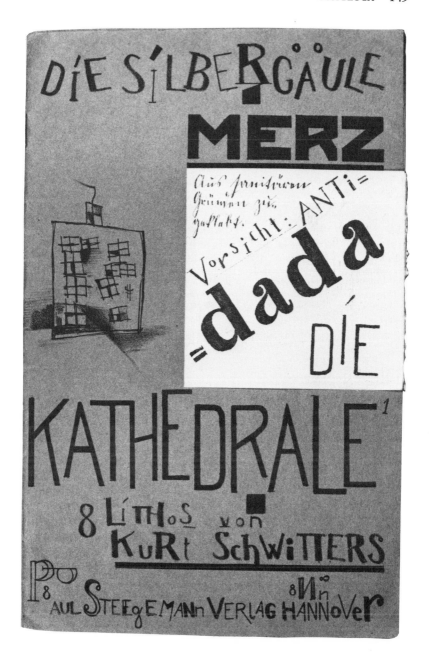

Kurt Schwitters, *Die Kathedrale*, 1920.
Collection of Arthur and Elaine Lustig Cohen.

NOTES

1. Stéphane Mallarmé, "The Book: A Spiritual Instrument," in *Mallarmé: Selected Prose, Poems, Essays & Letters*, Bradford Cook, trans. (Baltimore: Johns Hopkins University Press, 1956).
2. Paul Valéry, "Concerning *A Throw of the Dice*," in *Leonardo, Poe, Mallarmé*, Vol. 8 of *The Collected Works of Paul Valéry* (Princeton, New Jersey: Princeton University Press, Bollingen Series XLV, 1972).
3. László Moholy-Nagy, *Staatliches Bauhaus in Weimar, 1919-1923* (Munich: 1923), p. 141.
4. Tristan Tzara, "Dada Manifesto 1918," Ralph Manheim, trans., in Robert Motherwell, ed., *Dada Painters and Poets* (New York: Wittenborn, Schultz, Inc. 1951).
5. *Livre de peintre* is a term given to editions executed by artists, painters, and sculptors who are not primarily graphic artists.
6. Traditional examples of *livre de peintre*, that is books with the added decorative stimulation of a single print or scattered prints, are the Vollard *Ubu* series; the Paul Dermée/Juan Gris, *Beautés de 1918*; the Guillaume Apollinaire/Raoul Dufy, *Le Bestiaire ou cortege d'Orphée*; and Apollinaire/Andreé Derain, *L'Echanteur pourrissant*. On the other hand, such works as Matisse's *Jazz*; the Blaise Cendrars/Sonia Delaunay, *Prose du Transsibérien et de la petite Jehanne de France*; the Cendrars/Fernand Léger, *La Fin du Monde, filmée par l'Ange Notre-Dame*, among others, transcend the conventional *livre de peintre* precisely in their sense for the structure and totality of the book and the exercise of that sense upon the composition of images, or images and words.

BIBLIOGRAPHY—BOOKS BY ARTISTS

Apollinaire, Guillaume. *Calligrammes: Poèmes de la paix et de la guerre, 1913-1916*. Paris: Mecure de France, 1918.
Bauhaus Bücher. Eds. Walter Gropius and L. Moholy-Nagy. Munich: Albert Langen, 1925-1930. 14 vols.
Moholy-Nagy, László. Vol. 8. *Malerie, Fotographie, Film*. 1924.
Moholy-Nagy, László. *Painting, Photography, Film*. Cambridge, Massachusetts: M.I.T. Press, 1969 (Translation of *Malerie, Fotographie, Film*).
Der Blaue Reiter. Eds. Wassily Kandinsky and Franz Marc. Munich: R. Piper & Co. Verlag, 1912.
Cendrars, Blaise/Sonia Delaunay. *Prose du Transsibérien et de la petite Jehanne de France*. Paris: "Les Hommes Nouveaux," 1913.
Cendrars, Blaise/Fernand Léger. *La Fin du Monde, filmée par L'Ange N(otre)-D(ame)*. Roman. Composition en couleurs par Fernand Legér. Paris, Éditions de la Sirène, 1919.
Dictionnaire Abrége du Surréalisme. Eds. André Breton and Paul Éluard. Paris: Galerie Beaux-Arts, 1938.
Duchamp, Marcel. *Boîte-en-Valise*. Paris: Éditions Rrose Sélavy, 1938.
Duchamp, Marcel. *La Mariée mise à nu par ses célibataires, même*. Paris, Éditions Rrose Sélavy, 1934. (Also known as the *Green Box*.)
Ernst, Max. *Histoire Naturelle*. Paris, 1926.
Ernst, Max and Paul Éluard. *A l'intérieur de la vue. 8 poèmes visibles*. Paris, Pierre Seghers, 1947.
Hintz, Lise/Joan Miró. *Il était une petite pie*. Paris: Édition Jeanne Bucher, 1928.

Lissitzky, El. *Suprematisch worden van twee kwadraten in 6 konstrukties.* Haag: Stijl, 1922.

Mallarmé, Stéphane. *Un Coup de dés jamais n'abolira le hasard.* Paris: Éditions de la Nouvelle Revue Français, 1914.

Marinetti, Filippo Tommaso. *Les mots en liberté futuristes.* Milan: Edizioni Futuriste di "Poesia," 1919.

Masson, André. *Nocturnal Notebook.* New York: Curt Valentin, 1944.

Matisse, Henri. *Jazz.* Paris: Éditions de la Revue Verve, Ed. Tériade, 1947.

Matisse, Henri. *Jazz.* New York: Brazilier, 1983.

Picabia, Francis. *Poèmes et dessins de la fille née sans mère.* Lausanne: Imprimeries Réunis SA, 1918.

Schwitters, Kurt. *Die Kathedrale.* 8 Merz-Lithos. Hanover: Paul Steegmann, 1920.

Tschichold, Jan. *Die Neue Typographie;* ein Handbuch für zeitgemäss Schaffende. Berlin: Verlag des Bildungsuerbandes der deutscher Buchdrucker, 1928.

Tzara, Tristan. *Papillons Dada.* (Zurich, Paris, 1919-1920).

Tzara, Tristan. *Sept manifestes dada. Quelques dessins de Francis Picabia.* Paris: Éditions du Diorama Jean Budry & Co., 1924.

PERIODICALS AND JOURNALS

Exposition international du surréalisme: Le Surréalisme en 1947. Paris: Pierre à Feu, Ed. Maeght, 1947.

Mécano. Ed. I.K. Bonset (= Theo van Doesburg), Mécanicien plastique: Theo van Doesburg (Leiden, "De Stij," 1922-1923).

Merz. Ed. Kurt Schwitters (Hanover, Merzverlag, 1923-1932).

691. Ed. Francis Picabia (Paris, 1959).

Wendingen. Frank Lloyd Wright. 7 vols. Ed. H. T. Wijdeveld (Santpoort, Mees, 1925).

The Artist as Book Printer: Four Short Courses

by Betsy Davids and Jim Petrillo

A NTIPASTO: SPIRIT AGAINST MATTER

Since the Renaissance, with its emphasis on point of view, individuality, and specialization, the printer has been a skilled craftsworker, trained from adolescence in a single differentiated facet of a complex system of mechanical production. The first print shops represented the most advanced technologies of their time and required large sums of investment capital. Gutenberg's own printing establishment was put together with substantial loans from the banker Johann Fust. When squeezed into default, he lost his press, punches, type, and a couple hundred Bibles to Fust's son-in-law, his former pressman. Four hundred and seventy-five years later, Philo T. Farnsworth fared only slightly better with the invention of television. During all this time, one fact has been missed by almost no one: commercial considerations dictate the content and quality of production in communications technologies.

Arguments have been advanced by William Ivins and others that accurate mechanical reproduction of images is the single most important factor in the birth of the modern world.[1] If academic proclivities to date the blessed event at the time of the invention of moveable type are correct, surely the printing of picture-oriented block books which preceded it must be considered seminal. During the incunabula period, these new mechanical products did not, of course, meet with unlimited enthusiasm. In 1471, Bernardo Cennini brought the city of Florence a press and petitioned Lorenzo the Magnificent's patronage for a print shop to rival the barbarian municipalities of Northern Europe. The Magnificenzia rejected the proposal on good grounds: he already possessed a library considered one of the best in Europe and was spending

30,000 ducats a year on manuscripts. The stuff made by the machine would devalue his collection. Worse yet, when compared with the vibrant quality of hand illustration, it looked crude.

In spite of the Magnificenzia's stand for good taste, too many machine-made books had already been manufactured and the tide irrevocably turned. So it came to pass that the visual craftsworker (as distinguished from the visual artist) emerged as an unacknowledged but significant force in the development of modern culture, or, if you will, the cult of modernism. Fitting neatly into a compartmentalized system of material production, this specialist created verisimilitudinous images of botanical specimens, mechanical operations, depictions of persons or events, and reproductions of high art in a form that could be printed, cutting contour lines into wood and later more complex netting into metal plates that could be inked onto paper, itself the product of an even older, larger, and more highly capitalized industry. These printed pages were folded into signatures and turned over to binders to produce units sold by vendors to university students, politicians, businessmen, and Bible-thumping god-intoxicants, all promoting that most peculiar Western notion that it must be true, because "it's in the book."

It is curious that until the twentieth century very few historically significant artists emerged from the printing trades. The low craftsworker was bound by the dictates of material and the technology that transformed it. The printing process required uniformity of results and emphasized conformity of spirit. Around it grew a vocabulary of effects, a set of specific and predetermined values to be achieved and repeated *ad nauseam*. To this day, a major value of the fine print tradition is to give good impression. This ironclad value system is based on what is correct, rather than what is inspiring.

The visual artist, on the other hand, was by license and social contract expected to graze the high ground of the imagination, cutting out psychic templates through which we squeeze our spirit into a consensus behavior called "reality." In words and pictures, artists get to manipulate "the great ideas." You know the kind: Leda and the Swan, Judith and Holofernes, the Judgment of Paris, or, as in the fifties, "how to crystallize the basic plastic organic unity." More recent mumbo jumbo[2] has yielded such pedantic academic jargon as "structuring a system of marks" or, as one recent graduate student proclaimed, "I'm into corners." So much for transcendent metaphysics.

James Joyce has paid playful tribute to the essence of the dualism of high art versus low craft in the epic cosmology of his *Finnegan's Wake*. The title is derived from the traditional pub story of the hod carrier who fell off his ladder and was killed, only to be resurrected by some Irish whisky spilled on him during his wake. Because this could potentially

ruin everyone's good time, his friends kept pushing him back into his coffin every time he tried to get up. The critical metaphor here is the trade of the hod carrier. With his basic tool, a V-shaped cradle on a stick, he carries matter (bricks) up to the top of a building (sky, heaven) and returns spirit (air in the empty hod) back down to earth, enacting the cyclical rise and fall of matter and spirit. *Humus Con Espiritu!*

PASTA: THE MARRIAGE OF INSIGHT AND TECHNIQUE

William Blake was the only printing trade craftsman to be given serious credibility as a high artist, though the reward was almost entirely posthumous. He did it by creating a total cosmology, abandoning the limiting principles of his trade, and inventing a new printing technique that allowed his unique spirit to be transformed into material. He made the first artists' books. His methodology and achievements resonate with so many contemporary book artists that an account of his work can serve as the looking glass through which we better see ourselves.

Severely limited access to the establishment art world and to conventional publishing was the problem that drove Blake to the radically unconventional step of making his own books. From the age of fourteen he was trained as a reproductive engraver and, although well read, he had little other formal education; as a result, he had difficulty achieving credibility as a high artist or as a writer. At the same time, his employability as an engraving craftsman was marred by the very characteristics that made him an artist: vision, insight, commitment to his own content. For fully ten years he attempted to persuade publishers to commission a book for which he would not only create the images but also engrave the plates—normally separate functions. Eventually Blake had to self-publish, because he could find no other way to reproduce his peculiar combination of innovative writing, image-making, and printing.

He devised a new printing method appropriate to both his aesthetics and his poverty, facilitating integration of words and images on the page and enabling him to avoid the expense and division of labor involved in getting the text letterpress-printed. His method was a form of relief etching in which both words and images were formed in some sort of fluid resist on a single copper plate. The lines were probably brushed onto the plate with a small camel's hair brush, one of Blake's favorite tools, so that the platemaking process was essentially painterly, calligraphic, and much more direct than engraving, then dominated by the complexities of the engraver's net. The resulting plate would be etched in extremely shallow relief, making both sides of the plate

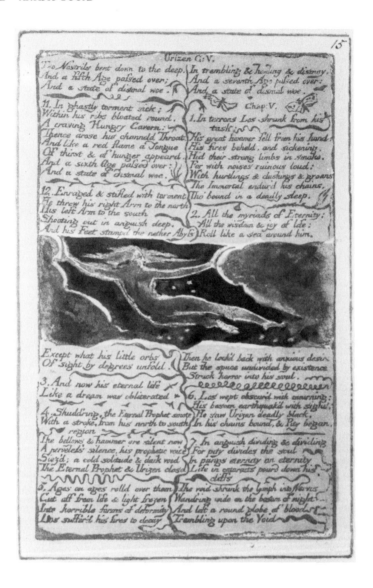

William Blake, *The First Book of Urizen*, 1794.

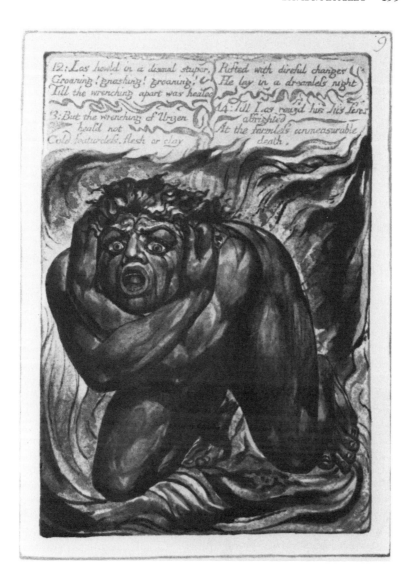

William Blake, *The First Book of Urizen*, 1794.

usable, for economy. (The single extant plate fragment is etched to only .12mm, less than half a point!) Then came inking, perhaps with the letterpress printer's inking balls, perhaps by transfer from an unetched inked plate, followed by printing on a rolling press, Blake's sole piece of printing equipment. The presswork must have been tricky, given the shallow relief, so some hand touch-up work would follow printing. And then, more often than not, the images would be hand-colored with water colors, so that the completed pages were really illuminated pages, painted prints.[3] All these steps were carried out very inexpensively by Blake himself or with the assistance of his wife Kate; this was a bookmaking process that allowed full personal control from beginning to end. The resulting books, when held in hand, have a vibrant appearance, a personal presence, an aura: precisely the quality that Walter Benjamin notes the loss of in "The Work of Art in an Age of Mechanical Reproduction."[4]

Thus the goals his method served were individual, aesthetic, and interdisciplinary rather than industrial or commercial. As an alternative printing process, it stands in contrast to Senefelder's invention of lithography, which was promoted among artists and publishers in London during Blake's lifetime and which achieved considerable commercial importance in the nineteenth century. But Blake developed his printing method privately and in quite a different direction, more akin to the medieval scribes and manuscript illuminators. He used it to make books that were almost one-of-a-kind. In fact, he didn't print editions; he printed only one copy at a time, as he got commissions, and he varied the sequencing, the basic ink color, and the hand coloring so that each copy is virtually unique.

Blake's bookmaking *oeuvre* is a remarkable example of the marriage of insight and technique. He began his first major cycle of bookmaking at the age of thirty, and his first attempts, *There is No Natural Religion* and *All Religions are One*, have the tentative and crude look of first books, preliminary tests of a new medium. He used them to set forth the central tenets of his thinking, a set of ideas that reverberated throughout his later books. These trial runs were quickly followed by *Songs of Innocence*, where—with the larger plate size and the addition of hand coloring—Blake was already handling his medium with the panache of an old pro. *Songs of Innocence* remains Blake's best-loved book, partly for its beauty, partly for the accessible, deceptively simple style of its language and the children's-book character of its images. It was issued in 1789 (the year the French Revolution began) and represents a naive and romantic view of the world. In 1794 (the year Danton went to the guillotine) Blake completed the *Songs of Experience*, representing a disillusioned world view, and thereafter always issued the two together under the combined title *Songs of Innocence and of Experience*,

with the subtitle *The Two Contrary States of the Human Soul.* Together, the two books represent what Blake's contemporary Hegel would have called thesis and antithesis.

Some guidelines toward the eventual synthesis that would become Blake's magnum opus, *Jerusalem*, are set forth in an early and very accessible work, *The Marriage of Heaven and Hell* (1790). As Blake explains, "Without contraries is no progression." He goes on to suggest how progression will occur, how the world can be seen as infinite and holy, rather than, as it now appears, finite and corrupt:

> This will come to pass by an improvement of sensual enjoyment. But first the notion that man has a body distinct from his soul is to be expunged; this I shall do, by printing in the infernal method, by corrosives, which in Hell are salutary and medicinal, melting apparent surfaces away, and displaying the infinite which was hid. If the doors of perception were cleansed everything would appear to man as it is, infinite. For man has closed himself up, till he sees all things thro' narrow chinks of his cavern.

The reference to printing by corrosives, to etching, indicates the function Blake envisioned for his printing work in reconciling the contraries and rerevealing the infinite world. The printing craft and the arts of the spirit are fully united here.

As writing, *The Marriage of Heaven and Hell* is the last of the illuminated books to adopt a language of clarity. At the same time, during the same seven-year stretch of bookmaking, Blake was also working on a series now called the prophetic books, where language and ideas are often obscure and difficult. It is useful to recognize that in Blake's time, the "prophesy" was understood as a particular genre of book in which picture-writing, or pictures with writing, were used to reveal eternal truths, as in what was believed to be the original form of the *Apocrypha* or *Book of Revelation.* So Blake's lineage as a bookmaker includes not only scribes and illuminators but also the ancient prophets, who were often pictured in the act of making books.

Taken as a whole, Blake's prophetic books present not only a full-scale cosmology but also a mapping of the psyche, an interpretation of history, and a myth of individual redemption. His first bookmaking cycle dealt with isolated fragments of this content in eight short prophetic books including *Visions of the Daughters of Albion, The Book of Thel, America a Prophecy, Europe a Prophecy,* and *The First Book of Urizen.* In his second cycle, after a nine-year hiatus, Blake produced the complete synthesis of his mythic system in the epic prophetic books *Milton* and *Jerusalem.* His largest bookmaking projects, *Milton* and *Jerusalem* are the fully integrated expression of his identity as artist,

writer, prophet, and visionary. A resolution thirty years in the making is achieved when Albion, the archetypal man, and Jerusalem, the archetypal woman, embrace in the last pages of *Jerusalem*, ending the separation of male and female, of humanity from eternity—and ending as well Blake's work as an artist-bookmaker.

ENTREE: WHAT WE DO IS BOOKS

Unfortunately, Blake's infusion of spirit into print technology evaporated faster than the sweat on a disco dance floor. At the time of his death, the invention of the steam engine and the cylinder press put the "mass" in mass production and civilization took a blindfold quantum leap into our brave new world. The artist was thus further alienated from direct access to the means of production by even greater demands for capital and specialization.

William Morris's late-nineteenth-century romantic attempt to infuse the printing trades with higher values now seems like a misguided sentiment buoyed up by a sea of money. The subsequent rise and rapid fall of the arts and crafts movement serves as a historical footnote, underlining the limited economic viability of hand-produced work. As Thomas Edison reputedly said of the light bulb, "We'll make them so cheap, only the rich will be able to afford candles."

The written word is a cultural memory device that often reminds us that history is made to be repeated. In spite of C. R. Ashbee's 1908 publication of *Craftsmanship in Competitive Industry*, a document of personal experience which lucidly articulates the inherent inability of cottage industry to compete with corporate capitalism, the 1970s arrived with an entirely new generation of artists assuming the Blakean burden of self-publishing.[5] "Let's bypass the galleries," went the chant. "Let's get past the expensive, unique art object and create works that are infinitely reproducible and accessible to everyone at low cost." Why not? The terms seemed new and the world seemed different. Technological innovation was creating products at an exponentially increasing rate. In its wake the industry cast off uncompetitive and depreciated equipment, which floated off to the Third World and into the waiting hands of financially unsophisticated artists. This time the motivation was to collect for the artist the rewards of mass production. But the rewards of mass production accrue only to those who can buy into the entire system of competitive machinery, big promotion budgets, and mass distribution. Just because you can print 2,000 copies of a book doesn't mean that you can get them into book stores, or that they will sell once on the

shelves.

Every new beginning needs its illusions, and this is no place to mourn the misplaced hopes of artist-bookmakers. Blake too had visions of 2,000 copies before he made his first book; in actual fact, his bestseller, *Songs of Innocence and of Experience*, sold a grand total of thirty copies over thirty-five years. The point is: the "artist" hardly ever becomes a "printer" as the industrial trade understands the term, and vice versa. The artist is more likely to be a "printmaker." Printmaking is what artists do when they approach printing as a fine-arts process.

Blake was this kind of book printer, whose remarkable technical innovations rejected the trade aims of uniformity, consistency, and infinite reproducibility in favor of a process whereby each print of each page was virtually unique. Among artist-bookmakers of our era, similar ends are served by the overprinting processes explored by Kevin Osborn and by Frances Butler, for example. Both have developed flexible presswork procedures in which several images are overprinted in several colors on each sheet. Not every image will be printed in the same color on every sheet; ink is applied as if it were paint, layering, adding, changing ink color as the press runs. And in a typical Osborn work, not every image will be printed in the same position on each sheet. The choice of which images to print in which colors and which positions on which sheets is made during the presswork and by eye, rather than according to a fixed plan. The result is an edition in which each sheet varies slightly. In contrast, the standard trade version of overprinting is

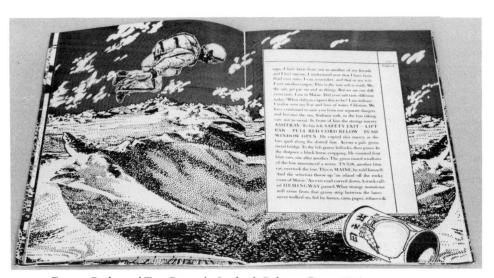

Frances Butler and Tom Raworth, *Logbook*, Poltroon Press, 1976.

four-color separations, or multi-color printing matched to pretested color keys, producing a virtually uniform edition. In trade printer terminology, there is the "art" (the original to be reproduced) and there is the printing, which attempts within limits to reproduce the "art." Butler and Osborn's work pushes toward a situation in which the printing and the art are not separable. Blake would have understood. Restructuring the printing process allows the printer to function primarily as artist rather than primarily as technician, directly manipulating by hand the emergence of spirit into matter.

As a stance toward presswork, this is considerably less repressive than is the norm among "real" printers. Left to themselves, printing presses would not produce consistent and uniform prints; they have to be forced to do so, and much of the trade pressman's time is spent in coaxing the press toward consistency. Watching Frances Butler on the press is an education in the value of a more permissive attitude toward presses. She is an energetic, enthusiastic, ink-slinging, sloppy, spirited printer who achieves surprise results that would be impossible through the meticulous restraint more commonly practiced by printers. Similar work styles, similar attitudes toward tools and materials are by no means uncommon among painters turned printmakers, but rare among nonartist-printers.

Artist-printers tend to prefer personally selected content produced on small-scale equipment controllable by a single individual. Accordingly, hand-operated presses, which in the trade are used only for repro proofs, are often the sole equipment used by artists, like the offset repro press favored by Daniel Tucker in the late seventies, or the Vandercook repro presses used by letterpress artist-bookmakers like Butler or Susan King. Todd Walker has worked extensively on a Multilith 1250, the Volkswagen Bug of offset presses. Jim Koss works on platen presses, those outdated favorites of private press printers. All these low-tech presses are fairly simple to operate and allow considerable hand intervention in the presswork. What's more, they are relatively affordable to buy and use.

Affordability is by no means irrelevant. After all, Blake was born poor (and got poorer) while Morris was born rich (and got richer), and how and what each produced was in no small measure determined by those facts. Given the sparse economic opportunities available to artists in our time and the large number of contemporary artists who come from a working middle-class background, it is an economic fact of life that their printing activities are usually conducted on the lowest possible level of capitalization. Innovations specifically designed to make book printing cheaper are one by-product of artists' involvement with printing: for example, the development of alternative color separation processes, which make interesting versions of process-color printing

available to artists at considerably lower expense than the high-tech color separations used in the trade.

But the low-tech, low-capital, private print shop can't fulfill all the printing needs and desires of artist-bookmakers, however comfortably it fits the dominant mythologies and work habits of the individual artist. For one thing, not all artist-bookmakers want to print their own books. And so the seventies saw the emergence of a class of facilitators: artists or art-trained people who also have a high level of printing expertise, like Joan Lyons at Visual Studies Workshop, Conrad Gleber of Chicago Books, Kevin Osborn at the Writer's Center, Michael Goodman at Nexus, Stan Bevington at Coach House Press, Philip Zimmermann at Space Heater Multiples, Barry Singer of Singer Printing, Susan King at the Women's Graphic Center. Working in larger shops or institutional settings, often greened by the government funds available to nonprofit organizations with service programs, these artist-printers close the gap between artists who have little knowledge of printing and printers who have little knowledge of art. The largest of the artist-run print shops begin to approach trade shops in range and quality of equipment. When artist-printers of this caliber function as facilitators, they raise the technical quality level of other artists' books; when they function directly as artist bookmakers, making their own books, the results are often particularly fine examples of the genre.

Whatever the working situation, the books printed by artists do not necessarily differ greatly in printing style from books produced in similar shops by private presses or trade printers. Simply putting an artist on a press is not an automatic formula for innovative printing, as those of us who teach printing can testify. An interesting question to ask about any given artist-printed book is: did this book *have* to be printed by the artist? Could it, would it have been printed in much the same way by a nonartist printer? Sometimes the features that distinguish an artist's book from other books are matters of image quality, text content, conception, page design, or object quality, rather than the printing *per se*. An example might be Koss's books, which incorporate images, structures, and conceptions one would not expect to see outside the visual art context, but whose letterpress printing style is fully shared with many fine printers.

The close, hands-on involvement of artists with printing has its most noticeable effects when the artist reimagines the printing process along high-art lines. Not only does the printing itself, the ink on paper, achieve a rich unpredictability in color and texture, but the rethinking of the printing process sets up a ripple of aftershocks affecting other formal aspects of the book.

When we get right down to it, the inbred visual conservatism of books in general is one of the main reasons why artists' books look so

new. A representative collection of artists' books often does not seem visually remarkable in a gallery, where a wide range of visual experience is the norm. The same collection, installed in a library or bookstore, can seem visually startling almost beyond the limits of decorum. Artist-bookmakers have brought to the book a broader visual vocabulary, heightened emphasis on image content, a correspondingly altered attitude toward text and toward the relationship of text to images. These simple shifts of emphasis and attitude can seem so major to the book-trained eye that your standard book collector, your basic librarian, and your average fine printer are likely to look at a fairly normal artist's book as if it were some kind of unassimilable object, some indigestible exotic fruit.

After all, much of the 500-year history of the printed book has been dominated by the inviolability of the written word. The text block is a fortress, the treasures of meaning hidden within and the alien claims of the visual sealed out. The inflexibility of metal type is partly to blame, but really we're in the presence of an old, stern, and rigid cultural attitude about the written—especially the printed—word. Only in children's books and advertising have words been allowed to appear in short fragments, more or less freely interspersed with images (children and profit have their own special cultural priorities). Writers, those residents of the fortress, and editors, their doormen, are frequently hostile even to the idea of illustration, much less to images that might carry some content of their own not controlled by the text. Typography is unavoidably visual and accordingly has been relegated to servant status. The typographic principles which are still dominant, still rattled off right and left like a catechism, hold that typography should be a crystal goblet, transparent, as *in*visible as possible, so that the words themselves may shine through. The essence of words, mind you, is ineffable spirit and the nature of type is base matter in drastic need of humbling and purification lest it rip off some of the attention which rightly belongs to the words. The authoritarian, even sadomasochistic tone which pervades many discussions of book typography is, to say the least, inhibiting to any but the most conservative and classical approaches. In this hierarchy of values, "tastefully restrained" gets an A+, the best your humble servant can hope for; "elegant" gets A-, already a little questionable; "bold" or "flamboyant" are grounds for exclusion.

In mainstream book history, the word—the text—has been both inviolable virgin and high priest. Baiting virgins and priests is a cheap shot, so suffice it to say that images and type, which are perfectly capable of carrying spirit and content too, have needed some elbow room in the book. And the artist's book seems a natural place for some remodeling work on the old fortress.

One way of reintroducing the visual into the core of the reading ex-

perience is to abandon altogether the separatist rigidities of metal type. This was Blake's solution. By brushing both words and image outlines onto the same relief plate he facilitated a fluid intermingling of words and images unknown since medieval manuscript books. In our time, offset printing technology offers easy integration of handwritten words with drawn images, an option which has been recognized, though not very fully developed, in artists' books, where handwritten texts are much more common than in other contemporary bookmaking tradi- tions. A good example is Paul Zelevansky's work, in which hand- lettered and rubber-stamped texts share page space and content value with visual material.

Another way of reasserting visual values within the text is to play up the visual character of type itself, as the dada typographers discovered early in this century. Some of the finest examples of visual typography among contemporary artist-bookmakers occur in Johanna Drucker's books. Her handset book work accepts the rectilinear squareness of let- terpress technology; unlike the dada typographers, she does not at- tempt to coax the metal type, against its nature, into diagonals. Within these limits, the visual range of her typography is very broad, as is the range of the articulated reading experience thereby created. *From A to Z*, her most extravagant typographic cadenza, uses several dozen type- faces in a full spectrum of sizes—as many as half a dozen faces on any given page, often mixing bold with italic within a passage, or caps with lower case within a word, and for the final scherzo, a "SouRCZs qUoTEd" section that does it all more and faster. This is not humble servant typography, but there is no offense to the writer's ego, because Drucker is both typographer and writer. The page design provides suc- cessive installments from page to page of several literary styles and con- tents; each page becomes a sort of literary/typographic collage with multiple perspective. The book is a reader's steeplechase, ranging from straightforward prose narratives in easily legible type that can be read at a gallop to high-hurdle passages that are considerably sportier reading, with abbreviations, run-on words, secret meanings, alphabet soup. Since much of the explicit content of this book is about erotic desire and its obstacles, the best overall descriptive term might be something like "flirtatious," a quality which is equally applicable to the typog- raphy, the content, and the literary style. This work is a clear demon- stration that the visual limits of typography can be greatly expanded without disservice to text. The crystal goblet is shattered, and yet no wine is spilled.

When the caste attitudes elevating verbal over visual content are set aside, the way is open for images to move off the isolated illustration pages, in from the margins, out from under the subordinate role as "decoration," adopting a different set of interrelationships with text.

i.e. THERE'S NO 'I' KNOW
It's just not going to happen,
That's all.
The hero in the story,
hero of the story,
Isn't going to put out: Is all
For love - meaning lord knows...
In secure advance
Of quasi-realized,
Much applauded, will.

GLOVELESS LOVE; da-N;11q.
8l.x??W HoW PRzœnæl
Œb.JX hv ffl.EbbY NARRZZiz-
Tik UNION & EROz hv JUST
EX.finE fflŒ.

Johanna Drucker, *From A to Z*. Photograph by Betsy Davids, 1977.

The artists' books of the seventies included separatist "visual books," in which text was excluded altogether, allowing full play to printmakerly visual printing. There were also separate-but-equal books, like Todd Walker's *for nothing changes. . . .*, in which he cited the "obligation" for a book to include text and satisfied it with texts that maintained considerable distance in content and page position from the images, which he declared were not illustrations. Mutilated scapegoat texts, garbled or fragmented, also appeared with regularity in artists' books. A fully egalitarian and genuinely integrated visual-verbal book might be Zelevansky's *The Case for the Burial of Ancestors*, where both elements contribute and neither would be complete without the other.

These explorations of text/image relationships within the book are still in the bud stage, not fully matured. The artist's book is their principal field of growth, considerably facilitated by the increasing number of artists who also write and print, so that new text/image/print integrations can be worked out by a single imagination. If writers would move with equal energy into making images perhaps the marriage of heaven and hell could be achieved on schedule.

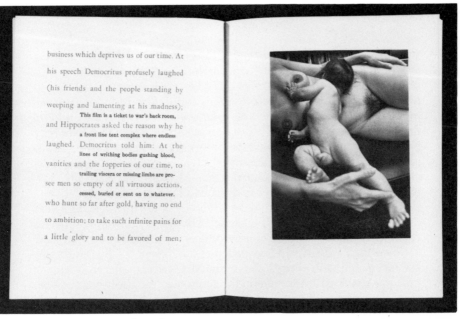

Todd Walker, *for nothing changes*, 1976.

The guiding spirit in all these developments is the desire to take the whole book as the field of work. Again, the relevant ancestral role model is Blake, who was author, artist, and printer of his books, and his own publisher and bookseller as well. We need to remind ourselves what a rare phenomenon that is in the history of bookmaking. A committee of scholars researching that entire history probably couldn't dredge up half a dozen good examples of pre-twentieth-century visual artists who approached bookmaking in such a comprehensive and integrated way. But now it's not at all uncommon. Just a browse through the book in your hands will produce plenty of examples of artists who author their own texts, artists who design or print or construct their own books, artists who publish and sell their own books, or do several of the above. It's quite possible that almost every artist who acknowledges the term "artist's book" performs one or another of these historically rare role combinations. Wholistic versatility is a basic distinguishing feature of the current era of artist-bookmakers. The artist as book printer is only one aspect of that larger integrative movement within the artist's book.

DESSERT: GÖTTERDÄMMERUNG, SHORT AND SWEET

As we enter the post-modern, post-literate, post-humanistic, post-avant-garde, post-mechanical age of electronic technologies, the book as we have known it may become archaic and anachronistic—a dinosaur, so to speak. Executives of corporate communications companies know that if their book divisions continue to be losers they will be disposed of or reformed. Yet, to its lovers, a book is a wonderful thing. As an embodiment of spirit, it is a totemic object that requires a personal, intimate involvement to unlock its mysteries and reveal its pleasures. Is it possible that this visual, literary, intellectual memory device, this commodity of the soul, this *mojo* of Western civilization is facing the scrap heap of history? Is this a bad dream or an opera?

Enter the artist as tenor. It's the last scene of the final act and he has just stepped off the top of the citadel. On his way down, he sings his concluding aria: "There are more producers of artists' books than there are consumers. It's true democracy and bad business." Stage left, one can make out the shadowy figure of the Muse, who points an enigmatic finger at the words projected on the scrim over the badly painted sunrise: "The book as it will be is yet to be discovered."

NOTES

1. William M. Ivins, Jr., *Prints and Visual Communication*. Cambridge, Massachusetts, Harvard University Press, 1953.
2. Among the Mandingos of the western Sudan, the Mumbo Jumbo is the tutelary genius of a village, represented by one of the men, who, in masquerade and with a headdress of pompons, wards off occult forces of evil and keeps the women in awe and subjection.
3. The precise details of Blake's printing method have been the subject of long debate. This description is based on the findings of Robert Essick in *William Blake, Printmaker* (Princeton, New Jersey, Princeton University Press, 1980), the most thoroughly researched and convincing investigation to date.
4. Walter Benjamin, *Das Kunstwerk im zeitalter seiner technischen Reproduzierbarkeit; drei Studien zur Kunstsoziologie*. Frankfurt am Main: Suhrkamp Verlag, 1968. Translated into English as "The Work of Art in the Age of Mechanical Reproduction" in *Illuminations*, ed. Hannah Arendt. New York: Schocken Books, 1969.
5. C.R. Ashbee, *Craftsmanship in Competitive Industry, being a record of the Workshops of the Guild of Handicrafts, and some deductions from their twenty-one years' experience*. Campden and London, Essex House, 1908.

BIBLIOGRAPHY—BOOKS BY ARTISTS

Blake, William, *All Religions are One*. London: William Blake, c. 1788.
Blake, William, *America a Prophecy*. Lambeth: William Blake, 1793.
Blake, William, *The Book of Thel*. London: William Blake, 1789.
Blake, William, *Europe a Prophecy*. Lambeth: William Blake, 1794.
Blake, William, *The First Book of Urizen*. Lambeth: William Blake, 1794.
Blake, William, *Jerusalem, The Emanation of The Great Albion*. London: William Blake, 1804.
Blake, William, *The Marriage of Heaven and Hell*. London: William Blake, 1790.
Blake, William, *Milton a Poem in 2 Books*. London: William Blake, 1804.
Blake, William, *Songs of Innocence*. London: William Blake, 1789.
Blake, William, *Songs of Innocence and of Experience, Shewing the Two Contrary States of the Human Soul*. Lambeth: William Blake, 1794.
Blake, William, *There is No Natural Religion*. London: William Blake, c. 1788.
Blake, William, *Visions of the Daughters of Albion*. London: William Blake, 1793.
Butler, Frances and Tom Raworth, *Logbook*. Berkeley, California: Poltroon Press, 1976.
Drucker, Johanna, *from A to Z*. Oakland: Chased Press, 1977.
Osborn, Kevin, *Real Lush*. Glen Echo, Md.: Kevin Osborn, 1981.
Walker, Todd, *for nothing changes.* Gainsville, Florida: the press of Todd Walker, 1976.
Zelevansky, Paul, *The Case for the Burial of Ancestors*. New York: Zartscorp Inc. Books and Rochester, New York: Visual Studies Workshop Press, 1981.

"Pinocchio," a handmade wooden mimeographer.

Independent Publishing in Mexico

by Felipe Ehrenberg,
Magali Lara, and Javier Cadena

ALL TOO LITTLE is known about the booming small press move-
ment in Mexico which, at most, is some eight years old. In spite of
its youth and its relatively few adherents, this movement has produced
not only magnificent examples of all types of books but has also
spawned unexpected applications that go beyond the established
boundaries of fine art, into those of culture in its widest sense. To un-
derstand the difficulties faced upon writing this account, it should be
kept in mind that until very recently no investigators or collectors of
small press productions in Mexico existed, private or otherwise, and
that the largest archive of small press and artists' books in Mexico—
very incomplete at that—can be found on the shelves of my studio.

To my knowledge then, nothing comprehensive has been written
about this aspect of our creative work, save isolated commentaries or
reviews, brief statements by bookmakers, and a passing remark or two
found in other contexts. These notes, then, published beyond our bor-
ders, may be the first attempt to make an inclusive review of an interest-
ing and complex phenomenon which, in order to explain it, I have
bisected into two categories: visual presses and literary presses.

Another point raised here concerns the so-called marginal nature
of this activity—and a much debated one at that. This I shall leave up to
art sociologists or historians to define, if need be, for the simple reason
that I can't pretend any sort of objectivity, living as I do, in the eye of the
hurricane. Unlike other unexpected offspring of established art prac-
tices, that may suddenly erupt onto the scene and struggle against odds
until finally occupying a place in the framework of accepted aesthetics
and distribution, small, independent publishing activity embraces a
spectrum of possibilities too wide to make it "manageable" by our
chroniclers, even under the best conditions. This is especially difficult

The Hungarian Schmuck, Beau Geste Press.
Photograph by Lourdes Grobet, 1973. Collection of Felipe Ehrenberg.

where there is no infrastructure to speak of, as in Mexico, and where the practice of art, state-sponsored to a surprising degree, faces contradictions unknown in other places; I shall say more about this later.

During the years I spent in England (1968-1974) I sporadically sent home examples of the productions made at Beau Geste Press, which I co-founded with Chris Welch, David Mayor, and Martha Hellion. Coincidentally, an Argentine poet living in New York, Elena Jordana, established a one-woman operation called El Mendrugo/Ediciones Villa Miseria (Crumb/Slum Editions) and, prior to settling in Mexico, also sent examples of her publications. If anything, these all had been indifferently received, considered at best, amusing eccentricities. Upon

my return to Mexico in 1974, I had under my belt the Beau Geste Press experience and felt motivated to pursue it somehow. How I didn't know, but my interest had much to do with breaking away from the orthodoxy which prevailed in Mexican art and which, compared to what I had been able to do in Europe, constrained me and, I felt, constrained other artists of my generation. Books and self-publishing were my only answers. The way to put this into practice, I knew, meant swimming upstream.

Gradually, as I wove my way back into the fabric of the country's art scene, my project, as vague as it was—more visceral than practical— defined itself and I was able to visualize a strategy. Chance events, of course, determined tactical moves. By mid 1974, I had set up house in Xico, a tiny mountain city deep in coffee country. I was hired by the State University of Veracruz, a few miles away, and started teaching mimeographic, electrostatic, and offset techniques. I also organized an art school press. Then, I found myself involved in one of the labor movements that periodically shake the university and was summarily fired.

Early in 1967, painter Ricardo Rocha invited me to address his students at the old National School of Visual Arts, then known as the

Pages by Ikou Scukuzawa from *The Japanese Schmuck*, Beau Geste Press. Photograph by Lourdes Grobet, 1976. Collection of Felipe Ehrenberg.

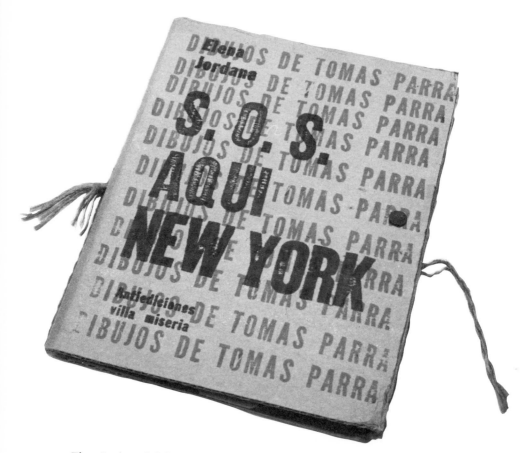

Elena Jordana, *S.O.S. Here in New York* (second edition) n.d., Antiediciones Villa Miseria. Photograph by Lourdes Grobet. Collection of Felipe Ehrenberg.

Academy of San Carlos. I talked to them about the feasibility and need for artists to publish their own books. As an example we produced an assemblage called *El Libro de los 24 Hrs.* (*The 24 Hr. Book*), which consisted mainly of photocopies made on machines in stationary shops. This book, a first of its kind, so fired the students' imagination that they convinced me to demonstrate other publishing techniques. So, disregarding the school's red tape for hiring teachers, I simply occupied a covered patio in the heart of the ancient building and held my first seminar on graphic techniques and, of course, on small press operations. I taught with a hand-made wooden duplicator, or mimeographer which I'd named "Pinocchio." I was a pirate teacher for nearly six

months, traveling to and from Xico weekly, until someone in the administration noticed this activity and shamefacedly asked me to stop such nonsense. But by then the damage had been done: practically every one of my students went on to publish his or her work, very often involving his or her friends in their ventures and spreading the word about presses and mimeography.

Meanwhile I co-founded Grupo Proceso Pentágono, the first of the artists' collectives formed during that decade which shook the Mexican art scene with their radical politics and practices. Our combined efforts legitimized an expanded space for the unorthodox, which included artists' publications.[1] By 1978 I was giving lectures, seminars, and workshops not only to visual artists, mostly younger ones, but also to budding graphic designers studying at various universities, notably the Autonomous Metropolitan University (UAM) where several friends and colleagues taught.

Not long after, I was able to offer a curriculum for a small press workshop to the Ministry of Education and, in association with half a dozen of my former students, I traveled and taught throughout the country. This development confirmed that it is possible for art, for the practice of art, to occupy spaces other than the limited one it has been assigned.[2]

A major problem in Mexico is the exaggerated political, economic, and social centralism, which has characterized the country since independence. For this reason, most of the nation's art—in every field—is still produced and distributed in the capital, forcing artists to migrate

Three books from El Mendrugo/Ediciones Villa Miseria: Ernesto Sabato, *Carta a un joven escritor*, 1975; Nicanor Parra, *Los profesores*, n.d.; Elena Jordana, *S.O.S. Aquí New York*, 1971.

from other cities and settle there. For mainstream art production at least, this centralism is convenient. However, a meager and largely uneducated art market offers no hospitality to innovations, unwilling to risk money on undefined quality. Generally speaking, avant-garde art can only develop under distressingly difficult circumstances: there exists no supporting criticism, so experimentation develops in a vacuum. And there is no funding whatsoever, no enterprising galleries willing to bet on rising talent, no private foundations, no specific government grants, nothing.[3]

For these reasons, universities have traditionally been a refuge for fringe artists and mavericks, who can at least depend on a fixed income, albeit insufficient. But their position within such structures provides a measure of maneuverability, allowing them—depending on their negotiating skills—to publish or exhibit their latest work. These are practically the only institutions which offer a network of alternative spaces for new art forms and practices.

Of the various universities that knowingly sponsor such production, the most important is, undoubtedly, the National Autonomous University of Mexico, the oldest and largest in the country. Some younger, progressive universities in the city and other parts of Mexico and the State Universities of Puebla and Veracruz, also shelter alternative spaces.

An uninformed outsider must first remember that Mexico's art is generated in specific circumstances that differ greatly from those in the U.S. and Europe. The differences include the almost cosmic shock, inherited by one generation from its predecessor, of people invaded by a European nation, which grew into a world power as a result of a bloody and rapacious colonization. The repercussions of this economic and cultural exploitation are so great as to be still discernible throughout the country. This condition is further complicated by continuous pressures imposed on our society by an alien culture and way of life—that of the U.S.—with whom we share one of the largest borders existing between any two countries.

Like our northern neighbor, Mexico has also been a melting pot, fusing the Spanish—who also were a mixed lot—with those indigenous people who conquered and mixed with each other even before this. This process did not end with the Conquest or even after the colonial period; it has continued with successive waves of migrants, some more numerous than others.

Since the fifteenth century, our territory received Christian and Sephardic Spaniards, Catalonians, and Basques, then Turkish and Lebanese Christians, Italians, Chinese, English, and French, a large number of Africans, some Irish, and even a smattering of Germans. The twentieth century has also witnessed the arrival of East and Mid-

European Jews, Republican Spaniards, and lately, a considerable number of nationals from other Latin American countries, notably Colombia, Chile, and Argentina, and now, Central America. Though our language, religion, and national habits remain predominately Spanish, and intermarriage has somewhat homogenized our society, grave racial and class problems persist.

If, after our birth as a nation in 1810, we began our advance towards political and economic independence from Spain, we also began to suffer onslaughts from the U.S., which invaded our territory more than once. The effects of such a turbulent history are reflected, obviously enough, in all our artistic endeavors: chauvinism clashes continuously with isolationism, and efforts towards finding a national identity—doomed to failure by our very pluralism—clash head on with attempts at internalization. Quality statements or judgments regarding our arts are practically impossible to make, since any attempt will be submerged in myriad related considerations.

It's difficult to describe how a few individual actions snowballed into a collective one. I've approached two outstanding participants in these events and asked each to write a text. In the first, Magali Lara describes what we call "visual presses;" in the second, Javier Cadena gives an account of "literary presses." Both exist side by side, converging once in a while, mainly in the area of distribution. It should be noted that visual presses take care of their own production, handmaking their books from beginning to end. Literary presses, on the other hand, seldom manufacture their own products, relying on small printing jobbers to do the work. Our three testimonies, abbreviated as they are, should triangulate information into a suitable introduction to the larger phenomenon.

Felipe Ehrenberg

VISUAL PRESSES

Rather than attempt a detailed study of artists' publications in Mexico, I will simply offer some comments on a few presses whose productions typify developments since the mid-seventies. In 1980 I and members of the staff of *Artes Visuales* magazine organized a book show for Artworks in Venice, California. We intended to offer an overview of work being produced at that time, without delving into the attitudes or motives behind it. The intention of the exhibition was to demonstrate that "a movement" existed.[4] Mostly produced by collectives, the visual publications exhibited indicated a search for alternatives to the dynamics espoused by the highly politicized artists' groups then dominating

Mauricio Sandoval, *Diario Bestiaje*, Editorial La Cocina, 1984.
Photograph by Lourdes Grobet, 1984.

the art scene, while still sharing an unorthodox and independent attitude towards officialdom.[5] Members of the various presses explored different relationships between text and image, and options in graphic languages which could make low-cost, higher speed production possible. The idea of producing multiples was important, but the desire to control production processes and to establish an intimate relationship between the published object and its user was foremost in their considerations.

Between 1977 and 1978, SUMA group presented the first photocopy publications. Mainly interested in urban images, they rescued—not without tinges of nostalgia—all kinds of media imagery, and recycled these in their first productions: books in which a certain narrative character predominates, by means of sequences and the repetition of permutated images. In many later editions made on duplicators by people not familiar with these books, this nostalgia for urban imagery is again found in the repeated use of cheap and discontinued stationery, snap-

shot photography, turn-of-the-century rubber stamps and decals, as well as texts and images taken from old police gazettes and extinct comics.

In 1976, Felipe Ehrenberg taught several courses at the National School of Visual Arts, and he introduced the hand-made wooden mimeographer, better known as "Pinocchio." In a short time his seminars became the principal source of inspiration, know-how and information for the first small artists' presses. Thus SUMA group was born, and two of its members, upon leaving the group, started publishing consistently: Gabriel Macotela, a painter and multi-media artist, founded his Editorial La Cocina (Kitchen Press) and painter Santiago Rebolledo signed his productions Agru-pasión Entre Tierras, an untranslatable title which puns on the words "association" and "passion."

Working with Yani Pecanins and Walter Doehner, Macotela's La Cocina published poetry anthologies and boxed, loose-leaf graphics, all on an old Gestetner mimeograph machine, and soon attracted young artists with various skills. Its first productions relied on text and image, either supporting each other or, at times, independent of each other. This then led to the publication of a haphazard periodical called *Paso de Peatones* (Pedestrian Crossing). At the same time, Pecanins, a visual poet, produced loose-leaf books in very limited editions since these required hard-to-get objects such as strange clothes buttons and

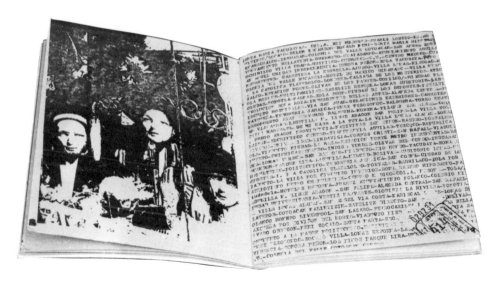

Paso de Peatones (Pedestrian Crossing), an occasional periodical from Editorial La Cocina.

fans, which she pasted into her books. In contrast to the rest of La Cocina's output, Pecanin's work is imbued with a very specific unity, reminiscent of rediscovered love letters, backward glances into a time when tinsel taste was good taste.

For his part, Santiago Rebolledo could well be considered the born chronicler of Anycity. Colombian by birth, he interrupted his trip to New York some eight years ago and stayed in Mexico. People say it was then that his taste was born for the city's anonymous and discarded imagery so prominent in his paintings and bookworks, all of which are characterized by hand-written scrawls that record his personal experience.

Of the visual presses, La Cocina is the oldest. Some of their collaborators have, in turn, formed their own presses. One such case is painter Emilio Carrasco, who moved to the northern city of Zacatecas, where, in association with writer Alberto Huerta, he founded La Rasqueta (The Squeegee). In La Rasqueta's publications we find many similarities to Macotela and Pecanin's work. More important, though, is Carrasco and Huerta's intention to publish the unpublishable. Living in a provincial city as they do, they are aware of the difficulties local artists and poets face in making their work known, so the press's intention is to open distribution channels. Every once in a while they receive modest donations, and they work hard to sell their publications at local fairs and community gatherings. La Rasqueta's inventory consists of a trunkful of basic tools, their "Pinocchios" and stocks of paper discarded by the local university and government offices. They publish a bulletin almost monthly called *Ahí Viene el Rascuache*, which could be translated as "Here Comes Measly." And they encourage people to produce community newsletters and teach them to publish other items which have immediate relevance to their everyday lives.

Small presses continue to proliferate, many of them modeled after the suggested use of "Pinocchio." Outstanding among the more recent ones are La Flor de Otro Día (Another Day's Flower), and Tinta Morada (Purple Ink). As these prosper they also outgrow the handmade, hand-powered wooden duplicators and turn to more sophisticated technology. La Flor de Otro Día's characteristic productions are book-objects very reminiscent—perhaps unwittingly—of the sundry items formerly turned out by neighborhood printers, which have practically disappeared: ingenious calendars, paper-strip movies, tickets, boxes with pop-out figures. Its initiators, Marieliana Moutaner and

Top: Bebopoemas, text by Chac and graphics by Jazzamoart, published by La Flor de Otro Día as a ticket to a concert/show in 1983.
Bottom: One-of-a-kind corn husk book, author unknown, c. 1982.
Photographs by Lourdes Grobet. Collection of Felipe Ehrenberg.

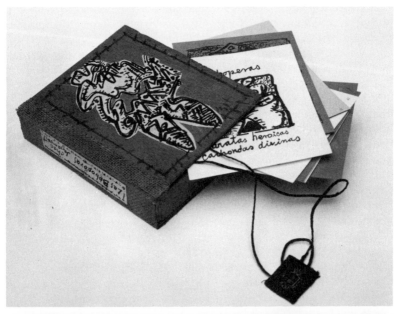

Chac, almost invariably present their latest edition on stage, with jazz accompaniment and happenings. Curiously, many of their productions celebrate national festivities, although in very peculiar ways. Their images are crisp and clear, designed by Chac especially for duplicating, quite different from the business favored by La Cocina or La Rasqueta.

Tinta Morada, by comparison, only publishes magazines, *Lacre* and *Tendedero* (*Sealing Wax* and *Clothesline*). *Lacre* is an artists' assembling printed in editions of 100 copies. *Tendedero* publishes intimate texts—literary lingerie so to speak—works in progress, unfinished texts, and manuscripts full of corrections, all consciously visual and quite nostalgic. *Tendedero* is very much like our childhood notebooks, full of stamped symbols and tinsel stars like those used by our teachers to grade homework. The magazine's cover changes according to the types of stickers the editors might uncover at old stationery shops downtown. They use such materials not so much because they are cheap, but because they try to "rescue feelings and sensations which are disappearing" from common memory.

Another outgrowth of the visual press movement, producing work in this vein, is the one-woman operation called Tres Sirenas (Three Mermaids). Poet Carmen Boullosa became "visual" in order to create books where each book *is* the poem. Boullosa handsets type and operates a small letterpress, a skill she learned at another small press called Martín Pescador (Fisher Martin). Martín Pescador was founded by Juan Pascoe who for several years has been publishing exquisite poetry *plaquettes* in the best letterpress tradition, producing miniscule editions of the finest examples of hand-set type and binding. Tres Sirenas, by comparison with other visual presses, employs finer papers and the books are hand-finished, not for the sake of appearance but for the sake of the poem. Boullosa's concept of the book entails the closest relationships between image and text, a relationship which, according to her, can be neither casual nor divisible.

More recently, small and newly established publishing houses have started to issue the type of artists' books we have discussed above. Editorial Los Talleres brought out an offset and silkscreen book by Lourdes Grobet and myself called *Se escoge el tiempo* (*Time is Chosen*), which consists of texts on photographs; Editorial Penélope published artist Alberto Castro Leñero's *Crónico de Veinte Días* (*20 Days' Chronicle*). And in 1984 the nonprofit printing shop of the National School of Visual Arts, in a project called "Imageries," issued a call for poets and artists to submit proposals for possible publication.

From these notes it might be concluded that we, the visual artists, grant our "yea" to printed matter, at least for the time being.

Magali Lara

De Vírgenes y otras Madres, La Flor de Otro Día, 1983.

LITERARY PRESSES

Mexico has a long history of alternative or marginal publications, but for our purposes here, I will limit myself to comments on three aspects of recent development: the production of books of literary nature (since the field of magazines is so much larger and complex); the production in Mexico City—by which it is not implied other presses don't exist elsewhere, fortunately, or unfortunately, I'm not sure, most are concentrated in the capital city; and the period during the years 1976-1983, because it is during this time that independent publishing achieves what I've termed its "Golden Epoch," mainly due to very specific socio-economic reasons.

In 1539 Imprenta Sevillana (Sevillian Press) set up a branch office in the capital of New Spain in charge of the Spanish master printer, Juan Pablos. Some fifteen years later, Juan Pablos became independent and established himself as the first publisher in the country. Since then Mexico has enjoyed plentiful production of books, magazines, and newspapers. But also, from this time on, their production and distribution have been controlled, in most cases, by a very few powerful publishing houses who've imposed or disposed of trends, tastes, and authors, arbitrarily blocking the way of many, particularly younger writers. They, in turn, have always fought back, managing to open other channels for new styles and setting new trends. In recent times, these instances have been termed "alternative," "independent," or "marginal"—this last being a word in vogue during the rise of the social sciences from the late fifties to the early seventies. They have made themselves heard through magazines, newspapers, and journals, leaflets, pamphlets, and authors' editions.

It wasn't until 1976 that a real movement became consolidated and a spate of small presses created a presence through obstinacy and energy. There starts, then, the "Golden Epoch" of independent publishing. Economically speaking, this period owes its successful development to the "administration" and "distribution" of our oil wealth, all of which—as can be proven by recorded facts—has gone up in smoke. In spite of the fact that at the end of President Luis Echeverría's regime (1970-76) our currency was devalued by almost 100 percent, the discovery and exploitation of bountiful oil resources made it possible to stabilize the cost of certain industries, among them publishing.[6] Thus, in many cases the cost of production per book did not exceed the price of ten or twenty pesos. This, added to the need to publish, encouraged young authors to become their own publishers and to form their own presses.

Presses born between 1976 and 1983 share various common fea-

tures, among which the following stand out: they are born as personal or friends' enterprises; their aim is not profit but simply to make new work known; their founders share the ostracism imposed on them by established publishing houses; they function as outlets for young authors and, in most cases, it is those very authors and their friends who create the presses; most print only poetry, short stories, and, very seldom, short novels or novelettes; their editions are small, 1,000 copies at most; in most instances, authors finance and supervise their productions; authors/publishers distribute their own books with a little help from their friends. This is mainly because ninety nine percent of the bookstores refuse to handle their books since they see no possible profit; a few make an exception and some presses find space in places like Ghandi, El Parnaso, El Agora, and the small bookstore in the lobby of the Palace of Fine Arts; recently Marginalia, dedicated exclusively to distributing this sort of material, opened at the University Museum of El Chopo. All too often the texts they publish are low quality since most are produced by novice writers beginning their search for a personal language and a style; in some instances, authors set up a marginal press or are published in order to acquire a name for themselves and then move into the larger publishing houses; and, finally, most never register and so pay no taxes.

I've made a selection, perhaps arbitrary, of the presses which could be considered most representative of the period I'm discussing. La Máquina Eléctrica (The Electric Machine) was, undoubtedly, the first to emerge. This press signaled the beginning of the "Golden Epoch." Its founder, poet Raúl Renán, says of its birth: "In 1976 a group of poet friends of mine and I met at the Alto café, on Insurgentes Avenue ... [and] between sips of fine coffee we realized that we all had enough material to publish one more book each ... so we decided then to form our own press, a manual one, domestic in character, where most of the material would be processed by our own hands, using cheap materials and relying on the mimeographer."

La Máquina de Escribir (The Typewriter) started in 1977. It has published nearly fifty titles, though at the time of this writing it hasn't produced for several months. On why it was begun and how it functions, Carlos Chímal, one of its founding members, says: "La Máquina was born for us friends to enjoy each other, to give each other our texts. ... Later on, more and more people started approaching us who wanted to publish, so we formed a selection committee made up of authors who had published with us." La Máquina de Escribir manages distribution mostly by post or by hand, and they were able to build a mailing list of "Friends of the Typewriter" which included people in Europe, Japan, and the rest of the Americas; that is, it was a marginal press on an international level.

Liberta-Sumaria was formed in 1979. One founding member, Alfonso López, explains, "We felt the need to open alternative accesses for new authors. Our intention always was to publish poetry. We never sought profits and survived thanks to the dues we all provided and to some sales which we usually made ourselves." Liberta-Sumaria survived until 1981, though still, in March of 1983, it managed to publish a bilingual anthology of North American poets edited by Isabel Fraire, called *Pandora's Box*.

Editorial Penélope was conceived by poet Eduardo Hurtado, later joined by Ilya and Yuri de Gortari, who provided some capital. "The press was born," says Yuri, "to publish the good things bigger publishers turn down." At the time of this writing, Penélope is the largest of the small presses and has its own workshops. It has published nearly twenty titles. It is also the only marginal press to have made a serious attempt to handle both production and distribution, by forming Unicornio, a distribution concern started in 1981, marketing not only their books but those of other presses, such as Amate, Los 4 Jinetes, and Mester, among others.

Letra (Letter) initially started out as a magazine, in 1979, and shortly thereafter became a press, with three books out to date. One of its editors, Arnulfo Rubio, tells us: "The magazine was started with the intention of combining texts and visuals."

El Segundo Piso (Second Story), like Letra, began as a magazine in 1981 but soon started publishing books. One of the first, *To Whom It May Concern*, by Arturo Trejo, was co-produced with Letra.

Sáinz-Luiselli was established by writers Gustavo Sáinz, Alexandra Luiselli, and Gerardo María. "Our aim," says María, "is to publish texts by Chicanos, Mexican migrant workers, and Latin American exiles living in the U.S. We attempt to unite them so as to unite us too." Their first published book, by a Chilean writer Juan Villegas, is called *The President's Visit*.

The presses listed above, are not the only ones operating, nor are they necessarily the best. Others which might be included are, for example, Prometeo Libre (Prometheus Unbound), Virginia's Toucan, Luzbel, Mester, Word and Voice, Amate, The Four Riders, Signs, Pamphlet and Pantomime, and the Federation of Mexican Publishers: the later publishes a promising arts magazine called *La Regla Rota* (The Broken Rule). But they do characterize the boom and, have paved the way for a new generation of new talents.

Every period of success tends to end. Our thriving marginal presses are now threatened by many factors, foremost among them economic ones. In February of 1982 our currency suffered a new devaluation. Inflation has blown costs sky high, and our years of prosperity are past. Now, unfairly fixed wages and a stratospheric foreign debt make it

practically impossible for anyone to make ends meet, let alone plan on setting up new presses.

Javier Cadena

AN AFTERWORD

Socio-economics notwithstanding, the independent press boom, or "Golden Epoch," shows no sign of waning. On the contrary, there are many indications that after bubbling about for nearly a decade, it will come to a good boil. On the evening of the twenty ninth of February 1984, painter Arnold Belkin, the recently appointed director of the University Museum of El Chopo, invited me to draw the velvet curtain covering a small plaque. Bulbs flashed and cameras whirred and we proceeded to inaugurate a miniscule bookshop located at the base of one of the two cast-iron pillars that flank the entrance to this contemporary art museum. The shop is Marginalia, and it is the first space ever in Mexico dedicated exclusively to the distribution of small press editions. It is being ably managed by Javier Cadena. That same evening, a small exhibit also opened, titled "Palabrartes y Librobras," two neologisms which, roughly translated mean "artwords" and "bookworks."[8] Nearly simultaneously, on March eighth, another exhibition opened at the other end of the city, at the National School of Visual Arts (ENAP), like the museum, a part of the UAM. This show, titled "Alternative Presses," was organized by Magali Lara and presented the almost complete production of six of the most enterprising visual presses in Mexico City.

Both openings mark what is, in my opinion, a very important moment in the development of independent art production in Mexico. They are no less than the culmination of a sustained effort by book artists and small press publishers to legitimize our work, expand the field of our contemporary arts, and face the politics of our moment.

Felipe Ehrenberg

NOTES

1. See *Expediente Bienal X* (Tenth Biennial File) (Mexico: Editorial Libro Acción Libre/Beau Geste Press, 1980).
2. See "Art Is an Excuse: An Interview with Felipe Ehrenberg," by Martha Gever. *Afterimage* Vol. 10, No. 9 (April 1983).
3. State "sponsorship" of the arts should be liberally interpreted. It is indirect and no grant program of any sort exists. An isolated exception was in 1979, when the National Institute of Fine Arts held a First Experimental Salon at the National Auditorium and financed eleven proposals. See catalogue for *Salón Nacional de Artes Plásticas* (Mexico: Sección Anual de Experimentación, INBA, 1979).
4. *Artes Visuales* was the house organ of the Museum of Modern Art of Mexico. See Nos. 27/28 (January-March 1981).
5. See catalogue for *Exposición Arte/Luchas Populares en Mexico* (Mexico: Museo Universitario de Ciencias y Artes, UNAM, 1980).
6. The Mexican peso fell from 12.50 to 24.00 per U.S. dollar.
7. *Plural*, a monthly literary magazine published by the *Excelsior* newspaper consortium, was started by poet Octavio Paz, who subsequently resigned for political reasons and went on to publish *Vuelta*, another literary magazine.
8. "Artwords and Bookworks" was a phrase, used by Judith Hoffberg and Joan Hugo in 1978, as the name of a large artists' books exhibition they curated at the Los Angeles Institute of Contemporary Arts.

Expediente: Bienal X. Editorial Libro Acción Libre/Beau Geste Press, 1980.

BIBLIOGRAPHY—BOOKS BY ARTISTS

Chac, with graphics by Jazzamoart. *Bebopoemas*. La Flor de Otro Día, 1983.

Chac, Eliana Montaner, Lourdes Grobet, and Patricia Mendoza. *De Virgenes y otras Madres*. Coyoacan, Mexico: La Flor de Otro Día, 1983.

Ehrenberg, Felipe and students. *El Libro de los 24 Hrs.* Mexico: Academy of San Carlos, 1976.

Grobet, Lourdes and Magali Lara. *Se escoge el tiempo*. Mexico, Editorial Los Talleres, n.d.

Jordana, Elena. *S.O.S. Aquí New York*. New York: El Mendrugo/Ediciones Villa Miseria, 1971.

Jordana, Elena. *S.O.S. Aquí New York* (second edition) n.p.: Antiediciones Villa Miseria, n.d.

Lenero, Alberto Castro. *Crónico de Veinte Días*. Mexico: Editorial Penélope, n.d.

Parra, Nicanor. *Los profesores*. n.p.: El Mendrugo/Ediciones Villa Miseria, n.d.

Sabato, Ernesto. *Carta a un joven escritor*. Argentina: El Mendrugo/Ediciones Villa Miseria, 1975.

Sandoval. *Diario Bestiaje*. Mexico: Editorial La Cocina, 1984.

Trejo, Arturo. *To Whom it May Concern*. Mexico: El Segundo Piso/Letra, n.d.

Villegas, Juan. *The President's Visit*. Mexico: Sáinz-Luiselli, n.d.

Expediente: Bienal X: La historia documentada de un complot frustrado. Mexico: Editorial Libro Acción Libre/Beau Geste Press, 1980.

The Hungarian Schmuck. Beau Geste Press, 1973.

The Japanese Schmuck. London: Beau Geste Press, 1976.

Paso de Peatones. Mexico: Editorial La Cocina, 1978.

La Regala Rota (an arts magazine). Mexico: Federation of Mexican Publishers.

Walker Evans, *American Photographs*, 1938.

Photobookworks:
the Critical Realist Tradition

by Alex Sweetman

THE PHOTOGRAPHIC SERIES is an expressive device. The photographer/editor must come to terms with the difficulties and possibilities of visual communication; the deliberate articulation of the relationships between images, the attitude that informs the photographs with a consistency and point of view. All this in order to widen and deepen the channels of emotional and experiential discourse.

Photobookworks are a function of the inter-relation between two factors: the power of the single photograph and the effect of serial arrangements in book form. Such arrangements may be viewed as worlds which the individual photographs inhabit and, therefore, as their context. Individual pictures may act as expressive images and/or as information; combinations of these can produce series, sequences, juxtapositions, rhythms, and recurring themes.

The photobookwork, then, is a series of images—that is, a tightly knit, well-edited, organized group or set of images in a linear sequence presented in book form. Linearity is important because it gives the imagery its temporal quality. Events occur, stories unfold, things are shown and said; through the progression of the construct, we view the conditions of being in the world, the flow of time as experience.

In the nineteenth century book form and culture changed dramatically as photographs, first pasted onto pages, came to be printed in ink together with texts. This development set in motion a process of immense significance: the mechanical reproduction of any aspect of appearance allowed the miniaturization or enlargement of the visible world. When photographs began to appear next to each other on the same page or on adjoining pages a new benchmark in the evolution of seeing and thinking had arrived. This, in turn, prepared the ground for new possibilities and conditions for explorations in visual language.

The cumulative impact and elaboration of the page as frame for the display of photographs eventually altered concepts of the page and of photography. A history of the page (and the double-page spread) as a framing device for displaying and interpreting pictures becomes the history of a category of space which encompasses everything from illogical coincidences to strictly determined relations. As more active groupings and arrangements, more aggressive and intelligent layout and design altered relations between and among pictures, accepted conventions disintegrated. Relativism replaced totality as a guiding principle, describing a multiplicity of traditions, cultures, and values where previously there had been only one tradition, one culture. Mona Lisa grew a moustache.

By the 1920s the photograph as well as the context in which it appeared were both recognized as crucial to the interpretation, the reading of the picture. It was noted that a shift in context or caption altered the meaning of the photograph. And it is precisely this manipulation of meanings that characterizes a distinctly modern attitude towards the use of photographs.

> There is no more surprising, yet, in its naturalness and organic sequence, simpler form than the photographic series. This is the logical culmination of photography. The series is no longer a "picture," and none of the canons of pictorial aesthetics can be applied to it. Here the separate picture loses its identity as such and becomes a detail of assembly, an essential structural element of the whole which is the thing itself. In this concatenation of its separate but inseparable parts a photographic series inspired by a definite purpose can become at once the most potent weapon and the tenderest lyric. The true significance of the film will only appear in a much later, less confused and groping age than ours. The prerequisite for this revelation is, of course, the realization that a knowledge of photography is just as important as that of the alphabet. The illiterate of the future will be ignorant of the use of the camera and pen alike.
>
> —László Moholy-Nagy[1]

One of the first important demonstrations of a truly modern attitude towards photographs can be found in the picture section of László Moholy-Nagy's *Painting, Photography, Film*. This visual display is presented as supporting evidence, the proof that his didactic arguments are true. The sequence is rough and at times naive, but soon more books appeared that used photographs as the key to modernity. *Es Kommt der neur Fotograf!*, by Werner Gräff, is a product of the New Vision, the New Objectivity, the New Realism, the *neue sachlikeit,*

which Moholy-Nagy helped formulate. As evidenced on the pages of this and other photobooks published during the 1920s, new graphic techniques and film montage had had an impact. The best photobook from this period was done as a catalogue for exhibitions of film and photography sponsored by the Deutche Werkbund in 1929: *Photo-Eye,* by art critic Franz Roh and designer Jan Tschichold. The design for *Photo-Eye* was premised on the assumption that while we see things in relation to each other—particularly when pictures are joined on a page or paired across facing pages, or when one picture follows another, as in a film, we do not, and indeed cannot forget the picture we have just looked at. This type of visual comparison is a basic technique in the wave of visual invention that swept through the publications of the 1920s.

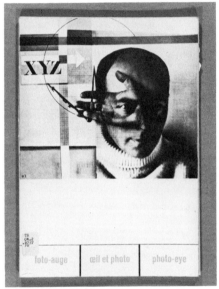

Photo Eye, edited by Franz Roh and Jan Tschichold, 1929.

In an early article on photobooks published in *The Complete Photographer,* Elizabeth McCausland discusses twenty two books produced between 1925 and 1942. McCausland, a journalist with a searching interest in photography, felt compelled to comment on the phenomenon in which she was both a witness and a participant.

The problem of form for photographic books involves this concept of photography as a second language of communication and of the harmonious union of verbal language and of the photo-

graphic pictorial second language to make a single expressive statement.[2]

Most of the books described in McCausland's article cited above can be called social documentary or documentary photobooks, many modeled on documentary films from the same period. Many of these publications were influenced by graphic design innovations originating in Europe and transmitted to America by emigrés. The new look sponsored by the New Vision became internationalized, apparent and prevalent in illustrated magazines and advertising of all sorts. The *U.S.S.R. under construction*, for example, distinctly resembles the more innovative pages of *Fortune*, but without advertising.

Since McCausland's article is one of the first on photography of the period, her conclusions are worth noting. Although she does not mention *Photo-Eye*, she singles out *Es kommt der neue Fotograf!* as a real union of two media, words and pictures. Eugene Atget's work, poorly reproduced in *Atget Photographe de Paris* "tell their own story." Evans's books are "an awkward arrangement" (*American Photographs*) and "a somewhat unusual arrangement" (*Let Us Now Praise Famous Men*). Richard Wright's *12 Million Black Voices* uses Farm Security Administration photos, edited by Edwin Rosskam, "like a movie."[3] Thus, even though most of these photobooks employ extensive texts they lead us in the direction of the purely visual and discursive use of photographs, constituting what I call a photobookwork.

Walker Evans noted that the decade of the thirties was the time for photobookworks, and he produced several outstanding examples. *American Photographs* remains an enduring response to the American culture of that period: "An epoch so crass and so corrupt," commented Lincoln Kirstein, "that the only purity of the ordinary individual is unconscious."[4] Evans's book has little text, except for lists of titles at the end of each of the two picture sections, and an essay by Kirstein who writes:

> Physically the pictures in the book exist as single separate prints. They lack the obvious continuity of the moving image picture, which by its physical nature compels the observer to perceive a series of images as parts of a whole. But these photographs, of necessity seen singly, are not conceived as isolated pictures made by the camera turned indiscriminately here or there. In intention and in effect they exist as a collection of statements deriving from and presenting a consistent attitude. Looked at in sequence they are overwhelming in their exhaustiveness of detail, their poetry of contrast, and for those who want to see it, their moral implication. Walker Evans gives us the contemporary civilization of Eastern America and its dependencies as Atget gave us Paris before the

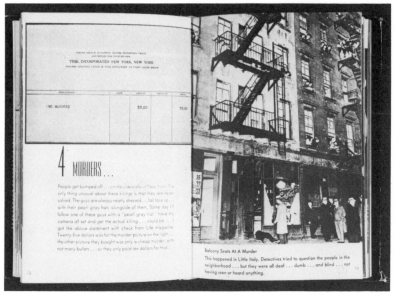

Weegee, *Naked City*, 1945.

war and as Brady gave us the war between the states.[5]

In *American Photographs* the potential for a photobookwork was articulated.

Evans's aesthetic is reflected in his enthusiasm for the book form and for the print which does not call attention to itself as a singular art object. His vision and social iconography typify prevailing definitions of documentary photography. But more importantly, this aesthetic was a response to the inherent reproducibility of photographs, which entails the concept of photographs as transparent representations, as visual statements. Thus, mechanical reproduction was identified as one aspect of critical realist work and aesthetics.

McCausland's standards for the photobook were fulfilled by another photographer working during the depression and after: the photojournalist Weegee. His books, *Naked City* and *Weegee's People*, are among the most exuberant examples of popular camera journalism. The blend of innocence and cynicism, the brilliant, seemingly omnipresent, even psychic camera work is exemplary of the thirties ideal of a full integration of words and pictures, accessible to a broad, semiliterate audience. One needs no more sophistication than the average reader of comics to get Weegee's message.

Equally successful realizations of depression era realist aesthetics, re-

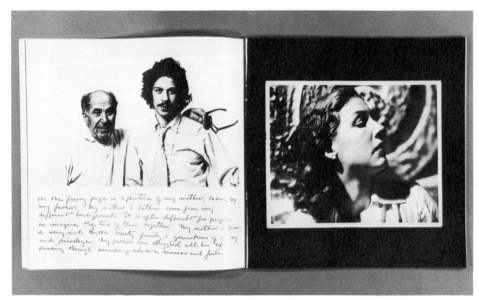

Danny Seymour, *A Loud Song*, 1971.

lated no doubt to the addition of sound to the motion picture, are Paul Strand's books. Beginning in 1950 with *Time in New England*, Strand's book publishing career spans decades. His books are elegant presentations of documentary-style photographs which employ a variety of strategies to link language and pictures. These works foreshadow a plethora of publications in which social documentary photographs joined the vast literature of travel photography, a branch of camera journalism. Structurally, Strand's work succeeds as a method for presenting photographs in book form because of his keen sense of how to balance and present pairs of pictures—particularly in his use of more abstract, often close-up details of walls or other flat surfaces on one page opposite a more "realistic" "human interest" shot, such as a portrait or group photograph.

This editorial strategy reappears with force in the 1970s, notably in Ralph Gibson's trilogy, *The Somnambulist, Deja-Vu,* and *Days at Sea,* particularly in *Deja-Vu*. In this work, the author seems so proud of his editorial achievements that he appears on the back cover taking a handstand while wearing nothing but a bathing suit and a top hat. The accomplishment which prompted the boast is simply the astute pairing of pictures in the manner of Strand, stressing the subtle psychological and/or formal connections between diverse types of subjects. Gibson's Lustrum Press produced some of the most original photobookworks of

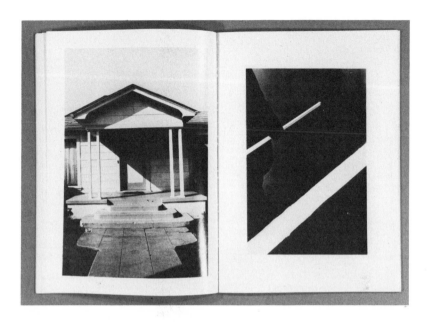

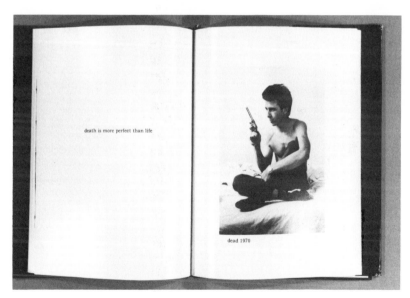

Top: Ralph Gibson, *Deja-Vu*, 1973.
Bottom: Larry Clark, *Tulsa*, 1971.

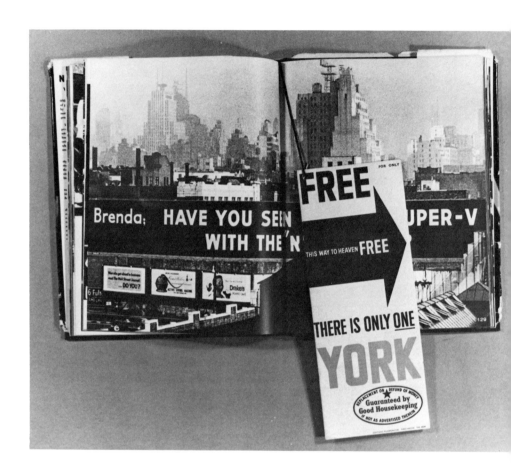

William Klein, *New York*, 1956.

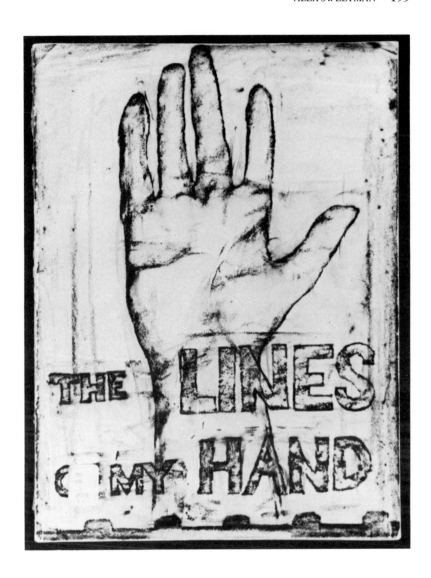

Robert Frank, *The Lines of My Hand*, 1972.

the seventies, including Larry Clark's *Tulsa*, Danny Seymour's *A Loud Song*, Neal Slavin's *Portugal*, and *Dark Light* by Michael Martone.

Many excellent books were also self-published during the seventies including *Self Portrait*, Lee Friedlander's ironic portrayal of himself as a shadow or reflected fragment in the urban environment, and *Meta Photographs* by Richard Gordon, which explores that peculiar form of picture and picturing called photography. The cover photograph is a sign that reads: "TV'S CAMERAS GUNS": tools we use to lay claim to and dominate the world; tools we use to define ourselves and our world.

Like Strand, William Klein, who authored one of the most unusual publications of the 1950s, was also involved in filmmaking—a fact which can be perceived in his incorporation of photographs in book form. Klein, originally a painter, left his hometown, New York City, for Paris after World War II. Armed with an iconoclastic avant-garde freedom, he later returned to the U.S. and proceeded to produce an anthropological collection of photographs, which he then took back to France. But his *New York* was a parody of the typical travel book, presented as a comic strip contact sheet in harsh, often high-contrast, blurry, grainy photographs. The aggressive density, complexity, and intensity of the pictures and their layout mirrors the surreality of the urban chaos Klein found in his native land. The book was published in Italy, France, and Great Britain, though never in the U.S., which may explain why Klein is better known in Europe.

A separate pamphlet included with the book is superimposed with a large arrow; it boldly announces, "This way to heaven." Inside the book, we read, "Life is good and good for you in New York." But pop parody of the hype of commercial tourism and travel books is only introductory. The subtitle, "Trance Witness Revels," prepares us for a voyage through a cross-section of reality. Chapters titled: Album de Famille, Merry Christmas, Inhale Exhale, Gun, Extase, ?, and Paysage, suggest a very different sort of trip than that usually offered by travel books—a visual journey of an emigré. The book ends with what appears to be airbursts of a nuclear weapon over Manhattan seen from a luxury apartment building, a comfortable disaster. One French critic responded, "You have to seek for precedent in the novel, the film, or the nightmare—there has never been a book like it."[6]

The photographer's testimony in *New York*, the revelations of the "Trance Witness," are diametrically opposed to those in the contemporary "Family of Man" exhibition organized by Edward Steichen at the Museum of Modern Art. In the 1955 exhibit and the book of the same title, ahistorical and photogenic accounts of our common humanity appear wholesome and cheerful compared with the raw, violent, surreal, expressionistic, and aggressive *New York*. The ideology of the "Family of Man" is as much one of Klein's targets as is the classical, restrained

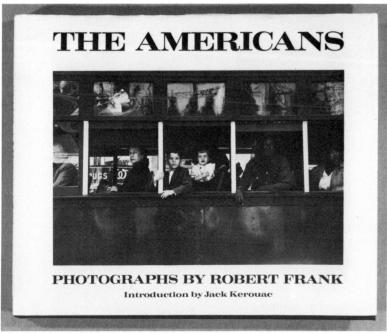

Robert Frank, *The Americans*, 1959.

style of Henri Cartier-Bresson's photography books.

Another early and influential figure in the movement of hand-camera workers opposed to technique for its own sake was Alexy Brodovitch. His book *Ballet* was described by his protege, Irving Penn, as one of the most important photography books ever published because it "spat in the face of technique and pointed out a new way in which photographers could work." In the same article his book was said to prove that "you can make an exciting book out of terrible pictures."[7] These high-contrast, blurry images were creations, not records. And Brodovitch spoke to a generation of photographers, among them Robert Frank.

In the project which became *The Americans*, Frank set out to make what he called a "contemporary document." His discontented vision of violence, ugliness, and a horrible blankness was political and antagonistic, and for this he was savaged by critics.[8] But a few years later *The Americans* became a touchstone for a generation in revolt, a counter-culture classic. If Walker Evans's work undercut official reality by showing the repressed real of the street, the ordinary look that typifies the American scene, Frank's work was more aggressive and subjective,

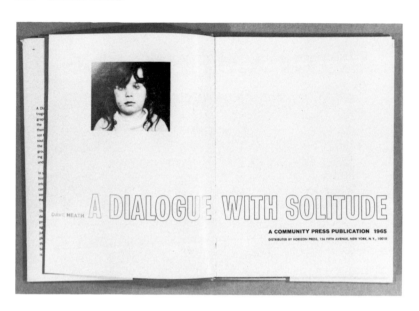

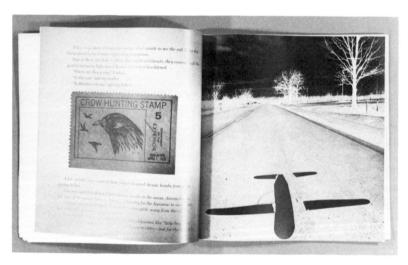

Top: David Heath, *A Dialogue With Solitude*, 1965.
Bottom: Gaylord Herron, *Vagabond*, 1975.

more clearly hostile to official reality, more openly challenging the status quo.

The repetition of cultural icons: flags, juke boxes, blank faces that look like masks, and images of death—plays an important part in Frank's statement. More important, however, is his use of contrast and juxtaposition to present oppositional pairs: young/old, white/black, powerful/powerless, etc. On the subject of this book, John Szarkowski wrote, "It was not the nominal subject matter of Frank's work that shocked the photography audience, but the pictures themselves, the true content of which cannot be described in terms of iconography, since it also concerns a new method of photographic description, designed to respond to experience that is kaleidoscopic, fragmentary, intuitive, and elliptical."[9]

The Americans was originally published in France by Frank's friend Robert Delpiere, with an anti-American text quoting prominent authors. A year later the avant-garde Grove Press brought out a U.S. edition; the French text was dropped. Another of Frank's friends, Jack Kerouac, wrote an introduction that has been reprinted in all subsequent editions of the book.

Frank's "new method of photographic description" was critical, political, and an original anti-American reading of American culture. But it was also a book addressed to the culture of the book, taking its place alongside others, in the classic photobook tradition.

In 1965 Dave Heath published *A Dialogue With Solitude*, a book which contained the existential and expressionistic despair of Frank's work and included, as text, quotations from great modern poets. Ed van der Elsken's stark, high contrast, surreal voyage, *Sweet Life*, appeared the following year. This entirely visual book uses single large images, or pairs of images, to depict a bizarre, erotic, and cruel world of the family of man. One of the more singular photo-essays of the 1950s, *Love on the Left Bank*, by the same author, describes in a fictional narrative, using pictures and text, the sexual liberation of the romantic life of beats, poet, painters, jazz musicians, and emigrés living in Paris during the McCarthy era. In *The Sweet Flypaper of Life*, another photo/text exposition of a real-life situation, the quiet and simple story of a grandmother in Harlem is told in an exquisite use of words and pictures. The book is a collaboration between the photographer, Roy DeCarava, and the writer, Langston Hughes.

Frank's second book, *The Lines of My Hand*, is an autobiographical work which, by means of a dense display of multiple imagery, provides an explanation and contextualization for his photographs. In its format it breaks from the one-picture-per-page layout of *The Americans*, resembling more than anything else a personal scrapbook or family album. This scrapbook/album was perfectly adapted to the expres-

sionism and pessimism of a post-war generation of photographers who adopted its confessional, subjective mode.

Since the 1840s photo albums have taken many forms and existed as both physical and conceptual objects, the largest number being the familiar store-bought snapshot album—the "*Grand Album Ordinaire*," as Dave Heath titled his slide-tape show which dealt with such material. This book of life, the receptacle for the snapshot, is a modern democratic vernacular, a folk art: albums have replaced the family Bible as a source of meaning and social cohesiveness.

Boyhood Photos of J. H. Lartigue: The Family Album of the Guilded Age was a signal publication. Tipped in photos, italic captions, and simulated leather binding made this cheerful and nostalgic look at a doomed epoch into an exemplary publication. Here the personal album joins public memory to become a history of a period. *Vagabond*, Gaylord Herron's monumental autobiography, is perhaps the only album-style publication to approach the exuberence of Lartigue's, but in a peculiarly American crazy sort of way. Walker Evans's *Many Are Called* is a completely different kind of album, in which eighty nine photographs of people in the subway, seen one after the other, remind us of nothing so much as the repetition of faces in the family album. Ralph Eugene Meatyard addressed this phenomenon in *The Family Album of Lucybelle Crater*, where the same masks appear in each of the sixty four photographs. Marcia Resnick's witty, erotic, and semi-autobiographical album *Re-visions* uses photographs and captions to allude to the experiences of a girl child passing into womanhood.

Albums of another sort are also the prototypes for many of the photobooks published in the last two decades, a period which has produced a flood of monographs, travelogues, inventories, histories, exhibition catalogues, and so forth. These are, for the most part, not far removed from the albums of the last century compiled by an energetic and wealthy middle class. Lee Friedlander's *The American Monument* is a good example of the type of nineteenth-century album characterized as a "collection." It is different from the collections of Sol LeWitt or Ed Ruscha, for instance, because it is not literal and makes good use of various camera strategies to elaborate the theme of American monuments. Friedlander's photographs are like the brilliant *etudes* composed by the masters to exercise the fingers, to display virtuosity. The book is constructed as a portfolio—a large portfolio—and it resembles a ledger with canvas covers and a screw post binding. The suggestion of a ledger and the implications of record-keeping is appropriate for the kind of accounting procedure we make going through the book. While it clearly does not include every monument, it seems as though we have a comprehensive grouping, and perhaps many more than we might want to see.

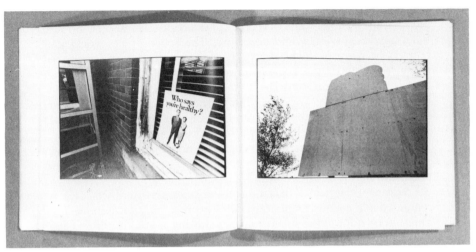

Nathan Lyons, *Notations In Passing*, 1974.

The reader might expect any essay on photobooks to mention *The Decisive Moment* and *The Europeans* by Cartier-Bresson, as well as books by Irving Penn, Richard Avedon, and Edward Steichen—surely the most sought after photobooks of the twentieth century—but these elegant presentations of photographs fall short of being bookworks. The art here is the single image, not the expressive action of the whole. And this is true of the bulk of photography books, monographs, and exhibition catalogues which remain merely collections—portfolios between covers.

I will conclude this excursion into photobookworks with a discussion of Nathan Lyons's *Notations In Passing*. This book was born from the critical realist tradition, and, like most of the books considered here, it takes as its subject American life, time, and place. The book begins with a photograph of an Indian rock carving depicting the arrival of the white man and concludes with a monstrous totem of a parent monster giving birth to a child monster and simultaneously wrenching its face into a happy face, made all the more grotesque by the absurd distortion caused by the exertion. In between there is an inventory and exploration of the facts of our era, and especially the visual languages we use and which use us. Nowhere is it more evident that the world is full of images waiting to be read.

Notations In Passing proceeds in pairs of pictures and groups of pairs which usually begin and end with single images adjoining a blank page. In its image progression, the book represents knowledge—that is, the activity of achieving consciousness as a process "visualized" in dialogue

with socially constructed reality. The primary language here is that of pictures and various kinds of visible constructions, like shop windows, buildings, monuments, and sculpture. The space of the world presented, the space of the book, is the familiar, uniform, cohesive social space from which there is no escape, either into nature or self. A moralist disenchanted with the insane course of official culture, Lyons invites this culture to appear within the network of relations between signifying objects, pictures, environments. This photobookwork mines codes of legibility, systems of representation of all kinds. It uses intellectualized, recondite pictures to comprehend the invisible, intangible, seamlessness of the immediate environment. The work is didactic and open, and fulfills one possibility for visual language.

To say anything which deviates from the messages of official culture contained and carried by photographs one must inflect their meaning. This may be done in the single image by shifting toward the more autographic types of visual art, by diminishing its realism. Another way of dislocating or preventing the readings of the official culture is to use pictures differently, to inflect them by altering the context in which they are seen and by extension, interpreted. Ansel Adams's superrealism and Aaron Siskind's abstraction are examples of the former. Books by Evans, Frank, Klein, and Lyons are examples of the latter.

In a photobookwork, the relations between images may be either systematic or suggestive of system. They may be literal, poetic, public, personal, concrete, abstract, idiosyncratic, obscure, or transparent. I have no doubt that the types of relations formed by linking disparate photographs into a singular and complex array in book form, or as any other time-based art, is one of the most distinctive functions and features of the photographic medium. Spatially, the relationship of image to image on a page is important because the positioning of elements within a display is potentially a linguistic operation in which position becomes a signifier. The complementary aspect of temporality is of even greater importance in relation to the phenomenon of the photobookwork and the historical development of vision.

As structure, a photographic series may be understood as a means of encoding a message, of guiding and controlling associations as well as a method for systematically inducing relations among pictures. Repeated elements within a series may be simple or complex informationally, they may become symbols or metaphors, or perhaps just props or traces of memories, dreams, sensations, emotions. If our concern is with an individual's experience or our own, the impalpable, poetic, and perhaps illogical nature of the totality of experience should be admitted as a starting point, together with the acknowledgement of the difficulty of any single or singular revelation of this totality.

The photobookwork which takes as its subject our lives and times

describes a place which is multiple, pervasive, and extensive, a space that rolls up and unrolls time. The best are social, critical, didactic, and significant.

Paul Strand, *Time in New England*, 1950.

NOTES

1. László Moholy-Nagy, "From Pigment to Light," in *Photographers on Photography*, Nathan Lyons, ed. (Princeton, N.J.: Prentice-Hall, 1966), p. 80.
2. Elizabeth McCausland, "Photographic Books." *The Complete Photographer*, Issue No. 43, Vol. 8 (Nov. 20, 1942), p. 2783.
3. *Ibid.*, p. 2783.
4. Lincoln Kirstein, essay in Walker Evans, *American Photographs*. (New York: The Museum of Modern Art, 1938), p. 194.
5. *Ibid.*
6. Chris Marker, quoted on the dustjacket for William Klein, *New York* (London: Photography Magazine, no date).
7. Charles Reynolds, "Focus on Alexey Brodovitch," *Popular Photography*, Vol. 49, No. 6 (December 1961), p. 81.
8. See "An Off-Beat View of the U.S.A.," reviews by Bruce Downes, Les Barry, John Durniak, Arthur Goldsmith, H. M. Kinzer, Charles Reynolds, and James Z. Zanutto, *Popular Photography*, Vol. 46, No. 5 (May 1960), pp. 104-106.
9. John Szarkowski, *Mirrors and Windows*. (New York: The Museum of Modern Art, 1978), p. 20.

BIBLIOGRAPHY—BOOKS BY ARTISTS

Atget, Eugene. *Photographe de Paris*. New York: Weyhe, 1930.

Bresson, Henri-Cartier. *The Decisive Moment*. New York: Simon and Schuster, 1952.

Bresson, Henri-Cartier. *The Europeans*. New York: Simon and Schuster, 1955.

Brodovitch, Alexey. *Ballet* (Text by Edwin Denby). New York: J.J. Augustin, no date.

Clark, Larry. *Tulsa*. Los Angeles: Lustrum Press, 1971.

DeCarava, Roy and Langston Hughes. *The Sweet Flypaper of Life*. New York: Simon and Schuster, 1955.

van der Elsken, Ed. *Love on the Left Bank*. Harlem, Netherlands: Andre Deutsche, 1956.

van der Elsken, Ed. *Sweet Life*. New York: Abrams, 1966.

Evans, Walker. *American Photographs* (essay by Lincoln Kirstein). New York: MOMA, 1938.

Evans, Walker and James Agee. *Let Us Now Praise Famous Men*. Boston: Houghton Mifflin Co., 1941.

Evans, Walker. *Many Are Called* (introduction by Jame Agee). Boston: Houghton Mifflin Co., 1966.

Frank, Robert. *Les Americans* (text by Alain Bosquet). Paris: Delpiere, 1958.

Frank, Robert. *The Americans* (text by Jack Kerouac). New York: Grove Press, 1959.

Frank, Robert. *The Lines of My Hand*. Tokyo: Yugensha, 1972.

Frank, Robert. *The Lines of My Hand*. New York: Lustrum Press, 1972.

Friedlander, Lee. *The American Monument* (essay by Leslie George Katz). New York: Eakins, 1976.

Friedlander, Lee. *Self Portrait*. New City, New York: Haywire Press, 1970.

Gibson, Ralph. *Days at Sea*. New York: Lustrum Press, 1974.

Gibson, Ralph. *Deja-Vu*. Los Angeles: Lustrum Press, 1973.

Gibson, Ralph. *The Somnambulist*. Los Angeles: Lustrum Press, 1970.

Gordon, Richard. *Meta Photographs* (afterword by Alex Sweetman). Chicago: Chimera Press, 1978.

Graff, Werner. *Es Kommt der neue Fotograf!* Berlin, 1929.

Griffiths, Phillip Jones. *Vietnam, Inc.* New York: Macmillan, 1971.

Heath, David. *A Dialogue With Solitude.* Culpepper, Virginia: a Community Press Publication, 1965.

Herron, Gaylord. *Vagabond.* Tulsa: Penumbra Projects, 1975.

Klein, William. *New York.* London: Photography Magazine, 1956.

Lartigue, J.H. *Boyhood Photographs of J.H. Lartigue, The Family Album of a Guilded Age.* Switzerland: Ami Guichard, 1966.

Lyon, Danny. *The Bikeriders.* New York: Macmillan, 1968.

Lyon, Danny. *Conversations with the Dead: Photographs of Prison Life with the Letters and Drawings of Billy McCune #122054.* New York: Holt, Rinehart and Winston, 1971.

Lyons, Nathan. *Notations In Passing,* Cambridge, Massachusetts: MIT Press, 1974.

Meatyard, Ralph Eugene. *The Family Album of Lucybelle Crater.* North Carolina: The Jargon Society, 1974.

Moholy-Nagy, László. *Painting, Photography, Film.* Cambridge, Massachusetts: MIT Press, 1969. (Translation of *Malerei, Photografie, Film* which originally appeared as volume 8 in the *Bauhausbucher* series in 1925.)

Photo-Eye. (edited by Franz Roh and Jan Tschichold), Tubingen, Germany: verlag Ernst Wasmuth, 1973. (reprint of the 1929 edition).

Resnick, Marcia. *Re-visions.* Toronto: Coach House Press, 1978.

Seymour, Danny. *A Loud Song.* New York: Lustrum Press, 1971.

Slavin, Neal. *Portugal* (afterword by Mary McCarthy). New York: Lustrum Press, 1971.

Strand, Paul. *Time in New England* (text selected and edited by Nancy Newhall). New York: Oxford University Press, 1950.

Weegee (Arthur Fellig). *Naked City.* New York: Essential Books, 1945.

Weegee (Arthur Fellig). *Weegee's People.* New York: Essential Books, 1946.

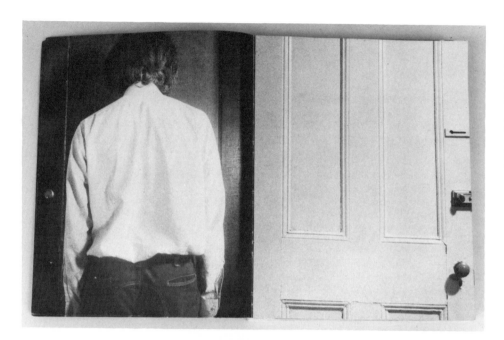

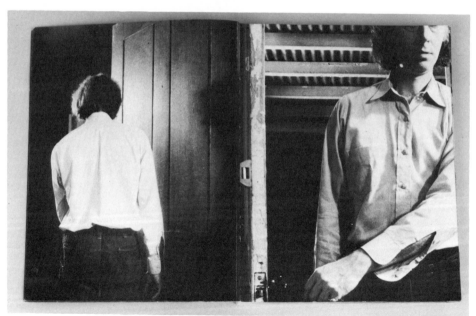

Michael Snow, *Cover to Cover* (two openings), 1975.

Systemic Books by Artists

by Robert C. Morgan

*T*HE PLAY ON SYSTEMS in artists' books is a mediumistic as well as a conceptual concern. Attention is focused upon the book as object—a direct manifestation derived from a given set of parameters. Systems set forth in artists' books develop from artists' concepts which, in turn, evolve from a confluence of images, ideas, pre-determined constructs, and linguistic propositions. Not all are explicit systems. Some books are more visual, concerned with defining the book as a structure; others are more conceptual, concerned primarily with the content of ideas.

Systemic books by artists became most ostensible during the conceptual movement in North America, Europe, and eventually in Latin America. Much of this activity was concurrent with the media explosion of the 1960s heralded in the writings of Marshall McLuhan. While certainly not the sole influence, McLuhan's theories suggested possibilities for processing ideas and images in the form of "information" which could then be transmitted bereft of traditional art objects. Consequently, artists' books—and systemic books, in particular—became a convenient form of presentation for these conceptual concerns. However, such bookmaking practices constituted only one fraction of the avant-garde activity during the late 1960s, and therefore, may be viewed less from a normative art historical perspective, and more through a descriptive analysis based on the intention of individual artists.

Sometimes a book serves as a container for a system of ideas expressed outside the book itself as, for example, in an installation or performance work. In such an instance, the book's emphasis is generally less about the medium of bookmaking and is more given to the process of documentation within a systemic format which may echo the sys-

temic content of the event being documented.

Some conceptual artists who produced books in the late 1960s used the paginal format as a readily available means to present their ideas, often to disseminate information in a re-contexturalized manner. But there were others who saw the book more in terms of a structure, a means for presenting original work, emphasizing systems designed specifically to be viewed through the turning of pages. Such artists included Sol LeWitt, Stanley Brouwn, Lawrence Weiner, Hanne Darboven, the Bechers, and Peter Downsbrough.

It was not until the seventies, a period when the formalist grip on American art began to dissipate in favor of something called "pluralism," that the artist's book began to find acceptance by a wider art audience. This occurred largely through the publishing and organizational efforts of individuals such as Dick Higgins, Bern Porter, Judith Hoffberg, Martha Wilson, Sol LeWitt, Lucy Lippard, Peter Frank, Germano Celant, and Kasper König.

Artists' books, which had been an underground establishment for several years, suddenly appeared in great numbers from areas outside of New York, Paris, Milan, Amsterdam, Dusseldorf, Cologne, and other major art centers. Books by artists were seen as an alternative to the gallery network, a way of by-passing the fixed strategies of the marketplace and giving one's ideas publicity without compromise. This assumed, of course, that the artist took upon herself or himself the task of either self-publishing or finding a publisher or financial backer who understood the concept. The latter task was often quite arduous.

One must remember, however, that the term "book" was being used by artists more loosely than it had been used by commercial publishers. Instead of relying upon expensive typesetting techniques, corrected margins, and sewn bindings, many artists were printing their books with quick and inexpensive reproduction methods, such as copy machines and instant offset presses. Many of these "books" were stapled or wire-bound; some consisted of loose-leaf pages placed in envelopes, or configurations presenting only the most perfunctory evidence of what a book might be.

Conceptual artists naturally gravitated toward the book medium, usually with a highly simplified approach. Sol LeWitt, whose systemic books are perhaps the best-known publications to emerge directly out of conceptual art, clearly fits into the reductive formalism of the 1960s in the New York avant-garde. His original contribution to conceptualism is the presentation of a dialectical space between a language paradigm and its concretization as visual form. The latter evidence may take the form of three-dimensional cubic structures, wall drawings, and—of primary concern here—his artist's books.

LeWitt's use of systems is explicit. In other words, the focus of his

Sol LeWitt, *Brick Wall*, 1977.

books is upon how the language paradigm works in relation to the visual system, the latter being either serial or sequential. In that LeWitt's books are predicated on the syntax of his language paradigms (which often read as titles, captions, or instructions), his visual configurations operate as translations which, in turn, become modular structures sytemically evolving through the temporal occasion of experiencing a book.[1] The experience of viewing these works is an abstract one. They function as reproductions or explorations of a structural idea in order to derive its essential meaning. LeWitt's books present themselves as literal facts.

The Location of Lines is a somewhat complex schemata presented as a logical progression of intersecting lines. The reader/viewer is expected to decipher some rather dense logic in written form which corresponds to the placement of the lines. The dialectic between linguistic structure and visual manifestation is repeated on each double page spread. The logic begins at an elemental level, showing the placement of a single line, and gradually develops in complexity as new elements are added to each subsequent proposition. For some readers, there is a tendency to become less involved with the phenomenon of LeWitt's concept and more focused (or unfocused) on the sheer tedium of the logic.

In *Geometric Figures and Color*, the pages are sectioned into three equally visible, color-coded sections: The first reads "On Red"—the second, "On Yellow"—and the third, "On Blue." In each section,

there are six basic shapes, one to a page, which include a circle, a square, a triangle, a rectangle, a trapezoid, and a parallelogram. Each geometric figure advances through the color sections in a given order; thus, the viewer may apprehend the color relationship of the figure-to-ground interaction based on memory and logic as to what figures will appear in relation to the color system. It is the hue that may startle the viewer's expectations—even though the grid-sequence of the color/figure relationships is clearly stated at the beginning of each section.

The seriality used in LeWitt's *Geometric Color and Figures* is not involved with value changes, but with shifting expectancies. The permutations are clear, the rules are set. All variables have been delimited. The system is investigated thoroughly within its given parameters.

In 1977, LeWitt produced two books of photographs, entitled *Brick Wall* and *Photogrids*. In contrast to the abstract linear progressions used in earlier books, these compendia of photo-images emphasize qualities of implicit structure through use of the camera. In terms of concept, there is little relationship between the two books. *Brick Wall* is a sequence of thirty black and white photographs taken of a section of wall. Each image extends to the edges of a single page. The concept of the book appears very close to that of Monet's painterly studies of the facade of the Rouen Cathedral. In each case, the viewer must "read" the tones of light shifting across the facade of a richly textured surface. At the outset of *Brick Wall*, the surface is flooded with intense light; by the conclusion, the wall is encased in a barely discernible density of dark tones. The system is essentially a photographic one, a comment perhaps on the medium; yet it has more to do with the effects of light—as does Impressionism—than with the actual physical structure of the wall. What appears as a simple book is transformed into one of ultimate mystery and equivocal meaning, raising complex cognitive and phenomenological issues about the conditions of light and time and about the nature of how we perceive reality.

Photogrids is considerably less adventuresome. It is a larger size book which reads as an assemblage of square format Rollei snapshots. The order of each nine-unit page emphasizes the proverbial grid within which LeWitt loosely categorizes various "found grids," such as manhole covers and window frames, into a generalized statement about urban visual semiotics. *Photogrids*, in retrospect, is the public component of LeWitt's later *Autobiography*, a more successful book in which the artist's concrete personalized view of details in his studio environment approaches a narrative structure.

In each of LeWitt's books, the use of systems plays heavily in the content; the outcome can be pleasurable in the sense that listening to music can be pleasurable. But sometimes LeWitt gets too heavy-handed in his methodology. His best books are those in which the visual signs flow

easily and work in parallel consort to the clarity of his language; in fact, where explicit language is mitigated in favor of conceptual meaning. The reduction of language becomes meaningful as it challenges our understanding of the visual parameters and their systemic interrelatedness.

At this juncture I would like to suggest that there are two kinds of systems at work in those books which hold forth artists' concepts: *narrative* and *concrete*. Narrative systems work in relation to a theme which may be either literary or visual. They tend to unfold sequentially, but not necessarily according to a serial logic. Concrete systems, on the other hand, tend toward abstract logic and seriality. Concrete systems tell no story; rather they present an interrelationship of elements as formal design. The organization of a concrete system is more tightly regimented; hence, the book reads more in terms of an explicit modularity. Concrete systems are about literal facts; narrative systems tend toward literary illusions. A concrete system is contained by the literalness of what it is; a narrative system implies other levels of meaning behind what is there. Narrative systems do not require linearity; concrete systems often do.

Although he has made many one-of-a-kind books dealing with narrative systems, some of Keith Smith's most fascinating books operate precisely as concrete systems.[2] Smith began doing "no-picture books" in the early 1970s. He numbers his books in consecutive order. *Book 30* and *Book 102* both incorporate the use of simulated dye-cut circles.

Keith Smith, *Book 102*, 1984.

Book 97 is a leather-bound one-of-a-kind book consisting of cut-out grids. In each case, Smith has used the literal space from the patterned cuts revealed on each of the pages. There is a sense of physicality in that the book operates as a kind of sculptural unit. In *Book 102*, for example, the content can be literally seen and understood opened-up in a display case. Each page is a serialized cut-out circle which forms a tunnel of vision through the book. In an editioned work, entitled *Book 91*, Smith has extended the sculptural meaning of the book by using cords that provide tension points between the various pages. His is concerned with the light and sound effects as one engages in the function of "moving through" the book page by page. The concept, in fact, echoes that of Rauschenberg's *White Panels* (1952), a painting in which the viewer sees his or her shadow against the modular surface. Smith's *Book 91* invites the viewer to see the linear configuration of the cords as shadows playing against the pages of the book. The concreteness of these systems is in the fact that the significance of these books is totally literal. It is the reality of holding the book, seeing through it, turning the pages, that registers meaning.

A good example of a narrative system is Paul Zelevansky's *The Book of Takes*, a non-linear pictographic novel. The layout of *The Book of Takes* is basically tripartite. Images and text can be read in three vertical columns. The reader can choose to read both vertically and horizon-

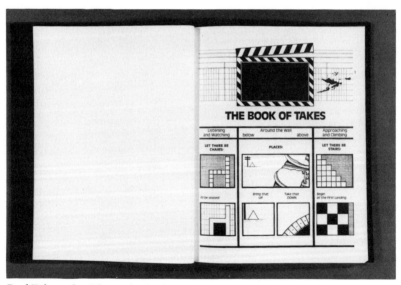

Paul Zelevansky, *The Book of Takes*, 1976.

tally, moving forwards and backwards in a network of semiotic disclosures and abrupt shifts in syntax. Zelevansky's book attempts to provide the reader with a grammatical system in both visual and typographical terms. The images are entirely drawn and therefore cohere as subtle ideogrammatic configurations. The content takes place largely in the region of Sinai and arbitrarily includes audience participation. A map is included as a separate element to indicate to the reader his or her location in respect to the action of the narrative.

When speaking of a system intrinsic to the structure of a visual book, this should not imply narration only in the classical sense. Artists' books tend not to have a beginning, a middle, and an end, but rather function in terms of given sets of parameters which may operate either sequentially or thematically, sometimes both. When Ulises Carrión says that artists' books can be comprehended without necessarily viewing the entire book, he implies that the concept which supports the system is possessed with considerable weight.[3] Although the truth of his statement is clearly exaggerated, the point is well taken; yet I would footnote Carrión's assertion by saying that the kind of book system to which he refers is most often within the context of the concrete, not the narrative system. In Zelevansky's book, for example, a concrete system is employed, but the resolution is entirely through the narrative structure. Without attending to the content of the narrative, the system could be easily oversimplified, even misunderstood.

Some of Richard Kostelanetz's books, such as *Constructs, Exhaustive Parallel Intervals*, and *Numbers, Poems, and Stories*, are excellent examples of concrete systems. The implication of the latter work, published as a newsprint tabloid in 1976, suggests that the concreteness of Kostelanetz's numerical paradigms has somehow taken a leap into narrative, that the parameters of these magic number constructs are not unrelated to the work of formalist fiction writers. However, upon examining the constructs in *Exhaustive Parallel Intervals*, in which the dimensions of a diamond-shaped paradigm increase gradually using integers 0 through 5 in serial progression, one realizes how indelible the classical structure appears. The ordering is linear and not at all unpredictable. In this case, the play upon an abstract system has replaced the literary content of a random theme—the condition of randomness being more characteristic of narration than its concrete counterpart. *Exhaustive Parallel Intervals* is concerned with language games as numerical constructs that do not so much defy former categories of narration as give them a reduced classical appearance. The structure itself is not revolutionary, rather the content has shifted from the literary representation to the literal presentation. Kostelanetz may be suggesting that concrete systems can be interpreted, maybe recontextualized, as narrative fiction in order to signify that concrete systems can be *read* as well as de-

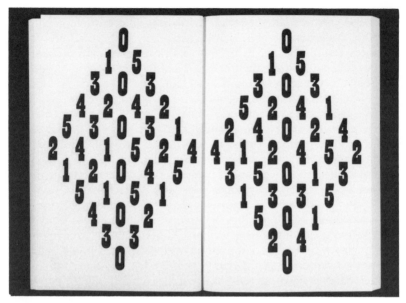

Richard Kostelanetz, *Exhaustive Parallel Intervals*, 1979.
Collection of the Rochester Institute of Technology.

ciphered in purely mathematical terms. Regardless of the interpretation, the system at work is still a concrete one, and it is the concreteness of Kostelanetz's systemic ventures which offers the real intrigue. How these systems are read or interpreted may have more to do with the frame of mind one brings to the occasion of receivership, and less to do with the premise that narration is simply another form of concrete reasoning logically expressed through abstract models of seriality.

Other artists' books may appear "systemic" by maintaining a marginal conceptual concern, while relying more explicitly on loosely collaged styles of narration, closer perhaps to experimental cinema than to conventional fiction or confessional writing. In Kevin Osborn's *Real Lush*, the obsession with printed overlays gives way to a frenzied juxtaposition which keeps a narrative distance between any thematic concept and the employment of accessible printing techniques. This gap is reinforced continuously by what appears as a conscientious striving toward image glut. The density of information, appropriated and mixed, makes any concern for language seem irrelevant. Without some attempt at making visual language discernible, the vocabulary turns to morass. When the morass pretends to issue narrative meaning apart from its rigorous attempt to dissolve formal intention, the work is likely to become what e.e. cummings once termed "an uncomic non-book."

Real Lush, quite simply, is recontextualized "cheap thrills" given a modestly sophisticated facelift within the genre of artists' books. Osborne has demonstrated how an utter plethora of printing techniques bereft of a clearly designated conceptual underpinning may approach a kind of hallucinogenic solipsism. Ironically, *Real Lush* also approaches academic formalism in the process of testing those formal limits. The emphasis is upon visual effects which can exist independently from a specific narrative theme.

Another work which employs a narrative system, though within a performance medium, is Carolee Schneemann's notecard assembly, entitled *ABC—We Print Anything—In the Cards*.[4] Intended as a set of cue cards for reading aloud, *ABC* involves a tri-color coding system in which intimate remarks from three different sources have been printed. The cards are used as a ploy in order to structure the meaning of their confessional content. While the passages reflect actual feelings, they offer little disclosure as to the real psychological motivation behind them. The effect is ultimately one of narcissism, zestfully achieved by means of a non-linear narrative technique. The use of a narrative system in Schneemann's *ABC* does not rely upon a conventional narrative structure. The content of the cards is discovered through the system employed, and like any system, the parameters are clearly contained, though not always clearly discernible.

In contrast, Martha Rosler's seminal feminist ideolog, *Service*, is conventional in formal terms, but revolutionary in terms of both context and content. The text is a series of three narrative accounts, each describing the working conditions of three women in the labor force. The tone of each narrative is confessional. The total message is one of sexual and economic exploitation. The book in itself does not carry an explicit systemic significance. However, the narrative points directly at the larger social/political/economic implications of the capitalist system which tends to consider such human services as expendable. *Service* is a book about systemic exploitation; it is through the narrative that the impact of the system begins to unfold and achieve significance.

Much of what has passed for systemic bookmaking is really more in the category of documentation; that is, the book itself merely serves as a vehicle or container by which to transport a concept geared towards another mode of delivery, namely, performance and installation works often involving music, video, dance, and multi-media.

Upon occasion, as in the "activity" manuals produced by Allan Kaprow throughout the 1970s, the line of distinction becomes tenuous. Although Kaprow's manuals appear to many as documentation of his performance works, they are, in fact, components for use within the context of the works themselves. One example would be the book, *Blindsight*, designed by an event performed at Wichita State Univer-

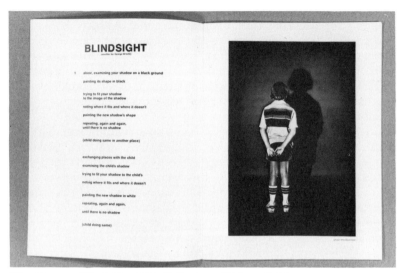

Allan Kaprow, *Blindsight*, 1979. Collection of Robert C. Morgan.

sity.[5] The piece involved twelve children and twelve adults who paired off and drew their shadows in various configurations over one another on the wall. Although not published until after the event, the performance manual theoretically serves as an instruction guide or script for others to use in reconstructing the event. Incorporated into the manual, however, are documents from the original performance at Wichita, including photographs and statements by various participants.

The use of photography and photo-reproductive techniques by artists who do not consider themselves photographers by profession is a curious development in recent years which has found its way into the production of artists' books, magazine pages, catalogues, and tabloids. Two of Sol LeWitt's books have already been examined in this context. To some extent, Allan Kaprow is another artist who has frequently relied on photographs in order to clarify his intentions. Ed Ruscha is perhaps the most celebrated of book artists who has used photographs extensively. Much commentary has already been written on Ruscha's books, but because of their relationship to systems, one cannot ignore some mention of his work.[6]

In *Royal Road Test*, co-authored by Ruscha, Mason Williams, and Patrick Blackwell, documentary photographs and captions describe an event which occurred 122 miles southwest of Las Vegas, Nevada, on August twenty first, 1966. A Royal Typewriter was hurled out of a speeding Buick convertible traveling at ninety miles per hour. In the af-

termath, each part of the violently dismantled typewriter was fully documented, using photographs and captions, much like a police accident report. In another book, *Crackers*, a series of photographs describe another absurd incident in which a male performer (Larry Bell) makes a salad on a hotel bed and invites a woman to undress and recline in it. The protagonist then retires to his own hotel room to eat a box of crackers. In each book Ruscha is dealing with a narrative system based on fantasy in which he uses photographs in sequence. Given the straight documentary approach of most Ruscha books, these two are exceptional.

Another artist, Peter Downsbrough, uses two parallel vertical lines in a repetitive sequence, often in reference to photographs. One the cover of *In Front*, a photograph documents a sculpture made of two parallel vertical steel rods, one shorter than the other. The pages inside the book refer to the image on the cover, but also the book itself. Downsbrough is highly reductive in his imagery. He works with concrete systems in which the pages of the book are "marked" in repetition in order to reemphasize the position of the viewer's eye as it makes contact with the page. In the more recent publications, such as *In Passing*, photographs of dice are repeated along with drawings and text. Together they reveal a well developed systemic complexity which comments

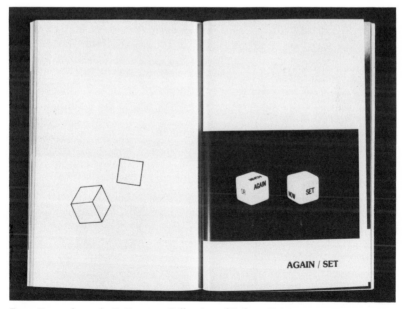

Peter Downsbrough, *In Passing*. Collection of Robert C. Morgan, 1975.

metaphorically upon current power struggles in world politics.

The NFS Press in San Francisco, coordinated by Lew Thomas and Donna-Lee Phillips, has produced a series of interesting compendia dealing with various issues related to photography and language. Thomas's own work, *Structural(ism) and Photography*, is essentially a catalogue of image-systems realized primarily through serial photography. Although the book functions like a catalogue, Thomas offers considerable insight into the temporal meaning of photographic imagery by way of a rigorous, nearly clinical documentation of mundane activities, such as closing a garage door or observing a sink fill up with water and then drain again. Thomas's approach is one of distancing himself from his subject matter, no matter how closely tied to the object or person he may be in real life. This allows the time of the action to progress through modularity, more or less, as a concrete system. Although there may be allusions to narrative in his work, there are no pure effects. Even so, the term "conceptual photography" used in his earlier work could be interpreted as a misnomer. Thomas's real contribution is his ability to take personal subject matter and distance its reading and therefore give it the function of objective language.

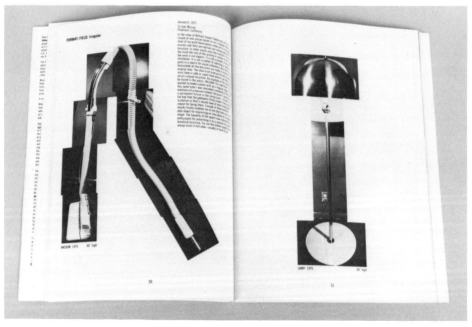

Lew Thomas, *Structuralism and Photography*, 1978.

The notion of using the camera to document a mundane activity as standard routine has been epitomized by the Soviet emigré artist, Vagrich Bakhchanyan. In *Diary (1-1-80—12-31-80)*, Bakhchanyan has confronted the camera each day for the duration of the year 1980. Each "self-portrait" shows the artist with the day's date attached to his forehead, thus recalling an affinity with the seminal date paintings by conceptualist On Kawara. At the outset of the year, Bakhchanyan is bald; by the completion of the year, he has long flowing hair. The photographs in *Diary* were instant offset, bound, and collated in an edition of 250 copies. Bakhchanyan's books reflect the ingenuity of an artist committed to the pleasure of art as a reflective activity. By giving emphasis to the distribution of ideas, the importance of material quality in the production of the work becomes less of an issue.

One oustanding example of a systemic narrative employing photographs is Michael Snow's *Cover to Cover*. Again, much has been said about Snow's "structural" films. The fact is that this Canadian artist has given equal energy to other media, including painting, sculpture, photography, music, installation works, and artists' books. To encounter the complexity of his book, *Cover to Cover*, is in some ways a cinematic

Vagrich Bakhchanyan, *Diary (1-1-80—12-31-80)*, 1981.

experience. In other ways, it may be compared to the architectural illusions found in some Spanish mosques, given the layering of spatial disorientations and sequential ambiguity that Snow has presented between the covers of a book. A primary concern, for Snow, is that photographic representation exists in its own space as it exists concurrently in a surrounding environmental space which has the potential to intercede upon one's perception of an image. On the front cover, a detail of a door is photographed. On the back cover, the reverse of what appears as the same door is an image of the door re-photographed. This is indicated by the presence of the artist's finger holding the image. Throughout the book, the viewer is confronted with forward and backward views of objects and events related to the artist's life as he goes from his house to his car to his gallery and back to his house again. What may appear as a firsthand representation of reality is suddenly twice removed as the artist's hand is used to cover an image, thereby confounding our expectations of what we are seeing and *how* we are seeing it. Michael Snow's *Cover to Cover* surpasses the purely visual element on one level by elevating our cognizance of photographic imagery toward a multileveled strata of narrative.

Systemic books do not have to comment upon the medium of bookmaking, although as previously indicated, many do. Two books by California computer analyst Aaron Marcus, entitled *Soft Where, Inc.*, published in 1975 and 1982 respectively, are diaristic accounts of his conceptual projects. In each volume, Marcus sets a system into motion and then proceeds to give a detailed narrative as to how the system resolves itself as it interacts with everyday situations. These works are technique oriented and deal with problems of communications and language.

One of the most entertaining entries, documented in Volume 2, is a project called "Light Line." In this piece, the artist attempts to establish communication with an ex-student who is about to become Queen Nur el Hussein of Jordan. The revelation of how security functions on an international scale, particularly in the Arab state, is both informative and illuminating.

The importance of *Soft Where, Inc.* is in the realization that advanced techniques in communication, without advanced attitudes about technology, has very little to offer human beings in the post-modern age. Formally speaking, *Soft Where, Inc.* functions as a series of narratives. The form is both diaristic and documentary. In each entry Marcus records the development of a specific work in progress. In addition to the narrative text, there are diagrams, charts, and photographs which assist the reader in re-constructing the artist's intentions for each piece. In doing so, Marcus successfully bridges the gap between the operation of a concrete system within a social context and an intimate narrative des-

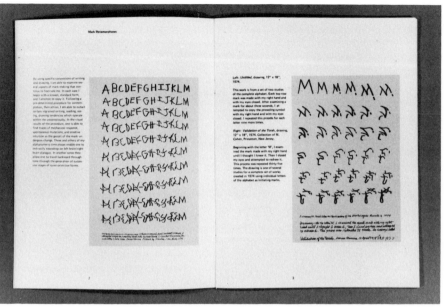

Aaron Marcus, *Soft Where, Inc.* Collection of Robert C. Morgan.

cription of how it is happening.

This essay has been an attempt to explicate a variety of applications of systemic art to the artist's book. It has by no means been inclusive of the many excellent works available. In stating a theoretical position, the problem of selectivity is always eminent and therefore should not imply objective taste insofar as the issue of quality is concerned. Systemic books deal with systemic ideas; they need not imply a tautology—that such books are exclusively about the system of the book itself. However, this is clearly one criterion in dealing with the problem. Certainly another central criterion would be the distinction between concrete and narrative systems. Other criteria are the fact that technical manipulations in printing do not substitute for conceptual resolution, that most photography used within the context of systemic books is not always concerned primarily with photography as a fine art, and that where documentation is used as the intention for doing a book, the issue becomes one of how well the elements function within the context of the artist's system.

© *1984 by Robert C. Morgan*

NOTES

1. See my discussion of LeWitt's books in "The Pleasure in Photographs/The Components in Language," *Kansas Quarterly*, Vol. 11, No. 4 (Fall 1979). An excerpt of the article, including the section of LeWitt, appeared in the LAICA *Journal* (September 1979).
2. For a fully documented resource guide to this artist's work, see Keith A. Smith, *Structure of the Visual Book (Book 95)*. Rochester, New York: Smith and Visual Studies Workshop Press, 1984.
3. Ulises Carrión, *"The New Art of Making Books."* Amsterdam, Void Distributors, 1980. This essay is reprinted in this book.
4. A version of this work appears in Anina Nosei Weber, ed., *Discussion: The Aesthetic Logomachy*. New York, Out of London Press, 1980.
5. This was the subject of an interview with Allan Kaprow which appeared in the LAICA *Journal* (September 1979).
6. See my two articles analyzing Ruscha's books in the LAICA *Journal* (September 1979) and LAICA *Journal* (December 1981).

BIBLIOGRAPHY—BOOKS BY ARTISTS

Bakhchanyan, Vagrich. *Diary (1-1-80—12-31-80)*. Mechanicsville, Maryland: Cremona Foundation, 1981.
Downsbrough, Peter. *In Front*. Gent, Belgium: Jan Vercruysse, 1975.
Downsbrough, Peter. *In Passing*. Paris: Editions E. Fabre, 1982.
Kaprow, Allan. *Blindsight*. Wichita, Kansas: Wichita State University, 1979.
Kostelanetz, Richard. *Constructs*. Reno, Nevada: WCPR, 1975.
Kostelanetz, Richard. *Exhaustive Parallel Intervals*. New York: Future Press, 1979.
Kostelanetz, Richard. *Numbers, Poems, and Stories*. New York: Assembling Press, 1979.
LeWitt, Sol. *Autobiography*. New York: Multiples, and Boston: Michael and Lois K. Torf, 1980.
LeWitt, Sol. *Brick Wall*. New York: Tanglewood Press, 1977.
LeWitt, Sol. *Geometric Figures and Color*. New York: Abrams, 1979.
LeWitt, Sol. *Location of Lines*. London: Lisson Gallery, 1974.
LeWitt, Sol. *Photogrids*. New York: Rizzoli and Paul David Press, 1977.
Marcus, Aaron. *Soft Where, Inc., Volume 1*. Reno, Nevada: WCPR Press, 1975.
Marcus, Aaron. *Soft Where, Inc., Volume 2*. Reno, Nevada: WCPR Press, 1982.
Osborn, Kevin. *Real Lush*. Glen Echo, Maryland: Writer's Center, 1981.
Rosler, Martha. *Service*. New York: Printed Matter, Inc., 1977.
Ruscha, Ed. *Crackers*. Hollywood: Heavy Industry Publication, 1969.
Ruscha, Ed, Patrick Blackwell, and Mason Williams. *Royal Road Test*. Los Angeles, 1967.
Schneemann, Carolee. *ABC—We Print Anything—In the Cards*. New Paltz, New York: Tresspass Press, 1977.
Smith, Keith A. *Book 30*. Rochester, New York, 1972.
Smith, Keith A. *Book 91*. Rochester, New York and Barrytown, New York, Space Heater Multiples, 1982.
Smith, Keith A. *Book 97*. Rochester, New York, 1984.
Smith, Keith A. *Book 102*. Rochester, New York, 1984.
Snow, Michael. *Cover to Cover*. Halifax: The Press of the Nova Scotia College of Art and Design and New York University Press, 1975.
Thomas, Lew. *Structural(ism) and Photography*. San Francisco: NFS Press, 1978.
Zelevansky, Paul. *The Book of Takes*. New York: Zartscorp, Inc. Books, 1976.

Artists' Book Collections

The following information has been compiled by Helen Brunner and Don Russell to identify libraries and collections with substantial holdings of artists' books. The list is not complete, especially in regard to personal collections and college libraries, but it does provide an initial sampling of the collections available for research.

Albright-Knox Art Gallery Library
 1285 Elmwood Avenue
 Buffalo, NY 14222
 (716) 882-8700
 Hours: By appointment
 Type of Collection:
 Museum library, collecting since 1978
 300 books (96% multiples, 2% one-of-a-kind, 2% artists' magazines/ 100% 1975-82)
 Also Collects:
 Artists' recordings, art documentations, reference materials
 Cataloguing:
 By title and artist
 Programs/Services:
 Exhibitions

The Archives/Art Information Centre
 P.O. Box 2577
 3000 CN Rotterdam
 Holland
 (010) 364-986
 Contact: Peter Van Beveren
 Hours: By appointment
 Type of Collection:
 Personal collection, collecting since 1972
 1500 books (70% multiples, 30% one-of-a-kind/ 33% 1975-84, 33% 1970-75, 33% 1965-70)
 Also Collects:
 Art documentations, exhibition catalogues
 Cataloguing:
 By title, artist, publisher
 Programs/Services:
 Exhibitions, catalogues, lectures

Art Institute of Chicago (School of)
 School Library
 Jackson and Columbus
 Chicago, IL 60603
 (312) 443-3774
 Contact: Nadene Byrne/Jessie Affelder
 Hours: M-F 8:30am-9pm, Sat. 9am-5pm, Sun. 10am-5pm
 Type of Collection:
 College/university library, collecting since 1970
 500-1000 books (80% multiples, 10% one-of-a-kind, 5% artists' magazines, 5% literary small press/ 75% 1975, 15% 1970-75, 10% 1960-70) Annual acquisitions budget: $1,000.00
 Also Collects:
 Artists' recordings, mail art, artists' video, reference materials
 Cataloguing:
 Computerized LC cataloguing; classified by title and artist
 Programs/Services:
 Group, thematic, contemporary and historical exhibitions; catalogues; lectures

Art Metropole Archives
 217 Richmond St. West
 Toronto M5V 1W2
 Ontario, Canada
 (416) 977-1685
 Contact: Tim Guest
 Hours: M-F 12-5pm, by appointment
 Type of Collection:
 Artists' organization, collecting since 1974

4000 books (60% multiples, 35% artists' magazines, 5% literary/ 48% 1975-84, 30% 1970-75, 20% 1960-70, 1% 1930-50, 1% 1910-30)
Also Collects:
Artists' magazines, exhibition catalogues, audio and video recordings, multiples, information files.
Cataloguing:
Classified by title
Programs/Services:
Exhibitions, catalogues, reference publications, lectures, special events

Art Research Center
(New Circle Publications/Rice Memorial Archive)
820 E. 48th Street
Kansas City, MO 64110
(816) 931-2541
Contact: Thomas Michael Stephens
Hours: Sat., Sun. 2-6pm
Type of Collection:
Artists' organization, collecting since 1964
1000-2000 books (50% multiples, 10% one-of-a-kind, 30% artists' magazines, 10% literary small press/ 50% 1974-84, 25% 1969-74, 20% 1960-68, 5% 1950-60)
Also Collects:
Artists' recordings, artists' video, films, fine prints, photographs, art documentation
Cataloguing:
By title, artist, and subject
Programs/Services:
Research prints and slides, exhibitions, posters, catalogues; will loan for exhibition

Artists' Books Archive/Dr. Klaus Groh
Five Towers Micro Hall Center
Al. Siedlung 45
D-2913 Augustfehn II
West Germany
(04489) 59-54
Hours: by appointment
Type of Collection:
Personal collection, collecting since 1969
1500 books (10% multiples, 50% one-of-a-kind, 20% artists' magazines, 20% literary small press/ 85% 1975-84, 13% 1970-75, 2% 1960-70)
Also Collects:

Stamp art, artists' recordings, mail art, fine prints, art documentations, photographs, sound poetry
Cataloguing:
By artist and genre
Programs/Services:
Exhibitions, catalogues

Artpool
c/o G. Galantai
Frankel Leo ut 68/B, 1023
Budapest, Hungary
162-659
Contact: George and Julia Galantai
Hours: By appointment
Type of Collection:
Artists' organization, collecting since 1978
500-1000 books (25% multiples, 25% one-of-a-kind, 25% artists' magazines, 25% literary small press/ 90% 1975-84, 10% 1970-75)
Also Collects:
Artists' recordings, mail art, fine prints, art documentations, photographs
Cataloguing:
Classified by artist and publisher
Programs/Services:
Exhibitions and catalogues

Jean Baker Brown Archives
Shaker Seed House
Tyringham Institute
Tyringham, MA 01264
(413) 243-3216
Contact: Jean Brown
Hours: By appointment only
Type of Collection:
Personal collection, collecting since 1952
1000-2000 books (25% multiples, 25% one-of-a-kind, 25% artists' magazines, 25% literary small press/ 12% 1975-84, 12% 1970-75, 12% 1960-70, 12% 1950-60, 12% 1930-50, 25% 1910-30)
Also Collects:
Artists' recordings, mail art, artists' video, fine prints
Cataloguing:
Classified by artist
Programs/Services:
Study collection for scholars

Helen Brunner and Don Russell
5813 Nevada Avenue, NW
Washington, DC 20015

(202) 966-4724
Contact: Helen Brunner or Don
Russell
Hours: By appointment
Type of Collection:
Personal collection, collecting since 1974
1000-2000 books (85% multiples, 3%
one-of-a-kind, 12% artists' magazines/
90% 1975-82, 8% 1970-75, 2% 1960-
70)
Also Collects:
Art documentations, reference
materials
Cataloguing:
Classified by artist

Center for Creative Photography
University of Arizona
843 E. University
Tuscon, AZ 85719
(602) 626-4636
Contact: Terence R. Pitts, Curator and
Librarian
Hours: M-F 9-5pm, Sun. 12-5pm
Type of Collection:
College/University library, collecting
since 1975
300 artists' books (90% multiples,
10% one-of-a-kind/ 95% 1975-82)
Also Collects:
Photographs, negatives, books on
photography
Cataloguing:
LC cataloguing
Programs/Services:
Slides and research prints, exhibitions

Centre De Documentacio D'Art Actual
Carrera de la Fussina, 9
Barcelona (08003)
Spain 22 3106162
Contact: Raphael Tous

Conchise County Library
Drawer AK
6 Main Street
Bisbee, AZ 85603
Contact: Colleen Crowlie

Collection of Experimental Poetry
Laboratorio di Poesia
Via Alfieri, 17
73051 Novoli
Italy
(083) 271-2619
Hours: By appointment and M-F 6-8

pm (October to June)
Type of Collection:
Artists' organization, collecting since
1967
500 books (60% multiples, 10% one-
of-a-kind, 10% artists' magazines, 20%
literary small press/ 20% 1975-82,
50% 1970-75, 30% 1960-70)
Also Collects:
Artists' recordings, fine prints, art
documentations
Cataloguing:
By title and artist

Exempla Archives
Via Marsala 4
50137 Firenze
Italy
055-679-378
Contact: Maurizio Nannucci
Type of Collection:
Personal collection, collecting since
1967
2000/3000 books (30% 1975-82, 40%
1975-80, 30% 1960-70, 200 books
1910-30)
Also Collects:
Artists' recordings, concrete and sound
poetry, art documentations/ see also
Zona Archives
Cataloguing:
Classified by title
Programs/Services:
Exhibitions, catalogues; will loan for
exhibition

Experimental Art Foundation
P.O. Box 167, 59 North TCE
Stepney 5069, Hackney 5069
South Australia
(08) 424-080
Contact: Louise Dauth
Hours: M-F 10am-5pm; Sat. 2-5pm
Type of Collection:
Artists' organization, collecting since
1972
600 books (80% multiples, 20% one-
of-a-kind, also literary small press).
Annual acquisitions budget: $500.00
Also Collects:
Posters, artists' recordings, mail art,
artists' video, documentations,
photographs
Cataloguing:
Classified by artist
Programs/Services:

Exhibitions, catalogues

Peter Frank
712 Broadway
New York, NY 10003
(212) 505-1140
Contact: Peter Frank
Hours: Not open to the public
Type of Collection:
Personal collection, collecting since
1966
2000-3000 books (10% multiples, 2%
one-of-a-kind, 35% artists' magazines,
53% literary small press, 45% 1975-82,
35% 1970-75, 20% 1960-70)
Also Collects:
Artists' recordings
Cataloguing:
Classified by artist

Franklin Furnace Archive
112 Franklin Street
New York, NY 10013
(212) 925-4671
Contact: Martha Wilson, Director/
Mathew Hogan, Curator
Hours: T-Th 12-6pm
Type of Collection:
Artists' organization, collecting since
1976
11,000 books (75% multiples, 3%
artists' magazines, 2% mail art, 5%
ephemera, 15% reference/ 75% 1975-
84, 20% 1970-75, 4% 1960-70, 1%
1950-60)
Also Collects:
Artists' recordings, mail art, art
documentations, printed ephemera,
one-of-a-kind book slide registry
Cataloguing:
Classified by artist with limited subject
access
Programs/Services:
Exhibitions, catalogues, internships,
newsletter; limited loan for exhibition

Galerie A
Kleine Gartmanplantsoen 12
1017 RR
Amsterdam
The Netherlands
227-065
Contact: Harry Ruhe
Hours: Tues.-Sat. 2-6pm
Type of Collection:
Personal and gallery collection,
collecting since 1967

10,000 books (25% multiples, 5% one-
of-a-kind, 10% artists' magazines, 30%
literary small press/ 50% 1975-84,
25% 1970-75, 25% 1960-70). Annual
acquisitions budget: $3000.00
Also Collects:
Artists' recordings, mail art, catalogues
Cataloguing:
Classified by artist
Programs/Services:
Exhibitions, catalogues; will loan for
exhibition

Generative Press
3753 N. Freemont Street #1
Chicago, IL 60606
(312) 929-5720
Contact: M. Day
Hours: By appointment
Type of Collection:
Personal library, collecting since 1977
500 books (60% multiples, 25% one-
of-a-kind, 5% artists' magazines, 10%
literary small press/ 70% 1975-82,
15% 1970-75, 15% 1960-70). Annual
acquisitions budget: $0.00
Also Collects:
Artists' recordings, mail art, art
documentations
Cataloguing:
By title, artist, and publisher
Programs/Services:
Exhibitions, lectures, catalogues

Groninger Museum
Praediniussingel. 59
9711 AG Groninger
Holland

Judith A. Hoffberg
P.O. Box 40100
Pasadena, CA 91104
(818) 797-0514
Contact: Judith Hoffberg
Hours: By appointment
Type of Collection:
Personal collection, collecting since
1959
2200 books (80% multiples, 20% one-
of-a-kind/ 60% 1975-84, 20% 1970-
75, 20% 1960-70)
Also Collects:
Artists' recordings, mail art, fine prints,
art documentations, art reference
materials, photographs, umbrelliana
Cataloguing:

By artist
Programs/Services:
Exhibitions, catalogues, lectures

International Concrete Poetry Archive
11 Dale Close, St. Ebbe's
Oxford OX1 1TU
England
Contact: Paula Claire
Hours: By appointment
Type of Collection:
Personal collection, collecting since
1980
Under 500 books
Also Collects:
Artists' recordings, mail art, fine prints,
photographs, concrete poetry
Cataloguing:
Classified by artist
Programs/Services:
Exhibitions, catalogues, lectures; will
loan for exhibition

Minneapolis College of Art and Design
Library
200 E. 25th Street
Minneapolis, MN 55404
(612) 870-3291
Contact: Richard Kronstedt
Hours: M-F 8am-5pm
Type of Collection:
College library, collecting since 1978
200 books (95% multiples, 5% one-of-
a-kind/ 90% 1975-84, 10% 1970-75).
Also Collects:
Artists' recordings, artists' video
Cataloguing:
Classified by artist
Programs/Services:
Occasional displays

Museo Español de Arte Contemporaneo
Ciudad Universitaria
Madrid
Spain
449-7150
Contact: Angeles Duenas
Hours: Daily, 10am-6pm
Type of Collection:
Museum library, collecting since 1981
Under 500 books (75% multiples, 25%
one-of-a-kind/ 100% 1975-82)
Also Collects:
Fine prints, photographs
Cataloguing:
Classified by artist

Programs/Services:
Exhibits, catalogues

The Museum of Contemporary Art
Artists' Books Collection
237 E. Ontario
Chicago, IL 60611
(312) 280-2660
Contact: Mary Jane Jacob, Ann
Goldstein
Hours: Tues.-Sat. 10am-5pm, Sun. 12-
5pm
Type of Collection:
Museum library, collecting since 1980
850 books (97% multiples, 2% artists'
magazines, 1% literary small press/
70% 1975-82, 25% 1970-75, 5% 1960-
70). Annual acquisition budget:
$1500.00
Also Collects:
Artists' recordings, mail art, artists'
video, fine prints, art documentations,
photographs
Cataloguing:
By artist
Programs/Services:
Exhibitions, catalogues

The Museum of Modern Art Library
Artists' Books Collection
11 West 53rd Street
New York, NY 10019
(212) 708-9431/33
Contact: Clive Phillpot
Hours: M-F, 11am-5pm
Type of Collection:
Multiple edition artists' books from
c1960; total c2000. Collection begun
1977.
Other Collections:
Important holdings of Futurist,
Constructivist, Dada, Surrealist and
other artists' publications are
integrated with the Library's Special
Collections.
+ extensive holdings of artists
magazines since 1880.

National Gallery of Canada, Library
Ottawa K1A 0M8
Canada
(613) 995-6245
Contact: J. Hunter, Chief Librarian
Hours: M-F 12-6pm
Type of Collection:
Museum library

National Library of Canada—Rare Book
 Division
 395 Wellington
 Ottawa, Ontario K1A 0N4
 Canada
 (613) 996-1318
 Contact: Liana Van der Bellen
 Hours: M-F 8:30am-5pm
 Type of Collection:
 National library, collecting since 1949
 Legal deposit library for all monographs
 published in Canada. Over 1000 books
 (75% livres d'artistes, 25% multiples,
 33% 1975-84, 33% 1970-75, 33%
 1960-70)
 Also Collects:
 Reference material on the history of
 books and graphic art
 Cataloguing:
 Part of rare book collection
 Programs/Services:
 Exhibitions, catalogues

National Museum of American Art
 Library
 Smithsonian Institution
 Washington, DC 20560
 (202) 357-1886
 Contact: Susan Gurney, Assistant
 Librarian
 Hours: M-F 10am-5pm
 Type of Collection:
 Museum library
 Under 500 books (33% 1975-84, 33%
 1976-75, 33% 1960-70)

Nova Scotia Collection of Art
 Library
 Halifax, NS
 Canada

Rochester Institute of Technology
 Wallace Memorial Library
 1 Lomb Memorial Drive
 Rochester, NY 14623
 (716) 475-2567
 Contact: Barbara Polowy
 Hours: M-F 8:30am-4:30pm
 Type of Collection:
 University library
 Over 1000 books (80% multiples, 10%
 one-of-a-kind, 2% artists' magazines,
 5% literary small press/ 70% 1975-84,
 20% 1970-75, 10% 1960-70). Annual
 acquisitions budget: $1500.00
 Also Collects:

Fine prints and photographs
 Cataloguing:
 Library of Congress cataloguing
 Programs/Services:
 Exhibitions, lectures

RSM Company
 Box 1997
 Cincinnati, OH 45201
 (513) 241-7830
 Contact: J.R. Orton, Jr.
 Hours: By appointment
 Type of Collection:
 Corporate collection, collecting since
 1972
 1000 books (95% multiples, 5%
 literary small press/ 50% 1975-84,
 50% 1970-75)
 Also Collects:
 Fine prints, photographs
 Cataloguing:
 By artist

Ruth and Marvin Sackner Collection of
 Concrete and Visual Poetry
 Miami Beach, FL 33139
 Contact: Marvin Sackner
 Hours: By appointment
 Type of Collection:
 Personal collection, collecting since
 1974
 8000 books (5% multiples, 95%
 literary small press/ 30% 1975-84,
 45% 1970-75, 25% 1960-70)
 Cataloguing:
 Computerized by author
 Programs/Services:
 Catalogues

Gilbert and Lila Silverman Collection
 Southfield, MI
 Hours: Not open to public except on
 exhibition
 Type of Collection:
 Personal collection, collecting since
 1978
 500 books (60% multiples, 10% one-
 of-a-kind, 30% artists' magazines/
 20% 1975-84, 20% 1970-75, 60%
 1960-70)
 Also Collects:
 Artists' recordings, mail art, artists'
 video, fine prints, art documentations,
 photographs
 Cataloguing:
 By title, artist, publisher

Programs/Services:
Exhibitions, catalogues

The Swedish Archive of Artists' Books
(SAAB)
Leifs vag II, S-237 00
Bjarred
Sweden
(046) 292280
Contact: Leif Eriksson
Hours: By appointment
Type of Collection:
Personal collection, collecting since
1976
2000 books (70% multiples, 10% one-
of-a-kind, 10% artists' magazines, 10%
literary small press/ 20% 1975-84,
45% 1970-75, 35% 1960-70)
Also Collects:
Artists' recordings, mail art, art
documentations
Cataloguing:
Classified by artist
Programs/Services:
Exhibitions, catalogues, directories,
lectures

Lew Thomas
243 Grand View Avenue
San Francisco, CA 94114
Hours: By appointment
Type of Collection:
Personal collection, collecting since
1964
1000-2000 books (85% multiples, 5%
one-of-a-kind, 5% artists' magazines,
5% literary small press/ 40% 1975-84,
40% 1970-75, 20% 1960-70)
Also Collects:
Artists' recordings, photographs
Cataloguing:
Classified by artist

Tyler School of Art
Temple University Library
Beech and Penrose Avenues
Philadelphia, PA 19126
(215) 224-7575
Contact: Ivy Bayard
Hours: M-F 8:30am-4pm
Type of Collection:
College library
Under 500 books (50% multiples, 50%
artists' magazines)
Also Collects:
Artists' video, fine prints

Cataloguing:
Library of Congress cataloguing
Programs/Services:
Exhibitions

University of Alberta
Bruce Peel Special Collections Library
Edmonton Alberta T6G 2E1
Canada
Contact: Mr. John Charles
(403) 432-5998 or 2923

University of Louisville
Art library
Louisville, KY 40208
Contact: Gail Gilbert
(502) 588-6741
Hours: M-Th 8am-9pm, F 8am-5pm,
Sat. 10am-2pm, Sun. 2pm-6pm
200 books (100% multiples)
Also Collects:
Fine arts and architectural history

Virginia Commonwealth University
University Library Services
901 Park Avenue
Richmond, VA 23284
(804) 257-1112
Contact: Janet Dalberto
Hours: M-F 8am-5pm
Type of Collection:
University library, collecting since 1979
1000-2000 books (99% multiples, 1%
one-of-a-kind/ 74% 1975-84, 25%
1970-75, 1% 1960-70). Annual
acquisitions budget: $1500.00
Also Collects:
Art documentations, reference
materials
Cataloguing:
By title. Will receive Library of
Congress Cataloguing
Programs/Services:
Exhibitions, catalogues, educational
programs

Visual Studies Workshop
Independent Press Archive
31 Prince Street
Rochester, NY 14607
(716) 442-8676
Contact: Robert Bretz
Hours: By appointment
Type of Collection:
Artists' organization, collecting since
1972

3000-4000 books (90% multiples, 5% one-of-a-kind, 5% artists' magazines/ 85% 1975-84, 10% 1970-75, 5% 1960-70)
Also Collects:
Mail art, artists' video, art documentations, photographs, reference materials
Cataloguing:
By artist, title, publisher, and subject
Programs/Services:
Exhibitions, publications, educational programs

Whitney Museum Library
945 Madison Avenue
New York, NY 10027
(212) 749-7898
Contact: May Castleberry
Hours: By appointment
Type of Collection:
Museum library, collecting since 1978
Under 500 books (30% multiples, 5% one-of-a-kind, 30% artists' magazines, 5% literary small press/ 55% 1975-84, 35% 1970-75, 10% 1960-70). Annual acquisitions budget: $1000.00
Also Collects:
Artists' recordings, art documentations, photographs
Cataloguing:
By title and artist

Dr. Ira G. Wool
5811 Dorchester Avenue
Chicago, IL 60637
(312) 962-1341 (O)
Type of Collection:
Personal collection, collecting since 1972
1000 books (75% multiples, 10% one-of-a-kind, 10% artists' magazines, 5% literary small press)
Also Collects:
Artists' reordings, mail art, artists' video, fine prints, art documentations, photographs, painting, and sculpture
Cataloguing:
Classified by artist

Yale University—Sterling Memorial Library
Arts of the Book Collection
New Haven, CT
(203) 436-2200
Contact: Gay Walker

Hours: M-F 2-5pm
Type of Collection:
University library, collecting since 1967
500 books (10% multiples, 5% artists magazines, 85% literary small press/ 33% 1975-84, 33% 1970-75, 33% 1960-70)
Also Collects:
Mail art, fine prints
Cataloguing:
Classified by artist

Zona Archives
Box 1486
Firenze
Italy
(055) 679-378
Contact: Maurizio Nannucci
Hours: By appointment
Type of Collection:
Artists' organization
2000-3000 books (90% multiples, 10% artists' magazines/ 30% 1975-84, 40% 1978-75, 30% 1960-70)
Also Collects:
Art documentaries, artists' postcards/ See also Exempla Archives
Cataloguing:
By artist
Programs/Services:
Exhibitions, catalogues, will loan for exhibition

Tony Zwicker
15 Gramercy Park
New York, New York 10013
(212) 982-7441
Hours: By appointment
Type of Collection:
Gallery/bookstore, collecting since 1982
1500 books (48% multiples, 30% limited edition, 15% one-of-a-kind, 2% artists' magazines, 5% literary small press/ 80% 1975-84, 10% 1970-75, 10% 1960-70)

Bibliography of Secondary Sources

This bibliography was compiled from several separate bibliographies provided by Janet Dalberto (Virginia Commonwealth University), Judith Hoffberg (Umbrella Associates), Clive Phillpot (The Museum of Modern Art), and Barbara Tannenbaum (Oberlin College). These bibliographies were collated, expanded, and verified by Barbara Bosworth and Glenn Knudson of the Visual Studies Workshop under the direction of Helen Brunner. Don Russell, Skúta Helgason, Robert Hewitt, David Kwasigroh, Natalie Magnan, Scott McCarney, Linn Underhill, and James Via provided research assistance. Additional assistance regarding European sources was provided by Ulises Carrión (Other Books And So) and Leif Eriksson (The Swedish Archive of Artists' Books). Barbara Tannenbaum has updated the bibliography to include references from September, 1983 (when the project was concluded at Visual Studies Workshop) to September, 1984.

ARTICLES

Adams, Hugh. "Alexander Rodchenko: The Simple and the Commonplace." *Artforum* (Summer 1979): 28-31.

Alexander, John. "Distribution." *The Dumb Ox* 4 (Spring 1977): 25.

Alloway, Lawrence. "Artists as Writers." *Artforum* 12, no. 8 (April 1974): 30-35.

Alloway, Lawrence. "Notebook Art." *Arts Magazine* 41, no. 8 (Summer 1967): 22-23.

Alloway, Lawrence. "Sol LeWitt: Modules, Walls, Books." *Artforum* 13, no. 8 (April 1975): 38-44.

Anderson, Alexandra. "Book Ends." *Flue* 3, no. 1 (1983): 30.

Anderson, Alexandra. "Scrapbooks, Notebooks, Letters, Diaries–Artists' Books Come of Age." *Artnews* 77, no. 3 (March 1978): 68-70.

"Art Alternatives in Print." *Lightworks* 14/15 (Winter 1981/82): 57-60.

"Art Publishing Conference to be Held in Rochester." *Umbrella* 2, no. 5 (September 1979): 101.

"Art Publisher and Jobber Opens a Bookshop in New York." *Publishers Weekly* 212, no. 25 (December 26, 1977): 54.

"Artists' Magazines: The Raw and the Resurrected." *Afterimage* 8, no. 8 (March 1981): 17.

Ashton, Dore. "New York Community." *Studio International* (May 1968): 272-273.

"Associated Art Publishers Conference in Chicago: An Overview." *Umbrella* 1, no. 6 (1978): 131.

Attwood, Martin. "The Art World: Artists' Books, Art Books, and Books on Art." *New Yorker* (January 25, 1982): 74-75.

Austin, Gabriel. "The Modern Illustrated Book: A Neglected Field for Collectors." *Print Collector's Newsletter* 4, no. 6 (January-February 1974): 130-131.

Avgikos, Jan. "So Many Bookies in One Place." *Atlanta Artworkers Coalition Newspaper* (January 1980): 6-7.

Barendse, Henri Man. "Ed Ruscha: An

Interview." *Afterimage* 8, no. 7 (February 1981): 8-10.

Bauer, G. "Max Ernst's Collagenroman, 'une semaine de Bonte.'" *Wallraf-Richartz Jahrbuch* (1977): 237-257.

Bell, Doris. "Artists' Books." *Contemporary Art Trends 1960-1980: A Guide to the Sources.* Metuchen, New York: Scarecrow Press, 1981: 25-27.

Bell, Jane. "Dada in Iowa." *Art Express* 1, no. 2 (September-October 1981): 36-40.

Bois, Y.-A. "El Lissitzky: Reading Lessons." *October*, no. 11 (Winter 1979): 113-128.

"Bookworks: 82 Update." *Umbrella* 5, no. 4. (September 1982): 87.

Bool, Flip and Gerrit Jan de Rook. "Het Boek als Kunstwerk in Nederland." *M.J.; museumjournaal voor moderne kunst* 22 (December 1977): 250-259.

Bourdon, David. "Ruscha as Publisher: (Or All Booked Up)." *Artnews* 71, no. 2 (April 1972): 32.

Braun, Barbara. "Artists' Books." *Small Press* 2, no. 1 (September-October 1984): 64-73.

Braun, Barbara. "Art Books-3: Leftovers and New Directions." *Publisher's Weekly*, 244, no. 18 (October 28, 1983): 64-73.

Brody, Jacqueline. "On and Off the Wall: Barton Lidice Benes." *Print Collector's Newsletter* 9, no. 6 (January-February 1979): 183-189.

Brody, Jacqueline. "Peter Frank: A Case for Marginal Collectors." *Print Collector's Newsletter* 9, no. 2 (May-June 1978): 40-46.

Buchloh, Benjamin H.D. "Marcel Broodthaers: Allegories of the Avant-garde." *Artforum* 18, no. 9 (May 1980): 52-59.

Buonagurio, Edgar. "Artists' Books and Notations." *Arts* 53, no. 3 (November 1978): 5.

Burnham, Linda. "Franklin Furnace— Linda Burnham Interviews Martha Wilson and Bill Gordh." *High Performance,* 5, no. 3, Issue 19 (1982): 48-57.

Cameron, Eric. "Lawrence Weiner: The Books." *Studio International* 187, no. 962 (January 1974): 2-8.

Candau, Eugenie. "Philip Smith: Artist of the Book." *Fine Print* 2, no. 1 (January 1976): 1-5.

Carrión, Ulises. "Mail Art and the Big Monster." *(LAICA) Journal* 20 (October-November 1978): 54-56.

Carrión, Ulises. "We Have Won! Haven't We?" *Flue* 3, no. 2 (Spring 1983): 39-41.

Carrión, Ulises. (see listing in the BOOKS section of this bibliography).

Cebulski, F. "Books in an expanded context." *Artweek* (July 4, 1981): 5-6.

Celant, Germano. "Book as Artwork 1960/70" *Data* 1, no. 1 (September 1971): 35-49. Text in Italian.

Celant, Germano. "Book as Artwork: 1960-72." *Books by Artists.* Tim Guest, ed. Toronto: Art Metropole, 1981: 85-104.

Celant, Germano. "Das Buch aß Kunstform 1960-1970." *Interfunktionen* 11 (1974): 80-105. Includes Bibliography of Artists' Books 1960-1974.

Celant, Germano. "Le Livre Comme Travail Artistique 1960-1970." *VH 101* 9 (Autumn 1972): 5-28. Includes Bibliography of Artists' Books 1960-1972.

Chapon, F. "Ambroise Vollard Éditeur." *Gazette des Beaux-Arts* 94, 95 (July 1979, January 1980): 33-47, 25-38.

Claura, Michel. "Libri e Dischi d'Artista/ Artists' Books and Records." *Contemporanea.* Firenze: Centro Di, 1973; 411-422.

Cohen, Arthur A. "Futurism and Constructivism: Russian and Other." *Print Collector's Newsletter* 7, no. 1 (March-April 1976): 2-4.

Cohen, Arthur A. "Gunnar Kaldewey's New York." *Print Collector's Newsletter* 10, no. 5 (November-December 1979): 156.

Cohen, Arthur A. "The Bolted Machine-Book of Fortunato Depero." *Art News* 81 (May 1982): 118-119.

Cohen, Arthur A. "The Typographic Revolution: Antecedents and Legacy of Dada Graphic Design." *Dada Spectrum: The Dialectics of Revolt,* Stephen C. Foster and Rudolf E. Kuenzli, eds., Madison, Wisconsin: Coda Press, Inc., and Iowa City, Iowa: University of Iowa, 1979: 71-89.

Cohen, Ronny H. "Art and Letters: Please Mr. Postman Look and See . . . Is There a Work of Art in Your Bag for Me?" *ArtNEWS* 80 (December 1981): 68-73.

Cohen, Ronny H. "Seeing Between the Pages." *Artforum* 18, no. 6 (February 1980): 50-52.

Cohen, Ronny H. "Ida Applebroog: Her Books." *Print Collector's Newsletter* 15, no. 2 (May-June 1984): 49-51.

Coleman, Allan D. "Ed Ruscha (I): 'My Books End Up in the Trash.'" *Light Readings.* New York: Oxford University Press, 1979: 113-115. (Also published in *New York Times*, August 27, 1972).

Coleman, Allan D. "Ed Ruscha (II): 'I'm Not Really a Photographer.'" *Light Readings.* New York: Oxford University Press, 1979: 116-118.

Coleman, Catherine. "The Artist's Book in Spain" (in Spanish). *Libros de Artistas.* Madrid: Ministerio de Cultura. Dirección General de Bellas Artes, Archivos Y Bibliotecas, 1982: 36-45.

Cook, Jno. "Visual Criticism in Photography." *Nit & Wit* 3, no. 5 (November-December 1981): 39-41.

Coplans, John. "Edward Ruscha Discusses His Perplexing Publications." *Artforum* 3, no. 5 (February 1965): 24-25.

Creeley, Robert. "Some Place Enormously Moveable." *Artforum* 18, no. 10 (Summer 1980): 37-41.

Cummings, Stephen. "Artists' Books and Bookworks: A Review of Recent Evidence." *Amphora* 49, (September 1982).

Cundy, David. "Marinetti and Italian Futurist Typography." *Art Journal* 41, no. 4 (Winter 1981): 349-351.

Curtay, Jean-Paul. "Chronology." *Visible Language* XVII, no. 3 (Summer 1983): Special Issue, "Lettrisme: Into the Present": 13-17.

Curtay, Jean-Paul. "Super-Writing 1983 – America 1683." *Visible Language* XVII, no. 3 (Summer 1983): Special Issue, "Lettrisme: Into the Present": 26-47.

d'Arbeloff, Natalie. "The Artist as Book Maker: The Production and Distribution of a Contemporary livre d'artiste." *Art Libraries Journal* (Spring 1976): 33-38.

Dalberto, Janet. "Acquisition of Artists' Books." *Art Documentation* 1, no. 6 (December 1982): 169-171.

Dalberto, Janet. "Contemporary Multiple Edition Artists' Books: A Bibliography of Information Sources." *Art Documentation* 1, no. 6 (December 1982): 178-181.

Dane, William. "Remarks." *Art Documentation* 1, no. 6 (December 1982): 173-174.

DeAk, Edit. "According to the Book." *Printed Matter Catalog 1981.* New York: Printed Matter, Inc., 1981: 5.

DeAk, Edit and Robinson, Walter. "Printed Matter and Artists' Books." *Journal* no. 13 (January-February 1977): 28-30.

[DeNeve, Rose] "On the Moonlight Express, a Book is only Paper Sewn Together." *Print* 30, no. 1, (January-February 1976): 64-70.

Dittmar, Rolf. "Ein Buch ist nicht nur Lesegriessbrei." *Kuntsformen International* 21, no. 3 (1977).

Dittmar, Rolf. "Metamorphosen des Buches." *Documenta* 6 (1977): 296-299.

Dittmar, Rolf. "Metamorphosis of the Book: Artists' Books." *Kunstwerk* 30 (June 1977): 8.

Drucker, Johanna. "Letterpress Language: Typography as a Medium for the Visual Representation of Language." *Leonardo* 17, no. 1 (1984): 8-16.

Duciaume, Jean-Marcel. "Le Livre d'artiste au Québec: Contribution à une histoire." *Etudes Francaises* 18, no. 2 (Automne 1982): 89-98.

Dugan, Thomas. "Moves and Changes: an Interview with Telfer Stokes." *Afterimage* 10, no. 3 (October 1982): 5-7.

Edgar, Anne. "A Conversation with Printed Matter." *Afterimage* 12, no. 6 (January 1985): 9-11.

Edgar, Anne. "Franklin Furnace." *Art Documentation* 1, no. 6 (December 1982): 176.

Edmiston, Lori. "Book Art is Book Art is Not." *Throttle* (November-December 1982): 14.

Eiland, Bill. "State of the Artbook: An

Essay." *Mid-South Small Press Design Exhibition.* Clarksville, Tennessee: Austin Perry State University, 1982.

"Enkat/Short Survey." **Konstnärsböcker/ Artists' Books.* Sven Nordgren, ed. Ahus: Kalejdoskop, 1980: 23-33. Illus. *Statements by 17 artists on artists' books.

Enzenberger, Hans Magnus. "The Virtues of the Needle and the *Other Book.*" *Disraise* no. 2 (Summer 1980). (Also published in *Die Zeit,* April 28, 1978).

Eriksson, Leif. "Svenska Konstnärsböcker." *Paletten* 4 (1981): 13-19.

Eriksson, Leif. "Swedish Artists' Books, Franklin Furnace, Scandinavia Today och NUNSKU!" *Konst-och bildforskning* 4 (1983): 34-35.

Farmer, Jane M. "Prints and the Art of the Book." *Print Review* 13 (1981): 69-80. Illus.

Finkel, Candida. "Chicago Books Begins Publishing Program." *Afterimage* 5, no. 9 (April 1978): 17-18.

Finkel, Candida and Buzz Spector. "McLuhan's Mistake–The Book is Back." *The New Art Examiner* 5, no. 6 (March 1978): 6-7.

Frank, Peter. "Confessions of a Professional Bookie." *The Dumb Ox* 4 (Spring 1977): 58.

Frank, Peter. "Fluxus in New York." *Akademie der Kunste, Berliner Festwochen* (October 1976). Also published in *Lightworks,* no. 11/12 (Fall 1979): 28-36.

"Franklin Furnace Launches Newsletter." *Afterimage* 8, no. 4 (November 1980): 21.

Friedman, Ken. "Bookworks Bloom in '82." *Art Economist* 11, no. 13 (October 27, 1982): 8.

Friedman, Ken. "George Maciunas: In Memoriam." *Umbrella* 1, no. 3 (1978): 69. Also published in *High Performance* (Spring 1981): 20-27.

Friedman, Ken. "Ken Friedman Live." *Impressions* (Spring 1980): 4-5.

Friedman, Ken. "Notes On The History of the Alternative Press." *Lightworks* 8/9 (January 1978): 41-47.

Friedman, Ken and Felipe Ehrenberg. "Facts in Flux." Letter to the editor from Ken Friedman, and Felipe

Ehrenberg's reply. *Afterimage,* Vol. 11, nos. 1&2 (Summer, 1983): 2.

Gerlovin, Rimma and Valery. "Russian Samizdat Books." *Flue* 2, no. 2 (Spring 1982): 10-15.

Gever, Martha. "Artists' Books, Alternative Space or Precious Object?" *Afterimage* 9, no. 10 (May 1982): 6-8.

Gever, Martha. "Art is an Excuse: An Interview with Felipe Ehrenberg." *Afterimage* 10, no. 9 (April 1983): 12-18.

Gill, Eric. "The Artist and Book Production." *Fine Print* 8, no. 3 (July 1982): 96-97.

Gilmour, Pat. "The Book as Object." *Art & Artists* 4, no. 4 (July 1971): 24-27.

Giusto, Joann. "Art Publisher and Jobber Opens a Bookshop in N.Y." *Publishers Weekly* 212, no. 25 (December 26, 1977): 54.

Glier, Mike. "Printed Matter." *Artery* 5, no. 4 (April 1982): 10-11.

Glueck, Grace. "When Is a Book Not a Book?" *New York Times* (Friday, March 18, 1977): C18.

Goldberg, Stephanie. "Art Facts: Chicago Artists Press Forward." *The Reader* (Chicago) (October 13, 1978): 7.

Goldstein, Howard. "Some Thoughts on Artists' Books" (in Spanish). *Libros de Artistas.* Madrid: Ministerio de Cultura. Direccion General de Bellas Artes, 3 Archivos Y Bibliotecas, 1982: 29-35.

Godine, David. "The Small Press as Business." *Fine Print* 7, no. 4 (October 1981): 118-120, 149-150.

Graham, Dan. "The Book As Object." *Arts Magazine* 41, no. 8 (Summer 1967): 23.

Green, Simon. "Raw Materials for Papermaking." *Fine Print* 7, no. 2 (April 1981): 40-43, 68-69.

Greenwood, David. "The Book as an Aesthetic Object." *Fine Print* 2, no. 4 (October 1976): 57-60.

Greyson, John. "Art Publishers Conference." *Fuse* 4, no. 2 (January 1980): 80-82.

Griffiths, Julia. "Making Books." *Women Artists News* (Summer 1982): 19-21.

Hagen, Charles. "Robert Cummings Subject Object." *Artforum* 21, no. 10 (June 1983): 36-41.

Hamilton, Richard. "The Books of Diter

Rot." *Typographica* 3 (June 1961): 21-40.

Harris, Eugenia. "Artists' Books: Distribution is the Problem." *Afterimage* 4, no. 4 (October 1976): 3.

Harris, Leon. "Are you in a bind for a Christmas gift?" *Town and Country* (May, 1981): 211.

Heller, Steve. "Artists' Sketchbooks." *Print* 35, no. 6 (November-December 1981): 33-63.

Heller, Steve. "Raw Art." *Print* 35, no. 3 (May-June 1981): 32-34.

Hendricks, Jon and Gilbert Silverman. "Aspects of Fluxus from the Gilbert and Lila Silverman Collection." *Art Libraries Journal,* 8, no. 3 (Autumn, 1983): 6-25.

Henry, Gerrit. "It's Delightful, It's Delicious, It's Deluxe." *Print Collector's Newsletter* 15, no. 2 (May-June 1984): 45-46.

Hershman, Lynn Lester. "Slices of Silence, Parcels of Time: The Book as a Portable Sculpture." *Artists' Books.* Philadelphia: Moore College of Art, 1973.

Hess, Thomas B. "A Tip from the Bookmakers (Invest in Artists' Books)." *New York* (January 17, 1977): 92.

Higgins, Dick. "A Book." *New Wilderness Letter,* no. 11 (December 1982): 46-47.

Higgins, Dick. "The Epickall Quest of the Brothers Dichtung." *High Performance* 1, no. 4 (December 1978): 16-18.

Higgins, Dick. "What to Look for in a Book – Physically." *Something Else Press, Inc. Catalogue* (1965-66).

Higgins, E. F. III. "Artists' Stamps." *Print Collector's Newsletter* 10, no. 5 (November-December 1979): 154-156.

Hodell, A. "Ur Kerberos Memoarer/From Kerberos's Memoirs." *Konstnärsböcker/Artists' Books.* S. Nordgren, ed. Åhus: Kalejdoskop, 1980: 42-53.

Hoffberg, Judith. "Alternative Art Publishing Conference." *Umbrella* 2, no. 6 (1979): 128-131.

Hoffberg, Judith. "Artists' Books." *Paper-Art and Technology.* Paulette Long, editor. San Francisco: World Print Council, 1979: 70-75.

Hoffberg, Judith. "Artists' Books: A Selected Bibliography of Exhibition Catalogs and Exhibitions." *The Dumb Ox* 4 (Spring 1977): 63.

Hoffberg, Judith. "Bern Porter: An Interview." *Umbrella* 3, no. 5 (September 1980): 93-94.

Hoffberg, Judith. "Bookworks: 1982 Conference in Philadelphia." *Umbrella* 4, no. 4 (1981): 82.

Hoffberg, Judith. "Introductions: Ligua Press, La Jolla." *Umbrella* 4, no. 2 (1981): 29.

Hoffberg, Judith. "Libros de Artistas Mexicanos en Artworks/Obras en Formato de Libro: Renacimiento entre los Artistas Contemporáneos." *Artes Visuales* 27/28 (March 1981): 42-60.

Hoffberg, Judith. "The Museum is the Mailbox." *Artwords and Bookworks: An International Exhibition of Recent Artists' Books and Ephemera.* Los Angeles: Los Angeles Institute of Contemporary Art, 1978: n.p.

Hoffberg, Judith. "Paul Zelevansky: A Bookmaker With a Case." *Umbrella* 4, no. 5 (1981): 128-129.

Hoffberg, Judith. "Profile: Other Books and so." *Umbrella* (January 1978): 1.

Hoffberg, Judith. "Regula Huegli: Bookmaker from Basle." *Umbrella* 4, no. 4 (1981): 109-110.

Hoffberg, Judith. "Back and Forth, Open and Close: An Interview with Kevin Osborn." *Umbrella* 6, no. 2 (March 1983): 34-38.

Hoffberg, Judith. "From Book Heaven to the Inferno: On the Road with JAH." *Umbrella* 6, no. 5 (November 1983): 138-142.

Hoffberg, Judith. "Profile: Maurizio Nannucci and Zona, Florence." *Umbrella* 6, no. 5 (November 1983): 143-145.

Hoffberg, Judith. "Profile: Coach House Press, Toronto." *Umbrella* 7, no. 1 (January 1984): 3-7.

Hoffberg, Judith. "Profile: Coracle Press, London." *Umbrella* 7, no. 1 (January 1984): 26.

Hoffberg, Judith. "The Women Artists' Books: A Select Bibliography." *Chrysalis* 5 (1977): 85-87.

Hoffberg, Judith A. "The Artists' Book Anthologist: Alex Heibel." *Umbrella* 6, no. 1 (January 1983): 24-26.

Hoffberg, Judith A. "Spineless Books and

Courageous Artists." *Artery* 5, no. 4 (April 1982): 3-6.

Hogan, Matthew. "A Report From the Archives." *Flue* 3, no. 1 (1983): 3-4.

Howell, John. "A Syntax of Self." *Art-Rite*, no. 14 (Winter 1976-77): 32-35.

Huebner, Carol. "Artists' Books: A Survey 1960-1981." *Artery* 5, no. 4 (April 1982): 1-2.

Hugo, Joan. "Artists' Books: Primers of Visual Literacy." *The Dumb Ox* 4 (Spring 1977): 22-23.

Hugo, Joan. "A French Connection." *Artweek*, 14, no. 42 (December 10, 1983): 7.

Hugo, Joan. "Museum without Walls." *Artwords and Bookworks: An International Exhibition of Recent Artists' Books and Ephemera*. Los Angeles: Los Angeles Institute of Contemporary Art, 1978: n.p.

Hugunin, James. "Rachel Youdelman: A Pleasant Sense of Ennui." *Afterimage* 7, no. 7 (February 1980): 6-7.

Hunt, Annette. "Women's Graphic Center: New Funding." *Spinning Off* (September 1979): 1.

Iskin, Ruth E. " 'Female Experience in Art:' The Impact of Women's Art in a Work Environment." *Heresies* I (January 1977): 71-78.

Janecek, Gerald. "Kruchonykh: Maker of Minimal Books." *Lightworks* 14/15 (Winter 1981-82): 48-49.

Katz, Vincent. "Interview with Tom Phillips." *Print Collector's Newsletter* 15, no. 2 (May-June 1984): 47-49.

Kingsley, April. "The Lengthening Shadow or the Legacy of Marcel Duchamp." *The Village Voice* 24, no. 10 (March 5, 1979): 72.

Kingsley, April. "Looks in print." *Village Voice* (August 14, 1978): 67.

Knowles, Alison. "On the Book of Bean." *New Wilderness Letter*, no. 11 (December 1982): 35-40.

Kostelanetz, Richard. "Book Art." *Only Paper Today* 5, no. 9 (December 1977): 1.

Kostelanetz, Richard. "Book Art." *Journal* 17 (January-February 1978): 32-33. (Also published in S. Nordgren, *Konstnärsbücher*, 1980).

Kostelanetz, Richard. "On Book-Art." *Leonardo* 12, no. 1 (Winter 1979): 43-44. (Also published in S. Nordgren,

Konstnärsbücher, 1980).

Kuenzli, Rudolf E. "The Semiotics of Dada Poetry." *Dada Spectrum: The Dialectics of Revolt*. Madison, Wisconsin: Coda Press, Inc. and Iowa City: University of Iowa, (1979): 51-70.

Kyle, Heidi. "The Featured Bookbinding: *Anaphanda*." *Fine Print* 10, no. 3 (July 1984): 114-115, 132.

Labrot, Syl. "Syl Labrot: Work in Progress." *Afterimage* 2, no. 3 (September 1974): 7-10.

Lederman, Stephanie Brody, Theodora Skiptares and Amy Brook Snider, eds. "Twenty-Seven Personal Records," *Heresies* (May 1977): 57-70.

Leverant, Robert. "How Is It That The Familiar Is Repeated In Photography Books?" *Afterimage* 6, no. 6 (January 1979): 6-9.

Lewis, Rebecca. "Spreading the Word(s and Images): Artist's Book Distribution." *Afterimage* 12, nos. 1&2 (Summer 1984): 7.

Linker, Kate. The Artist's Book as an Alternative Space. *Studio International* 195, no. 990 (1980): 75-79.

Linker, Kate. "Out of the Galleries, Into the Books." *Seven Days* 2, no. 15 (October 13, 1978): 28-29.

Linn, Nancy. "Women Artists' Books." *Woman's Art Journal* 3, no. 1 (1982) 27.

Lippard, Lucy. "The Artist's Book Goes Public." *Art in America* 65, no. 1 (January-February 1977): 40-41.

Lippard, Lucy R. "Fast Forward, A Rapid Zineology." *The Village Voice* (September 6, 1983): 72

Lippard, Lucy. "Going Over the Books." *Artweek* 7, no. 37 (October 30, 1976): 11-12.

Lippard, Lucy. "The Structures, the Structures and the Wall Drawings, the Structures and the Wall Drawings and the Books." *Sol LeWitt*. Alicia Legg, ed. New York: Museum of Modern Art, 1978.

Lippard, Lucy. "Surprises: An Anthological Introduction to Some Women Artists' Books." *Chrysalis* 5 (1977): 71-84.

Lloyd, Gary. "A Talk with Ed Ruscha." *The Dumb Ox* 4 (Spring 1977): 5-7.

Loach, R. "Handmade Book ... A Contemporary Update." *Visual Dialog*

4, no. 4 (Summer 1979): 29-31.

Loeffler, Carl E. "La Mamelle." *The Dumb Ox* 4 (Spring 1977): 40-41.

Lord, Catherine. "Getting Down to Business in Philly, or, You Can Tell a Bookwork by its Package." *Afterimage* 10, no. 5 (December 1982): 3.

Lord, Catherine. "NEA Announces 1982 Fellowships for Photography, Video, Artists' Books." *Afterimage* 10, no. 3 (October, 1982): 3.

MacDonald, Scott. "ALL HAN ZON DEK!" *Afterimage* 12, no. 6 (January 1985): 4-6.

Mackay, Allan. "Iain Baxter/N.E. Thing Co. Ltd." *Pluralities 1980 = Pluralities 1980*. Ottawa: National Gallery of Canada, 1980: 23-28.

Mallarmé, Stephane (translated by Michael Biggs). "Le Livre, Instrument Spirituél (The Book Spiritual)." *New Wilderness Letter*, no. 11 (December 1982): 1-5.

Magnan, Nathalie. "The Independent Press Archive at the Visual Studies Workshop Research Center." *Art Documentation* 2, no. 5 (October 1983): 142-143.

"Making Book." *Art in America* 64, no. 3 (May-June 1976): 152.

Markovich, Ann. "Artists' Books Subject of Philly conference." *New Art Examiner* 10, no. 2 (November 1982): 30.

Martin, F. "Art and History–Mail Art." *Artweek* 12, no. 37 (November 7, 1981): 3.

Martin, Henry. "An Interview with George Brecht." *Art International* 11, no. 9 (November 20, 1967): 20-24.

Marzorati, Gerald. "Franklin Furnace: Artists' Books." *Art Workers News* (October, 1976): 9.

Medvedow, Jill. "(Con)Texts: Update on the Collection/International Mail Art." *Flue* 2, no. 1 (1981): 7-8.

Meinwald, Daniel. "Making Book." *Camera Arts* 3, no. 7 (July 1983): 10-13, 77.

Mitchell, Breon. "German Expressionist Art and the Illustrated Book." *Fine Print* 3, no. 2 (April 1977): 25-30.

Mitchum, Trina. "A Conversation with Ed Ruscha." *(LAICA) Journal* 21 (January-February 1979): 21-24.

Moore, Barbara. "George Maciunas: A Finger in Fluxus." *Artforum* 21, no. 2 (October 1982): 38-45.

Morgan, Robert C. "Fables, Grids and Swimming Pools: Phototexts in Perspective." *Journal-Southern California Art Magazine.* 24 (September-October 1979): 39-43.

Morgan, Robert D. "Pastel, Juice and Gunpowder: The Pico Iconography of Ed Ruscha." *(LAICA) Journal* 30 (September-October 1981): 26-31.

"Multiples." *Art and Artists* 4, no. 3 (June 1969): 27-65.

"Multiples 2." *Art and Artists* 5, no. 8 (November 1970): 57-81.

"Multiples by Latin American Artists." Introduction by Fatima Brecht. *Flue* 3, no. 2 (Spring 1983): 31-38.

Myers, George Jr. "Terry Braunstein: perceptive bookmaker." *Umbrella* 6, no. 4 (September 1983): 105-106.

Needham, Paul. "Reference Shelf." Review of *The Printing Press as an Agent of Social Change* by Elizabeth Eisenstein. *Fine Print* 6, no. 1 (January 1980): 32-35.

Neidel, H. "Bücher als Kunstobjekte." *Du* 1 (1981): 82-83.

"News of the Print World: People and Places: Books plain & fancy—supply & demand." *Print Collector's Newsletter* 15, no. 2 (May-June 1984): 61-62.

"New Type at Printed Matter." *Print Collector's Newsletter* 9, no. 1 (March-April 1978): 16.

O'Grady, Holly. "Dick Higgins and the Something Else Press." *Reallife Magazine* 2 (October 1979): 13-14.

Olin, Ferris. "Artists' Books: From the Traditional to the Avant-Garde." *Art Documentation* 1, no. 6 (December 1982): 172-173.

Osterman, Gladys. "Printed Matter." *Women Artists News* 7, no. 6 (Summer, 1982): 13-18.

Overy, Paul and Lavinia Learmont. "London." (Ian Breakwell). *Art and Artists* 2, no. 2 (March 1977): 30-34.

"Paradine's Artists' Books." *Arts Review* 30, no. 22 (November 10, 1978): 609.

Paschall, Jo Anne. "Artists' Books— Access and Publicity." *Art Documentation* 1, no. 6 (December 1982): 172.

Payant, René. "L'Émancipation du Livre

d'Artiste." *Etudes Francaises* 18, no. 3 (Hiver 1983): 119-129.

"Permanent Press." *Lightworks*, no 11/12 (Fall 1979): 56-58.

Perreault, John. "Some Thoughts on Books as Art." *Artists' Books.* Philadelphia: Moore College of Art, 1973.

Phillips, Deborah C. "Definitely Not Suitable for Framing." *Artnews* 80, no. 10 (December 1981): 62-67.

Phillpot, Clive. "Artists' Books and Book Art." In *Art Library Manual: A Guide to Resources and Practice,* edited by Philip Pacey, 355-363. NY: Bowker, 1977.

Phillpot, Clive. "Artists' Books." *Art Journal* 39, no. 3 (Spring 1980): 213-217.

Phillpot, Clive. "Artists' Books." *Flue* 1, no. 1 (September 1980): 1-2.

Phillpot, Clive and Lynne Tillman. "An Interview with Charles Henri Ford." *Flue* 1, no. 4 (December 1980): 5-8.

Phillpot, Clive. "Art Magazines and Magazine Art." *Artforum* 18, no. 6 (February 1980): 52-54.

Phillpot, Clive. "Book Art Digressions." *Artists' Books*, edited by Martin Attwood. London: Arts Council of Great Britain, 1976.

Phillpot, Clive. "Books Bookworks Book Objects Artists' Books." *Artforum* 20, no. 9 (May 1982): 77-79.

Phillpot, Clive. "Collecting Printed Ephemera." *Print Collector's Newsletter* 9, no. 2 (May-June 1978): 48-49.

Phillpot, Clive. "Feedback." *Studio International* 184, no. 947 (September 1972): 64.

Phillpot, Clive. "Feedback." *Studio International* 186, no. 957 (July-August 1973): 38.

Phillpot, Clive. "Leaves of Art: Book Art in Britain." *British Book News* (April 1977): 271-273.

Phillpot, Clive. "Two Decades of Book Art." *Views* 5, no. 1 (1983): 13-15.

Pindell, Howardena. "Alternative Space: Artists' Periodicals." *Print Collector's Newsletter* 8, no. 4 (September-October 1977): 96-109, 120-121.

Pindell, Howardena. "Artists' Periodicals: An Event for 1984 or Page 2001." *Art Journal* 39, no. 4 (Summer 1980): 282-283.

Pindell, Howardena. "Artists' Periodicals Update, 1977-80." *Print Collector's Newsletter* 9, no. 1 (March-April 1980): 13.

Pontbriand, Chantal. "General Idea." *Pluralities 1980 = Pluralities 1980.* Ottawa: National Gallery of Canada, 1980: 61-66.

Princenthal, Nancy. "Recent Artists' Books, or How to Invest $100 in Artists' Books Published Since 1980." *Print Collector's Newsletter* 15, no. 2 (May-June 1984): 52-56.

"Profile: Center for Book Arts." *Umbrella* 1, no. 5 (1978): 99.

"Profile: Forrest Avenue Consortium, Atlanta." *Umbrella* 1, no. 6 (1978): 142.

"Profile: Warja Lavater, Bookmaker Extraordinaire." *Umbrella* 2, no. 6 (1979): 144-145.

Quasha, George. "Auto-Dialogue on the Transvironmental Book: Reflections on *The Book of Bean*." *New Wilderness Letter*, no. 11 (December 1982): 41-43.

Radice, B. "Interview with Ed Ruscha." *Flash Art*, no. 54-55 (May 1975): 49.

Restany, P. "Forum: Mail Art for Panama." *Domus* 598 (September 1979): 54-55.

Robertson, Clive. "Booking Off." *Fuse* 5, no. 10 (January-March 1982).

Roman, Gail. "The Ins and Outs of Russian Avant-Garde Books: A History 1910-1940." *The Avant-Garde in Russia, 1910-1930: New Perspectives.* S. Barron and M. Tuchman, eds. Los Angeles: Los Angeles County Museum of Art, 1980: 102-109.

Roman, Gail Harrison. "Russian Avant-Garde Book Design." *Flue* 2, no. 1 (Winter 1982): 3-5, 30-31.

Rosenbaum, Lee. "Making Book." *Art in America* 64, no. 3 (May-June 1976): 152.

Roth, Helen. "Women's Graphic Center." *The Dumb Ox* 4 (Spring 1977): 38-39.

Roth, Moira. "Visions and Re-Visions: Rosa Luxemberg and the Artist's Mother." *Artforum* 19, no. 3 (November 1980): 36-39.

Rubinfien, Leo. "Artists' Sketchbooks." *Artforum* 15, no. 7 (March 1977): 53-55.

Russell, John. "Illustrated Books Are Making a Comeback." *New York Times* (August 28, 1983).

Russell, John. "In the Shadow of Duchamp." *New York Times* (July 27, 1979): C16.

Salle, David. "Between Covers." *Art-Rite*, no. 14 (Winter 1976-77): 36-37.

Samson-Le Men, S. "Quant au Livre Illustré . . ." *Revue de l'Art* 44 (1979): 85-102.

Sharp, Willoughby. ". . . A Kind of a Huh?" *Avalanche* 7 (Winter/Spring 1973): 30-39.

"Shoulder Notes." *Fine Print* 3, no. 3 (July 1977): 66.

Sifford, Harlan L. "Artist Book Collecting and Other Myths of Art Librarianship." *Art Documentation* 1, no. 6 (December 1982): 174-175.

Simon, Joan. "The Art Book Industry Problems and Prospects." *Art in America* (Summer 1983): 19-25.

Sischy, Ingrid. "If Marshall McLuhan were a Gypsy and his Teacup the Art World; the Tea Leaves Would Be Artists' Books." *National Arts Guide 1*, no. 1 (January-February 1979): 2-3.

Smith, Keith. "Visual, Physical, Conceptual Transition in Books." *The New Art Examiner* 5, no. 6 (March 1978): 8.

Smith, Phillip. "Balancing the Books; Notes on Two Different Worlds of Bookmaking." *Fine Print* 3, no. 1 (January 1977): 1-4.

Sonneman, Eve. "Street-talk on artists' books." *Art-Rite*, no. 14 (Winter 1976-77): 49.

Spector, Buzz. "Artists' Books." *New Art Examiner* 6, no. 3 (December 1978): 8, 23.

Spector, Buzz. "Interview with Ira Wool." *Flue* 3, no. 1 (1983): 12-14, 28.

Spector, Naomi. "A tour among seventeen titles with almost as many definitions of artists' books." *Art-Rite*, no. 14 (Winter 1976-77): 46-48.

Spies, Werner. "Take and Devour: The Book as Object." *Focus on Art*. Translated by Luna Carne-Ross and John William Gabriel. New York: Rizzoli, 1982, 238-242.

Stellweg, Carla. "Impresiones: Libros de Artistas." *Artes Visuales* 27/28 (March 1981): 41.

Stern, Anatol. "Avant-garde Graphics in Poland between the Two World Wars." *Typographica* 9 (June 1964): 2-20.

Suess, Penelope. "Women and the Printing Arts." *The Dumb Ox* 4 (1977): 39.

Tannenbaum, Barbara. "Artists' Books: A Chronology of Secondary Sources." *Flue* 3, no. 1 (1983): 20-21, 24-25, 28.

Tannenbaum, Barbara. "Artists' Books: Touch Me, Feel Me, Take Me Home." *Michigan Artists' Books 1980*. Ann Arbor: Evergreen Art Alliance, 1980: n.p.

Tannenbaum, Barbara. "The Medium Is Only a Part, But a Very Important Part of the Message" (in Spanish). *Libros de Artistas*. Madrid: Ministerio de Cultura. Dirección General de Bellas Artes, Archivos Y Bibliotecas, 1982: 18-24.

Taylor, M. "Books for Whose Sake?" *Crafts* no. 63 (July-August 1983): 15-19.

Tomkins, Calvin. "Artists' Books, Art Books, and Books on Art." *New Yorker* (January 25, 1982): 74.

Tousley, N. "Artists' Books." Review of an exhibition at Moore College of Art. *Print Collector's Newsletter* 4, no. 6 (January-February 1974): 131-134.

Trebay, Guy. "Charles Henri Ford has a Better Idea." *The Village Voice* 25, no. 48 (November 26-December 2, 1980): 57.

Treib, Marc. "Blips, Slits, Zits, and Dots: Some (Sour) Notes on Recent Trends in Graphic Design." *Print* 35, no. 1 (January-February 1981): 27 + .

Upton, B. "Photographs and Books as Natural Partners." *Museum News* 54, no. 3 (January-February 1976): 32-37. Illus. (Includes Ruscha *Sunset Strip*).

Vallier, D. "Le Livre-objet." *Oeil*, no. 333 (April 1983): 56-57.

van Raay, Jan. "Profile: Ulises Carrión: An End and A Beginning." *Umbrella* 2, no. 5 (September 1979): 120-121. First published in *Artzien* 1, no. 3 (January 1979).

Van Vliet, Claire. "Some Thoughts on Expressionism." *Fine Print* 3, no. 2 (April 1977): 26-27.

von Zahn, Irena. "Jaap Rietman, the reigning art book dealer in Soho." *Art-*

Rite, no. 14 (Winter 1976-77): 50.

Waterston, Sue. "Artists' Books." *Arts Review* 30, no. 22 (November 10, 1978): 600-602.

Weinberg, Adam. "Art Between the Covers." *Afterimage* 7, no. 6 (January 1980): 16.

Welish, Marjorie. " 'The Page as Alternative Space, 1909-1980,' at Franklin Furnace." *Art in America* 69, no. 9 (November 1981): 172.

West, Celeste. "Roll Yr Own: A Guide for New Publishers, Self-Publishers and Authors." *Chrysalis* 7, n.d.

Whitfield, Tony. "Between the Covers." *Live* 5 (1981): 30-31.

Whitfield, Tony. "The Philadelphia Story: An Interview with Don Russell." *Flue* 3, no. 1 (1983): 8-9.

Whitfield, Tony. "Printed Matter." *Art Documentation* 1, no. 6 (December 1982): 177-178.

Williams, Emmett. "Diter Rot: Recent Writings ..." *Pages* 1 (Autumn 1970): 4.

Wilson, Martha. "Artists' Books." *Antiquarian Book Monthly Review* 6, no. 2, Issue 58 (February 1979): 75-77.

Wilson, Martha. "Artists' Books." *Artery* 5, no. 4 (April 1982): 7-8.

Wilson, Martha. "Artists' Books as Alternative Space." *Artists' Books: New Zealand Tour 1978.* New York: Franklin Furnace Archive (1978): 2-8. (Also published in *The New Artspace: A Summary of Alternative Visual Arts Organizations.* Los Angeles: Los Angeles Institute of Contemporary Art, 1978).

Wilson, Martha. "The Page as Artspace, 1909 to the Present" (in Spanish). *Libros de Artistas.* Madrid: Ministerio de Cultura. Dirección General de Bellas Artes, Archivos Y Bibliotecas, 1982: 6-17.

Yonemoto, B. "Survey Australia, Video and Bookworks: Los Angeles Institute of Contemporary Art." *Artweek* 11, no. 1 (January 12, 1980): 13.

Young, J.E. "Reevaluating the Tradition of the Book." *Artnews* 74, no. 3 (March 1975): 44.

Young, Karl. "Bookforms." *New Wilderness Letter,* no. 11 (December 1982): 25-30.

Zimmer, William. "Making Book." *Soho Weekly News.* (July 19, 1979): 40.

Zurbrugg, Nicholas. "Towards the End of the Line: Dada and Experimental Poetry Today." *Dada Spectrum: The Dialectics of Revolt,* Stephen C. Foster and Rudolf E. Kuenzli, eds. Madison, Wisconsin: Coda Press, Inc. and Iowa City, Iowa: The University of Iowa (1979): 225-248.

Zurbrugg, Nicholas. "Towards the Death of Concrete Poetry." *Pages* 2 (Winter 1970): 37-38.

Zutter, Jörg. "Boekwerken van Kunstenaars Documenta 6." *M.J.; Museum Journaal voor Moderne Kunst* 22 (August 1977): 153-156.

SPECIAL ISSUES

Art-Rite, no. 14 (Winter 1976-1977) special issue on artists' books. Contains artists' statements; thematic anthology; and features and reviews by Lawrence Alloway, A. A. Bronson, Peter Frank, Peggy Gale, Rosalee Goldberg, John Howell, Al Moore, David Salle, Eve Sonneman, Naomi Spector, and Irena von Zahn.

Art Documentation, Bulletin of the Art Libraries Society of North America 1, no. 6 (December 1982) special issue, "An ABC of Artists' Books Collections" edited by Clive Phillpot.

Artery: The National Forum for College Art 5, no. 4 (April 1982) special issue in conjunction with the exhibition *Artists' Books: A Survey 1960-1981* held at Ben Shahn Gallery, William Paterson College.

Craft International (October, November, December, 1984) special issue "The State of the Book Arts." With guest editor Douglas Wolf. Articles by Frances Butler, Glenn Goluska, Helgi Skuta, Claire Van Vliet, Stephanie

Brody Lederman, Anne Edgar, Kathryn Markel, Jean-Paul Curtay, Cathy Courtney, Francis O. Mattson, Annabel Levitt, Richard Minsky, and Michelle Stuart.

The Dumb Ox, no. 4 (Spring 1977) special issue on artists' books, edited by James Hugunin and Theron Kelley. Articles by Gary Lloyd, Joan Hugo, John Alexander, Helen Roth, Peter Frank, also Book Reviews and artists' pages.

New Wilderness Letter, no. 11 (December 1982) special issue "The Book, Spiritual Instrument." Edited by Jerome Rothenberg and David Guss. Articles by Herbert Blau, Eduardo Calderón, Becky Cohen, Paul Eluard, Dick Higgins, Edmond Jabès, Alison Knowles, J. Stephen Lansing, Stéphane Mallarmé/Michael Gibbs, David Meltzer, Tina Oldknow, George Quasha, Jed Rasula, Gershom Scholem, Dennis Tedlock, Karl Young.

"From Bookworks to Mailworks." Also published in the catalogue to the exhibition of the same name at Municipal Museum, Alkmaar, October, 1978 (in Dutch and English); and in the catalogue to an exhibition at Fiatal Müvészek Klubja, Budapest, December 1978 (in Hungarian and English).

"Mail Art and the Big Monster." Also published in (LAICA) *Journal*. no. 20, 1978; *Winscherm*, no. 9-10, Gouda, 1978 (in Dutch); *The Erratic Art Mail International System*, the Egmont Hojskolen Hou, 1979 (in English and Danish).

"The New Art of Making Books." Also published in *Plural* no. 41, Mexico City, 1975 (in Spanish); *Kontexts* no. 6-7, Amsterdam, 1975; *Contents*, catalogue to an exhibition at Remont Gallery, Warsaw, 1976; *Art Contemporary*, no. 9, III no. 1, San Francisco, 1977; and *Linia* February-March, Warsaw, 1977 (in Polish).

"Personal Worlds or Cultural Strategies."

"Rubber Stamp Art." Also published in the catalogue *Stamp Art*, Amsterdam: Daylight Press, 1976.

"Rubber Stamp Theory and Praxis." Also published in *Rubber* 1, no. 6, Stempelplaats, Amsterdam, 1978.

"Table of Mail Art Works."

BOOKS

Anderson, Elliott and Mary Kinzie, editors. *The Little Magazine in America: A Modern Documentary History.* New York: Pushcart Press in association with *TriQuarterly,* 1978.

Bell, Doris. *Contemporary Art Trends 1960-1980: A Guide to the Sources.* Metuchen, New York: Scarecrow Press, 1981.

Bojko, Szymon. *New Graphic Design in Revolutionary Russia.* New York: Frederick A. Praeger, 1972.

Carrión, Ulises. *Second Thoughts.* Amsterdam: VOID Distributors, 1980, includes the following essays: "Bookworks Revisited." Also published in *Print Collector's Newsletter* 11, no. 1. (March-April 1980): 6-9.

Celant, Germano. *Book as Art Work, 1960-72.* London: Nigel Greenwood Inc. Ltd., 1972.

Celant, Germano, ed. *Offmedia: Nuove tecniche artistiche: video, disco, libro.* Bari: Dedalo Libri, 1977.

Coleman, Allan D. *Light Readings.* New York: Oxford University Press, 1979.

Compton, Susan P. *The World Backwards: Russian Futurist Books 1912-16.* London: British Library Board, 1978.

Coser, Lewis A., Charles Kadushin and Walter W. Powell. *Books, The Culture and Commerce of Publishing.* New York: Basic Books, Inc., 1982.

Dada Spectrum: *The Dialectics of Revolt.* Madison, Wisconsin: Coda Press, Inc. and Iowa City: University of Iowa, 1979.

Dada Zeitschriften Reprint. Hamburg: Edition Nautilus, 1978.

I Denti del Drago e le Trasformazioni della

Pagina e del Libro. Milan: L'Uomo e l'arte, 1972.

Diringer, David. *The Hand Produced Book.* New York: Philosophical Library, 1953.

Dugan, Thomas. *Photography Between Covers: Interviews with Photo-Bookmakers.* Rochester, New York: Light Impressions, 1979.

Eisenstein, Elizabeth. *The Printing Press as an Agent of Social Change; Communications and Cultural Transformations in Early-Modern Europe.* New York: Cambridge University Press, 1979.

Engell, Annabel T., ed. *Contemporary Artists' Books.* London: Eaton House Publishers Ltd., 1979.

Frank, Peter. *Something Else Press: An Annotated Bibliography.* New Paltz, New York: McPherson, 1983.

Guest, Tim and Germano Celant. *Books By Artists.* Toronto: Art Metropole, 1981.

Happening and Fluxus. Cologne: Koelnishcher Kuntsverein, 1970.

Heibel, Axel. *Buchobject.* Hegen: Karl Ernst Osthaus Museum, [197-?].

Hendricks, Jon, ed. *Fluxus, Etc. (The Gilbert and Lila Silverman Collection).* Bloomfield Hills, Michigan: Cranbrook Academy of Art Museum, 1981.

Hendricks, Jon, ed. *Fluxus, Etc.— Addenda I. (The Gilbert and Lila Silverman Collection).* New York: Ink, 1983.

Hendricks, Jon, ed. *Fluxus, Etc.— Addenda II. (The Gilbert and Lila Silverman Collection).* Pasadena, California: California Institute of Technology, 1983.

Hendricks, Jon, ed. *Fluxus, Etc.— Addenda III. (The Gilbert and Lila Silverman Collection).* Houston, Texas: The Contemporary Arts Museum, 1985.

Hofer, Philip. *The Artist and the Book, 1860-1960.* Boston, Massachusetts: Museum of Fine Arts, 1961.

Nordgren, Sven, ed. *Konstnärsböcker/ Artists' Books.* Åhus, Sweden: Kalejdoskop, 1980.

Kostelanetz, Richard. *Visual Language.* Brooklyn, New York: Assembling Press, 1970.

Kostelanetz, Richard, ed. *Visual Literature Criticism: A New Collection.* Carbondale: Southern Illinois University Press, 1979.

Kostelanetz, Richard. *Wordsand, 1967-1978: Art With Words, Numbers and Lines, In Several Media: An Unillustrated Catalog with Related Documents.* Burnaby, B.C.: Simon Fraser Gallery, Simon Fraser University; New York: RK Editions, 1978.

Kostelanetz, Richard, ed. *Visual Literature Criticism: A New Collection.* Reno, Nevada: Fox, McAllister and Ransom, 1979.

Lippard, Lucy R. *Six Years: The Dematerialization of the Art Object from 1966 to 1972;* a cross-reference book of information on some aesthetic boundaries.... Edited and annotated by Lucy R. Lippard. New York: Praeger, 1973.

McMurtrie, Douglas C. *The Book: The Story of Printing and Bookmaking.* New York: Oxford University Press, 1943.

Massin. *Letter and Image.* Translated by Caroline Hillier and Vivienne Menkes. New York: Van Nostrand Reinhold Co., 1970.

Miller, Joni K. and Lowry Thompson. *The Rubber Stamp Album.* London: Rainbird Publishing Group, 1978.

Owens, Bill. *Publish Your Photo Book.* Livermore, California: Bill Owens, 1979.

Reid, Terry, ed. *Tentatively Titled, Positively Colored Yellow Pages.* International directory of small presses and mail artists. Sydney (Australia): Fluxus and the Eternal Network in conjunction with the Biennale of Sydney, 1976.

Richman, Gary. *Offset: A Survey of Artists' Books.* Boston, Massachusetts: New England Foundation for the Arts, Inc., 1984.

Ruhé, Harry. *Fluxus, the Most Radical and Experimental Art Movement of the Sixties.* Amsterdam: Harry Ruhé, 1979.

Schraenen, Guy. *Editions et communications marginales d'Amerique Latine.* Le Havre, France: 1977.

Smith, Keith. *Structure of the Visual Book.* Rochester, New York: Keith Smith and Visual Studies Workshop, 1984.

Smith, Philip. *The Book: Art and Object.*

Surrey, England: Philip Smith, 1982.
Spencer, Herbert. *Pioneers of Modern Typography*. New York: Hastings House, 1969.
Weese, Kate. *Book*. Providence: Rhode Island School of Design, 1979.

BOOK REVIEWS

Alloway, Lawrence. "A book review." Review of *The Fall* by Michelle Stuart. *Art-Rite*, no. 14 (Winter 1976-77): 41.
Alloway, Lawrence. "Review of Books: Artists' Books." Review of *Pontormo's Diary* by Rosemary Mayer. *Art in America* 72, no. 6 (Summer 1984): 33-34.
Bares, Peter. Review of *An Art History of Ephemera/Gretchen Garner's Catalogue* by Gretchen Garner. *Views*, 4, no. 2 (1983): 22.
Bertelson, Christy. "Recent Press Books: Rebis Press." Review of *Half Off*, by Mimi Pond. *Fine Print* 8, no. 2. (April 1982): 61-62.
Block, L. "May Stevens." Review of *Ordinary/Extraordinary*. *Block*, no. 5 (1981): 28-33.
"Book Review: *Diter Rot*." Review of *Diter Rot*, pub. by William and Noma Copley Foundation. *Typographica* 12 (December 1965): 46 + insert.
Bronson, A. A. Review of *The Rise and Fall of the Peanut Party* by John Mitchell and Vincent Trasov. *Art-Rite*, no. 14 (Winter 1976-77): 44-45.
Brush, Gloria DeFilipps. Review of *Thirty Five Years/One Week* by Linn Underhill. *Exposure* 21, no. 1 (1983): 41.
Chrissmass, Dwight. "*Evidence*." Review of *Evidence* by Mike Mandel and Larry Sultan. *The Dumb Ox* 4 (Summer 1977): 54.
Chrissmass, Dwight. "*Spring*." Review of *Spring* by Bart Thrall. *The Dumb Ox* 4 (Spring 1977): 44-45.
Coleman, Allan D. "Danny Seymour: *A Loud Song*." *Light Readings*. New York: Oxford University Press (1979): 81-82.
Coleman, Allan D. "Larry Clark: *Tulsa*." *Light Readings*. New York: Oxford University Press (1979): 79-81.
Coleman, Allan D. "Robert Frank: *Lines of My Hand*." *Light Readings*. New York: Oxford University Press (1979): 112-113.
Cook, Jno. "Robert Frank's America." Review of *The Americans* by Robert Frank. *Afterimage* 9, no. 8 (March 1982): 9-14.
Crary, J. "Edward Ruscha's Real Estate Opportunities." *Arts* (January 1978): 119-121.
Creek, David. "Received and Noted." Review of *Journey Through Seven Circles* by Elena Sheehan. *Afterimage* 11, no. 6 (January 1984): 21.
Dann, Alec. "Cruel and Unusual." Review of *Killing Time*, by Bruce Jackson. *Afterimage* 5, no. 8 (February 1978): 24-25.
Dietrich, Dorothea. "Anselm Kiefer's 'Johannisnacht II: A Text Book.'" *Print Collector's Newsletter* 15, no. 2 (May-June 1984): 41-44.
Dunn, Debra. "Rape is . . . " Review of *Rape Is*, by Suzanne Lacy. *The Dumb Ox* 4 (Spring 1977): 54-55.
Durland, Steven. "Viewpoint: Full of Beans." Review of *A Bean Concordance, Vol. 1, Summer 1983* by Alison Knowles. *High Performance* 6, no. 4 (Issue 24): 76.
Edgar, Anne. "Commercial Art." Review of *Catalogue* by Paul Rutkovsky and *The Crossroads Novelty Corp Spring Catalogue* by Paul Zelevansky. *Afterimage* 11, no. 6 (January 1984): 19-20.
Edgar, Anne. "Scriptease." Review of *Danger Live Artists* by John Fekner, and *Initiation Dream* by Pauline Oliveros and Becky Cohen. *Afterimage* 10, no. 8 (March 1983): 18.
Edgar, Anne. "Word Play and War Games." Review of *Lines on Lines* by Kay Rosen, *Short Cycle* by Dennis Walsak, and *This is a Test* by Mimi Smith. *Afterimage* 11, no. 4 (November 1983): 17-18.
Frank, Peter. "*Additional Meanings*."

Review of *Additional Meanings* by Karen Shaw. *The Dumb Ox* 4 (Spring 1977): 46-47.

Fuerst, April. "*Problems/Solutions.*" Review of *Problems/Solutions* by John Lanzone. *The Dumb Ox* 4 (Spring 1977): 49.

Furlong, Cindy. "Circumstantial Evidence." Review of *Ransacked/Aunt Ethel: An Ending* by Nancy Holt. *Afterimage* 8, no. 10 (May 1981): 19-20.

Gale, Peggy. "Samples: Publications by Italian Artists." Review of *Cimeli* by Guglielmo Achille Cavallini, *Continuola serie* and *25 Quadri della Collezione Cavallini, Definitions 1970* by Maurizio Nannuci, *In Principio Erat* by Ketty La Rocca, and *Controllo colonizzazione e fascismo sul territorio* by UFO. *Art-Rite*, no. 14 (Winter 1976-77): 42-43.

Gever, Martha. "Received and Noted." Review of *Cock Fight Dance* by Sol LeWitt. *Afterimage* 9, no. 7 (February 1982): 21.

Gever, Martha. "Circular Reasoning." Review of *Equilibrium and the Rotary Disc* by Robert Cumming. *Afterimage* 9, no. 9 (April 1982): 16.

Gever, Martha. "Received and Noted." Review of *I Can't, It's Very Simple, Stop Crying, Untitled, I Mean It, So?,* by Ida Applebroog. *Afterimage* 10, nos. 1 & 2 (Summer 1982): 36.

Gever, Martha. "Received and Noted." Review of *Emotional Reactions,* by Janet Zweig. *Afterimage* 10, nos. 1 & 2 (Summer 1982): 36.

Gever, Martha. "Topolemique." Review of *Tropicartica* by Francis Coutillier, Serge Morin and Pavel Skalnik. *Afterimage* 10, nos. 1 & 2 (Summer 1982): 31-32.

Gever, Martha. "Received and Noted." Review of *Artifacts at the End of a Decade,* ed. by Carol Huebner and Steven Watson. *Afterimage* 10, no. 4 (November 1982): 19.

Gever, Martha. "Received and Noted." Review of *Body in Revolt* by Donna Rini. *Afterimage* 10, no. 4 (November 1982): 19.

Gever, Martha. "Received and Noted." Review of *Parallel* by Kevin Osborn. *Afterimage* 10, no. 4 (November 1982): 20.

Gever, Martha. "Received and Noted." Review of *Girls and Boys* by Lynda Barry. *Afterimage* 10, no. 6 (January 1983): 20.

Gever, Martha. "Received and Noted." Review of *Guide to Coloring Hair* by Anne Fessler. *Afterimage* 10, no. 7 (February 1983): 19.

Gever, Martha. "Received and Noted." Review of *The Animal* by Tony Conrad and Barbara Broughel, and *Not Altogether True, Not Altogether False* by Nancy Garruba. *Afterimage* 12, nos. 1 & 2 (Summer 1984): 34.

Goldberg, Rosalee. "Performing Burden, And The Legendary Bruce McLean, Piece." Review of *Chris Burden 71-73* by Chris Burden, and *Bruce McLean Retrospective (King for a day and 999 other pieces)* by Bruce McLean. *Art-Rite* no. 14 (Winter 1976-77): 40.

"Goldilocks's Cosmic Touch-in (Buckminster Fuller's Tetrascroll)." *ARTnews* 76, no. 3 (March 1977): 19-21.

Gonchar, Nancy. "Received and Noted." Review of *Housescapes* by Laurel Beckman. *Afterimage* 10, no. 5 (December 1982): 19.

Hagen, Charles. "'*Deja-Vu*': the Photographer as Bookmaker." Review of *Deja-Vu* by Ralph Gibson. *Afterimage* 1, no. 8 (September 1973): 12.

Hagen, Charles. "Robert Frank: Seeing Through the Pain." Review of *The Lines of My Hand* by Robert Frank. *Afterimage* 1, no. 5 (February 1973): 4-5.

Harmel, Carole. "Adam and Adam." Review of an exhibition of the work of Keith Smith at In a Plain Brown Wrapper, Chicago. *Afterimage* 8, no. 3 (October 1980): 14.

Healy, Eloise Klein. "True Crow &." Review of *Natural Assemblages and the True Crow* by Alison Knowles. *New Women's Times Feminist Review* (March-April 1982): 4.

Helgason, Skúta. "Received and Noted." Review of *Regular Words* by Michael Joseph Winkler. *Afterimage* 11, nos. 1 & 2 (Summer 1983): 50-51.

Heller, Steve. "Raw Art." Review of *Raw Magazine. Print* 35, no. 3 (May-June

1981): 32-38.

Hugunin, James. "Animated Discourse." Review of *Animated Discourse* by Larry Bel and Guy De Cointet. *The Dumb Ox* 4 (Spring 1977): 48-49.

Hugunin, James. "Endless Quantification." Review of *Interruptions in Landscape and Logic* by Robert Cumming. *The Dumb Ox* 5 (Summer 1977): 49-50.

Hugunin, James. "On Mandel's Baseball Photographer Trading Cards." Review of *Baseball Photographer Trading Cards* by Mike Mandel. *The Dumb Ox* 4 (Spring 1977): 52-53.

Hugunin, James. "Thirteen Stories." Review of *Thirteen Stories* by Vaughan Rachel. *The Dumb Ox* 4 (Spring 1977): 50-51.

Hugunin, James. "Waterpower." Review of *Water and Power* by Rachel Youdelman. *Afterimage* 5, no. 7 (January 1978): 22-23.

Jarmusch, Ann. "Lawrence Bach's *Paros Dream Book*." *Afterimage* 5, no. 6 (December 1977): 16-17.

Johnstone, Mark. "Hee Hee?" Review of *He/She* by Robert Heinecken. *Afterimage* 8, no. 8 (March 1981): 13-14.

Jukovsky, Martin. Review of *gar-báj* by Chris Enos. *Views* 4, no. 2 (1983): 25.

Kelley, Jeff. "Patterns of Thought." Review of *Col·umns* by Doris Cross. *Artweek* 14, no. 31 (September 24, 1983): 13.

Lada-Mocarski, Polly. "Book of the Century: Fuller's *Tetrascroll*." Review of *Tetrascroll* by Buckminster Fuller. *Craft Horizons* 37 (October 1977): 18.

Lewis, Joe. "Books." Review of *How to Commit Suicide in South Africa* by Sue Coe and Holly Metz. *Artforum* 22, no. 8 (April 1984): 72-73.

Lewis, Rebecca. "Received and Noted." Review of *The Birth of the Child of Choice* by Susan Baker. *Afterimage* 11, no. 4 (November 1983): 19.

Lewis, Rebecca. "Received and Noted." Review of *Word Events* by Keith Shein, co-edited by David Arnold. *Afterimage* 11, no. 8 (March 1984): 21.

Lewis, Rebecca. "Received and Noted." Review of *50 Hours* by Dorothea Lynch and Eugene Richards. *Afterimage* 11, no. 10 (May 1984): 19.

Lewis, Rebecca. "Received and Noted." Review of *Light Motifs* by Howard Bond. *Afterimage* 12, nos. 1 & 2 (Summer 1984): 34.

Loeb, Arthur. "Recent Press Books: Arion Press." Review of *Flatland* by Edwin Abbott Abbott. *Fine Print* 8, no. 1 (January 1982): 19-21.

Lord, Catherine. "Received and Noted." Review of *Bird Songs, Heartbeats* by Susan Weil. *Afterimage* 9, no. 3 (October 1981): 19.

Lord, Catherine. "Received and Noted." Review of *The Book of Hair: A Selection of Hair Iconography and Habits, Fully Illustrated with Educational Pictures which Stimulate the Mind and Give a View of the Myths of Hair and Historical Evidence of Hair Adornment* by Rebecca Michaels. *Afterimage* 11, Nos. 1 & 2 (Summer, 1983): 50.

Lord, Catherine. "Received and Noted." Review of *The Vanishing Cabinet: A Photographic Illusion* by Andrew Lanyon. *Afterimage* 9, no. 3 (October 1981): 20.

Lord, Catherine. "Received and Noted." Review of *Mark/Marking* by Jack Sal. *Afterimage* 9, no. 10 (May 1982): 19.

Lord, Catherine. "Received and Noted." Review of *Cupid, you are a KILLER* by Patty Carroll. *Afterimage* 10, Nos. 1 & 2 (Summer 1982): 36.

Lord, Catherine. "Received and Noted." Review of *Walk* by Gary Schwartz. *Afterimage* 10, no. 3 (October 1982): 21.

Lord, Catherine. "Received and Noted." Review of *Implosion* by Mark Sullo. *Afterimage* 10, no. 6 (January 1983): 20.

Lord, Catherine. "Received and Noted." Reviews of *Sadat's Journey, The Stones Roll On,* and *Empress Bullet: An Allegory* by Louise Neaderland. *Afterimage* 10, no. 6 (January 1983): 21.

Magnan, Nathalie. "Received and Noted." Review of *january 20, 1980-march 15, 1980* by Nancy Weaver. *Afterimage* 10, no. 6 (January 1983): 20.

Magnan, Nathalie. "Received and Noted." Review of *Interference* by Philip Zimmerman. *Afterimage* 10, no.

10 (May 1983): 19.

McPherson, Michael. "Reference Shelf." Review of *The Avant-Garde in Print: a series of visual portfolios documenting twentieth-century design and typography* by Arthur A. Cohen. *Fine Print* 8, no. 4 (October 1982): 141-145.

Meinwald, Dan. "Bumper Crop." Review of *Landscape, See* and *Tahitian Eve* by Marcia Resnick. *Afterimage* 3, no. 4 (October 1975): 14-15.

Mitchell, Peter. "Exquisite Corpse." Review of *Murder Research* by Kenneth Fletcher and Paul Wong, published as Issue 21 of *Image Nation. Afterimage* 8, nos. 1 & 2 (Summer 1980): 36-37.

Moore, Al. Review of *Self Hipnosis* by Leandro Katz. *Art-Rite* no. 14 (Winter 1976-77): 38-39.

Moore, Sarah J. "Viewpoint: Package Extends Performance." Review of *Brumas, A Rock Star's Passage to a Life Revamped* by Joanna Frueh. *High Performance* 6, no. 4 (Issue 24): 75-76.

Morgan, Robert C. "Nature Morte." Review of *Still Life* by Peter Nadin. *Afterimage* 11, no. 9 (April 1984): 18-19.

Morgan, Robert C. "Received and Noted." Review of *The Book of Do's* by Bern Porter. *Afterimage* 10, no. 8 (March 1983): 20.

Muller, Gregoire. "Silver Desert." Review of *Mojave* by Guy Russell. *Afterimage* 6, no. 7 (February 1979): 17.

"Multiples & Objects & Artists' Books." Review of *Passage* by Daniel Buren, *Album* by Antoni Miralda and *Vom Licht* by Günther Uecker. *Print Collector's Newsletter* 5, no. 2 (May-June 1974): 42-43.

"Multiples & Objects & Artists' Books." Review of *Polaroid Portraits* by Richard Hamilton and *A-E Portfolio O* by Francesca and Dusty Moss. *Print Collector's Newsletter* 5, no. 4 (September-October 1974): 89.

"Multiples & Objects & Artists' Books." Review of *Incomplete Open Cubes* by Sol LeWitt and *Interlude: Kinesthetic Drawings* by Richard Tuttle. *Print Collector's Newsletter* 6, no. 1 (March-April 1975): 16.

"Multiples & Objects & Artists' Books." Review of *Untitled* by Stephen Antonakos. *Print Collector's Newsletter* 6, no. 3 (July-August 1975): 75.

"Multiples & Objects & Artists' Books." Review of *Throwing a Ball Once To Get Three Melodies and Fifteen Chords* by John Baldessari, and *Grids, Using Straight, Not Straight and Broken Lines In All Their Possible Combinations* by Sol LeWitt. *Print Collector's Newsletter* 6, no. 3 (September-October 1975): 109.

"Multiples & Objects & Artists' Books." Review of *Owl Feathers* by William Crutchfield. *Print Collector's Newsletter* 6, no. 6 (January-February 1976): 162.

"Multiples & Objects & Artists' Books." Review of *Mary Shiminski I Love You* by Richard Prince. *Print Collector's Newsletter* 7, no. 5 (November-December 1976): 151.

"Multiples & Objects & Artists' Books." Review of *Tetrascroll* by Buckminster Fuller, *Untitled* by Clinton Hill, *The Fall* by Michelle Stuart, and *Two Notebooks* by Susan Weil and Sylvia Whitman. *Print Collector's Newsletter* 8, no. 1 (March-April 1977): 18-19.

"Multiples & Objects & Artists' Books." Review of *The Location of Straight, Not-Straight and Broken Lines and All Their Combinations* by Sol LeWitt. *Print Collector's Newsletter* 7, no. 4 (September-October 1976): 119.

"Multiples & Objects & Artists' Books." Review of *If I Were an Astronomer, If I Were a Botanist* by Joyce Kozloff and *Editions of One: Summer Dreams* by Marilyn Rosenberg. *Print Collector's Newsletter* 8, no. 5 (November-December 1977): 146.

"Multiples & Objects & Artists' Books." Review of *Codex For The Love of Leaves* by Carolyn Greenwald, *Bodies* by Susan Grieger, and *Brick Wall* by Sol LeWitt. *Print Collector's Newsletter* 8, no. 6 (January-February 1978): 184-185.

"Multiples & Objects & Artists' Books." Review of *Trunk Pieces* by Jackie Apple, and *Parete* by Marco Gastini. *Print Collector's Newsletter* 9, no. 3 (July-August 1978): 93.

"Multiples & Objects & Artists' Books." Review of *Postage Due* by Barton Lidicé Beneš, *Sacred Text* by Vitaly Komar and Alexander Melamid, and *Shades of Day* by Susan Rubenstein.

Print Collector's Newsletter 9, no. 5 (November-December 1978): 164.

"Multiples & Objects & Artists' Books." Review of *Ornithological Specimens* by David Hanson. *Print Collector's Newsletter* 10, no. 1 (March-April 1979): 21.

"Multiples & Objects & Artists' Books." Review of *Will and Testament by Anthony Burgess and Joe Tilson*. *Print Collector's Newsletter* 10, no. 5 (November- December 1979): 164.

"Multiples & Objects & Artists' Books." Review of *Isometric Systems in Isotropic Space: Map Projections from the Study of Distortions Series 1973-1979* by Agnes Denes, and *Telling Time* by Judy Levy. *Print Collector's Newsletter* 10, no. 6 (January-February 1980): 203.

"Multiples & Objects & Artists' Books." Review of *A Russian Abecedary* by Frances Barth, *She Decided to Look Like "a Woman of a Certain Age"* by Stephanie Brody Lederman, and *Little Pleasures* by Athena Tacha. *Print Collector's Newsletter* 11, no. 2 (May-June 1980): 56.

"Multiples & Objects & Artists' Books." Review of *Words, Images and Objects* by Bilgé Friedlaender, *Gilgamesch* by Anselm Kiefer, *Crownpoint* by Sol LeWitt, and *Wood Twirls* by Athena Tacha. *Print Collector's Newsletter* 12, no. 2 (May-June 1981): 50-51.

"Multiples & Objects & Artists' Books." Review of *Dante's Inferno* by Tom Phillips. *Print Collector's Newsletter* 14, no. 3 (July-August 1983): 107.

"Multiples & Objects & Artists' Books." Review of *Dancing Figure* by Louise Kruger, and *Shades of the City* by Susan Rubenstein. *Print Collector's Newsletter* 11, no. 1 (March-April 1980): 18.

"Multiples & Objects & Artists' Books." Review of *Minsky in London* by Richard Minsky. *Print Collector's Newsletter* 11, no. 4 (September-October 1980): 133.

"Multiples & Objects & Artists' Books." Review of *Eating Friends* by Jenny Holzer and Peter Nadin. *Print Collector's Newsletter* 12, no. 4 (September-October 1981): 113-114.

"Multiples & Objects & Artists' Books." Review of *Cuts* by Stephen Antonakos,

and *The Case for the Burial of Ancestors* by Paul Zelevansky. *Print Collector's Newsletter* 12, no. 5 (November-December 1981): 152.

"Multiples & Objects & Artists' Books." Review of *Artifacts at the End of a Decade, Folded Mountains* by Caroline Greenwald, *I Only Have Eyes For You* by Richard Hambleton and *Eleven Pictures of this Time* by Arnold Kramer. *Print Collector's Newsletter* 12, no. 6 (January-February 1982): 187-188.

"Multiples & Objects & Artists' Books." Review of *Steve Gianakos* by Steve Gianakos, and *Breath* by Christopher Wilmarth. *Print Collector's Newsletter* 13, no. 2 (May-June 1982): 59.

"Multiples & Objects & Artists' Books." Review of *Blue Books* by Ida Applebroog. *Three Small Books* by Roz Chast, *KKKK* by William Christenberry, and *Post Card Books* by Elaine Reichek. *Print Collector's Newsletter* 13, no. 6 (January-February 1983): 220.

"Multiples & Objects & Artists' Books." Review of *I Have Found a Cockroach in Your Product!* by Barton Lidicé Beneš. *Print Collector's Newsletter* 14, no. 1 (March-April 1983): 21.

"Multiples & Objects & Artists' Books." Review of *Ghost Dance* by Christine Bourdette, *The Summer Solstice* by Joe Marc Freedman, Marsha Eva Gold and Paul Wong, and *Indulgences: A Book of Common Images* by Allan Jones. *Print Collector's Newsletter* 14, no. 2 (May-June 1983): 67.

"Multiples & Objects & Artists' Books." Review of *No Progress in Pleasure* by Barbara Kruger, and *This is a Test* by Mimi Smith. *Print Collector's Newsletter* 14, no. 4 (September-October 1983): 145-146.

"Multiples & Objects & Artists' Books." Review of *Chalkis/Hypnos* by Jürgen Partenheimer. *Print Collector's Newsletter* 14, no. 6 (January-February 1984): 216.

"Multiples & Objects & Artists' Books." Review of *Mud Book: How to Make Pies and Cakes* by John Cage and Lois Long. *Print Collector's Newsletter* 15, no. 1 (March-April 1984): 27.

"Multiples & Objects & Artists' Books." Review of *Twelve Picturesque Passions*,

and *Point Richmond, San Francisco* by Gordon Cook. *Print Collector's Newsletter* 15, no. 2 (May-June 1984): 67.

Murray, Joan. "Book Reviews." Review of *Making Chicken Soup* by Les Krims. *Artweek* 4, no. 20 (May 19, 1973): 10.

Murray, Joan. "Books." Review of *The Tri-X Chronicles* by Bill Paul. *Artweek* 3, no. 26 (July 15, 1972): 10.

Murray, Joan. "Photography, Books, Books, Books." Review of *Journey of the Spirit After Death* by Duane Michals. *Artweek* 3, no. 7 (February 12, 1972): 9.

Murray, Joan. "Two Exhibitions/Two Books." Review of *18th Street Near Castro x 24* by Hal Fischer, and *Structural(ism) and Photography* by Lew Thomas, exhibited at Lawson De Celle Gallery, San Francisco. *Artweek* 10, no. 16 (April 21, 1979): 15.

Neuwirth, K. "*Pulp:* A Self-Published Book." Review of *Pulp* by James Hugunin. *The Dumb Ox* 5 (Summer 1977): 51-52.

Normile, Ilka. "On the Road." Review of *Baggage* by D. H. Porter. *Afterimage* 4, nos. 1 & 2 (May-June 1976): 13.

Oliver, Catherine. "Received and Noted." Review of *Morally Superior Products: A New Idea for Advertising. Afterimage* 12, no. 3 (October 1984): 17.

Perrin, Peter. "*Cover to Cover:* A Book by Michael Snow." *Artscanada* 33 (October 1976): 43-47.

Pouter, Darryl. "Marginal Gloss: A Theory of Notes." Review of *Pulp* by James Hugunin. *The Dumb Ox* 5 (Summer 1977): 53.

Power, Kevin. "Dieter Roth—*96 Piccadillies.*" *Arts Review* 30, no. 22 (November 10, 1978): 606.

Raimi, Jessica. "Natural Narrative." Review of *The Projector* and *The Park* by M. Vaughn-James. *Afterimage* 1, no. 9 (December 1973): 10-11.

Rice, Shelley and Reagan Upshaw. "Book Reviews." Reviews of *Nurse Duck Approaches and Enters and Leaves the Garden of Eden* by Willyum Rowe, *Still Photography: The Problematic Model,* ed. Lew Thomas and Peter D'Agostino, *Real Family Stories* by Anne Turyn, and *Ruffled Passions* by Sandra Lerner. *Flue*

3, no. 1 (1983): 5.

Rice, Shelley. "Glenda Hydler, *The Clocktower*". *Artforum* 18, no. 9 (May 1980): 80-81.

Rice, Shelley. "Nots and Lots of Knots." Review of *Cultural Connections* by Eldon Garnet, and *Dressing our Wounds in Warm Clothes* by Donna Henes. *Afterimage* 10, nos. 1 & 2 (Summer 1982): 33-34.

Rice, Shelley. "Book Reviews." Review of *Windows* by H. Terry Braunstein, *Media Sites/Media Monuments* by Antonio Muntadas, *Monday Morning Movie* by Barbara Cesery and Marilyn Zuckerman, and *The Big Relay Race* by Michael Smith. *Flue* 3, no. 2 (Spring 1983): 45.

Robertson, Clive. "Books." Review of *This Book or Mental Scortation* by Opal L. Nations. *Centerfold* (April 1978): 35.

Sherman, Tom. "Heaven on Earth." Review of *Bewilderness: The Origins of Paradise* by Glenn Lewis. *Centerfold* (February-March 1979): 133-134.

Shipman, Dru. "Publications." Review of *Notations In Passing* by Nathan Lyons. *Exposure* 13, no. 2 (May 1975): 33-34.

Smith, E. L. "Ever so Nice (Gilbert and George's 'Dark Shadow')." *Art and Artists* (March 1977): 27-29.

Solomon, Nancy. "The Layered Look." Review of *A Humument: A Treated Victorian Novel* by Tom Phillips, *Primer: Ritual Elements (Book One)* by Helen Brunner, and *Real Lush* by Kevin Osborn. *Afterimage* 11, nos. 1 & 2 (Summer 1983): 48-49.

Spector, Buzz. "N.A.M.E. Book 1: Statements on Art." *New Art Examiner* 5, no. 1 (October 1977): 13.

Spector, Buzz. "Stayin' Alive: *Survivors* by Alex Sweetman." *Afterimage* 6, no. 7 (February 1979): 16-17.

"Special Supplement: The Netherlands." Review of *Otterlo: Eleven Bicycles— One Trowel* by Roland van den Berghe, *In Alphabetical Order* by Ulises Carrión, and *Tunesian Curve/Italian Curve* by Johan Cornelissen. *Print Collector's Newsletter* 11, no. 5 (November-December 1980): 181.

Svenbro, J. "Till en bok av Enrico Pulsoni/To A Book by Enrico Pulsoni." Review of *The Book of Ep. Konstnärsböcker/Artists' Books.* S.

Nordgren, ed. Ahus: Kalejdoskop, 1980: 73. Illus.

Sweetman, Alex. "Duane Michals's Disappointing Journey." Review of *The Journey of the Spirit After Death* by Duane Michals. *Afterimage* 1, no. 3 (October 1972): 7.

Sweetman, Alex. "Reading *The Breadbook* and *A Ten Page Note:* The Experience Exceeds the Information." Review of *The Breadbook* by Kenneth Josephson, and *A Ten Page Note* by John Wood. *Afterimage* 2, no. 1 (March 1974): 10-11.

Sweetman, Alex. "*Tulsa:* Death is the Unconscious Goal." Review of *Tulsa* by Larry Clark. *Afterimage* 1, no. 2 (April 1972): 8-10.

Tannenbaum, Barbara, Buzz Spector and Miles Decoster. Reviews of *A Mideast Kaleidoscope* and *Empress Bullet: An Allegory* by Louise Neaderland, *Emotional Reactions* by Janet Zweig, *The Book of Hair* by Rebecca Michaels, *The Un/Necessary Image* by Peter d'Agostino and Antonio Muntadas (eds.), and *Basic Meaning in Four Parts* by Phillip Gagliani. *Exposure* 21, no. 3 (1983): 37-41.

Thomas Lew. "Michael Snow: *Cover to Cover.*" *Art Contemporary* 2, nos. 2 & 3 (1977): 37. (Also published in *Dumb Ox*, no. 4, Spring 1977).

Tuten, Frederick. "Ranxerox." Review of *Ranxerox* by Stefano Tamburini and Tanino Liberatore. *Artforum* 22, no. 3 (November 1983): 69-71 and vol. 22, no. 4: 70-71.

Whitfield, Tony. "Three Books—Three Lives." Review of *Essential Documents: The F.B.I. File on Jean Seberg* by Margia Kramer, *Ransacked* by Nancy Holt, and *Autobiography* by Martha Wilson. *Fuse* 4, no. 3 (March 1980): 170-175.

Yalkut, Jud. "Towards an Intermedia Magazine." Review of S.M.S. and *Aspen Magazine. Arts Magazine* (Summer 1968).

Yampolsky, Michael. "Received and Noted." Review of *Second Thoughts* by Ulises Carrión. *Afterimage* 9, no. 3 (October 1981): 19-20.

EXHIBITION CATALOGUES

Alkmaar (Holland). Alkmaar Municipal Museum. *From Bookworks to Mailworks–Van Kunstenaarsboeken tot Postkunst.* Exhibition October 9-29, 1978. Text by Ulises Carrión. Illus.

Baltimore (Maryland). Enoch Pratt Free Library. *Signatures: Baltimore Artists' Books.* Exhibition March 21-May 2, 1981. Baltimore: Merzaum's Desire Productions and the Enoch Pratt Free Library, 1981.

Baltimore (Maryland). Maryland Art Place. *Art As Book As Art Maryland 1984.* May 11-June 16, 1984. Jane M. Farmer, curator.

Barcelona. Metronom. *Libri d'Artista/ Artists' Books.* Barcelona: Metronom, 1981.

Bloomington (Indiana). The Lilly Library. Indiana University. *Beyond Illustration: The Livre d'Artiste in the Twentieth Century.* Breon Mitchell, curator. Bloomington: Indiana University, 1976.

Brescia (Italy). Multimedia. *Il Chiodo Mancante.* Exhibition December 1979. Introduction by Romana Loda.

Brighton (England). Gardner Centre Gallery. *Artists' Books.* Exhibition April 1976.

Budapest (Hungary). Fiatal Müvészek Klubja. *From Bookworks to Mailworks.* Text in Hungarian. Catalog of exhibition held December 8-14, 1978.

Cambridge (Massachusetts). New England Foundation for the Arts. New England Visual Arts Touring Program. *Re: Pages/An Exhibition of Contemporary American Bookworks.* Traveling exhibition organized by the Hera Educational Foundation. Introduction by Gary Richman. Cambridge: New England Foundation for the Arts, 1981. Illus.

Catskill (New York). The Catskill Gallery. *Bound to Be: Fine Press and Artists' Books.* Exhibition April 17-May 12, 1981. Leonard Seastone and Jim Zunk, curators. Catskill, New York: The Greene County Council on the Arts, 1981.

Chicago (Illinois). Museum of Contemporary Art. *Dieter Roth.* Exhibition 1984. Text by Ann

Goldstein. Illus.

Chicago (Illinois). Museum of Contemporary Art. *Permanent Collection: Artists' Books.* Exhibition March 31-May 31, 1981. Introduction by Pauline A. Saliga. Chicago: Museum of Contemporary Art, 1981.

Chicago (Illinois). Museum of Contemporary Art. *Words at Liberty.* Exhibition May 7-July 3, 1977. Text by Judith Russi Kirshner. Chicago: Museum of Contemporary Art, 1977. 18 p. Illus.

Chicago (Illinois). School of the Art Institute of Chicago Library. *International Artists' Book Show.* Exhibition January 17 to February 15, 1981. Essays by Michael Day and Janice Snyder. Edited by Jessie Affelder. Chicago: School of the Art Institute of Chicago, 1981. 28 p.

Chicago (Illinois). West Hubbard Gallery. *Art in Print: Books and Periodicals.* October 13-November 5, 1978. Illus.

Clarksville (Tennessee). Austin Perry State University. *Mid-South Small Press Design Exhibition.* Exhibition March 1-31, 1982. Introduction by Bruce Childs. Essay by Bill Eiland. Clarksville: Austin Perry State University, 1982. 24 p. Illus.

Dayton (Ohio). Dayton Art Institute. *Book Forms.* October 20, 1978-February 11, 1979. Text by Pamela Houk. Dayton: Dayton Art Institute, 1978. 64 p. Illus.

Detroit (Michigan). Detroit Institute of Arts. *Art/Book/Art.* Text by Mary Jane Jacob. 1980. Detroit: The Detroit Institute of Arts, 1980.

Detroit (Michigan). Willis Gallery. *Michigan Artists' Books: 1980.* Text by Lori Christmastree and Barbara Tannenbaum. Detroit: Willis Gallery, 1980.

Freiburg im Breisgau (Germany). Universitätsbibliothek. *Buchobjekte.* Exhibition June 13-July 10, 1980. Freiburg im Breisgau: Universitätsbibliothek, 1980. Illus.

Halifax (Nova Scotia, Canada). Anna Leonowens Gallery. *A.R. Penck—Installation.* October 2-23, 1973. (Exh. checklist). Halifax: Anna Leonowens Gallery, 1973.

Hamilton (New York). Gallery Association. *Artists' Books.* Exhibition organized by Martha Wilson of the Franklin Furnace and circulated by the Gallery Association of New York State. Text by Martha Wilson. Hamilton: Gallery Association of New York State, n.d., 1979.

Hanover. Kestner-Gesellschaft. *Dieter Roth-Buchner.* May 10-June 30, 1974. Hanover: Kestner Gesellschaft, 1974. 146 pp. Illus.

Hanover (Germany). Kestner-Gesellschaft. *Jochen Gerz: Foto/Texte 1975-1978.* Exhibition September 8-October 22, 1978. Carl-Albrecht Haenlein, editor. Hannover: Kestner-Gesellschaft, 1978.

Hempstead, Long Island (New York). The Emily Lowe Gallery and The Hofstra University Library. Hofstra University. *The Book Stripped Bare: A Survey of Books by 20th Century Artists and Writers.* An Exhibition of Books from the Arthur Cohen and Elaine Lustig Cohen Collection, supplemented by The Howard L. and Muriel Weingrow Fine Arts Library of Hofstra University. Exhibition September 17-October 21, 1973. New York: Emily Lowe Gallery, 1973. Illus.

Hou (Denmark). Egmont Højskolen. *Rubber Stamp Books.* Exhibition February 1979.

Houston (Texas). Contemporary Arts Museum. *American Narrative/Story Art: 1967-1977.* Exhibition December 12, 1977-February 25, 1978. Essays "Give Me an 'N'" by Alan Sondheim and "Photographs and Narratives" by Marc Fridus. Introduction by Paul Schimmel, Houston: Contemporary Arts Museum, 1978.

Iowa City (Iowa). The University of Iowa. *Lettrisime: Into The Present. Visible Language,* Vol. XVII, no. 3. Exhibition October 29-Decembr 11, 1983. Stephen C. Foster, Curator. Essays by Stephen C. Foster, Jean-Paul Curtay, David W. Seaman, Frederique Devaux.

Kassel (Germany). Documenta. *Documenta 6: Volume 3.* Text by Rolf Dittmar and Peter Frank. Kassel: Documenta, 1977. In German.

La Jolla (California). Mandeville Art Gallery, University of California, San

Diego. *The Artists' Book.* Exhibition April 18-May 15, 1977. Introduction by Linda Rosengarten. La Jolla: University of California, San Diego, 1977. 10 p.

London (Great Britain). Arts Council of Great Britain. *Artists' Books.* London: Arts Council of Great Britain, 1976-. Listing of new British artists' books. Published at irregular intervals.

London (Great Britain). Arts Council of Great Britain. *Edward Ruscha: prints and publications 1962-74.* London: Arts Council of Great Britain, 1975. 3 p. Illus.

London (Great Britain). British Council. Fine Arts Department. *Artists' Bookworks: Kunstwerke in Buchform.* A traveling exhibition arranged by Martin Attwood [et. al.]. London: British Council, 1975.

London (Great Britain). Institute of Contemporary Art. *Between Poetry and Painting.* October 22-November 27, 1965. London: Institute of Contemporary Art, 1965. Illus.

Los Angeles (California). Feminist Studio Workshop. Women's Building. *Women and the Printing Arts.* Exhibition January 11-February 1, 1975. Curated by Sheila Levrant de Bretteville and Helen Alm. Los Angeles: s.n., 1975.

Los Angeles (California). Frederick S. Wight Art Gallery. University of California, Los Angeles. *Words and Images.* Exhibition March 14-May 7, 1978. Text by E. Maurice Bloch. Los Angeles: Frederick S. Wight Art Gallery, 1978. 15 p.

Los Angeles (California). Los Angeles Institute of Contemporary Art. *Artwords and Bookworks: An International Exhibition of Recent Artists' Books and Ephemera.* Exhibition February 28-March 30, 1978. Co-curated by Judith A. Hoffberg and Joan Hugo.

Madrid (Spain). Salas Pablo Ruiz Picasso. *Libros de Artistas.* Exhibition September 15-November 1, 1982. Essays by Catherine Colman, Martha Wilson, Barbara Tannenbaum, Anne Rosenthal and Howard Goldstein. 96 p. Illus.

Malmö (Sweden). Malmö Konsthall. *Tecken, Lettres, Signes, Ecritures.*

Exhibition March 22-May 7, 1978. Malmö, Sweden: Malmö Konsthall, 1978. 200 p. Illus.

Melbourne (Australia). Ewing and George Paton Galleries. *Artists' Books Bookworks.* Essays by Joan Hugo, Martha Wilson and Judith Hoffberg. Melbourne: Ewing and George Paton Galleries, 1978. 125 p. Illus.

Minneapolis (Minnesota). Institute of Arts. *Bookmaking in the '70s: Redefining the Artists' Book.* Exhibition July 13-September 16, 1979. Essay by Louise Lincoln. Illus.

Montreal (Quebec, Canada). Powerhouse Gallery. *Women's Bookworks: A Survey Exhibition of Contemporary Artists' Books by Canadian Women Including Unique Book-Objects and Printed Editions.* Curated by Doreen Lindsay and Sarah McCutcheon. LS. 1.: [S.I.: s.n., 1979].

Munich (Germany). Kunstraum München. *Bookworks* (by Barbara and Gabriele Schmidt-Heins). Essay by Hermann Kern. Munich: Kunstraum München, 1976.

Munich (Germany). Produzentengalerie Adelgundenstrasse. *Künstlerbücher Zweiter Teil.* Exhibition May 16-July 26, 1980. Munich: Produzentengalerie Adelgundenstrasse, 1980. 60 p. Illus.

Munich (Germany). Produzentengalerie Adelgundenstrasse. *Künstlerbücher Dritter Teil.* Exhibition November 7-January 24, 1981. Munich: Produzentengalerie Adelgundenstrasse, 1981. 58 p. Illus.

New Brunswick (New Jersey). *Artists' Books: From the Traditional to the Avant-Garde.* Essay by Clive Phillpot. New Brunswick: Rutgers University, 1982.

New York (City). Arthur A. Houghton, Jr. Gallery, The Cooper Union. *Book Makers: Center for Book Arts First Five Years.* Exhibition October 24-November 9, 1979. Bruce Schabel and Kathleen Weldon, curators. Essay by Rose Slivka. New York: Center for Book Arts, 1979. 11 p.

New York (City). Center for Book Arts. *Book Makers: Center for Book Arts' first five years.* Essay by Rose Slivka. New York: Center for Book Arts, 1979.

New York (City). Center for Book Arts. *Entrapped: The Book as Container.* Essay by Clive Phillpot. New York: Donnell Library Center, 1981.

New York (City). Center for Book Arts. *To be continued: the sequential image in photographic books.* Curated by Norman B. Colp. New York: Center for Book Arts, 1981.

New York (City). Franklin Furnace Archive. *Artists' Books: New Zealand Tour 1978.* Essay by Martha Wilson. Introduction by Jacki Apple. New York: Franklin Furnace Archive, 1978. 60 p.

New York (City). Franklin Furnace Archive. *Avant-garde Books from Russia, 1910-1930.* Exhibition December 19, 1981-February 20, 1982. Curated by Gail Harrison Roman. New York: Franklin Furnace Archive, 1981. 20 p.

New York (City). Franklin Furnace. *Bern Porter.* Text by Charles J. Stanley and Judd Tully. New York: Franklin Furnace, 1979.

New York (City). Franklin Furnace. *Cubist Prints/Cubist Books.* Edited by Donna Stein, Ron Padgett, and George Peck. *Flue* 4, nos. 1&2 (Fall 1983).

New York (City). James Yu Gallery. *Stella Waitzkin: Rare Books.* Exhibition February 15-March 8, 1974. New York: James Yu Gallery, 1974. Illus.

New York (City) and Washington D.C. Independent Curators Incorporated. *Artists' Books USA.* Exhibition 1978-1980. Curated by Peter Frank and Martha Wilson.

New York (City). Metropolitan Museum of Art, Thomas T. Watson Library. *Books Alive.* Exhibition January 12-February 10, 1983. Susan Share and Mindell Dubansky, curators. Essay by Susan Share.

New York (City). The Museum of Modern Art. *Information.* Exhibition July 2-September 20, 1970. Edited by Kynaston L. McShine. New York: Museum of Modern Art, 1970.

New York (City). Museum of Modern Art. *Printed Art: A View of Two Decades.* Exhibition February 14-April 1, 1980. Preface by Riva Castleman. New York: The Museum of Modern Art, 1980. 144 p. Illus.

New York (City). New York Chapter of the Women's Caucus for Art. *Views by Women Artists: Sixteen Independently Curated Theme Shows.* New York: The New York Chapter of the Women's Caucus for Art, 1982.

New York (City). Touchstone Gallery. *Artists' Books and Notations.* Exhibition November 4-30, 1978. Introduction by Eric Siegeltuch. New York: Touchstone Gallery, 1978.

Palatka (Florida). Fine Arts Gallery. Florida School of the Arts at St. John's River Community College. *Art Books: Books as Original Art.* Exhibition August 19-September 9, 1978. Palatka: Florida School of the Arts, 1978. Illus.

Palo Alto (California). Stanford University Art Gallery. *Aktuel Art International.* Exhibition December 2-28, 1967. Palo Alto: Stanford University, 1967.

Paris (France). Bibliothèque Nationale. *Le Livre et l'artiste: tendances du livre illustré français, 1967-1976: Bibliothèque Nationale.* Exhibition June 25-September 11, 1977. Catalogue par Antoine Coron. Paris: Bibliothèque Nationale, 1977. Illus.

Paris (France). N.R.A.-Shakespeare International. *Livres d'Art et d'Artistes III.* Exhibition February 4-March 28, 1981. Introduction by Filberto Menna.

Philadelphia (Pennsylvania). Moore College of Art. *Artists' Books.* Exhibition March 23-April 20, 1973, Moore College of Art; January 16-February 24, 1974, University Art Museum, Berkeley.... Text by Lynn Lester Hershman and John Perreault. Philadelphia: Moore College of Art, 1974. 77 p. Illus.

Philadelphia (Pennsylvania). Nexus. *The Reading Room: An Exhibition of Artists' Books.* Exhibition March 28-May 17, 1980. Curated by Suzanne Horovitz and Sandra Lerner. Text by Anne Sue Hirshorn. Philadelphia: Nexus, 1980. Illus.

Philadelphia (Pennsylvania). Philadelphia Art Alliance. *Words and Images: A Contemporary Artists' Book Exhibition.* Exhibition May 18-June 20, 1981. Text by Peter Frank. Philadelphia: Philadelphia Art Alliance, 1981.

Philadelphia (Pennsylvania). Philadelphia

College of Art. *Words and Images.* Exhibition September 15-October 12, 1979. Paula Marincola, curator. Philadelphia: Philadelphia College of Art, 1979.

Reykjavik (Iceland). Nýlistasafnid. *Other Books.* Exhibition November 21 to December 14, 1980. Text in Icelandic and English.

Richmond (Virginia). James Branch Cabell Library and Anderson Gallery. *In Celebration of Book Art.* Richmond: Virginia Commonwealth University, 1980.

Rochester (New York). Visual Studies Workshop. *The Czech Avant-Garde and the Book, 1900-1945.* Curated with text by Jaroslav Anděl. Published as supplement to *Afterimage* 12, no. 6 (January 1985).

San José (California). Union Gallery. San José State University. *The Printed Work: An Exhibition of Artist-Produced Books March 22-April 9, 1976.* Text by C.E. Loeffler. San José: San José State University, 1976.

Schiedam (Holland). Stedelijk Museum. *Kunstenaarsboeken—Artists' Books from the Other books and So Archive.* Exhibition March 27-April 26, 1981. Interview with Ulises Carrión by Jörg Zutter. Schiedam, Holland: Stedelijk Museum, 1981. Illus.

Solothurn (Germany). Museum der Stadt Solothurn. *Dieter Roth: eine Buchverzweigung.* November 19-December 1976. Text by Franz Eggenschwiler and Dieter Schwarz. Solothurn: Museum der Stadt Solothurn, 1976. 16 p. Illus.

Syracuse (New York). Everson Museum of Art. *Stella Waitzkin: Selected Work 1973-1983.* Exhibition March 25-May 29, 1983. Syracuse: Everson Museum of Art, 1983. Illus.

Syracuse (New York). Joe and Emily Lowe Art Gallery, School of Art, College of Visual and Performing Arts, Syracuse University. *The Ambiance of the Book: Recent Artistic Book Forms.* Exhibition May 4-September 6, 1980. Syracuse: The Joe and Emily Lowe Gallery, 1980. Illus.

Teheran (Iran). Museum of Contemporary Art. *The Book of the Art of Artists' Books.* Text by Rolf Dittmarn.

Teheran: Shahbanou Farah Foundation, 1978.

Tokyo (Japan). Gallery Lunami. *Artists' Books, 1983.* Exhibition. Text by Tim Guest. Illus.

Toronto (Ontario, Canada). Kensington Arts Association. *Language and Structure in North America: The First Large Definitive Survey of North American Language Art.* Exhibition November 4-30, 1975. Curated by Richard Kostelanetz. Toronto: Kensington Arts Association, 1975.

Vancouver (British Columbia, Canada). Vancouver Art Gallery. *955,000.* Exhibition January 13-February 8, 1970. Lucy Lippard, curator. Vancouver, B.C.: Vancouver Art Gallery, 1970.

Walnut (California). Mt. San Antonio College. *Word Works.* Exhibition April 16-May 9, 1974. Curated by Jessica Jacobs. Walnut, California: Mt. San Antonio College, 1974.

Warsaw (Poland). Galeria Remont. *Other Books and So—Inne Ksiazki.* Text in Polish by Henryk Gajewski and Ulises Carrión. Exhibition May 8-30, 1977.

Washington, D.C. and New York (City). Independent Curators Incorporated. *Artists' Books USA.* April 1978-March 1980. Peter Frank and Martha Wilson, curators. Washington, D.C.: Independent Curators, Inc., 1980.

Washington, D.C. Fendrick Gallery. *The Book as Art.* Exhibition January 12-February 14, 1976. Washington, D.C.: [Fendrick Gallery], 1976. Illus.

Washington, D.C. Fendrick Gallery. *The Book as Art II.* Exhibition February 15-March 12, 1977. Text by Daniel Fendrick. Washington, D.C.: Fendrick Gallery, 1977. Illus.

Washington, D.C. Fendrick Gallery. *The Book as Art III.* Washington, D.C.: Fendrick Gallery, 1979.

Washington, D.C. United States Information Agency. *American Bookworks in Print,* 1984. Anne Catherine Fallon and Kevin Osborn.

Washington, D.C. Washington Project for the Arts. *5x20 Books.* Don Russell and Skúta Helgason.

Watford (England). Watford School of Art. *Printed in Watford: A Traveling*

Exhibition of Books Produced or Published at Watford School of Art Between 1966 and 1974. Watford, England: Watford School of Art: distributed by Wittenborn and Company, 1974.

Wayne (New Jersey). Ben Shahn Center for the Visual Arts. William Paterson College. *Artists' Books: A Survey 1960-1981.* Wayne, N.J.: Student Art Association, Art Dept., William Paterson College, 1982. Special issue of *Artery* magazine (vol. 5, no. 4, April 1982).

Wichita (Kansas). Edwin A. Ulrich Museum of Art. Wichita State University. *Artists and Books: The Literal Use of Time.* Exhibition November 28, 1979-January 6, 1980. Text by Robert C. Morgan, Wichita: Edwin A. Ulrich Museum of Art, 1979.

Williamstown (Massachusetts). The Clark Art Institute Library. *Paginations.* Exhibition May 1984. Illus.

EXHIBITION REVIEWS

Anderson, Isabel. "Reading Artists' Books." Review of *Moveable Type and Hand Held Lives* at Beyond Baroque Library/Arts Center, Venice, California. *Artweek* 13, no. 24 (July 17, 1982): 4.

"Artwords and Bookworks: Los Angeles Institute of Contemporary Art." *ARTnews* 77, no. 5 (May 1978): 144.

"Book Objects." Review of exhibition at Jeffrey Fuller Fine Art Gallery, Philadelphia. *Artnews* 81 (December 1982): 127.

"Boston: Art and the Book." Review of *The Artist and the Book: 1860-1960* at the Boston Museum of Fine Arts. *Art News* 60, no. 4 (Summer 1961): 38-39.

Brown, Gordon. "Stella Waitzkin, James Yu Gallery, New York." *Arts Magazine* 50, no. 3 (November 1975): 22.

Brumfield, John. "Fluxus Revisited." Review of exhibition at Baxter Art Gallery, California Institute of Technology, Pasadena, California. *Artweek* 14, no. 34 (October 15, 1983): 3.

Buonagurio, Edgar. "Artists' Books and Notations." *Arts* 53, no. 3 (November 1978): 5.

Cebulski, Frank. "Books in an Expanded Context [Book as Art, Eaton/Shoen Gallery, San Francisco]." *Artweek* 12, no. 23 (July 4, 1981): 5-6.

Coatts, M. "Bookworks [South Hill Park Arts Centre, Bracknell: Ikon Gallery, Birmingham, Bluecoat Gallery, Liverpool]." *Crafts* 51 (July-August 1981): 52.

Cohen, Ronny H. "Multiples by Latin American Artists" at Franklin Furnace, New York. *Artforum* 22, no. 2 (October 1983): 73.

Coker, Gylbert. "'Apply Within' and 'Vigilance' at Franklin Furnace." *Art in America* 68, no. 7 (September 1980): 125-126.

Collins, J. "Exhibition Reviews." Review of *Artists' Books*, Pratt Graphics Center. *Artforum* 12, no. 4 (Dec. 1974): 84-86.

Colpitt, F. "Umbrellas through the mail: UC Riverside Gallery, Riverside, California." *Artweek* 10 (September 8, 1979): 1.

Crichton, F. "London Letter." Review of *Artists' Books* at Institute of Contemporary Arts. *Art International* 20, no. 8-9 (October-November 1976): 30-33, 62-63.

Cushing, Sara and Gina Shorto. "Bookworks and Sequences." Review of an exhibition at the Corcoran School of Art. *Artery* (October-November 1982): 12-13.

Davis, Bruce. "Books for Looking." Review of the Exhibition *Printed Art* at the Museum of Modern Art. *Artweek* 11, no. 26 (August 2, 1980): 7.

Einzîg, H. "Bookworks." Review of exhibition at South Hill Park Arts Centre, London. *Arts Review* 33, no. 7 (April 10, 1981): 130.

Foster, Hal. "*Alain Robbe-Grillet and Robert Rauschenberg.*" Review of an exhibition at Castelli Graphics. *Artforum* 18, no. 1 (September 1979): 73-74.

Franklin, Colin. "Hand Bookbinding Today: An International Art." *Fine Print* 4, no. 2 (April 1978): 33-34 + supplement.

Gallati, Barbara. "Artists' Books." *Arts Magazine* 57, no. 7 (March 1983): p. 34. Review of "Second Annual Artists' Book Show" December 7-31, 1982.

Gould, Trevor. "*Books by Artists.*" Review of exhibition at the National Gallery of Canada, Ottawa. *Parachute* 25 (Winter 1981): 29.

Groot, Paul. "Flash Art Reviews: Holland." Review of exhibition and catalogue of James Lee Byars at Stedelijk Van Abbemuseum, Eindhoren. *Flash Art*, no. 115 (January 1984): 40-41.

"Handmade Paper Book." Review of exhibition at American Craft Museum II, New York." *American Craft* 42 (August-September 1982): 8-9.

Heinrich, Theodore Allen. "Sculpture for Hercules: Documenta 6: The Artist and the Book." *Artscanada* 34 (October-November 1977): 14-15.

Hugo, Joan. "The Mission of the Avant-Garde." Review of *The Avant-Garde in Russia, 1910-1930: New Perspectives* at the Los Angeles County Museum of Art. *Artweek* 11, no. 27 (August 16, 1980): 1, 20.

Hugo, Joan. "Sophisticated Ladies." Review of work by Betye Saar, Alison Saar and Lezley Saar at Artworks, Los Angeles, California. *Artweek* 14, no. 1 (January 8, 1983): 16.

Kangas, Matthew. "Reading Room for Artists' Books." Review of *Artists' Books* at Northwest Artists Workshop, Portland, Oregon. *Artweek* 12, no. 12 (March 28, 1981): 4.

"Kathryn Markel Gallery, New York." *Arts* 57 (March 1983): 34.

Kelder, Diane. "Prints: Artists' Books." Review of *The Book Stripped Bare* at Hofstra University, Hempstead, New York. *Art in America* 62, no. 1 (January-February 1974): 112-113.

Kelley, Jeff. "Reviews: Los Angeles." Review of *California Bookworks: The Last Five Years* at Otis Art Institute of Parsons School of Design. *Artforum* 22, no. 10 (Summer 1984): 96-97.

Larkin, S. "Open and Closed Book: Contemporary Book Arts: Victoria and Albert Museum, London." *Crafts* 42 (January 1980): 52-53.

Larson, K. "Art [Samizdat Show of Artists' Books by Russian Artists and Émigrés]." Review of an exhibition at Franklin Furnace. *New York* (March 29, 1982): 74.

Larson, K. "Beyond the Canvas ... Artists' Books and Notations." *Artnews* 78, no. 1 (January 1979): 150-151.

Larson, Phillip. "Good Books, Good Looks." Review of Walker Art Center Show. *Print Collector's Newsletter* 12, no. 5 (November-December 1981): 143-144.

Martin, Fred. "The Artist and the Word." Review of *The Word Show* at La Mamelle in San Francisco. *Fine Print* 2, no. 4 (October 1976): 68.

Murray, Joan. "Two Exhibitions/Two Books." Review of *18th Street Near Castro x 24* by Hal Fischer and *Structural(ism) and Photography* by Lew Thomas, exhibited at Lawson De Celle Gallery, San Francisco. *Artweek* 10, no. 16 (April 21, 1979): 15.

Neminoff, D. "Women's Bookworks, Nickel Art Museum, University of Calgary." *Artscanada* 2, no. 234-235.

Ott, Betty J. "Exhibit Demonstrates Artists' Book Variety." Review of works by Ann Rosen exhibited at Lockwood Memorial Library. Buffalo, New York: *Courier Express,* November 18, 1979.

Reff, Theodore. "The Artist and the Book: 1860-1960." *Burlington Magazine* (May 1962): 217.

Rickey, Carrie. "Beyond the Canvas ... Artists' Books and Notations: Touchstone Gallery, New York." *Artforum* 17, no. 6 (February 1979): 60-63.

Robbins, Diane Tepfer. "Art/Book/Art." Review of exhibition by that name at Detroit Institute of Arts, Detroit, Michigan. *The New Art Examiner* 6, no. 9 (June 1979): Sect. 2, pg. 4.

Rubinfien, Leo. "Artists' Books, Kathryn Markel Gallery." *Artforum* 16, no. 7 (March 1978): 72.

"Russian Samizdat Art 1960-1982." Review of an exhibition at Franklin Furnace. *Umbrella* 5, no. 2 (March 1982): 1.

Smith, Philip. "Exhibit Review: *Book Works; Sculptural Books by Twenty*

Artists." *Fine Print* 8, no. 1 (January 1982): 11.

Sozanski, Edward J. "Books at Hera are More than Words on a Page." Review of *Re: Pages* at the Hera Art Gallery in Wakefield. *Providence Journal* (February 14, 1981).

Stofflet, Mary. "Books as Art at Eaton/Schoen." *Images and Issues Magazine* 2, no. 3 (Winter 1981-82): 83-84.

Tannenbaum, Barbara. "Book Forms." Review of "book forms" at Dayton Art Institute Experiencenter. *Re-dact: An Anthology of Art Criticism* 1 (1984): 182-184.

Tyson, Janet E. S. "Constructed Fictions." Review of the work of Nat Dean and Wayne Smith exhibited at The Union Gallery of San José State University. *Artweek* 12, no. 37 (November 7, 1981): 4.

Weisberg, Ruth. "Bound Statements." Review of *Art and Society: Book Works by Women*, at Beyond Baroque, Santa Barbara. *Artweek* 12, no. 37 (November 7, 1981): 4.

Welish, Marjorie. "The Page as Alternative Space, 1909-1980, at Franklin Furnace." *Art in America* 69, no. 9 (November 1981): 172.

Welles, Elenore. "Personal Books." Review of exhibition *Diaries, Notebooks and Journals by Women Artists 1970-1983* at Long Beach Museum of Art, Long Beach, California. *Artweek* 14, no. 34 (October 15, 1983): 16.

Whitfield, Tony. "Space Cases." Review of *The Page as Alternative Space, 1909-1929* and *De Appel at Franklin Furnace* at Franklin Furnace. *The Village Voice* 25, no. 46 (November 12-18, 1980): 87-88.

Whitfield, Tony. *"Vigilance: An Exhibition of Artists' Books Exploring Strategies for Social Change,* Franklin Furnace." *Artforum* 19, no. 1 (September 1980): 68-69.

Winter, P. "Dieter Roth—Books." Review of exhibition at Kestner-Gesellschaft, Hanover, Germany. *Kunstwerk* 27, no. 4 (July 1974): 39-40.

Wortz, Melinda T. "Jay McCafferty." Review of an exhibition of photographic books at The Long Beach Museum of Art. *Artweek* 5, no. 17 (April 27, 1974): 1, 16.

Zoeckler, L.K. "Books that artists make." Review of exhibition at Otis Art Institute of Parsons Design Center. *Artweek* 15 (February 4, 1984): 7.

SPECIAL RESOURCES

"Artists' Books: News and Reviews." Monthly in *Umbrella* (January 1979-September 1985).

Artists books sales. Catalogues from:
Printed Matter, New York
Art Metropole, Toronto
Writers and Books, Rochester, New York
Art in Form, Seattle, Washington

Index

About the Contributors

SUSI R. BLOCH is Assistant Professor of Art History at the College of Staten Island, CUNY. Her publications include: Review, "Jackson Pollack: A Catalogue Raisonné of Paintings, Drawings, and Other Works," *Art Journal,* Fall, 1979; "Giorgio Cavallon: A Painter's Painter," *Arts Magazine,* Summer, 1976; "Interview with Louise Bourgeois," *Art Journal,* Summer, 1976; and "Duchamp's Green Box," *Art Journal,* Fall, 1974.

JAVIER CADENA is a student of Philosophy and Literature at the National Autonomous University of Mexico (UNAM) and is preparing his dissertation on marginal literary presses. During 1984 he worked as an investigator at the University Museum of El Chopo where he helped open *Marginalia,* Mexico's first outlet for small press productions.

ULISES CARRIÓN was born in Mexico and presently lives in Amsterdam, where he founded "Other Books & So Archives," a bookstore and exhibition space for artists' books. Carrión has written and lectured widely on the phenomenon of artists' books and mail art. His publications include *Second Thoughts* (Amsterdam, Void Distributors, 1980).

As an artist-publisher Carrión has contributed to numerous collective publications and published (created) his own books.

BETSY DAVIDS and JAMES PETRILLO have produced one-of-a-kind books and editions under their Rebis Press imprint since 1972. They coordinate the Book Arts Workshops program at California College of Arts & Crafts. Their performance work includes Voice From the Fire, based on the life and work of William Blake.

FELIPE EHRENBERG is a working artist who engages in all facets of art production and distribution believing that art is an essential part of the social fabric, not the exclusive domain of a privileged elite. In 1969, Ehrenberg moved to England, where in 1970, he became a co-founder of Beau Geste Press in Devon. Since his return to Mexico, in 1975, he has continued the press under its alternative name, Libro Acción Libre. He is a painter, creator of happenings, performance artist, bookmaker, photographer. Ehrenberg has produced videotapes and films, taught art in many different settings, and written numerous articles on art and other subjects.

JON HENDRICKS is curator of the Gilbert and Lila Silverman Fluxus Collection, archivist of the Judson Arts Program Archive, and a member of the Guerilla Art Action Group. From 1976-1982 he was partner, with Barbara Moore, in Backworks. Hendricks is editor of *FLUXUS ETC.; FLUXUS ETC./ADDENDA I; FLUXUS ETC./ADDENDA II;* and *FLUXUS ETC./AD-DENDA III.* He is also editor of *Manipulations* and co-author of *GAAG.*

DICK HIGGINS (born 1938) founded Something Else Press in 1964. He published artists' books under its imprint until 1973 and continues to do so with the Printed Edition co-operative in New York.

RICHARD KOSTELANETZ has produced visual art with words, numbers and lines, videotapes, audiotapes, holograms, and films, in addition to over five dozen books on various subjects, including thirty-three titles classified as "book-art books." A complete list is available from P.O. Box 73, Canal Street Station, New York, New York 10013.

JOAN LYONS is founder and coordinator of the Visual Studies Workshop Press. Since 1972, the press has printed and/or published over 200 books by artists, photographers, and writers as well as theoretical and historical titles in the visual arts. Lyons is an artist who works in photography, books, and print media.

BARBARA MOORE is an art historian and writer specializing in alternative media—mostly publications and performance—of the second half of the twentieth century. She was the first editor (1965-1966) at the Something Else Press and co-owner of Backworks (1976-1983), the New York shop dedicated to promoting awareness of experimental art of the '50s and '60s. With her husband, photographer Peter Moore, she manages an archive of performance photos and related documents. She also currently publishes continuations of classic Fluxus editions under the imprint ReFlux Editions, and is working on a book about happenings artist Ken Dewey.

MAGALI LARA is a painter and a visual poet who teaches at the National School of Visual Arts in Mexico City, where she also coordinates the Department of Cultural Activities. An enterprising self-publisher, she has produced a series of visual texts and book-objects, of which "Se Escoge el Tiempo" (Time is Chosen), in collaboration with Lourdes Grobet, is her latest. In 1984 she organized a project called "Book Proposals," sponsored by the school, winners of which had an edition of their book-work published at the school's printing shop, thus effectively including experimental publishing in the institution's curriculum.

LUCY LIPPARD is a writer and an activist, author of thirteen books including *Ad Reinhardt, Eva Hesse, Changing: Essays in Art Criticism, Six Years: The Dematerialization of the Art Object, From the Center: Feminist Essays on Women's Art, Overlay: Contemporary Art and the Art of Prehistory, Get the Message? A Decade of Art for Social Change,* and a novel *I See/You Mean.* Lippard is a contributing editor to *Art in America,* and writes a monthly column for the *Village Voice.* She is co-founder of *Heresies,* Printed Matter, and P.A.D.D. (Political Art Documentation/Distribution) and has curated over thirty exhibitions throughout the world.

ROBERT C. MORGAN is a painter and intermedia artist with a Ph.D. in Art Criticism from New York University. In addition to his prolific output as an artist, Morgan has written extensively about contemporary art and has curated exhibitions, including the first retrospective of works by the Soviet emigres, Komar and Melamid, at the Ulrich Museum of Art (Wichita, Kansas) in 1980. Morgan currently teaches Twentieth Century Art

and History of Design at the Rochester Institute of Technology. His forthcoming book, *The Trade in Ideograms*, is scheduled for publication with Tanam Press in 1985.

CLIVE PHILLPOT, writer, lecturer, curator, and art librarian, is currently Director of the Library of the Museum of Modern Art, New York and a member of the Board of Directors of Printed Matter, Inc. Phillpot has written about artists' books since 1972, in magazines such as *Studio International, Art Monthly, Artforum, Art Journal, Art Documentation,* and *Arts in Virginia.* He was guest editor of *Art Journal* Summer, 1982 and *Art Documentation* December, 1982, as well as contributor to a number of books and catalogues about artists' books.

SHELLEY RICE, a New York based critic specializing in photography and multi-media art, has published articles in *Art in America, The Village Voice, Artforum, Afterimage, Ms. Magazine, The New Republic,* and other publications.

ALEX SWEETMAN is an educator, artist, and writer who teaches photography, art history, and criticism at the School of the Art Institute of Chicago. Well known as a lecturer and picture researcher, Sweetman has been writing about photography books and assembling a major collection of them for more than a decade. His creative work includes installation, bookworks, video and audio tapes, and photography. Presently working at the University of Colorado, Boulder, he is researching the photography of exploration and completing a book about photography books.